The
Throne of the Great Mogul
in Dresden

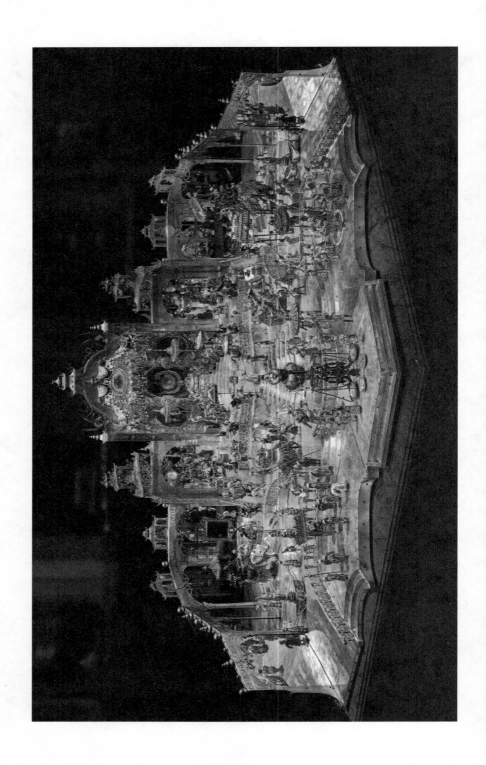

The
Throne of the Great Mogul in Dresden

The Ultimate Artwork of the Baroque

Dror Wahrman

Yale

UNIVERSITY PRESS

NEW HAVEN AND LONDON

Published with assistance from the Annie Burr Lewis Fund, and from the foundation established in memory of James Wesley Cooper of the Class of 1865, Yale College.

Yale University Press books may be purchased in quantity for educational, business, or promotional use. For information, please e-mail sales.press@yale.edu (U.S. office) or sales@yaleup.co.uk (U.K. office).

Frontispiece (Figure 1): Johann Melchior Dinglinger, *Throne of the Great Mogul*, 1701–1708

Set in Fournier MT type by IDS Infotech Ltd.
Printed in the United States of America.

Library of Congress Control Number: 2022941005
ISBN 978-0-300-25193-7 (hardcover : alk. paper)

A catalogue record for this book is available from the British Library.

This paper meets the requirements of ANSI/NISO Z39.48-1992 (Permanence of Paper).

10 9 8 7 6 5 4 3 2 1

To Roni and her vision

Contents

Plate section follows page 138

Illustrations

Figures

Plates (following page 138)

Note on Names and Dates

Names in the early modern period were fluid. Augustus the Strong's electoral title was Friedrich Augustus I, and then as king of Poland Augustus II. I refer to him by his most familiar nickname, Augustus the Strong.

I use below two spellings for the Mogul/Mughal Empire. For early modern voices I use the common spelling of the time, Mogul—as in the *Throne of the Great Mogul*. For the hindsight of the twenty-first century I use the standard scholarly form, Mughal.

Dates were also unstable in the early modern period. The default dates in what follows are New Style, corresponding to the modern calendar.

Acknowledgments

This is first and foremost a Wiko book. I wrote its lion's share at the Wissenschaftskolleg in Berlin, a perfect setting for an eclectic project. The conversation with fellow fellows and staff specializing in so many different fields inspired unexpected insights. I owe an enormous debt to the Wiko library team, who put their dedication and professional expertise at my disposal. Anja Brockmann, Stefan Gellner, Kirsten Graupner, Sonja Grund, and their colleagues provided many hundreds of sources and references and helped with difficult riddles, continuing remotely even after the coronavirus arrived.

This book also benefited enormously from the generosity of museum curators and restorers who shared their expertise and methodology, often distinct from that of academic scholars. First, at the Staatliche Kunstsammlungen Dresden: Michael Korey, Petra Kuhlmann-Hodick, Rainer Richter, Claudia Schnitzer, Dirk Weber, Julia Weber, Ulrike Weinhold, and above all Dirk Syndram, former director of the Grünes Gewölbe. Elsewhere: Peta Motture, Susan Stronge, Holly (Marjorie) Trusted, and Simona Valeriani, Victoria and Albert Museum; Philippe Malgouyres, Louvre; Paulus Rainer, Kunsthistorisches Museum; Dirk Jan Biemond and Suzanne van Leeuwen, Rijksmuseum; Sybe Martena, Bayerisches Nationalmuseum; Richard Ruhland, Museum Rupertiwinkel in Tittmoning; Valentina Conticelli, Palazzo Pitti; Lars Ljungström, Swedish royal collections; Anna Grochala, National Museum in Warsaw; Giulio Sommariva, Museo dell'Accademia Ligustica in Genoa; Wolfram Koeppe, Metropolitan Museum of Art; and Doron Lurie, Tel Aviv Museum of Art.

The research for this project and its presentation could not have been completed without the spectacular digitally created photographs of the Dresden-based photographer Jörg Schöner. The book illustrations were prepared by Christopher Martiniano, the English professor doubling as my

amazingly talented and patient graphic designer. Many scholars offered valuable angles and shared their knowledge on a wide variety of topics: Paul Babinski, Malcolm Baker, Hall Bjørnstad, Yigal Bronner, Maureen Cassidy-Geiger, Raz Chen-Morris, Fanny Cosandey, Annette Cremer, Ayelet Even-Ezra, Mary Favret, Luca Giuliani, Hanneke Grootenboer, Margaret Hunt, Peter Heinrich Jahn, Efrain Kristal, Tijana Krstic, Krystian Lada, Ian Maclean, Peter Mandler, Patrick Manning, Meredith Martin, Guido van Meersbergen, Peter Miller, Yair Mintzker, Martin Mulsow, Anne-Simone Rous, Daniel Schönpflug, Anna Schreurs-Morét, Alexander Schunka, David Shulman, Kim Siebenhüner, Larry Silver, Moshe Sluhovsky, Jonathan Spangler, Philip Stern, Allison Stielau, Barbara Stollberg-Rilinger, Daniel Stolzenberg, Z. S. Strother, Verena Suchy, Elisabeth Tiller, Achille Varzi, Helen Watanabe-O'Kelly, Paola von Wyss-Giacosa, and Zhiyi Yang. Over the past decade I presented this project in numerous settings; I am grateful to the participants for their thoughts and questions.

The research for this project was generously supported by the Israel Science Foundation (grants nos. 1397/13 and 439/18, as well as book grant no. 84/22), and early on by a grant from the College Arts and Humanities Institute at Indiana University–Bloomington.

At Yale University Press this book benefited from the professional expertise of Jaya Chatterjee, Bill Frucht, Amanda Gerstenfeld, Margaret Hogan, Jeff Schier, Eva Skewes, and Mary Valencia. Marie Deer meticulously prepared the index.

In addition to the astute readers for Yale University Press, my friends and colleagues Jonathan Elmer, Suzanne Marchand, Ray Schrire, and Jonathan Sheehan generously read the full book manuscript, each with a particular analytical eye and rhetorical ear. The unplanned conception of this book took place at Indiana University in 2010–2011, shortly before my first visit to the Grünes Gewölbe, in a lecture series that I organized with my longtime intellectual jousting partner Michel Chaouli, titled *Masterclasses in the Humanities: The Art of Interpretation*. Taking interpretation as a practice that marks the humanities as a whole but is not often reflected on as such, we invited master practitioners in different humanistic disciplines to present focused interpretations of single objects rather than mobilize these objects in support of an external argument. This fantastic series left me determined to attempt something similar—and somewhat to my surprise, this book turned out to be it.

My recent research students at the Hebrew University of Jerusalem lived with this project throughout their own. In my course "Art and History," intended to teach budding historians how to incorporate works of art into their archive, we practiced together ways of thinking that inform the following pages. Elya Assayag, Idit Ben Or, Boaz Berger, Tobias Bitterli, and Ray Schrire joined as my research assistants, especially valuable when I was juggling work on the book with serving as dean of humanities and then president of a college.

My daughters Shani and Maya are already used to the fact that all travel plans include museums with unusual exhibits and back rooms with few visitors, and I am gratified with their continuing enthusiasm for my quests. I met my life partner, Roni Taharlev, shortly after meeting Dinglinger. Being a painter from observation with the keenest eye, combined with the deepest grounding in the history of European art, she has transformed my way of facing artworks and of thinking about them. Although we still find sometimes our scholarly and artistic perspectives at cross-purposes, I see now many things I simply did not perceive before. The book is dedicated to Roni and her vision.

The
Throne of the Great Mogul in Dresden

Introduction

The Prince, the Jeweler, and the Mogul

This is a book about an art object. Reputedly the most expensive single artwork of the Baroque. Subjectively—since I have no idea with what metric to support such a claim—it may well have been the single most extraordinary decorative artwork in early modern Europe. It is perhaps best characterized as the ultimate flare of the Baroque, its final stand.

I first encountered this object a decade ago, walking out of the famous Grünes Gewölbe in Dresden. The treasury of the Saxon ruling family had only shortly before been reconstructed from the post–World War II rubble to its original 1733 layout, just as it was at the death of its founder, the elector Friedrich Augustus I, better known as Augustus the Strong. An audioguide accompanied me through a seemingly endless collection of extraordinary artworks, arranged by material and genre, the repetitive abundance of which spelled excess at every turn. And yet when I reached this particular object, titled the *Throne of the Great Mogul*, belonging to the same collection but now exhibited in an adjacent museum space, it stood out from the rest, heralding a whole new level of extraordinariness, one unmatched in Dresden and perhaps anywhere else (see frontispiece [fig. 1]; plate 2). For me, moreover, a historian interested in incorporating works of art into the historical archive of their time and place, it also stood out as the most inexplicable. Standing next to it for a long hour, the question that hammered in my head again and again, admittedly lacking much scholarly finesse, was, "*What the heck?*" That question was the birth of this book.

The *Throne of the Great Mogul* is the stuff that dreams are made of, not history books. The words that most readily come to mind for modern observers encountering this work of decorative art are borrowed from the realms of fantasy, marvel, and fable. As Allison Stielau has aptly put it, the *Throne of the Great Mogul* could well be the embodiment of the well-worn literary motif whereby a ruler challenges his most ingenious and daring subject with an impossible task; the hero triumphs by means of his prodigious material, mental, and magical resources, delivering an unparalleled invention and obtaining the just reward of the fairytale.[1]

The narrative expectations of fairytales, however, are not the same as those of history. The more closely one observes the *Throne of the Great Mogul*, the more one realizes that as an actual historical artifact, created by a historical agent in a concrete historical situation, it appears to make little sense. The quandary, furthermore, becomes vertiginous, as one also realizes that it is simply not possible—visually or conceptually—to hold together all the parts of the *Throne of the Great Mogul* at once, let alone place them in an explanatory narrative.

Consider the experience of visiting a Baroque church. As one slowly moves around, adjusting one's eyes and focus to different scales, the cumulative whole emerges gradually, piecemeal, from what at first appears as a dense excess of disconnected parts vying for the visitor's attention. This book attempts a similar experience for the beholder of the *Throne of the Great Mogul*, with the added difference that the parts range from a few centimeters down to a few millimeters at ever-shrinking scales which correspond with the Baroque drive to test human sensory limits. Importantly, the same proliferation of parts characterizes not only the form but also the content. One would be hard pressed to find another object or artwork in early modern Europe that strives to achieve so much, and that engages with so many big questions, in a single piece, let alone a piece that is some two human strides from side to side. The *Throne of the Great Mogul* is the ultimate Baroque artwork in the two senses in which the word "ultimate" is commonly used. It is in many ways the epitome of Baroque capabilities, Baroque sensibilities, and Baroque extravagant excess. It is also in many ways the last artwork of the Baroque, having set an unrepeatable example that indeed remained unrepeated.

Its creator, the Dresden court jeweler Johann Melchior Dinglinger, knew as much. In 1707 he offered the *Throne of the Great Mogul* to his Saxon

prince, Augustus the Strong, with the following words: "Such a work *has never yet been offered by any artist, and none will ever occur in times to come*. . . . Nowhere will such a piece be found in the cabinet of any great ruler."[2] As what follows demonstrates, this was no mere rhetorical flourish. There was indeed no precedent, parallel, or subsequent imitation to this singular work of art. Its very uniqueness, as I suggest in the penultimate chapter, was key to its meaning.

Writing a book about a complex art object that is manifestly unique in both form and content requires some bending of the historical genre. I have not written a book like this one, and I remain unaware of a precedent. Perhaps this is not surprising: the structure of this book, ultimately, is shaped by the unique features of the *Throne of the Great Mogul* itself.

What follows does not progress one step after another from question to answer while connecting the dots of a scholarly argument in the usual linear manner. Instead, *The* Throne of the Great Mogul *in Dresden: The Ultimate Artwork of the Baroque* progresses in what is best described as a floral pattern, in the manner that a child draws a flower. At the center of the flower stands the *Throne of the Great Mogul*. Each of the twelve chapters begins at the center and traces, petal after petal, a movement away from the artwork and then back again. Each petal-chapter introduces the reader to a different historical question or domain of historical experience brought up by a different aspect of Dinglinger's creation. These domains are variously political, diplomatic, artistic, intellectual, religious, or cultural. They range from the very tiny to the quasi-global. They represent the points of view, variously, of the prince, the jeweler, or the Mogul. They attain their meaning in different early modern settings, be they Dresden and Saxony, the Holy Roman Empire, or Europe as a whole, sometimes together with Asia and Africa.

Individual chapters advance specific arguments that represent freestanding contributions to their respective domains of historical inquiry. Inter alia, what follows reconsiders the drive of prince-electors of the Holy Roman Empire at the turn of the eighteenth century to cement their absolute rule, not least by obtaining a crown. It directs attention to a distinctive, previously unnoticed quasi-global pattern of exchange, imitation, and appropriation of embodiments and practices of absolute rulership, involving rulers from across the Eastern Hemisphere, in Asia and Africa as well as Europe. In the domain of art and material culture, other chapters highlight a distinctive

seventeenth- and early eighteenth-century pattern of European investment in miniaturized objects and scale-altering models, a heretofore unstudied cultural phenomenon that cut across multiple types of cultural artifacts. Another chapter, still within the history of European art, draws attention to a distinctive stage in the history of replication in certain genres, and to how some artists resisted the potential for replication. Another set of issues concerns religion, in particular a distinctive historical juncture in the balancing of religiosity and play in artistic objects. In a more intellectual-history vein, the *Throne of the Great Mogul* incorporates unexpectedly an elaborate subtext dealing with the survival and reenactment of early modern antiquarian theories of global religious history and their implications for understanding human diversity around the world. Finally, what follows draws connections between Dinglinger's masterpiece and the better-known story from the Dresden court during the very same years, namely the so-called invention of porcelain.

Each of these topics can and perhaps should be a separate essay in its own domain, but such dispersal would completely miss the point of the *Throne of the Great Mogul*. Hence the multiple petals of the flower. The outcome of these different chapters brought together is not a single argument but rather a cumulative, gradually emergent historical interpretation of a unique, almost infinitely complex object. The aggregate, I hope, does justice to Dinglinger's pride in the singular uniqueness of the *Throne of the Great Mogul*, not least by highlighting how the jeweler succeeded in a single artwork to comment on, intervene in, and sometimes literally embody so many of the most intriguing questions of his time.

Let me now set up the *mise-en-scène*, a brief introductory sketch of the *Throne of the Great Mogul* together with its cast of characters—the prince, the jeweler, and the Mogul—and its physical surroundings in the *Schatzkammer*, or court treasury, in Dresden.

The prince of our story is Friedrich Augustus I, who in 1694, upon the unexpected death of his brother, became the prince-elector of Saxony (plate 3). His common epithet, Augustus the Strong, derived from his inordinate physical strength: rumors circulated of a horseshoe bent by hand or of single combat with a bear, as well as of insatiable sexual prowess. That Augustus himself encouraged this image became clear in the medal he struck on the occasion of his accession to power, sporting an image of Hercules and the inscription *Hercules Saxonicus*. Saxony, the land that Augustus inherited,

was probably the richest principality in the Holy Roman Empire, that loose, decentralized conglomeration of multiple territories in the Germanic sphere. "Prince-elector" meant that the Saxon ruler was among the privileged individuals who participated in the electoral college selecting a new emperor. Saxony, owing its wealth primarily to mining, boasted two major cities: Leipzig, with its three famous annual international fairs, and Dresden, capital of Saxony since the mid-sixteenth century, with a population of some forty thousand people around 1700. The electors from the Albertine branch of the Wettin dynasty, to which Augustus belonged, invested in the city's architecture, in its cultural life—notably church music, opera, theater, and ballet— and in its rich royal collections. The palace, an impressive, multi-winged, fortified residence along the Elbe riverfront, boasted a *Schatzkammer* of unusual objects that was one of the richest in Germanic lands. Augustus, an obsessive collector, continued to expand the collection throughout his life on an unprecedented scale, part of his effort to turn the Dresden court into "the most dazzling in Europe," or at least to turn Dresden into a major capital city on par with Prague, Vienna, or Berlin.[3]

In 1697, in a complex set of maneuvers explained in chapter 2, Augustus became also king of Poland and Lithuania, under the name Augustus II. Shortly thereafter he became embroiled in a war against Charles XII of Sweden—known as the Great Northern War—and was mightily defeated, losing his crown and in 1706–1707 suffering a humiliating Swedish occupation of Saxony itself. It was then, at the low point of his public career, with his restive realm on the verge of bankruptcy and his soldiers rioting for lack of pay, that Augustus was approached by his court jeweler, Johann Melchior Dinglinger. Dinglinger, who arrived in Dresden in 1692 and became court jeweler six years later, was possibly the best goldsmith and jeweler working in Europe at the turn of the eighteenth century (plate 1). One measure of Dinglinger's international reputation was his close relationship with the Russian tsar Peter the Great, who, when visiting Dresden a few years later, was to insist on staying in Dinglinger's house for a full week, replete as it was with interesting objects for Peter to inspect. On 11 October 1707 Dinglinger sent Augustus the letter offering him the *Throne of the Great Mogul*, which Dinglinger and his two brothers had been creating in their workshop since 1701. Insisting that this was a decorative artwork the likes of which had never been seen nor would ever be again, Dinglinger requested for it a phenomenal price: the price, it has often been noted, of a rather large castle.[4] Within a year

and a half, the object, which Dinglinger completed and delivered together with an explanatory text, was on display as the *pièce de résistance* of Augustus's treasury collection, newly arranged around it.

The difficulties in conceptually encompassing the *Throne of the Great Mogul* as an ensemble of its many parts, or in providing it with a linear interpretation, are also obstacles to apprehending it in a succinct, adequate description. Already its name, *Der Thron des Großmoguls*, fails to capture adequately what actually goes on in this complex presentation. The *Throne of the Great Mogul* can be given numeric descriptors: it measures 142 x 114 x 58 centimeters; it sports 164 pieces; it contains 4,909 diamonds, 160 rubies, 164 emeralds, 16 pearls, and 1 sapphire (in addition to 391 gems now lost). These numbers, repeated in every depiction of this artwork, make one gasp in awe but bring us not much closer to a description. Other descriptions, from Dinglinger's 1707 letter that launched this artwork into the world down to the present day, take the form of inventories, substituting a list of the parts for a meaningful description of the whole. Of course, we can circumvent the verbal description with the unmediated photograph (plate 2; frontispiece). But not even the best panoramic photograph, taken with a special technique developed especially for this purpose, allows the beholder properly to discern the details of this creation, let alone to reconstruct the air of impossible lightness with which it impresses a viewer standing next to it.[5]

Furthermore, even an actual viewing in the Grünes Gewölbe in Dresden is not satisfactory. Modern museum visitors can only circle the *Throne of the Great Mogul* behind a protective glass cage that keeps them at a distance from the huge number of tiny details they are bound to miss. Their encounter with the *Throne of the Great Mogul*, moreover, is a visual experience only: it is not possible to hold the pieces, inspect them closely, or appreciate the different materials skillfully melded together. The visitor, therefore, rarely fails to express astonishment but is likely to depart confused and overwhelmed.

Let me then conclude this introduction with a brief description, leaving the more detailed discussion of specific details or ensemble parts for later chapters.[6] The ensemble of the *Throne of the Great Mogul* is set on a three-tiered, stage-like architectural scenery in the shape of a curved triangle, on a foundation of silver and gilt wood, ascending toward a crescendo in the throne canopy or baldachin. On this theatrically looking tabletop set, delimited by walls from three sides, are 164 miniature pieces, almost all

freestanding and moveable, arranged with the aid of balustrades and stairs. They include human figures—all male—some four to five centimeters tall, together with animals and inanimate objects. These are exquisite pieces of jewelry-work, combining gemstones with staggeringly intricate work in colorful enamel: the individual pieces by themselves could have been conversation pieces in any princely *Schatzkammer*. The scene they create together is the court of the Indian Mughal emperor Aurangzeb in Delhi, depicted at the time of his birthday celebrations. The Great Mogul sits on his throne at the center of the *mise-en-scène*, at the top of the golden staircase, underneath a huge sun, overshadowed by the highly ornate baldachin and flanked by imperial attendants (plate 4).

The court activities on the Great Mogul's birthday are marked in Dinglinger's tableau in two ways. Across the busy court, dignitaries with their retinues are presented bringing imposing gifts to the Great Mogul, thirty-two in number, all carefully identified in the accompanying text: from caparisoned elephants and camels, through a fully working European clock and a miniature chest hiding tiny weapons with working mechanisms (e.g., plates 5, 6, 26), to curious pyramids and standing hands densely covered with mysterious symbols (plates 38, 40). Since the pieces are freestanding, their placement is not fixed. Today's reconstruction is based on a careful reading of the descriptive text together with a 1739 engraving after a detailed drawing by Anna Maria Werner, a goldsmith's daughter and personal friend of Dinglinger's, which is the only visual documentation of the *Throne of the Great Mogul* from Dinglinger's lifetime (fig. 2).[7] At the front of the scene stands the most significant gesture to the Great Mogul's festive celebration: ornate scales with gold and silver coin baskets, attended by several functionaries (plate 7). The best-known event during the birthday of the Mughal emperor (though apparently discontinued at some point during Aurangzeb's reign) was the weighing ceremony, in which the emperor was placed on scales and weighed against gold, silver, rice, and, by some accounts, other items, which were then distributed as charity.[8]

These elements and many others are analyzed, each in its own context, in what follows. As I have already pointed out, it is not possible to hold together all the parts of the *Throne of the Great Mogul* at once. The whole is not simply bigger than the sum of its parts; it is on a different plane. This, ultimately, is what creates the fundamental indescribability of the whole, and why the overall effect is truly, literally, overwhelming.

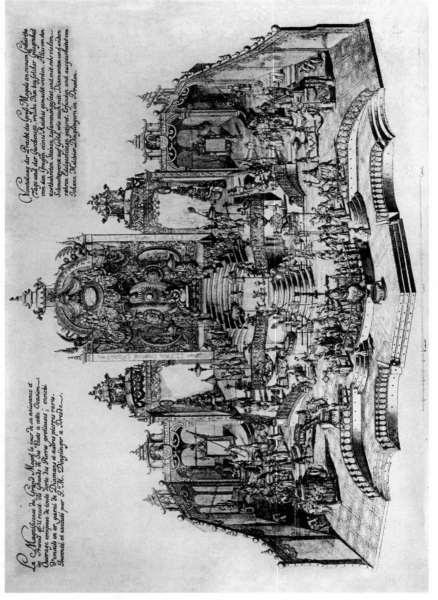

La Magnificence du Grand Mogol le jour de sa naissance et la fraicuy de sa course de Grandis de Sa Etat a cette Occasion. Ouvrage composé de toute sorte des Pierre prelieuses; enrichi d'Emaille en or, garni de Diamans et autres pierres rarus. Inventé et executé par J.M. Dinglinger à Dresd——.

Vorstellung der Pracht des Groß=Mogols an seinem Geburths Tage und der Porchause, welche Ihm bey solcher Gelegenheit von den Großen, seines Reichs gemacht werden. Alles von den kostbahresten Steinen, zusammengesetzt, und mit vielen dem, Schmelzwerk auf Gold, wie auch mit Diamanten und andern raboen Edelgesteinen gezieret. Erfunden und ausgearbeitet von Johann Melchior Dinglingen in Dresden.

Figure 2. Christian Philipp Lindemann's 1739 engraving of the *Throne of the Great Mogul*, after a drawing by Anna Maria Werner

I opened with my puzzlement when I first encountered the *Throne of the Great Mogul*. The questions that have driven me to write this book should now come into sharper focus. How can we understand the underlying transaction between Dinglinger and Augustus? Why did the prince agree to such an outrageous expense when the country was exhausted from war and its treasury depleted? Why did the jeweler spend eight years with his two brothers on a personal whim of a project that must have exhausted their resources, with no guarantee of a patron? Why select this particular theme of the *Thron des Großmoguls*—a representation of a living foreign potentate on the other side of the Northern Hemisphere (Aurangzeb died just as Dinglinger's work was about to be completed)? And why represent this theme in such a singular, impossibly intricate, unprecedented form, with so many unique and mysterious features? In short, how can we make sense of this object, of this transaction, of this tremendous artistic investment and effort? What does the *Throne of the Great Mogul* mean?

1. Mirrors (or, Fantasies of Absolute Rule)

In the second niche to the right of the Great Mogul in Dinglinger's creation we find a large freestanding mirror, framed with miniatures of antique cameos (fig. 3; plate 6, top). Originally there were two such mirrors, listed in Dinglinger's textual description as gifts to the Mogul from two dignitaries. Anna Maria Werner's drawing of the ensemble, printed in 1739 (see fig. 2), shows the two mirrors on each side of the Mogul facing the frontal viewer, as the surviving one does today.

On second look, the mirror is puzzling. It is nominally a gift to the Mogul and yet it does not rest on a litter like other large gift objects that are being paraded before him. Next to the mirror stands a single attendant; originally there were two, one for each mirror. Given that the mirror is about twice the height of the attendant, it is a miniature of quite a large and expensive object, requiring several carriers to move around. And most surprisingly for an object intended for the Great Mogul, the mirror faces the viewer standing in front of the model, not the Mogul himself, who is otherwise the focal point of every figure as well as the direction toward which every object is moving. (The mirrors may of course have faced the Mogul in the original arrangement of the pieces, but this is unlikely, given their frontal design and function and considering Werner's drawing.) It thus makes more sense to view the mirrors as ceremoniously analogous to the scales: objects that are part of the special equipment of the court on this day, placed in correspondence with its architecture and accompanied by attendants overseeing their proper use. Furthermore, the fact that the sidewalls of the court are covered with mirrors underscores that the ornamented, freestanding mirror right in

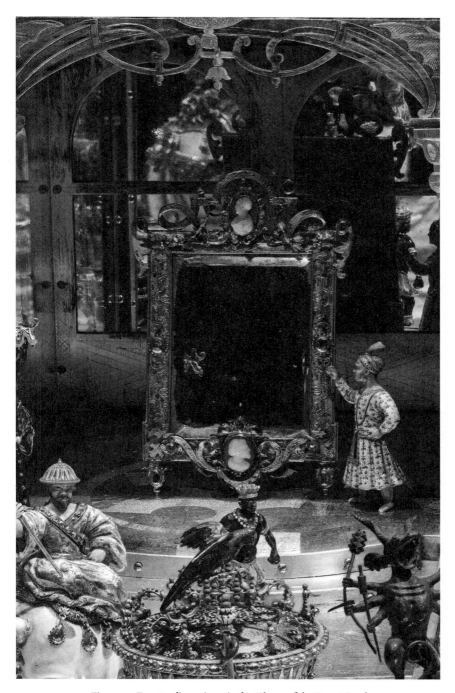

Figure 3. Freestanding mirror in the *Throne of the Great Mogul*

front of them is not there merely for functional reasons. So what was the purpose of these large, freestanding ceremonial mirrors, and who were they for? To answer these questions, we need to know a few things about mirrors.

In 1762 the Russian Empire experienced a coup d'état. The recently crowned Peter III, Peter the Great's grandchild and a German prince through and through, was deposed by his German wife, Princess Sophie Friederike Auguste von Anhalt-Zerbst-Dornburg, who ascended to the throne as Catherine II and later became known as Catherine the Great. Catherine dedicated the first months of her reign to bolstering her legitimacy and standing, overcast by the clouds of usurpation, regicide (Peter died mysteriously shortly after the coup), and femininity. To that purpose, in addition to planning the most sumptuous coronation spectacle in Russian history, the new tsarina also commissioned two regal portraits of herself, executed with great speed by the heretofore little-known Danish painter Vigilius Eriksen. Our interest here lies in Eriksen's second regal portrait, a rather unusual one entitled *Portrait of Catherine II before a Mirror* (plate 8).[1]

Eriksen's painting is really a double portrait. The "real" Catherine is turning her head and looking at the viewer with some emotion, her hand pointing to herself. The Catherine in the mirror is looking straight, erect and emotionless, complete with a Grecian profile that was immediately recognizable from her medals (themselves also minted for her by Western artists). The "escape" of the reflected monarch from the "real" monarch is intended to be immediately noticeable. The painting reminds the viewer that the empress has two bodies, two natures: one, eternal and transcendent, drawing on the antique origins of the crown; the other, dynamic, human, and feminine (note the fan in her hand and the coquettish satin shoe visible under her dress), drawn from the occupant of the position in the present. The King's (read Queen's) Two Bodies—a well-worn European theory of monarchy, here translated into visual terms in a portrait painted within months of Catherine's accession.[2]

Eriksen's device for conveying the monarch's double nature was a mirror. The role of the mirror is accentuated in the playful placing of the queen's scepter, positioned vertically to the mirror so that its reflection seems like the seamless extension of the "real" scepter, thus connecting both planes as a doubleness that represents one unified monarchical whole. While unusual, this device was in fact drawing on a venerable tradition going back

to the Renaissance and Middle Ages: a primarily literary tradition—"genre"
may be too constraining a word given the variety involved—of the texts
commonly referred to as "mirrors for princes." These texts, by one count
exceeding a thousand in number, were guides to the education and comport-
ment of princes. The "mirror" they put in front of their intended audiences
was that of the *exemplum*, the carefully drawn and diligently cultivated ideal
to which the prince should aspire.[3] The key to a mirror for a prince, then, is
that it does not *reflect* the real prince it faces but rather presents to the prince
an ideal image, a carefully designed picture that originates in an act of human
creation.

This, therefore, is precisely the painterly effect that Eriksen created for
Catherine the (soon to become) Great. Indeed, since the mid-seventeenth
century—a period in which the literary "mirrors for princes" actually began
a century-long terminal decline—there were several significant examples of
transpositions of the basic idea of the mirror for a prince into visual form.
When the *Speculum principum* of the fifteenth-century Spanish jurist Petrus
Belluga was republished in Brussels in 1655, the publisher added a frontis-
piece, apparently without precedent, showing a prince holding an actual
mirror (fig. 4).[4] As a mirror for a prince, however, the image it displays is not
a straightforward reflection of what is in front of it but rather adds to the
ruler an immaterial companion female figure, presumably one of the virtues.
The designer of this frontispiece underscored the unique function of the
mirror for the prince through a gratuitous juxtaposition with a second mirror,
a private oval looking-glass held by one of the female attendants to the
prince, thus differentiating the corporeal mirror serving vanity from the
princely one offering an exemplum.

In painting, the following year witnessed perhaps the earliest and most
famous example of a painted mirror for a prince, in Diego Velázquez's *Las
Meninas* (plate 9). This was actually a mirror for a princess: the painting is
focused on the five-year-old Spanish *infanta* Margaret Theresa. It is a
complex, multifigure composition involving the princess, her ladies-in-
waiting to her sides (the *Meninas*), a mirror above her head with the some-
what indistinct yet powerfully translucent reflections of the king and queen,
and the painter Velázquez himself, sitting in front of a huge canvas inacces-
sible to the viewer. Of the many interpretations offered for this arresting
painting, the most persuasive, in my view, is that which sees *Las Meninas* as
a clever visualization of the mirror for the prince. The mirror puts forth the

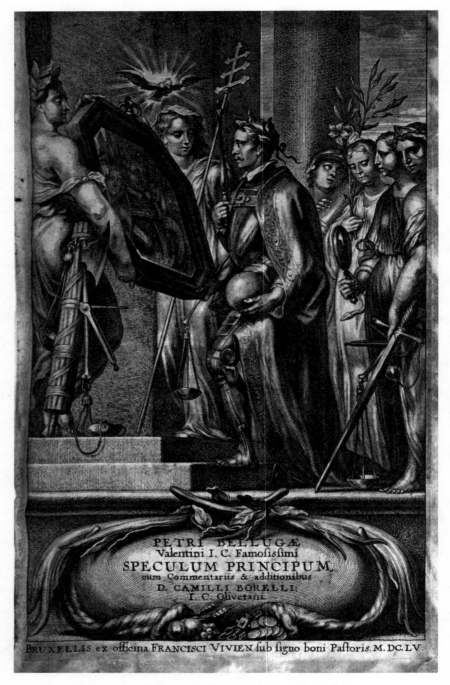

Figure 4. Petrus Belluga, *Speculum principum*, 1655 edition, frontispiece

ideal exemplum of the king and queen to which the princess ought to aspire, and the person who brings it into being and is thus instrumental in her cultivation is the painter himself, the "author" of this mirror. (Note the palette and brushes in the painter's hand, gesturing directly at the royal couple in the mirror.)[5]

Closer to our story, contemporaneously with Dinglinger's career in Dresden at the end of the seventeenth century, the same artistic representation of the mirror for princes appeared in two lesser-known European painterly compositions that juxtapose royal figures with mirrors, going beyond optical reflection to the realm of the ideal. One is a painting circa 1700 by Jacques Laumosnier, depicting a historic meeting between Louis XIV and Philip IV on the Isle of Pheasants on the French-Spanish border in which the two kings signed a treaty ending their longstanding war. The background to the painted encounter of the kings is an oversized mirror in which their reflections seem much closer and cozier than the two figures bowing respectfully toward each other in front of the mirror. That this image is a sign of continuity in the understanding of mirrors for princes is reinforced by the fact that it was actually a reduced copy of a huge tapestry from 1660 that had already hinted at a similar discrepancy between the action and its reflection in the mirror, a hint greatly enhanced in the later painting.[6]

The second example is a bit more complex but bears a direct connection to the court in Dresden, to which we wish to return momentarily. It is a painting by a Swedish painter of noble descent, Amalia von Königsmarck, who in 1689 depicted herself presenting a portrait of her queen Ulrika Eleonora the Elder (plate 10).[7] Von Königsmarck's painting was however designed in such a way that the portrait of the queen also looks simultaneously like a mirror, in part reflecting the artist herself, with conspicuous "mirroring" in their respective crown/tiara, in their necklines, and in the play of fabrics. The portrait of the queen is thus presented also as a mirror created by the artist and reflecting her idealizing input: a perhaps cheeky twist on the edifying qualities of a mirror for the princess.

As it happened, Amalia von Königsmarck's sister Aurora became Augustus the Strong's first mistress soon after his accession to the Saxon elector's position in the mid-1690s. By 1696 Amalia was living in Dresden with her sister, who by then was carrying the prince's child, and repeatedly urged Aurora to introduce her in court. Amalia and Aurora stayed together even after the latter lost her charms with Augustus and spent much of their

time hobnobbing in Dresden with important courtiers and the "circle of women," or spending money at the Leipzig Fair. Amalia and her sister were thus moving in the same circles as the Dinglinger brothers. They even dined privately in Dresden with Peter the Great, who was to become one of Dinglinger's most important fans. It is likely that Amalia von Königsmarck and Johann Melchior Dinglinger knew each other, even more so when we learn from Aurora's will that she had professionally consulted Dinglinger about the value of certain pearls in her possession.[8]

This finally brings us back to the *Throne of the Great Mogul*. We cannot know whether Amalia von Königsmarck brought with her a sketch of her painting of the Swedish queen, though this would have been a plausible move for a confident, well-connected painter with aspirations to be presented at another court. We also do not know whether she and Augustus, or she and Dinglinger, ever discussed artistic strategies of royal presentation. And yet, as far as historical records go, there is a not insubstantial number of dots connecting them.

While enticing, such a connection is not at all essential to the argument. My goal in the past few pages has been to place the mirrors in the *Throne of the Great Mogul* in a broader European artistic-intellectual-political context by presenting several examples from different European courts for the visual deployment of the venerable motif of mirrors for princes. In all these examples, artists since the mid-seventeenth century used the visual medium to emphasize that what the prince's mirror shows—with the direction of the artist's skilled hand—is an inner-eye ideal representation of the prince's rule. There is little doubt that Augustus, closely aware of the goings-on in other European courts, and Dinglinger, a highly educated and well-read intellectual, were fully aware of the genre of mirrors for princes and of what to expect or infer from a mirror facing a prince.

Furthermore, they knew well what might have come closest to being an actual mirror for princes in the Dresden palace collections: the *Lüneburger Spiegel*, made by a pair of late sixteenth-century goldsmiths and given to a young new elector of Saxony by his mother, in which the mirror was framed rather heavy-handedly with dense gilded-silver biblical and classical allegories of good and bad government. As regarded Augustus, there was even a story circulating in court about an encounter with an astrologer in Venice who recognized Augustus while traveling incognito as a young prince, and who placed in front of the prince an actual mirror for princes in which he saw

not his reflection but the reflection of his future, first in the habit of an elector and then as king with crown and royal mantle.[9] And as for Dinglinger, there is in fact another creation of his, begun immediately after the *Throne of the Great Mogul*, with yet another miniature mirror bearing a crown. This one can only be understood as a mirror for the prince, in this case displaying a triumphant Hercules as the ideal exemplum for Augustus the Strong, "Hercules Saxonicus."[10]

So now recall again the singularity of the mirrors within the meticulous design of Dinglinger's *Throne of the Great Mogul*. (I am writing in the plural, though one mirror is lost.) They are listed as gifts, installed especially for the occasion. They are luxuriously ornamented objects (and in the early eighteenth century, very expensive), so they are certainly suitable for a ruler, all the more so given their larger-than-human size, which singled them out in the world of mirrors circa 1700—a point to which we will return later. They are freestanding yet not equipped with carriers and litters on which to be paraded. And most important, they are facing a viewer positioned in front of the display, rather than directed at the Great Mogul. So are they in fact intended to be mirrors for a prince? And if so, why, and what would such a conclusion actually mean?

The layout of the *Throne of the Great Mogul* as a whole further underscores the suggestion that the mirrors should be understood as mirrors for a prince. We have seen that Dinglinger's showpiece imitates a theatrical set and makes sure that the spectator is fully aware of this parallel. Seventeenth-century Baroque stage design had developed well-established norms about directionality and lines of perspective. The principle of "central perspective scenery," with one vanishing point at the back center of the stage, created a privileged viewpoint directly opposite that vanishing point, the only viewing position that allowed complete visual access to the whole scenery. This point of view became associated with the Baroque prince. It was given architectural expression in the development of the "royal box," positioned to face the center of the stage and elevated to be aligned with the scenery's vanishing point. As contemporaries often noted, for other members of the audience the performance was in truth a bipolar show, taking place on the stage and in the royal box. And as it happens, one of the earliest and best examples of such a royal (or in this case ducal) box facing the center of the stage was in the opera house opened in Dresden in 1667.[11]

We can thus reasonably assume that Dinglinger, like Augustus, was well aware of this principle of theater architecture when he staged the *Throne of the Great Mogul*. The *mise-en-scène* of Dinglinger's creation is thus determined by *two* focal points: on one side the throne of the Great Mogul, and on the other side the presumed spectator—namely, the prince for whom the whole display is arranged—in the imaginary royal box directly across from the Mogul and on the same level. Augustus the Strong's viewing experience of the model, from this imaginary royal box, needs therefore to be differentiated from that of all other spectators who, like the museum visitors today, walked around the model and viewed it top-down from all angles.[12] The mirrors in Dinglinger's model were part of the display directed at the princely spectator aligned with the Mogul. In the staging of this intricate arrangement according to Baroque principles of theatrical design, therefore, the mirrors' spatial positioning and optical function reinforced their role as mirrors for the prince.

Furthermore, the arrangement of the *Throne of the Great Mogul* as a theater stage in and of itself reinforced the mirroring relationship between the prince and the Mogul. In this, Dinglinger's ensemble followed well-established precedents set in various regal occasions of the second half of the seventeenth century in which this particular feature of Baroque theater architecture was mobilized precisely as a way of displaying large-scale mirrors for princes in theatrical form.

In Vienna in July 1668, for example, an operatic performance famous for its unprecedented scenery effects was staged to celebrate the recent marriage of Emperor Leopold I to the Spanish *infanta* Margaret Theresa of Spain, who had grown up since Velázquez playfully portrayed her under the mirror in *Las Meninas*, and who on this occasion celebrated also her seventeenth birthday. In the dénouement of the plot of the opera composed especially for this occasion, *Il pomo d'oro*, loosely based on the judgment of Paris, the goddesses declined Paris's choice, and turning to the audience, offered the golden apple to Margaret Theresa. At that dramatic moment the clouds suddenly opened to reveal at the vanishing point of the stage, directly opposite the royal box, images of Leopold and Margaret. In this staged mirror for princes, the emperor and empress appeared surrounded by their ancestors and their descendants, "whose name is legion," indicating their projected fecund future.[13] In Madrid, court guests experienced a similar effect in March 1680, during another royal wedding celebration, as part of the prologue to a

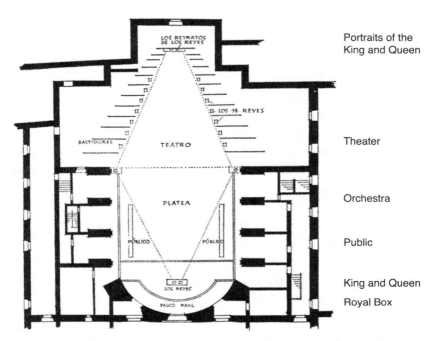

Portraits of the
King and Queen

Theater

Orchestra

Public

King and Queen

Royal Box

Figure 5. Coliseo Theater, Buen Retiro Palace, Madrid, arrangement for 3 March 1680

play dedicated to the praise of the monarchs. On this occasion the king and queen were suddenly faced with their own idealized painted portraits, enthroned under a sumptuous canopy, positioned at the vanishing point of the stage precisely opposite their own box (fig. 5). The effect was readily intelligible. One observer described the portraits as "a mirror of their originals," a mirror that showed "their singular perfections."[14] And yet this observer, like the rest of the audience, was excluded through the laws of optics as well as the norms of courtly hierarchy from the full experience of this mirroring doubleness, which was reserved for the monarchs alone.

Previous court stagings, then, especially arranged for regal celebrations, could lead to expectations of a mirroring relationship between the two focal points of the theater and the stage, one that serves as a mirror for princes to laud the exemplary monarch in the present and in the future. The attention drawn to these special occasions guaranteed familiarity with this device in other European courts. Thus, within a year of the festive encounter

in Madrid between the monarchs and their portraits, precisely the same arrangement was enacted with the images of the French king and queen in Jean-Baptiste Lully's opera-ballet *Le triomphe de l'amour,* performed for Louis XIV in Paris on the occasion of his son's wedding. This staging was then recorded with pride in the frontispiece to the published libretto of the opera-ballet. As it happens, we even know that a copy of this publication, with the frontispiece visualizing the stage-mirroring device for the celebration of the monarchs, was in the library of a collaborator of Dinglinger's in Dresden.[15] Such theatrical precedents, therefore, may well have also shaped expectations for the stage scenery that Dinglinger arranged so meticulously in miniature, likewise for a festive regal occasion, the Mogul's birthday. In Dinglinger's *mise-en-scène* this mirroring relationship took place between one ruler sitting in an imaginary royal box, namely Augustus the Strong, and another ruler sitting on his throne, namely Aurangzeb. The exemplary ideal that Dinglinger's theatrically staged mirror for a prince put forth for the Saxon elector and Polish king was that of the Great Mogul.

But why? Why focus on the Great Mogul as the exemplary ideal for the elector of Saxony and (erstwhile) king of Poland and Lithuania? The other mirrors for princes we have seen had not laid the ground for such an unusual juxtaposition. In order to understand this choice, we need to know something about the Mughal emperor. Or rather, about the image of the Great Mogul in late seventeenth-century Europe.

By the end of the seventeenth century, the Great Mogul had developed quite a reputation in the West. Its most famous expression was given a quarter century earlier by England's leading poet and playwright, John Dryden. Dryden's *Aureng-Zebe, a Tragedy* (1675)—to which some editions in the 1690s added the subtitle *The Great Mogul*—dramatized power rivalries between the aging Mughal emperor Shah Jahan and his four sons, including Aurangzeb, for political control of the throne coupled with private control of the women in court. Scholars have shown that Dryden, writing unusually about a contemporary, living ruler (an important trading partner who was likely to have gotten wind of the existence of the play), played fast and loose with the historical facts available to him in order to turn Aurangzeb into an exemplum of virtue, loyalty, and moral judgment, albeit a human one capable of making and correcting mistakes. King Charles II was apparently aware of the play's contents, and according to Dryden's dedication even lent the poet

a helping hand. Dryden's play has therefore reasonably been seen as a mirror for a prince—James, Duke of York, loyal contender for the succession—and a lesson for the English king at a time when the question of succession created considerable political tensions. What allowed Dryden to mobilize Aurangzeb for this purpose and simultaneously to retouch his history so as to make it palatable was the Mogul's considerable distance from London.[16] At one point Aurangzeb uses a somewhat different optical metaphor to convey just this situation:

> You hold the Glass, but turn the Perspective
> And farther off the lessen'd Object drive.

The glass perspective is a lens convex on one side and concave on the other, which can make an object larger or smaller, closer or further away. The distant Aurangzeb was suitable for Dryden's mirror for a prince of 1675 precisely because in some qualities one could hold the glass to show him up close, in others to "farther [him] off."[17]

As is often pointed out, Dryden's play was loosely based on information gleaned from François Bernier's account of the court of the Great Mogul, and in particular his account of the struggle of the four sons of Shah Jahan for succession to the crown, which ended with the triumph of Aurangzeb. Bernier was indeed a key source for the European knowledge of the Mughal Empire in the second half of the seventeenth century—a detailed eyewitness account based on nine years in India, written by a well-connected Parisian figure and translated immediately into several European languages. Subsequent accounts often took their cues from Bernier, who described in detail and sometimes from personal observation the ruthlessness and brutal ambition of Aurangzeb that eventually led him to the throne. Dryden completely bypassed this history as he labored to "turn the perspective" in rendering the Great Mogul into a model for a ruler.[18]

Just like Dryden's, Dinglinger's presentation of Aurangzeb was also highly selective, picking and choosing certain aspects of the Great Mogul's reputation, a reputation that by the end of the seventeenth century several other travelers and compilations had spread in addition to Bernier. Dinglinger's mirror for a prince, however, was different from Dryden's. Dinglinger was interested not in the history of Aurangzeb or in his moral dilemmas but rather in the qualities of his rule. Of the several accounts of the Mughals that were available to Dinglinger, one that he studied carefully was that by the

fellow jeweler and gem specialist Jean-Baptiste Tavernier, himself a former visitor to the Dresden court.[19] On a page with an illustration that Dinglinger used for certain details in the *Throne of the Great Mogul* he could also find the following assessment: "The Great Mogul is certainly the most powerful and the richest monarch in Asia; all the Kingdoms which he possesses are his domain, he being absolute master of all the country, of which he receives the whole revenue. In the territories of this Prince, the nobles are but Royal Receivers . . . so that this grand King of India, whose territories are so rich, fertile, and populous, has no power near him equal to his own."[20]

The Great Mogul was famous for his immeasurable riches, especially for his incomparable wealth in gems and jewels. The latter must have been an attractive mental image for the Saxon collector prince and his gem-expert jeweler. Yet in and of itself this image was probably not sufficient to encourage a cleaned-up and extraordinarily labor-intensive version of Aurangzeb as the idealized model for Augustus the Strong.[21] Rather, the key to Dinglinger's selective representation of the Great Mogul was what this passage reported as his absolute power. His was a *perfect absolutism*: a theme regularly repeated by Bernier, Tavernier, the popular armchair geographer Olfert Dapper, and others. This ideal absolutism manifested itself in a well-run, orderly kingdom in which every person knew their place; in a treasury overflowing with surplus; in influence extending both domestically and internationally; in regal magnanimity and beneficence; and in the global reach of the ruler's intellectual and cultural interests. Dinglinger inscribed each of these manifestations of the Great Mogul's perfect absolutism in the *Throne of the Great Mogul*. The point was evident in the overall design as well as in the minute details: the hierarchical arrangement of the court, the total obeisance of every figure in it, the sumptuousness of the Great Mogul's court and of the gifts presented to him, the diversity of architectural styles and the cultural variety of the gift-carrying embassies, the generosity expressed in the weighing ceremony, the cameralist order represented by the bureaucrat precisely noting the results (plate 7, top left), and so on. This perfect absolutism was the exemplum that Dinglinger's mirror for a prince put forth as the ideal rule for Augustus the Strong.

And yet, this was a risky choice.[22] The very same sources, after all, frequently also detailed the darker sides of Aurangzeb and his rule. Readers of Bernier would have also encountered his account of the lack of protection of private property and of the capricious status of Mogul law that together

led "as a sure and necessary consequence [to] tyranny, slavery, injustice, beggary and barbarism," inevitably opening the road "to the ruin of Kings and the destruction of Nations." As if forewarning directly against a future comparison like that to be proffered by Dinglinger—who himself was but a newborn baby at the time Bernier lived at the court of the Great Mogul—the Frenchman assured his compatriots: "There can be no analogy between a kingdom whose monarch [read Louis XIV] is proprietor of a few domains, and a kingdom where the monarch possesses, in his own right, every acre of the soil."[23] *There can be no analogy*: end of story.

Well, not quite. As many scholars have noted, other parts of Bernier's account contradict this decisive summation and show the Mogul in a much more positive light.[24] Bernier himself was well aware of these apparent inconsistencies, sometimes reflecting on their effect on European readers, other times trying to guide them ("I am sure that all those who reflect on this even a bit will not consider him [Aurangzeb] to be a barbarian, but rather a great and rare genius, a great political mind and a great king"[25]). For our purpose here, to be sure, it does not matter whether Bernier was inconsistent, deliberately provocative, currying favor with different intended audiences, or simply mistaken in his judgments, as readers from Voltaire to present-day scholars have variably suggested. Rather, what concerns us is that these judgments were likewise part of the potential baggage that Aurangzeb carried with him in the European imagination. Indeed, even the activity depicted in the *Throne of the Great Mogul* in such seductive detail, namely the presentation of gifts to the Mogul on his festive day, had by reputation a darker side. Bernier and more so Tavernier reported that these gifts masked what was in fact an act of extortion, "not at all agreeable to the *Omrahs*." The Great Mogul, they claimed, used his monopoly on gems and precious stones to compel his nobles to purchase jewels from him and bring them back as birthday gifts, "and in this manner the Emperor receives both the money and his jewels together."[26] All of this appears to have made Dinglinger's choice of Aurangzeb at his birthday as a model for Augustus the Strong quite risky: risky not only politically but also privately, given the Dinglinger brothers' extraordinary investment of time, money, and skill in making the point.

The risk apparently taken by the jeweler raises a question that has been nagging since the beginning of this story. *Did the prince know?* Was Augustus in on the choice of theme and design from the very beginning? Despite the

language of Dinglinger's letter in October 1707 suggesting a spontaneous generation of the *Throne of the Great Mogul* in his workshop, it would appear that Augustus probably had some knowledge of what Dinglinger was doing and some input into the project, already in its initial stages. Indeed, here and in some other Dinglinger creations, it is helpful to imagine a different model of patron-artist relationship: not a commission on the one hand, and not a freewheeling creation for a potential future transaction on the other hand, but rather something in between, a kind of ongoing exchange of ideas and expectations.

Several years before the creation of the *Throne of the Great Mogul*, at the time that Dinglinger was promoted to court jeweler, he had prepared for Augustus his first large-scale complex object, similarly a multipiece, multi-year team project without direct commission. Known as the *Goldenes Kaffeezeug* (Golden Coffee Service), this is a large table centerpiece in silver, gold, enamel, and thousands of precious and colored stones that unites in a pyramidal form forty-five vessels ostensibly for the drinking of coffee (see plate 15). It is reasonable to assume Augustus had been following its progress—for instance, during his return from Warsaw to Dresden between August 1699 and March 1700—since immediately upon its completion Augustus sent orders to Dinglinger to personally bring the new artwork to him in Warsaw. (In his new Polish capital Augustus displayed his extravagant *Gesamtkunstwerk* to the reluctant Polish nobles in support of his claims to royal status, a telling example of the direct use of *Schatzkammer* treasures as a spectacle to enhance the ruler's standing in front of his subordinates.)[27] So, did Dinglinger discuss with Augustus his plans for the next unprecedented large-scale project lacking a direct commission during his Christmas stay in Augustus's Warsaw court? Considering how the *Kaffeezeug* prefigured some key conceptual and staging moves in the *Throne of the Great Mogul*, considering the opportunity for the two men to speak—perhaps while examining the *Kaffeezeug* together—and considering the ongoing personal relationship between them, this is certainly possible and even plausible.

Later, in 1704, we have documentation that Augustus met Dinglinger in Dresden and may well have discussed details of the *Throne of the Great Mogul* work-in-progress.[28] But we can adduce one other piece of circumstantial evidence for such an exchange to have taken place already in Warsaw in 1701, before the project took shape. In order to appreciate it we need to recall a

distinctive trait of Augustus the Strong: his famously passionate if dilettan-
tish interest in architectural design. Many plans in the archives drawn or
annotated in Augustus's hand are testimony to this personal and sometimes
fanciful interest in the details of architectural arrangements and to his frequent
interventions in the work of his court architects. As his chief minister acerbi-
cally attested, "Next to gallantry, his [Augustus's] greatest amusement was
military and civil architecture, and everyone acknowledged that he had good
command of both. Nevertheless, he has not yet accomplished anything in
this, his desire for the approbation of all causing him often to change the
[architectural] designs, and thus he begins many things but achieves
nothing."[29] So, given Augustus's penchant for personal involvement in archi-
tectural planning, it is suggestive to note that the general architectural layout
of the Mogul court in the *Throne of the Great Mogul*—including its walls, its
open spaces, its alternating concave and convex staircases, and its alternating
convex and concave arcs—bears an uncanny resemblance to plans that had
been presented to Augustus the Strong in 1698–1700 for a royal palace in
Warsaw (plans that, like so many others, failed to materialize).[30]

Furthermore, the Grünes Gewölbe holds another work of art that,
while unconnected to Dinglinger, strengthens the possibility that Augustus's
wishes helped shape the *Throne of the Great Mogul*. It is a composite display
of three freestanding pieces that was made by the jeweler Johann Heinrich
Köhler between 1701 and 1705, that is to say, precisely at the same time the
Dinglinger brothers were busy setting up the *Great Mogul*. The three care-
fully ornamented pieces represent elements of ephemeral architecture for
festive regal occasions: two pyramidal obelisks and a triumphal arch (plate
11, top). The focal point of this inventive miniature architectural arrange-
ment is the bust of an African king at the center of the triumphal arch who
dominates the scene with his size, shiny black color, and dazzling pearl hat.
The royal context of this arrangement is evident in the unexpected crowns
topping the obelisks, as well as in the triumphal arch, an element closely
associated with royalty (most recently in the coronations of Augustus in
Krakow and Friedrich III/I in Königsberg).[31] Once again, then, in a
completely different setting, another ensemble of miniature syncretic archi-
tecture signifying a royal festive occasion was put together in the Dresden
court, honoring a centrally placed, distant, dark-skinned ruler. Of course,
this might be a coincidence. But it seems more plausible to conclude from
this similarity to the *Throne of the Great Mogul*—similarity in the broad

narrative content, in the detailed and unusual architectural arrangement, and in the exotic nature of the central protagonist—that if the top two jewelers in Dresden at the beginning of the eighteenth century were working simultaneously yet independently of each other on different compositions with precisely the same general concept, they were working under some explicit or implicit directive about the desires and wishes of their ruler: a ruler, to repeat once more, with a predilection not only for exuberant court festivities but also for the details of inventive architectural design.[32]

Finally, the Great Mogul himself may have made an unexpected appearance in Dresden in the year 1700. The circumstances are a bit vague. In that year a former law student and writer named Christian Reuter, who had been expelled from the University of Leipzig for poking fun at certain local figures, arrived in Dresden. Reuter's main work of 1696 was a pseudo-picaresque novel parodying the genre of travel narratives in the East and elsewhere, which Reuter had apparently studied well. A key moment in the narrative brings Schelmuffsky, Reuter's arch-liar hero, into the court of the Great Mogul. Schelmuffsky recounts a personal encounter with the Mogul, whose court includes "a grand marble staircase" leading to a hall that "flickered and flamed all of gold and precious gems." He describes how he rendered the Mogul a great service—for which he was rewarded and honored—by putting order into his account books, while expressing his amazement at "what loans and taxes were entered therein!" Four years after depicting these "events" Reuter moved to Dresden, taking a position as secretary to the chamberlain at court. He began a personal correspondence with Augustus the Strong, who even promptly intervened on Reuter's behalf in the matter of his university expulsion. One wonders what Augustus made of the best-known work of this new member of his court, a travel journal that on its opening page bore the dedication of the thankful fictional traveler "To the exalted Great Mogul (the elder) world famous king or rather emperor in India."[33] By the following year, then, when Dinglinger arrived in Warsaw with a well-wrapped *Kaffeezeug* in tow ready to discuss the next big project, and met with his prince, who may have been developing interest in a work of decorative art centered on a foreign, exotic, non-Christian absolute ruler, was the "world famous" Great Mogul already somewhere on Augustus's mind?

2. Crowns (or, The Men Who Would Be Kings)

At first glance, it appears that we now have a grasp on the political meaning of the *Throne of the Great Mogul*: the service it rendered Augustus the Strong, its designated spectator and ultimate buyer, and the message it paraded on his behalf. Dinglinger's creation served as a mirror for the prince, capitalizing—selectively—on the Great Mogul's reputation for perfect and unobstructed absolute power. It displayed the reflection of an ideal of rulership, or perhaps we should say a fantasy of absolute rule, of the Saxon elector who also became king of Poland and Lithuania. The prince/king is likely to have been in on the project from early on and was willing to pay its high price once it was completed (as Dinglinger assumed Augustus would), despite his own adverse circumstances at that moment.

But while on one level it seems patently self-evident that a European prince in the age of Louis XIV—or in the more loaded term to which we will return later, the Age of Absolutism—would be interested in an object enacting such a message, this does not explain the extraordinary investment in this particular work of art nor the extraordinary form in which it presented this message. Rather, the particular choices embodied in Dinglinger's unprecedented *Throne of the Great Mogul* were generated by specific political exigencies and needs. "Political" here refers to the perspective of the prince: whatever served the agenda of the prince in his quest for recognition, status, and power. The following three chapters unfold the political grounding and implications of the *Throne of the Great Mogul* by moving out in three

concentric circles: the political circumstances of Augustus himself; the broader European political scene, especially in the Holy Roman Empire; and finally the even broader political cross-continental configuration that unexpectedly connected many parts of the globe at the beginning of the eighteenth century.

Augustus the Strong's actions following his accession to the position of elector of Saxony in 1694, on the unexpected death of his brother, manifested a determined political plan with grand ambitions.[1] In Saxony, the now titled Elector Friedrich Augustus I immediately began a series of structural and administrative reforms intended to establish a state following his own ideas of a centralized, absolutist order. Beyond Saxony, Augustus the Strong set his eyes on a bigger prize, the crown of Poland and Lithuania, which could strengthen the standing of the Wettin dynasty and bring him closer even to the throne of the Holy Roman Emperor himself. Kingship in Poland was not hereditary but rather, according to a constitutional arrangement going back to 1573, elective, with the Polish nobility in the Sejm (parliament) electing a new king on the death of a previous one. So when the Polish king Jan III Sobieski died in 1696, Augustus made well-planned efforts to secure the Polish succession for himself. And yet in a field of more than a dozen possible candidates, supported by different factions in Poland and different patrons abroad, Augustus's success was far from likely; even a week before the election, his ambitions were dismissed by a French observer as "cette idée chimérique."[2] And yet as the field narrowed it was Augustus who emerged with the emperor's backing as the main competitor of the French finalist supported by Louis XIV, the Prince de Conti. To be a viable candidate, the Lutheran Augustus, still the underdog, converted secretly to Catholicism in spring 1697. Two rounds of voting, enormous bribes, and the persuasive proximity of Saxon troops were necessary before Augustus secured the crown of Poland and Lithuania by midsummer, choosing the royal title Augustus II. Earlier that year he had already drawn up the list of absolutist measures he would instill in his new coveted kingdom. Now everything was set to go.

The higher the aspirations, the greater the fall. The gap between Augustus's intentions and the political realities on the ground was insurmountable. Augustus appeared at first to have little understanding of the complications standing in his way, not only in Poland (whose language he did not know) but also in maintaining his rule in two realms so different from

each other. Polish political power was in the hands of the *szlachta*, or nobility: those who elected the monarch, those to whom the king had to apply for permission to leave the country (to travel to his other capital, Dresden, for instance), and those whose 140 lifelong senators controlled foreign policy. Official appointments were for life, so Augustus could not stack the highest state positions with his loyalists. And because from the middle of the seventeenth century decisions in the Sejm had to be unanimous, every *szlachta* member possessed considerable power. It was small wonder, then, that a full two-thirds of the sittings of the Sejm during Augustus's reign were thwarted by veto. So whatever absolutist program Augustus wished to implement, it ran aground in face of the blocking tactics of the Polish nobility.[3] The latter were suspicious of the conveniently converted Augustus to begin with and were then offended time and again by his violation of their codes of behavior (e.g., by bringing his mistresses to festivities in Warsaw). The sharp-witted Liselotte of the Palatinate, wife of Louis XIV's brother, who had long been well-disposed toward Augustus the Strong, presciently questioned upon Augustus's election his poor judgment in striving so hard "to become king over such an interested and unstable nation, in which he cannot be an absolute lord and master, but will be king only more in name than in deed."[4]

Ruling a noncontiguous realm with a court traveling between capital cities also ran into obstacles. In Dresden, which Augustus left behind in haste en route to be crowned in Poland and from which he subsequently absented himself for more than two years, the resentment was considerable.[5] Saxony, after all, was the cradle of the Reformation, and it did not take kindly to its elector's conversion to Catholicism or to his appointing a Catholic Swabian prince as governor in his absence.[6] A particular source of disapproval was the conspicuous chasm that his apostasy opened with his devout wife and mother. (Indeed, could it be that this break with the women in key positions in Augustus's court explains an odd feature of the *Throne of the Great Mogul*, namely that the numerous human figures in Dinglinger's miniature court include not a single woman?[7]) The Saxon landed estates—the *Stände*, represented in the *Geheime Rat*—strongly opposed Augustus in 1706 and demanded that he relinquish the Polish throne. Their resentment led to resistance to Augustus's efforts at political centralization, which in turn drove him to establish in 1706 a counterpoint in his personally appointed *Geheimes Kabinett*. Add to this the disastrous Northern War with which this book began: an overstepping miscalculation that resulted in huge military and

financial losses, in the forfeiture of the Polish-Lithuanian crown, and in the almost year-long Swedish occupation of electoral Saxony.

We can thus begin to understand the overwhelming sense of failure and frustration in Dresden in 1707. If ever there was a political situation calling for wishful fantasies of absolute power, Augustus the Strong's weak hold over his Saxon-Polish-Lithuanian dominions in the opening years of the eighteenth century was it.

And yet there is more. In order to gain further insight into the political meaning of Dinglinger's *Throne of the Great Mogul*, let us take another look at Aurangzeb himself. Dinglinger's greatest debt in the staging of the approach to the Great Mogul was to a travel book by Wouter Schouten, an employee of the Dutch East India Company (VOC) and ship doctor. The book, published in 1676 in both Dutch and German, includes an engraving of the Great Mogul presiding over the presentation of gifts during a celebration at court.[8] It is readily evident that Dinglinger followed Schouten's visual depiction closely (figs. 6, 7; plate 4): the gradually narrowing staircase with seven steps leading up to the enthroned Mogul, lined up with observers on both sides; the Mogul observing the court while sitting cross-legged on a cushion, supported from behind; the huge sun depicted on the back of the throne behind him and the baldachin above; and even the figure deeply prostrating itself at the bottom of the stairs, next to a small chalice or basin and another such figure to its right, complete with identical posture, robe, and protruding feet. The jeweler rendered the Dutchman's image into a three-dimensional *mise-en-scène*.

At the same time, there are of course also differences. Many are simply the result of the transformation in medium and perspective. In some details Dinglinger knowingly corrected Schouten. Thus, he altered the visages of the Mogul and some other figures to increase ethnic plausibility. He also added hanging weapons on the pilasters of the baldachin, following a detail he found in Tavernier's report.[9] But in two significant elements Dinglinger deliberately diverged from his prototype to suggest a different emphasis and meaning. First, Schouten's image shows in the left foreground a figure with his back to the viewer, opening a coffer from which he pulls out luxurious chalices and plates. Dinglinger retained the coffer but replaced its contents with exquisitely executed miniature weapons together with a tiny book, an alteration, as we shall see, that enhanced the effect of seemingly limitless miniaturization.

For our purpose in this chapter, however, Dinglinger's second deliberate alteration is the most telling. In Schouten's engraving, the Great Mogul is rather awkwardly holding a forwardly protruding sword and his head is covered with a turban—again awkwardly drawn—with an open-ended, feather-like ornament pointing upward. Our three-dimensional Mogul, by contrast, holds an upright scepter and wears a cap surrounded with a multi-pronged, metallic-looking crown (see fig. 7).

The cocked protrusion emerging from the Great Mogul's turban in Schouten's engraving actually represents an *aigrette*. Aigrettes (from the French for the feather plume of a heron), in India called *sarpech* or *jigha*, were jeweler-made headdress ornaments consisting of a spray of feathers and gems. The Moguls, like the Persians, fastened them to regal turbans and attached to them much importance, prohibiting their use outside the ruler's closest circle. Jean-Baptiste Tavernier recounted how Aurangzeb, before ascending the throne for the first time following the imprisonment of his father and the elimination of his brothers, requested of the incarcerated Shah Jahan to be allowed to use "some of his jewels on that day, so that he might appear before his people with the same magnificence as the other Emperors, his predecessors, had done."[10] The object of this request—itself surely one of history's pinnacles of chutzpah—is likely to have been a piece of jewelry that was the most conspicuous attribute of Mughal royalty. This was a turban ornament, an aigrette, that had been bestowed on Shah Jahan himself by his father, Emperor Jahangir, in a durbar (court) ceremony rendered visually many years later in a 1640 miniature by the Indian painter Payag (plate 12, top). Payag's depiction was so specific that observers would have recognized this important family jewel, previously worn by Akbar the Great and Jahangir himself. English ambassador Thomas Roe, an experienced gem dealer, was impressed by it. François Bernier marveled at it.[11] Schouten, however clumsy with his drawing pencil, captured it correctly as the pinnacle of the Great Mogul's headdress as he sat on the throne observing the court celebration.

Dinglinger knew that the Mogul emperors wore aigrette-adorned turbans, not crowns. He is unlikely to have seen Payag's work, but he did study Schouten's engraving, read Roe's and Bernier's texts in which the Great Mogul's aigrette was admired (with an emphasis bound to attract a fellow jeweler's attention on its "diamonds of extraordinary size and value, besides an oriental topaz, which may be pronounced unparalleled, exhibiting

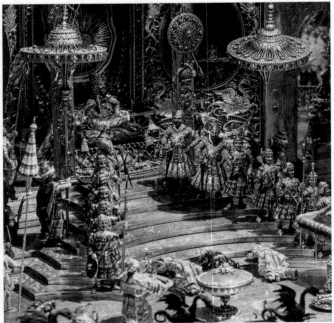

Figure 6. Wouter Schouten, book illustration showing the Great Mogul on his throne, 1676 (detail), with the Great Mogul and the stairs leading to the throne in the *Throne of the Great Mogul*

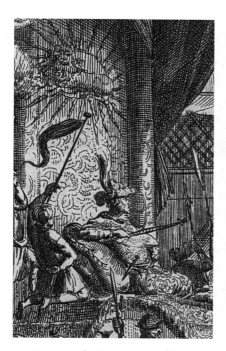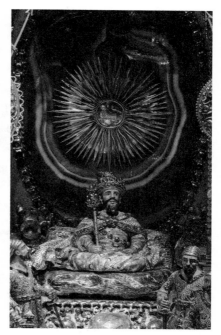

Figure 7. The Great Mogul on his throne in the *Throne of the Great Mogul* and in Wouter
Schouten's book illustration

a lustre like the sun"), and encounter other visual materials in which the
Mogul emperor's headdress was topped with an aigrette.[12] Dinglinger
certainly understood aigrettes, moreover, because he himself designed and
made two exquisite ones for Augustus the Strong, whose new modish and
unusual hat ornament could now replace the crown in public events.[13] That
Dinglinger was well aware of the conventions for representing the Great
Mogul is also clear from one other detail he carefully added to his miniature
Mogul: earrings, which were a characteristic attribute of the image of Mughal
emperors since Jahangir.[14] And yet, despite this effort at ethnographic
authenticity, despite his own familiarity with aigrettes, and despite the many
sources that detailed the Mogul's impressive headgear, Dinglinger made his
own Mogul carry a European-style scepter in his hand and an incongruous
European-style crown on his head.

Once more, at first glance, given Augustus the Strong's political path from
Dresden to Warsaw, this change appears not very surprising. Considering,

however, that in so many other aspects Dinglinger celebrated the exoticism and difference of the Great Mogul rather than domesticate them, such a deliberate and meaningful substitution, crowning Dinglinger's mirror for princes metaphorically as well as literally, may benefit from further interrogation.

The direction of this interrogation is in a sense the opposite of the beginning of this chapter. There I invoked Augustus's unique political predicament in Warsaw and Dresden in order to explain the depth of his own particular need for an absolutist fantasy. Now, conversely, I want to suggest that we raise our eyes and look around not for unique circumstances but for the commonalities between Augustus and his fellow princes, commonalities that reveal his political ambitions as very much part of their moment.

Allow me to begin with an unusual diplomatic meeting that took place in 1698 at the Düsseldorf court of Elector Johann Wilhelm of the Palatinate (von der Pfalz), a prince whose tastes and interests often aligned with those of Augustus the Strong. The audience was requested by a group of Armenian envoys led by one Israel Ori, a trader and scion of Armenian nobility who had settled in Düsseldorf a few years earlier. Ori is remembered as an early romantic hero of what would become the Armenian national liberation movement on account of his tireless efforts since the 1670s to free Armenia from Ottoman and Persian rule. Ori asked Johann Wilhelm for help in driving out the Muslim Ottomans and Persians, and in return promised to make the Elector Palatine the king of the wishfully soon-to-be-liberated Christian kingdom of Armenia.[15]

The historian who in the late nineteenth century reconstructed the archival trail of this episode described it as a "fantastical proposal," one perhaps inhabiting a fanciful realm akin to that of the *Throne of the Great Mogul*. But far from taking it as such, Johann Wilhelm saw in this plan a propitious political opportunity. And a timely one: it was only the previous year that he had tried like several others to secure for himself the crown of Poland, only to see the prize go to Augustus the Strong, a disappointment the Armenians were probably well aware of when they made their pitch. Johann Wilhelm and Israel Ori therefore embarked on three years of diplomatic maneuvers in order to turn this proposition into reality. Ori first traveled back to Armenia to secure the necessary documents and official permissions from his superiors (he even sent to the Palatinate exaggerated estimates of Armenian troop sizes), then to the Medici grand duke of Tuscany to secure his participation, and to Emperor Leopold I in Vienna, who promised his

support provided the Russian tsar participated as well, and thus also to Moscow. To Johann Wilhelm's chagrin, the plan was finally forsaken once the Northern War broke out and disrupted the negotiations, forcing these rulers to commit troops to more pressing needs.

Furthermore, his potential crowning was important enough for Johann Wilhelm to wish to see it commemorated whether it happened or not. A few years later we therefore find his court painter Antonio Pellegrini preparing a history painting of the Elector Palatine's putative coronation as king of Armenia, for which he had made a detailed drawing and a small-size oil-paint sketch (c. 1713–1714), though a full-size painting was apparently not completed (plate 12, bottom). Observing the arrangement in this preparatory painting of the (imaginary) king Johann Wilhelm on his throne under the baldachin, the stairs leading to the throne covered with a red carpet as one moves closer to the ruler, the widening triangle created by the two rows of dignitaries on the sides that include also some with oriental (presumably Armenian) dress, and even the man kneeling in front of the ruler, it is hard to miss an affinity with the arrangement of Dinglinger's Great Mogul.

So what did the Armenian self-appointed ambassador Israel Ori know, having lived for a while near the Palatine court, that led him to offer Johann Wilhelm the fantasy of the Armenian crown? What did Dinglinger know, working in the Dresden court, that informed his choice to place a crown on the head of the fantasy Great Mogul? They knew what was hardly a secret for any informed observer of European politics at the turn of the eighteenth century: *contemporary princes wanted to be kings*. This was especially true of the five prince-electors of the Holy Roman Empire (the nine-member-strong electoral college was completed with three archbishops and the king of Bohemia). Their royal ambitions appeared to drive them to spare no effort or expense in pursuit of a crown. This was true of Elector Friedrich Augustus of Saxony, whose insistent pursuit of the Polish crown not only brought about his religious conversion but also embroiled his homeland in decades of war and financial difficulties. This was true of Elector Johann Wilhelm von der Pfalz, whose royal ambitions transmuted into an Armenian flight of fancy. This was true of the son of Elector Maximilian Emanuel of Bavaria, who would have had a real shot at inheriting the Spanish crown on the death of Carlos II in November 1700 had he not died the previous year at the age of six. This was true of Elector Georg of Hanover and his mother, Sophia, granddaughter of James I of England, who following the death of the only

surviving son of the future Queen Anne in 1700 (and actually even earlier) had maneuvered to secure for themselves the Protestant succession to the throne of England and Scotland should William III and Queen Anne have no legitimate issue, efforts that were crowned with success in 1714.[16]

Most memorably, the desire to become king was realized in a spectacular fashion by Elector Friedrich III of Brandenburg at his *ab nihilo* coronation in Königsberg on 18 January 1701, around the time that Dinglinger began to work on the *Throne of the Great Mogul*. This monumental event, complete with a symbolically overloaded coronation ritual, a self-designed crown and thrones laden with royal attributes for the new king and queen, and an overall expenditure of about twice the annual revenue of the Hohenzollern administration, transformed the prince-elector into King Friedrich I in Prussia. ("In" and not "of": a carefully chosen title that acknowledged the emperor, who was suzerain of Brandenburg even though Prussia was outside the Holy Roman Empire.) Although Friedrich made sure to be anointed— with the aid of two bishops he (illegally) appointed, a Lutheran and a Calvinist, to cover all bases with the two official Protestant confessions in his realm—he actually crowned himself earlier by his own unaided hand, thus arriving with his wife at the Königsberg Schlosskirche already as crowned monarchs. Indeed, the Prussian coronation was notable for its "self-made" quality and its rejection of any pretense to an "invented tradition" anchored deep in a putative history. Friedrich I achieved royal status in a wholly new and unprecedented way, and was proud to show it.[17]

These episodes, to be sure, were hardly independent of each other. The German electors with their families and friends knew each other, corresponded with each other, were often related to each other, had agents or spies at each other's courts, and were continually observing each other as they pursued their respective royal aspirations. Augustus the Strong's Polish coronation, for example, according to the well-informed opinion of the English diplomat George Stepney, surely occasioned for Friedrich of Brandenburg "night thoughts"—presumably encouraging him to accelerate his own path to coronation.[18] Furthermore, this end-of-the-seventeenth-century "wave of regalization," as historian Christopher Clark has dubbed it, was not confined only to the Holy Roman Empire. The duke of Savoy and the grand duke of Tuscany competed hard to obtain from the emperor the right to be addressed in a manner equivalent to kings as "Royal Highness" (awarded to them in 1689 and 1691, respectively), from which the dukes of

Savoy made further tenacious and ultimately successful efforts to claim a crown—that of Cyprus, then Sicily or Sardinia—in pursuit of a royal title of their own.[19] In the German lands many others who were not so lucky as to have had even an unrealistic path to a possible crown settled on building new or restored palaces fit for royalty. The wave of palace-building in German lands around 1700, an architectural concomitant of the wave of regalization, included not only the famous Zwinger in Augustus the Strong's Dresden but also, among many other examples, Johann Wilhelm von der Pfalz's new hunting palace in Düsseldorf, which will cross our path later on.[20]

Perhaps the most moving embodiment of the shared regal aspirations in the society of princes—especially in the context of this book—is, like Dinglinger's work, an object in miniature, or to be more precise, a series of miniature objects, all hidden inside an ivory egg (plate 13, top). The egg was sent by Liselotte, the Palatine princess who became the wife of Louis XIV's younger brother, to Caroline of Ansbach, a Hohenzollern princess who in 1714 traveled to England with her husband, son of Georg of Hanover, as he assumed the title of the Prince of Wales and new heir to the English throne. The egg's sequence of nesting miniatures, bonding together two German princesses who had never met in person but who were tethered by links of family and friendship, was laden with emotional investment and political meaning. The ivory egg unscrews with its yolk to reveal a miniature gold diamond and enamel hen. The hen hides inside it a miniature pearl- and diamond-studded gold crown, a so-called closed crown, with bands crossing from back to front and between the sides to meet in the middle, which in moments that require extra emphasis proclaim a crown to be of royal—or even imperial—nature. (In 1602 Emperor Rudolf II had a famous *Bügel-krone*, or closed crown, specially made for himself. A hundred years later, the crown that Friedrich III/I fashioned for his invented coronation in 1701 was again a conspicuously closed one.[21]) Back to Liselotte's gift egg: inside the miniature crown is a minute ring. Under the ring's diamond are two inter-locking gold-wire "C" letters that identify the initially intertwined Elisabeth Charlotte—Liselotte's full name—and Caroline. Finally, next to their initials the keen eye discerns a minuscule electoral crown and hat. The symbolism of the two crowns, electoral and royal, physically arranged according to their hierarchy, and its adumbration of the narrative of these princesses' lives and ambitions, was summed up in a letter Liselotte wrote to her half-sister in 1715 about Caroline, shortly after the latter's move to England and a few years

before commissioning for her the miniature ivory egg: "But we are made of the same stuff and *from being electoral children we have become royalty*."[22] From electoral children to royalty: this was the shared dream of the princely generation around 1700. Liselotte's highly skilled, unnamed jeweler succeeded in packing this dream into a miniature crown secreted in an exquisite egg. Dinglinger achieved the same with his own miniature crown that proudly replaced the turban and aigrette on the head of the Great Mogul.

But why was the elevation from an electoral hat to a royal crown such a big deal? Why was Friedrich of Brandenburg and Prussia willing to expend a sum equivalent to two years of the entire revenue of his realm? Why was Johann Wilhelm willing to forego all practical thinking? Why was Augustus willing to alienate Protestant Saxony by his conversion, and to involve himself in huge financial expenditures and multiple wars? Conversely, why did King Charles XII of Sweden, Augustus's first cousin and indomitable foe in the Northern War, appear to be—not least in the eyes of increasingly annoyed British diplomats—so insistent that Augustus's "dethronization more than ever" was the only acceptable condition for ending the war, prolonging "it and their miseries" for no other reason than what George Stepney called "his dethroning humor"?[23]

Stepney's patronizing words suggest a youthful foible of the Swedish monarch, at that point not yet twenty years old. We have already seen the French envoy to Rome dismissing Augustus's ambitions as chimerical, the charge of reckless ambition that continued to be laid at his doorstep throughout his career. Even stronger was the derisive judgment of Friedrich II—"the Great"—with regard to the coronation of his grandfather Friedrich III/I: "He only desired the crown so hotly because he needed a superficial pretext to justify his weakness for ceremony and his wasteful extravagance."[24] And yet, as recent historians of the Holy Roman Empire have pointed out, a pattern that several major political actors repeated at great cost must have had a deeper rationale than mere personal foibles, even if such personal traits combined with a natural competitiveness between the electors to egg them on. In order to understand this rationale, we need to take a broader look at the Holy Roman Empire and the European international order over the previous half-century.

Since the Peace of Westphalia of 1648, commonly taken to be the founding moment of the modern international system, and since the Imperial

Diet that followed a few years later, the standing of rulers within the European international order had changed.[25] Previously, although the dominant place of a ruler such as Louis XIV was indisputable, the standing of most rulers and most polities in the European order had to be negotiated within a complex, finely graded, frequently overlapping hierarchy. The new agreements that ended the Thirty Years' War replaced this complex hierarchy with a binary distinction between *sovereigns* on the one hand and *subjects*, all other participants in the international order, on the other hand. As the participants in European diplomatic affairs in the second half of the seventeenth century gradually realized, this dichotomy became the most important distinction on the international stage, determining where and how their voices would be heard and which conversations they were invited to join.

For the prince-electors of the Holy Roman Empire, in particular, this new configuration created a pressing challenge. Were they, as the highest rank of imperial princes charged with the election of emperors, sovereign potentates or imperial vassals? Did they have the right and claim to discuss matters of war and peace as equals with other European monarchs and to be represented in their courts by *ambassadors*—the highest level of diplomatic envoys, which was reserved solely for sovereigns? These questions dominated the following half-century of electoral international activity. At the Regensburg Diet of 1653–1654, in which the implications of the Westphalian order for the Holy Roman Empire began to be hammered out, the electors and their envoys focused on obtaining from the emperor recognition to be treated as *gekrönte Häupter* (crowned heads), that is to say, as equivalent to monarchs. They did not succeed: the Emperor Ferdinand III defended the old imperial structure against such a concession, which would have transformed the empire into a league of loosely associated independent states. His successor, Leopold I, who ascended to the imperial throne in 1658 and remained on it through the early eighteenth century, proved stronger and more effective than might have been expected in this new age.[26] International events such as the peace conferences of Nijmegen (1678–1679) and Rijswijk (1697) increasingly revealed how the representatives of the prince-electors were treated as second-class, below the ranks of the ambassadors of monarchs and—what was especially galling for them—also below the representatives of the Italian city-states.[27] The 1689 and 1691 bestowals on the duke of Savoy and the grand duke of Tuscany of the status of "royal highnesses," with all the protocols and ceremonial procedures appertaining thereto, added insult to

injury. Even more so, perhaps, because the mediator behind the grand duke's coveted quasi-regal promotion was one of their own electoral circle, indeed none other than Johann Wilhelm the Elector Palatine, who thus secured the marriage with the grand duke's daughter Anna Maria Luisa de Medici.[28]

In short, in the specific political circumstances of the late seventeenth century it mattered greatly and immediately whether a ruler or prince belonged to the sovereign *gekrönte Häupter*.[29] And given the repeated frustrations of the German imperial electors' desire to obtain from the emperor the status of crowned heads by virtue of their electoral status alone, all the while jealously watching parallel developments elsewhere, it is hardly surprising that toward the end of the century they strove to circumvent these limitations within the Holy Roman Empire by securing for themselves, by whatever cost and whatever means they believed were in their reach, a crown outside it.[30]

Tellingly for this book, we have direct evidence that Dinglinger was aware of the significance of Augustus's ambition to belong to this club of sovereign crowned heads, and that Dinglinger had it very much on his mind when he created for Augustus the *Throne of the Great Mogul*. The connection is suggested in the very first sentence of the explanatory text Dinglinger handed over to Augustus at the occasion of the delivery of the completed work. This prefatory sentence extols the veneration in which "divers nations, especially those of the Orient"—and none more so than the subjects of the Great Mogul—hold their "*gecrönte souveraine Häupter*," and it was precisely this practice—thus continues the opening paragraph—that Dinglinger's ensemble is designed to represent. Dinglinger took this phrase directly from the late seventeenth-century discourse on the circle of sovereigns, a discourse especially pressing in electoral circles at this moment. What appears therefore at first glance as a timeless observation referring to all manner of rulers while introducing the Great Mogul becomes, within the context of the court of elector Augustus the Strong, who had just lost his crown and hoped to get it back, a highly specific utterance with its own time-sensitive loaded meaning, one that justified for Dinglinger the unlimited investment in his biggest project ever, "hav[ing] spared neither time, effort nor art."[31]

One final and crucial point: "crown" for the prince-electors circa 1700 was not only a metonymy for a coveted royal *position*, as we tend to use the word today ("The British Crown"). It was at the same time equally a coveted royal

object, an object that did not simply symbolize or mark kingly sovereignty but was actually in a fundamental way constitutive of it. In order to wrap our minds around this historical configuration, so different from our own, we need to understand better how contemporary rulers understood and experienced the political system of the Holy Roman Empire together with the international system around it.

At the turn of the eighteenth century, sovereignty, *pace* Jean Bodin's path-breaking theory of its abstract foundations in a polity, was in practice still taken to be anchored not in the intangible state but rather in the tangible person of the ruler, on which it was publicly and repeatedly reenacted. Whether this or that potentate was sovereign was determined in practice not by theoretical prescribed norms but by the shared acceptance of a ruler within the circle of sovereigns. Gottfried Wilhelm Leibniz famously recognized both of these needs of contemporary aspiring monarchs. In this period, he wrote in 1678, rulers were "insisting for good reason on the ceremonialia, because formalities"—such as the order of precedence, the details of ceremonial acts, the precise forms of dress and of address, the shape and use of regalia—"are beginning to be considered essentials." And in 1701 Leibniz further elaborated, in the context of the Prussian coronation, that "a king is he who is called a king and who is granted by the name, according to custom, the attached honors." Moreover, "Because the *königliche Ehren* [*honores regii*, i.e., royal honors] is not a *Domesticum* but a *res juris Gentium* [international law], it is necessary to assure [the help of] others," namely, "to be recognized by *Auswärtigen* [foreigners]."[32] Sovereignty was publicly staged, inscribed in an often staggering array of ceremonial details surrounding rulers and their representatives, and performed in a punctuated rhythm of ritualized events in the presence of other rulers and their own representatives.

Only once we relinquish our modern tendency to downplay the performative and ceremonial aspects of the enactment of power as epiphenomenal and secondary to its essence—the mistake that put the "enlightened" Friedrich II in the dark with regard to his grandfather's coronation—can we understand the fundamental importance for rulers of this period of the public, honorific, symbolic, and ritualistic aspects of kingship. This was particularly true for those like Augustus the Strong who aspired to a new and not-yet-secure royal status that would admit them into the circle of sovereigns. Pride of place among those constitutive elements of kingship was of course accorded to the crown itself, the object that above all actualized the

status of king. This is why Friedrich III/I took personal interest in the design
of his own outrageously expensive coronation crown, in the shape of a
helmet of precious metal closed at the top—echoing the *Bügelkrone* of the
Holy Roman Emperor—and studded throughout with diamonds. This is
why the dukes of Savoy, decades before they realized their claim to the
crown of Cyprus, already had their ducal coronet closed into a royal crown
on their coins as well as on title pages of books printed with their approval.[33]
This is why Augustus made dogged efforts to gain access to the heavily
protected original Polish crown and insignia for his coronation in Krakow in
1697. This is why he at the same time had costly substitutes made in Dresden
and brought over to Krakow just in case said efforts proved unsuccessful, and
why conversely his opponents spread the rumor that he was in fact crowned
with fakes. This is also why Augustus brought back to Dresden these ersatz
crown and regalia, together with his coronation robes, to be displayed as
palpable testimonial—by virtue of the fact that they had physically been
present at his coronation—to his legitimacy as sovereign king.[34] And this,
finally, is why Dinglinger placed a miniature European crown on the head of
the Great Mogul, encapsulating his prince's whole effort to be admitted into
the European circle of sovereigns with one well-placed act of substitution.

The logic of the aspiration to be king can also shed light on a perhaps strange
act on the part of Augustus the Strong shortly before the Swedish invasion of
Saxony in 1706, again involving Johann Melchior Dinglinger and in turn illu-
minating further the desire to be king. The years 1704–1705 were especially
difficult for Augustus in Poland.[35] In February 1704 Charles XII succeeded in
dethroning Augustus II through a general confederation in Warsaw. By July
Charles had orchestrated the selection of his own puppet Polish king,
Stanisław Leszczyński, who was crowned after some delays on 4 October
1705, under the protection of Swedish troops who by this point had taken
over most of Poland. Augustus was losing ground and on the move (not to
say on the run). And yet in the middle of his troubles, on 1 November 1705,
having traveled incognito from Saxony to the Lithuanian city of Tykocin to
meet Peter the Great, Augustus announced the founding of a new Polish
secular order of chivalry: the Order of the White Eagle. Augustus ceremoni-
ally bestowed the new honor on a group of Polish nobles and pinned on each
of them a precious *Kleinod* (jewel) of the White Eagle that was especially
designed by Dinglinger, who had delivered the pieces a few weeks earlier.[36]

The precise timeline of this episode is revealing. Augustus had commissioned from Dinglinger the first jewels of the Order of the White Eagle on 31 July 1704, just weeks after Leszczyński's election. Then, more than a year later and within weeks of Leszczyński's coronation, Augustus established the order and bestowed its first honors. Obviously, he saw in the Order of the White Eagle a countermeasure to the moves to dethrone and replace him. As with other ceremonial acts we have seen, one might question the effectiveness of an honorific or symbolic act for Augustus's increasingly desperate battle to keep this throne. And as with other ceremonial acts, such a question risks missing the early modern message.

The reason Augustus took the founding of a chivalric order to be such a resonant gesture in his struggle over the Polish crown was that this act was fundamentally intertwined with sovereignty. Sovereigns were the only ones who could change the social order, for instance by ennobling or by recognizing illegitimate children and turning them into legitimate ones.[37] Sovereigns were thus the only ones who were deemed able to bestow the honors of secular chivalric orders. Chivalric orders were among the most conspicuous expressions of kingly status, all the more so during stretches of time when there were no diplomatic congresses in which publicly to reconfirm one's position. Internally, chivalric orders reaffirmed the standing of the ruler vis-à-vis local elites and strengthened their attachment (a benefit that was especially pressing for Augustus facing the reluctant Polish nobles). Externally they were equally valuable, conferring honors on other rulers and prominent members of their circles, thus cementing one's international standing. An important event on the day before Friedrich III/I's coronation in Prussia, for example, was the founding and bestowal on carefully selected dignitaries of the Order of the Black Eagle—an obvious and immediate precedent for Augustus's White Eagle. Three years earlier Tsar Peter I founded his own Order of St. Andrew. The Danish king Christian V established the Order of the Elephant in 1693: it subsequently became a key honor sought after by members of the circle of sovereigns, worn proudly by—among others—both Friedrich and Augustus.[38] Indeed, the annals of chivalric orders show that after a hiatus of some two centuries after the late middle ages (the last chivalric order had been founded by Louis XI of France in 1469), the European "wave of regalization" was also accompanied by a late seventeenth- and early eighteenth-century wave of new or revived secular chivalric orders established by regal sovereigns, with no less than six of them coming into

being between 1671 (with an earlier order established by the king of Denmark) and Augustus's Order of the White Eagle of 1705, and a seventh when Emperor Charles VI revived the Order of the Golden Fleece in 1713 after failing in the War of Spanish Succession. Augustus's choice of timing was less like that of Friedrich III/I and more like Charles VI. When Augustus's Polish crown was threatened, this was how he proclaimed his confidence in his legitimate royal standing within the circle of sovereigns: through the proud flaunting of his new chivalric order. The order was physically embodied in Dinglinger's jewels, jewels that were naturally designed in Dinglinger's words "*mit einer Crone.*"[39]

Over the next two years Augustus lost some of his confidence, with good reasons. The low points were the Swedish occupation of Saxony and the signing of the treaty of Altranstädt. The treaty forced Augustus to renounce the crown of Poland and to send the Polish regalia back to Warsaw, leaving him for his lifetime only the title "king" ("King of Nothing," he complained in February 1707).[40] Augustus continued to insist that these were temporary setbacks and that he would return to Poland as king, and yet there were signs that he also began to put into motion a "plan B." We learn of this from a letter sent from Leipzig on 17 August 1707 by the British diplomat John Robinson, who reported on the publication of a pamphlet intended "to assert the right of the Electoral House of Saxony to the Kingdoms of Naples & Sicily. It is to be done by the Historiographer of King Augustus; but as 'tis printed without mention of the place or Printer, it is suppos'd to be done without authority." This pamphlet was undoubtedly Wilhelm Ernst Tentzel's anonymously published *Recht des Chur-Hauses Sachsen auf die Zwey Königreiche Neapolis und Sicilien.* Tentzel not only explained that the rule of the "Saxonian Solomon" would be more beneficial to the Neapolitan and Sicilian subjects than that of other princes. He went further to proclaim the ultimate suitability of "the dearest Augusto whose head [*Haupt*] is in any case worthy of the crown of the greatest emperor in the world / and whose one gaze cast far more majesty / gentleness [*Majestät / Douceur*] and wisdom than other whole beings." A head with an overabundance of majesty, worthy of an emperor's crown: small wonder that Robinson also reported this pamphlet was found offensive to the emperor, and added a week later that the court disavowed the publication and put the bookseller in prison.[41] And yet Robinson had little doubt that this was a trial balloon by Augustus

himself, testing a new claim to another royal crown should his Polish adventure fail—anything, however unlikely, to belong to the European circle of sovereigns. At the same time the language of this anonymously published claim chimed with what many already knew or suspected, and with what Augustus himself had written following Leopold I's death in 1705: that the long-term goal of Augustus's ambitions was attaining not only the crown of a sovereign king but ultimately that of the Holy Roman Emperor.[42]

During the same month of August, the Swedish forces began evacuating Saxony in their march to Russia in pursuit of their war with Tsar Peter I. By mid-September they were gone, to the Saxons' great relief. And then, within less than four weeks, we find Dinglinger meeting Augustus at the Leipzig Fair, where Augustus had taken two weeks for his own relief after the Swedish departure. It was here that Dinglinger handed Augustus in person the letter of 11 October 1707 that offered him the model of the Court of the Great Mogul.[43] Dinglinger invited Augustus to dedicate an hour to a close inspection of his unprecedented and unparalleled creation, centered on the figure of the enthroned Mogul, the Great Mogul who, as was well known, was himself a sovereign ruler with many tributary states underneath him— surely a king, but also an emperor, perhaps best fitting the words Tentzel used for Augustus, "the greatest emperor in the world."

Dinglinger could hardly have chosen a more suitable timing and place for his offer. The Leipzig Fairs, sponsored since the late middle ages by the dukes of Saxony and held three times a year, had become by the end of the seventeenth century the leading international trade centers in Germanic lands, followed by a further boost in East-West trade exchanges after Augustus became king of Poland. The eighteenth-century Leipzig Fairs recorded routinely more than a thousand foreign traders and guests, sometimes reaching as many as three thousand. Both Augustus and Dinglinger were regular and keen visitors to the Leipzig Fair. It was an event, after all, with a particular reputation as the showcase for "all the world's curious objects, all conceivable precious things."[44]

As for the timing, one needs to place Dinglinger's *Throne of the Great Mogul* not only in the auspicious context of the Swedish evacuation, which was concluded mere weeks before he chose to present Augustus with his letter and extraordinary creation, even though the latter was not yet fully completed. One also needs to place its political vision in the context of the nadir of Augustus's international fortunes following the year of the Swedish

occupation and the renunciation of the Polish throne in the treaty of Altran-städt. We actually have one more suggestive indication that Dinglinger was well attuned to this sequence of events. The multipiece ensemble of the miniature Mogul court, as we know, took seven years to complete and is signed in three different ways, with the dates 1701 and 1708 marking the beginning and the end of the project. But the underside of the figure of the Great Mogul himself includes an additional self-contained, time-stamped signature. This signature bears the names of both Johann Melchior and Georg Friedrich Dinglinger, and next to them the place and date: *Dresden 1707*. The two brothers, then, who had initially considered fleeing Saxony for Nuremberg in order to escape the invading Swedish forces, eventually not only decided to remain in Dresden but pinpointed the completion of the figurine of the miniature Mogul, equipped with his invented crown and scepter, precisely to this moment in which the city was under Swedish occupation and Augustus was a *"König mit der Krone im Koffer"* ("King with crown in his traveling bag").[45]

Augustus's story, as we know, had a happy ending: by late summer 1709 he was again king of Poland. In the context of this book, therefore, it is grati-fying to note that the *Throne of the Great Mogul* had its day in court, as it were, as a significant element in the march to reclaim the Polish crown. This was its greatest moment, the one in which it played a historical role of the kind that Dinglinger designed for it in service of the prince's royal cause.

The occasion was the month-long visit to Dresden of Augustus's cousin King Frederik IV of Denmark, which culminated in the signing of a new Saxon-Danish treaty on 28 June 1709. This was a long-awaited and care-fully planned diplomatic triumph, proclaiming to the whole of Europe that Augustus was now a welcome political and military ally and that the restric-tions submitted to in Altranstädt were no more. Augustus was certainly going to show his cousin the best side of his collections. For this purpose he dusted off an extraordinarily large rock crystal boat that he had already broken once when dragging it to Krakow for his 1797 coronation, and stuck a Danish flag in it to impress his guest. More to the point, he rearranged the traditional treasure chamber of the Saxon electors, called the "Geheime Verwahrung"—the Secret Depository, now less secret than previously—to accommodate Dinglinger's oversized *Throne of the Great Mogul* as the center-piece of the new arrangement. Indeed, the preparations for this display in

front of the Danish king were what finally prompted Augustus in February 1709 to seal the purchase of Dinglinger's creation, which had been on offer to him for over a year, and to take possession of it together with the text that Dinglinger appended to it as explanation.[46]

We have no record of Frederik IV's impression of the visit to the newly arranged treasury room with Dinglinger's elaborate miniature ensemble. But we know that Dinglinger was a key figure not only in the preparation of this state visit but also in executing it, all the way to hosting both kings for dinner in the roof garden of his private house, where they could enjoy an intimate viewing of so many curiosities.[47] We also know that throughout the month-long visit Augustus hammered again and again in different visual and material forms the theme of his desire for the restitution of his Polish crown. This was the key message not only of the proud display of the just-acquired *Throne of the Great Mogul* in its newly arranged space but also, for instance, of a new Medea bowl that Dinglinger finished in the nick of time (as evidenced by its bill dated to the last day of Frederik IV's visit). In this bowl Medea sits on top of a dragon proudly holding not, as you might expect, some accoutrement of her ancient story but rather an outsized, crowned monogram: "AR," Augustus Rex—Augustus's royal cyphers.[48]

Augustus's desire for recognition as king also shaped the rather heavy-handed message of the court festivities planned for the amusement of the Danish king. These were an art form in itself. When in a nocturnal ring race on 22 June Augustus slipped into an Apollo costume with a golden mask especially prepared for him by Dinglinger, the deliberate invocation of Louis XIV's famous appearance early in his reign was unmissable (plate 13, bottom).[49] Another highly elaborate event took place three days before: the "Carousel of the Four Continents" was invented by Augustus himself— down to annotating in his own hand costume drawings that were drawn from engravings of a similar event half a century earlier in Louis XIV's court— and was closely aided by Dinglinger. Frederik, the guest, rode as the king of the Europeans. Augustus, on the other hand, led the riders' quadrille of "Africa"—with his own horse bedecked with the saddle from his 1697 coronation—while dressed as an African king, complete with blackface. This theatrical gesture echoed the mirroring of the exotic dark-skinned ruler in the *Throne of the Great Mogul* and also Köhler's miniature triumphal arch of the same time with its miniature African king. The connection to the Great Mogul was likewise evident in the white elephants designed as part of the

African king's parade, which were in fact not African but rather Asian elephants, recalling those in the *Throne of the Great Mogul*. And finally, if all that was not clear enough, for Augustus's head as king of the Africans Dinglinger designed a special helmet—a far more expensive piece of equipment than that for the royal guest—"with a lion's head on top of which was a crown."[50] Yet another crown.

By the end of June Frederik IV and Augustus had traveled to Potsdam for the so-called *Dreikönigstreffen*—the three kings' meeting—in order to cement an alliance with Friedrich I of Prussia as well. Within a matter of weeks, Augustus marched back into Poland and reclaimed the Polish crown, the members of the Sejm having renewed their oath to him as their king on the 8th of August. (Even more than all these grand gestures, what made this change possible was the support of Peter the Great, who on 8 July had beaten Charles XII decisively at the battle of Poltava.) Realizing the ambition that the *Throne of the Great Mogul* as the centerpiece of the reception of King Frederik IV signified so well, and as was trumpeted heavy-handedly in the propagandistic painting commemorating the alliance with Frederik IV and Friedrich I (plate 14), Augustus was now again a full, card-carrying member of the sovereign *gekrönte Häupter*.[51]

3. Thrones (or, The Prince, the Mogul, and Cultural Mixing)

The discussion in the previous chapter hinged on distinctions in ruler headgear, namely between the crown on the head of the miniature Great Mogul and the turban ornament that appears in actual representations of the Mughal emperor, and on the significance of Dinglinger's substitution of the former for the latter in the context of Augustus the Strong's royal ambitions. Consider now two prints of Augustus the Strong as Augustus II, king of Poland (figs. 8, 9). The first was published in 1697 in conjunction with Augustus's coronation in Krakow, the city depicted in the bottom register. The second appeared in a Saxon publication in 1699 together with Augustus's horoscope, in which the text highlighted his royal destiny as proven in his Polish election and coronation.[1] The first portrait presents Augustus with an Eastern-style head wrap topped by a notable gem with a spray of feathers, an Asian appearance accentuated further by the earring and hint of a moustache. The second portrait has it both ways, or even three ways, straight down the central axis of the image. At the center of the bottom register, on an escutcheon in small scale, are Augustus's Saxon electoral arms capped with the Wettin electoral hat; encircling those are his Polish-Lithuanian royal arms, capped with a European closed crown; and in the upper register, on his head directly above the two crowns, is Augustus's oriental-style headgear, made of expensive cloth laced with gems and topped with a conspicuous aigrette. In fact, there are quite a number of such images of Augustus in Eastern-style headgear, or combining Eastern and Western styles, that

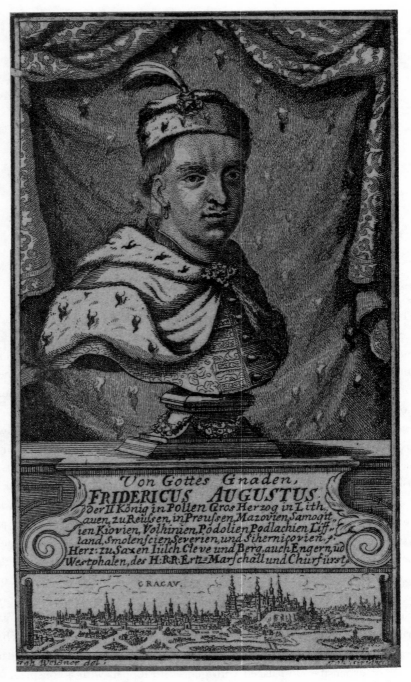

Figure 8. Augustus the Strong, portrait as king of Poland after his coronation, with view of Krakow, Augsburg, 1697. Engraved by Johann Stridbeck the Younger after drawing by Johann Weidner

Figure 9. Augustus the Strong as king of Poland, 1699. From Andreas Stübel,
Aufgefangene Brieffe, vol. 1, Wahrenberg [Leipzig], 1699

followed the 1697 coronation in Poland.[2] When the elector turned monarch is seen from a Polish perspective, the sharp dichotomy that organized the previous chapter is insufficient to capture the complexity of the story.

Poland, after all, was not simply an extension of Western and Central Europe but rather its own unique mixture of East and West. Nothing reflected this better than the idiosyncratic tradition of the Polish nobility (the *szlachta*) known as *Sarmatism*.[3] The historical mythology adopted by the Polish *szlachta* since the sixteenth century, presenting them as the descendants of an Iranian warrior race described as "Sarmatians" by ancient writers, was a pseudo-ethnic narrative that served to differentiate them from the rest of the Polish population and at the same time helped defend their independence vis-à-vis centralizing monarchical tendencies. Sarmatian ideology went hand in hand with the orientalization of costumes and accessories, which became ever more pronounced during the seventeenth century, complete with Asiatic-looking outer garments with slit sleeves (*kontusz*) or fur trim (*delia*) worn over a high-necked, long-sleeved tunic (*żupan*); Eastern-style Polish curved sabers (*karabela*); partly shaved hair in Tatar fashion; and impressive moustaches. This Eastern sartorial style, a Polish-inflected hybrid from Turkish and other Asian sources, came to be seen as a national costume, prevalent especially among privileged military officers, in ceremonies, and as insignia of kings. At the battle of Vienna in 1683, in which Augustus's predecessor King Jan III Sobieski led the European forces in a decisive victory over the Ottomans, the Polish king had actually found it necessary to command his Polish troops to wear straw cockades so that their European allies would not mistake them for Turks. Sobieski himself—the most Sarmatian of all Polish kings—was known as an avid collector of Islamic weapons and accessories, which he readily introduced into court, including the four hundred carts chockfull of war booty that he had captured from the encampment of the Ottoman grand vizier in the battle of Vienna. Already in 1674 Sobieski rode up to his coronation on a horse caparisoned with an Ottoman silk embroidery ornamented with gems that he had captured on the battlefield the year before.[4]

So when Augustus the Strong thrust himself forward as the triumphant candidate for the Polish crown, he suddenly found himself surrounded with Sarmatian noblemen and Sarmatian objects. Like other elected kings of Poland in the seventeenth century, Augustus too faced the need to adopt Sarmatian elements in his public appearance in order to meet the noblemen's

expectations or suffer their displeasure (as had famously happened to King Wiśniowiecki at the Sejm of 1672).[5] To his coronation Augustus arrived bedecked in a mixture of styles, combining a locally inspired feathered black hat with an ermine overcoat in blue without a Polish precedent that was probably an imitation of the French royal garb. Underneath it he wore the armor that had served him in the battle against the Turks in Hungary: the flip side of Sarmatian orientalization was the repeated reminders of triumphs against the Turks. But for the *Huldigung* on the following day, that is, the important ceremony in which the noblemen paid homage to the new king, who in turn confirmed their hereditary rights, Augustus arrived fully outfitted "*a la polonnaisse* [*sic*]," complete with a Polish robe cut in the manner of a Turkish *kaftan* and a parade battle-axe of a kind that had been popular since the Ottoman wars. Augustus was no Sarmatian—a political obstacle that added to his strains with the Polish elite—but he was visibly making an effort.[6]

It is to this effort to curry favor with the Sarmatian *szlachta* that we can perhaps attribute the rationale of one of Augustus's seemingly more reckless actions when it came to his invaluable *Schatzkammer* treasures. I am referring to the urgent order he gave Dinglinger to transport to Warsaw the exceedingly fragile *Goldenes Kaffeezeug* immediately upon its completion, so that the king could present it in front of the Polish nobility (plate 15). After all, the *CoffeZeug* (as it was originally titled), the work begun in the year of the Krakow coronation, was the most Sarmatian of Augustus's *Schatzkammer* showpieces. Coffee was a novel and exciting cultural phenomenon that was closely associated with the Turks. In Germany it was Leipzig, the site of Augustus's and Dinglinger's favorite international fairs, that witnessed in 1694 the first coffee-selling establishment, preceded by a Dresden apothecary selling "bon coffi" in 1685. The first German coffeehouse treatise was also published in Leipzig, in 1698, anticipated by another Saxon publication in 1686 that included the first in-depth German discussion of the new drink, in a translation from French of a treatise on the novel exotic drinks of the age. The frontispiece to the opening section on coffee inevitably presented the drink in the hand of a cross-legged Turk with a feathered turban.[7] Dinglinger's creation at the end of this decade of new beginnings, therefore, was a powerful homage to the most exciting and newsworthy contribution of the Turks to fashionable Saxon and European society.

That and more: the *CoffeZeug* secreted within it a literal and dramatic staging of this Turkish connection. Hidden within the pyramidal

Gesamtkunstwerk, and today all but invisible, is a large covered cavity, almost half a meter wide and more than 10 centimeters deep, with a surprising three-dimensional scene (plate 15, bottom). Four male figures—three of whom wear turbans—are sitting on the ground, next to a low table covered with an oriental carpet, and together with a standing female figure are all preparing and enjoying coffee in Turkish-looking utensils. The staging of a Turkish coffeehouse is remarkable for its effort to recreate a full scene with such ethnographic precision, which remains true even if it fails to understand properly how to represent cross-legged sitting. At the same time it is also puzzling, since the quality of execution of this cavernous scene is noticeably inferior to the exquisite pieces of the *Goldenes Kaffeezeug* that engulfs it.[8] Could the explanation for this curious anomaly in Dinglinger's consistently high-standard *oeuvres* be that this scene was hurriedly put together at Augustus's request, perhaps by another hand, as an addition that was important to the king in its content as well as entertaining in its surprising form, before the presentation of the whole ensemble to the restive Polish nobles in Warsaw?

There is no way to know, although the fact that this hidden scene is not mentioned in Dinglinger's otherwise detailed description of the *CoffeZeug* in his invoice to the king, as well as the fact that Dinglinger altered the ensemble in 1729 so as to make it harder for the spectator to view this scene that had been readily visible in 1701, are suggestive.[9] But what we can assert with greater certainty is that we should ascribe the group of regal portraits of Augustus II of Poland with which this chapter began, bearing oriental-style head-covers with feathers and aigrettes, sometimes paired in the same image with European-style crowns, to this same effort to curry favor with the Sarmatian *szlachta*. (It is not a coincidence that these portraits were often modeled after images of Augustus's popular predecessor, Jan III Sobieski, in some cases even reproducing them from the very same plates, simply altering them to substitute Augustus's face for that of his predecessor.[10]) The letter accompanying the print with Augustus's horoscope chart and the three varieties of regal headgear (see fig. 9) made this East-West claim explicit. According to this letter Augustus's horoscope had already proclaimed that "your royal majesty's fame is not only spread all over Europe, but also throughout Asia and without any doubt also through Africa and America and therefore throughout the whole globe." Asia was declared as fact, the rest of the globe as wishful thinking.[11]

Dinglinger, for his part, must have been familiar with the oriental-looking regal portrait prints of Augustus, as well as with the visual representation of Augustus's coronation, which clearly displayed dignitaries in Polish orientalizing costumes next to the European-style German ones. He may have also studied Romeyn de Hooghe's large print of Jan III Sobieski's coronation (still today in the Dresden palace collection), replete with oriental-looking figures, which bears some similarities to the *Throne of the Great Mogul*.[12] Be that as it may, it is likely that for both Augustus and Dinglinger the encounter with Polish Sarmatism following Augustus's coronation made them more at ease with cross-cultural mixtures in representations of rulership and more receptive, perhaps, to the intertwining of the Saxon elector/ Polish king with the Mughal emperor.[13] In chapter 1 I speculated that on the occasion of the delivery of the *Goldenes Kaffeezeug* to Warsaw the prince and the jeweler may well have discussed the germ of the idea that was to become *The Throne of the Great Mogul*. We can now add that the Polish culture of Sarmatism, with which the *Kaffeezeug* itself resonated, together with the exigencies that Sarmatism placed on Augustus's own self-presentation, may well have provided both a setting and a stimulus for the conversation about that unprecedented idea.

The cross-cultural amalgam of ruler styles evident in Augustus's coronation and post-coronation prints, then, especially in the mixing of European and Asian headgear, was a consequence of the very specific circumstances of the personal union of two crowns, electoral and royal, in such different political and cultural settings as Saxony and the Polish-Lithuanian Commonwealth. And yet the argument I wish to propose in this chapter and the next is that there is also a broader story here, one that goes beyond the particularities of Augustus's rule and is more surprising.

As a point of entry into this wider story I would like to return to Dinglinger's figure of the Great Mogul, shifting our attention from his crown to the eponymous throne, the focal and metonymic center of the whole presentation. (Dinglinger would have learned from Tavernier that Aurangzeb's very name means *Zierde des Throns*, "ornament of the throne."[14]) We have already seen in chapter 2 that Dinglinger based the general outline of his throne on the engraving in Schouten's travel book (see fig. 6). If we look closely at the throne itself, the reliance on Schouten's eyewitness visualization in the jeweler's three-dimensional recreation of the throne is evident in

many details (see fig. 7): the cushioned couch with a back that reaches above the Mogul's elbow and below his shoulder; the contours of the Mogul's folded legs covered by a garment busily decorated with disconnected curved lines; the shawl around the Mogul's neck; the high baldachin above the Mogul supported by two columns or pilasters; the towering sun that dominates the backdrop of the baldachin, and even more strikingly, the faint contours of a crouching lion at the center of Schouten's sun that Dinglinger adopted and amplified; and finally the decorated cloth (*lambrequin*) covering the upper canopy, complete with symmetrical recesses on both sides, a protruding round front, hanging tassels, and a second large sun at the center. Dinglinger deviated from Schouten's engraving, we recall, in replacing the Mogul's turban and sword with the incongruous crown and scepter, and also conversely by endowing him with earrings in accordance with conventions of Mogul self-presentation. In addition, Dinglinger augmented what he saw in Schouten with one other highly meaningful element, intended to signal to the well-informed viewer the faithful authenticity and cultural specificity of his Mogul's throne. That added element is a large peacock (plate 16).

An unsuspecting viewer walking around the *Throne of the Great Mogul* would not notice this peacock at all. Although sizeable, the peacock is hidden in the shadow of the cavity beneath the upper canopy of the throne's baldachin, and today can only be partially seen by crouching next to the model's protective glass cover. It therefore bears repeating that this ensemble was made for a patron who had more intimate access to Dinglinger's creation and to its individual components than present-day museum visitors. Furthermore, Dinglinger's work often includes details that are initially hidden and need to be discovered, creating suspense and drawing attention. In this case, the peacock sent an important message, especially for Augustus, the intended observer who was certainly aware of its existence: it identified the original throne modeled by Dinglinger as the most famous throne in the Mughal Empire, the Peacock Throne.

The Peacock Throne, Jean-Baptiste Tavernier marveled, was "the richest and most superb throne which has ever been seen in the world," a unique creation that stood out among the Great Mogul's "seven magnificent thrones." This particular throne was used only on special occasions. Tavernier recounted how he was invited to attend Aurangzeb's birthday celebrations in November 1665, when he had the opportunity to view the Peacock Throne. He thus launched into a detailed description of the throne,

including a business-like accounting of its gems (about 108 large rubies, 116 emeralds of between 30 and 60 carats, and so on), before finally arriving at the eponymous peacock: "Above the canopy, which is a quadrangular shaped dome, there is a peacock with elevated tail made of blue sapphires and other coloured stones, the body of gold inlaid with precious stones, having a large ruby in front of the breast, whence hangs a pear-shaped pearl of 50 carats or thereabouts."[15] Scholars have reasonably doubted the accuracy of Tavernier's description, not only because of its credulity-stretching precision but because it does not fully accord with Mughal textual and visual sources, sources that were likely to have had better access to the court and the throne (though these are themselves inconsistent in various details). In particular, the rare Mughal visual representations of the throne show two peacocks, not one (plate 17).[16] Dinglinger may well not have seen one of these rare images of the Peacock Throne, but we know that he studied Tavernier's text carefully (and indeed even Dinglinger's idiosyncratic spelling of "Aurang-Zeb" was identical to Tavernier's). The fact that Dinglinger's throne boasts only a single peacock reinforces the conclusion that it was Tavernier's vision of the Peacock Throne on Aurangzeb's birthday that led Dinglinger to add an elaborate peacock to his own *Throne of the Great Mogul*.

As Tavernier rightly noted, the Peacock Throne was in fact commissioned not by Aurangzeb—whose austerity would not have accorded well with such an extravagant creation (though it did not prevent him from using it)—but by his father, Emperor Shah Jahan. At his accession to the throne, Shah Jahan ordered the new and unprecedented throne to be made under the supervision of the Iranian head of his court goldsmiths, Sa'ida-ye Gilani, a many-faceted craftsman—the Mughal equivalent of Johann Melchior Dinglinger, one might say—whose numerous works included the gold-and-enamel screen for the tomb of the emperor's wife in the Taj Mahal. Like the miniature *Throne of the Great Mogul*, the new grand throne of the Great Mogul took seven years to complete. It was first displayed at the New Year celebrations of March 1635.[17]

François Bernier adds a curious detail. The peacocks on the throne, he wrote (he reported two not one), "were the artifice of a Frenchman named . . . [*blank in original*] who was a marvelous workman, and who after defrauding many European princes by means of false gems that he knew so well how to produce, sought refuge in this court [of the Great Mogul] where he made his fortune."[18] The identity and precise role of this unnamed

Frenchman are not certain. Most likely this was Augustin Hiriart from Bordeaux, a French goldsmith who had traveled to India and served both Jahangir and Shah Jahan. In a letter of 9 March 1632 Hiriart recorded having been "employed these [past] two years at Agra in making plans for a new throne which the King had ordered. . . . The King had required that two hundred times a thousand livres should be spent on this throne in gold, diamonds, rubies, pearls and emeralds."[19] Although the name "Peacock Throne" does not appear in Hiriart's letter (perhaps because the throne had not yet acquired its peacocks?), the timing is suggestive, and so is Hiriart's record of many years in the Mughal court. Already during the reign of Jahangir Hiriart designed several thrones for the Mughal emperor, for which the latter rewarded him with the title *Honarmand*—"the artist."[20] The Peacock Throne, the quintessential Mughal throne, pinpointed in the *Throne of the Great Mogul* through Dinglinger's carefully inserted miniature peacock as the famous seat of power of the great Eastern ruler, and as such offered to Augustus the Strong as the embodiment of absolute rule or *Herrschaft* in a distant exotic land, was in all likelihood, albeit in part, the outcome of French design.

Dinglinger, a careful reader of texts, probably pored over Bernier's description of the Peacock Throne. He may have savored the irony when he realized the symmetry in the roles played by himself and Bernier's unnamed French jeweler: how each of them drew on the force of imagined distant power as they intertwined East and West in their creations of the ideal form of rulers' thrones for their respective potentates. Or he may have missed it altogether. We also cannot know to what extent Dinglinger was aware of the fact that, for the Mughal court, the involvement of a European artist in making their own accoutrements of ruler self-presentation was part of a much broader pattern, and indeed whether this realization might have influenced his initial choice of the Great Mogul as the exemplum to be presented in a mirror for a prince for Augustus the Strong.

From our own perspective, however, we need to acknowledge that a European's involvement in the Peacock Throne would not have raised too many eyebrows in the Mughal court. I have already mentioned the several other thrones Augustin Hiriart designed for Emperor Jahangir. In fact, the Mughals were exceptional in their interest in and experimentation with ideas and aesthetic forms from other lands, be they Persian, Ottoman, or

European. This was true not only generally in their art but also specifically in their self-presentation as rulers, which is the practice of interest to us here.

It is well known that the Mughal emperors were interested in European visual art, collected European paintings and prints, made efforts to study them, and selectively appropriated European techniques and themes for their own artistic programs. An oft-recounted demonstration of this interest emerges from the report of Sir Thomas Roe, King James I's ambassador to the court of Jahangir. Roe's pride at the supposedly inimitable English minia-ture portrait he gifted to the emperor was tempered, he reported, by a wager in which Jahangir had his own court artist produce five copies of the portrait of such comparable quality that Roe could barely distinguish the Mughal copies from the English original.[21] Even more strikingly, Mughal emperors often adapted Western elements into their own portraits and public images. Take for instance the admittedly unusual Mughal dreamlike painting of Jahangir, sitting on an oversized hourglass, preferring the wisdom of a Sufi sage to the company of kings (plate 18). The kings are immediately recogniz-able as James I of England (facing the viewer), whose appearance is carefully reproduced from a specific English portrait miniature, and the Ottoman sultan, based on a portrait by a European artist. Next to them the painting sports many other Western elements: the Italianate angels, the probably German hourglass, the perhaps Venetian carpet.[22] Cartographic globes were another distinctive European object that the Mughal emperors, having first encountered such globes as diplomatic gifts, then "Mughalized" and incor-porated effectively into their regal self-presentation. During the period of Jahangir, Shah Jahan, and Aurangzeb, we often find terrestrial globes mobi-lized as a novel element of praise and adulation in the visual self-fashioning of the Mughal emperors.[23]

Or recall once more Payag's painting of Jahangir presenting the regal turban ornament to the future Shah Jahan (plate 12, top). Behind the Mughal emperor and the prince, observing this historically important scene from small windows in the back balcony, are four European faces including, unmis-takably, those of Jesus and Mary. Here, as in wall paintings in Jahangir's palace described by surprised European visitors, Jesus and Mary were roped in as divine witnesses supporting the claims of the Mughal dynasty. Indeed, they had a special importance in this role because of a claim that Timur came into the world through the immaculate conception of a Mongol prin-cess, equated with the Virgin Mary.[24] An even closer look at the Mughal

emperor's jewelry in Payag's painting reveals perhaps the most surprising element, so small as to be almost invisible: the Mughal ruler is wearing on his chest a miniature portrait, which on close examination proves to be a Western portrait medallion of recognizably English style. It is likely that this miniature displayed the portrait, once again, of King James I of England.[25]

A throne, however, is not quite like a painting. It is an actual physical object that holds the Mughal emperor's bodily presence on important formal occasions. The more precise complement therefore to the involvement of a European jeweler in the design of the Peacock Throne is to be sought less in visual art than in court architecture. And indeed, as art historian Ebba Koch has shown in detail, at the time of Shah Jahan, the great amateur architect of the Mughal dynasty, Western forms began to influence architecture as well, and in particular palace architecture for the formal public appearances of the Mughal emperor. Of the various European elements that were incorporated into Mughal court architecture—including, for instance, *pietre dure* plaques with unmistakable Florentine influence at the back of the throne structure— the most striking is an architectural innovation that takes us right back to the Peacock Throne.[26]

Look again at the Peacock Throne in the Mughal painting in plate 17. The throne baldachin is supported by four columns of a distinctive shape, with a pot-like element at the bottom, between the base and the shaft. This architectural element, called a baluster column, has no Asian parallels but was in fact a European design the Mughals encountered in images of ephemeral architecture for the celebration of European rulers, which they then "Mughalized," at first exclusively for the public presentation of the Mughal emperor. Koch presents a pair of images—one of Shah Jahan's throne *Jharoka* (a canopied viewing balcony in the audience hall) in the Diwan-i 'Amm in the Red Fort in Delhi, one of Lucas Cranach's print of King Christian II of Denmark some fifteen years earlier—which unmistakably show the influence of the European architectural arrangement with its baluster columns on the Mughal structure for the emperor's formal public presentation.[27] The same baluster columns appear in every contemporary pictorial representation of the Peacock Throne. Dinglinger, working from textual descriptions, not images, could not have been aware of them. And yet these baluster columns, together with the unspecified involvement of the French jeweler, demonstrate clearly the Western strands that went into the creation of the most unique of all Asian thrones, Shah Jahan's Peacock Throne. This

was the same throne that in Saxony, in turn, played a central role in Dinglinger's conception of the embodied power of the Great Mogul, set as an exemplum for his German prince.

This could have been a good place to conclude this analysis. The Mughal emperors were Muslim minority rulers of a largely Hindu population with a well-defined philosophy of toleration or universal acceptance, which joined with their intellectual ambitions into a particular penchant for cross-cultural borrowing.[28] The result was a unique formation in which South Asian rulers deliberately adopted and "Mughalized" certain European elements in their own self-presentation. Augustus the Strong was a pragmatically converted Catholic ruling over two incompatible and noncontiguous realms, a Protestant one belonging to the Germanic Holy Roman Empire and a Catholic one harking back to a mythologized, oriental past. The result was a unique set of circumstances in the personal union of crowns that led to Augustus's own mix of East and West in his self-presentation as king and elector. In the *Throne of the Great Mogul* Johann Melchior Dinglinger, whether knowingly producing a well-intuited pairing or simply through a fortunate coincidence, brought these two hybrid modes of rulers' self-presentation from two distant regions of Eurasia into a mirroring relationship with each other.[29] End of story.

But ending here risks missing the even bigger picture. It so happens that this apparent coincidence of two embodiments of *Herrschaft* mixing Eastern and Western elements belongs to a significant historical context that can place them in a quite different light. For this we need to raise our eyes far above the specific circumstances of the Saxon and Mughal examples. What we find, unexpectedly, is a much broader pattern of cross-national and cross-cultural exchanges of embodiments and signifiers of rulership, peaking in the late seventeenth and early eighteenth centuries. This heretofore unnoticed pattern in the self-presentation of rulers, specific to this point in time, situates the *Throne of the Great Mogul* within a framework that is in fact quasi-global. In the next chapter I therefore offer a few quick detours to other parts of the world in order to present some preliminary indications of this pattern and its surprising reach.

4. Rulers (or, When the Age of Absolutism Met the First Age of Globalism)

We begin our exploration of the broader, quasi-global framework for understanding the *Throne of the Great Mogul* in Sri Lanka. On 10 February 1948 the country that was then called Ceylon marked the opening of its first parliament, following its newly gained independence from Great Britain, with a grand ceremony (fig. 10). With the crowds watching from outside, the country's political leaders sat on the dais next to the representatives of the British crown, the duke and duchess of Gloucester. Above them we can see a second dais on which was displayed a single object: an empty throne. This was the historical throne that had belonged to the kings of Kandy. Traditionally it was associated with Dutugemunu, the Sinhalese king of Sri Lanka who ruled in the second century BCE. In 1818 the British, having deposed the last king of Kandy, seized the throne and removed it to Windsor Castle, where it was used in the investiture of the Knights of the Garter. When the Kandy throne was returned to Sri Lanka in 1934, within a month three-quarters of a million people flocked to see it at the Colombo Museum. At the opening of the independent parliament, few symbols could better embody Sri Lankan sovereignty, lost and now restored.[1]

The throne of Kandy, 1.5 meters high with a matching footstool, is carved of wood, covered in gold plate, and decorated with precious stones. That it is not an ancient throne of the 2nd century BCE is immediately obvious; its actual origins are less so. They were in fact revealed only in 1929, by a scholar who, puzzled by what appeared to him a deliberate obfuscation of the throne's history, sought and found a document recording the arrival

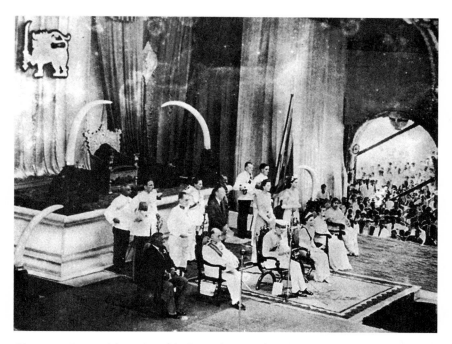

Figure 10. Ceremonial opening of the first parliament of Ceylon (Sri Lanka), 10 February 1948

of the throne of the kings of Kandy in Sri Lanka. It came as a gift from the Dutch East India Company (VOC) and was delivered by the newly appointed governor of Dutch Ceylon, Thomas van Rhee.[2] Indeed, the throne manifests an unmistakable mix of European Baroque style, in the manner of the Huguenot Daniel Marot, who was a key figure in creating the "Louis XIV" style before fleeing to the Dutch stadtholder's service in 1684, together with local Sinhalese elements contributed by the craftsmen who actually executed the commission. The goal of the gifts the Dutch governor presented to the king of Kandy on that occasion, in the words of the VOC document, was "to select such of them as may make up a regalia for his Majesty." These regalia included not only "1 throne with its accessories" but also, interestingly, a large mirror.[3] The date of this European effort to endow a South Asian ruler with the insignia that embodied his *majesté*, centered on a culturally hybrid throne with European and Asian elements, was 1693—within less than a decade, that is, of the *Throne of the Great Mogul*.

In 1708, the year that Dinglinger completed his Great Mogul ensemble, a new king ascended to the throne on the other side of the Eastern Hemisphere,

in the tiny kingdom of Whydah (or Hueda) in West Africa, in today's Benin.[4] Europeans, for whom Whydah was a uniquely lucrative West African slaving port, were involved in the sequence of events that led to the selection of the thirteen-year-old Huffon as king, and remained thereafter closely allied with him, competing among themselves—French, English, Dutch, Portuguese—for his favor. Following his installation as king, therefore, the English slave traders presented him with a crown. They were outdone by their French counterparts, however, who gifted to the king two shiploads of cargo, including an ornate throne. The throne was made of gilded wood, in the style of a Louis XIV armchair, with a French coat of arms on its back. Years later, when political circumstances finally allowed King Huffon to stage his own belated coronation ceremony, he presided over the proceedings from his European throne, wearing an unusual gilded helmet with red and white plumes. King Huffon was flanked to his left by his forty wives sitting on the ground and to his right by representatives of European traders sitting on stuffed chairs, with the French, naturally, closest to him: an elaborate, culturally hybrid hierarchy of seating shaped by the European presence and topped by the Louis XIV–style throne.[5]

Similar scenes were observable elsewhere in seventeenth- and early eighteenth-century Africa. Two travelers reported on "Damask Elbow-Chairs" that Europeans presented in 1670 to the king of Ardra, Huffon's neighbor, whereas the Dutch gifted to him in 1686 a sedan chair, that is, a portable throne.[6] Olfert Dapper's compilation of numerous sources about Africa, published in 1668, included an engraving of the enthroned king of Loango (a kingdom on the Atlantic coast of west central Africa, at the zenith of its power in the seventeenth century). The king, wearing a garment of European manufacture, sits on a wicker chair on a dais above which hangs a wooden board with pieces of Dutch and Spanish cloth.[7] In Angola, the leaders of the Chokwe people reinvented Portuguese chairs they had encountered since the seventeenth century as highly decorated thrones for the watchful supervision of the chief over the life of the community, based on European full-backed chair design but with distinctive Chokwe decorative content.[8] In the kingdom of Benin, King Eresoyen (r. 1735–1750) had a highly ornate brass stool-throne that was itself modeled after an earlier one reputed to have been sent to one of his ancestors in the sixteenth century by the Portuguese.[9]

In all the examples so far, early modern thrones in Asia and Africa appear to have involved an impetus—in intent, in perceived need, or in design—that originated in Europe. It is therefore important to note the coincidence between this emerging pattern of early modern Asian and African thrones on the one hand, centered around the second half of the seventeenth century, and on the other hand an intensive interest in new thrones in Europe at around the same time, the era that we often call the Age of Absolutism. The best known example of an elaborate throne during this period is probably the silver throne of Louis XIV in Versailles (1681). But in fact the bulk of the significant seventeenth-century efforts at endowing rulers with unique thrones, made with extraordinary efforts from rare materials, took place in the Germanic cultural sphere (plate 19). First came the Swedish with the unprecedented Silver Throne (1650), especially commissioned from the Augsburg silversmith Abraham Drentwett for the coronation of Queen Christina.[10] The Danes followed with the so-called Unicorn Throne (1671), a highly ornate construction made with the most precious if unwieldy material obtainable, narwhal tusks—believed to be the horns of unicorns, possessing numerous magical qualities. It was commissioned by King Frederik III from a Hamburg-trained master as a throne fit for Denmark's first absolute monarch, explicitly attempting to reproduce the throne of King Solomon.[11] Another silver throne was designed (and probably made) for the Great Elector of Brandenburg around 1680–1690.[12] The latter also commissioned the Amber Throne (1677), a unique and fragile creation from the "gold of the Baltic" designed in a specialist amber workshop in Danzig, which he sent as a gift to the Habsburg Emperor Leopold I of Austria, who admired it for "its rarity and beauty." Interestingly, the intricate decorative scheme for the emperor's Amber Throne, next to scenes referring predictably to a long string of classical and biblical rulers, also included, unusually, Chinese landscape views, unparalleled in known contemporary work in amber.[13] In other words, by the time Dinglinger offered Augustus the *Throne of the Great Mogul* in the first decade of the eighteenth century, European rulers and their artists, especially in Central Europe, had been preoccupied for half a century with the special role and unique design of thrones as the embodiment of their personal rule.

And yet, the role of the European impetus in non-European contexts needs to be approached with caution. First, even if European forms were adopted in non-European contexts, they were typically infused with local

meaning and incorporated into local understandings of *Herrschaft*. When the Sri Lankans in the mid-twentieth century placed the empty throne of the kings of Kandy on a dais at the pinnacle of the founding ceremony of their independent state, an arrangement familiar in Hinduism or in Balinese culture in which an invisible god or nonpresent ruler surveys a ceremony from high up; or when King Huffon sat on his French-made throne for his coronation with a bare torso adorned with gold chains and necklaces, wearing his gilded and plumed helmet, under a three-meter-wide umbrella held by one of his dignitaries with a gilded rooster on top, next to his forty wives sitting on the ground nude above the waist; or when the backs of the Chokwe chairs were deeply carved with distinctive Chokwe content, a form that often made them almost impossible to sit on, which suited their political leaders who did not approach their throne-chairs as Europeans would understand seating furniture; or (to add a somewhat different example) when Narai, the king of Siam, decided to order more than four hundred Dutch mirrors for his new palace and arranged several of them along the walls surrounding his traditional Thai throne—each of those examples reminds us, similarly to the Mughalizing of European globes and of the paintings of Mary and Jesus, that while these seventeenth-century potentates in Asia and Africa may have partially bought into a global or Western object of rule, they also infused these hybridized objects with culturally specific meanings and agency that were often very different from those associated with them in Europe.[14]

Secondly, not in all cases do we have a direct thread linking thrones to Western and Central Europe. So here are two examples that complicate the geographical axes of the seventeenth-century history of thrones. In 1664 an English embassy to Moscow had an audience with Tsar Alexey Mikhailovich. "The *Tzar* like a sparkling Sun (to speak in the *Russian* dialect) darted forth most sumptuous rays," they reported. "His throne was of massy Silver gilt, wrought curiously on top with several works and pyramids; . . . it rendered the person of this Prince transcendently Majestick."[15] It is likely that the throne which impressed the English was the tsar's brand new "Diamond Throne." Originating in Isfahan, this regalia piece was commissioned in 1659 from local Persian craftsmen (perhaps the court jewelers) by prominent merchants from the Catholic Armenian community in nearby New Julfa. Hoping to obtain patronage and exclusive trading privileges in the Russian Empire (which indeed were granted to them shortly thereafter), the Persian Armenians prepared as a gift for the tsar a unique throne, valued at eighty

thousand gold ducats. The throne is made of silver-plated sandalwood, studded throughout with over eight hundred diamonds as well as other precious stones and ornamented with superbly executed metalwork elephants with riders and animals in battle, as well as lacquered miniatures of hunting and other daily scenes with distinctly Asian figures. The Diamond Throne combines Persian furniture design and motifs with an embroidered inscription in Latin—the language of neither merchants, craftsmen, nor the potentate himself!—dedicating the throne to the "Potentissimo et invictissimo Moscovitarum Imperatori Alexio." Above the inscription is a crown held by two winged genies or angels whose facial features are unmistakably Central Asian.[16] While obviously a "curiously" hybrid object, the impetus for this throne was not European. And yet the Western visitors had no difficulty reading the correct message of majestic transcendence.

I left for last what may well have been the most consequential throne event of this period, as well as the one with the longest-standing repercussions. On one Friday in the year 1701—at the very same moment, in other words, that Johann Melchior Dinglinger was gearing up in Saxony for his grand project, the *Throne of the Great Mogul*—a golden throne fell from the heavens amid thunder and lightning, into the lap of a king sitting under a tree in the presence of his dignitaries. The king was Osei Tutu, founder of the Ashanti kingdom in today's Ghana. The interpreter of the fall of the "Golden Stool" was his paternal nephew and chief priest, Okomfo Anokye, who in preparation for the promised supernatural event demanded the surrender of all former regalia of the local chiefs, which he then promptly buried in the riverbed. Thus, this reputed miraculous event became the founding moment of the new Ashanti kingdom, uniting the formerly independent chieftaincies and ruled from a newly designed capital in Kumasi. Considered sacred and embodying the soul of the nation, the Golden Stool—by the end of this chain of events, the oldest surviving object embodying Ashanti rulership— was untouchable by any but the king. It was presented on special occasions on its own dedicated chair, which itself, as it happened, was a European-style chair. And yet it is clear that the Golden Stool was unlike any European throne: it was accorded honors like an individual of the highest rank, with its own set of regalia (e.g., state umbrellas), bodyguards, and attendants. Much later, when in 1900 the British governor of the Gold Coast in a moment of late-imperial hubris and incomprehension demanded to sit on the Ashanti stool, this provoked what became known as "the War of the Golden Stool,"

at the end of which the Ashanti kingdom was annexed to the British Empire but the stool remained hidden for safekeeping.[17]

The political significance of the Ashanti Golden Stool was immense. The king granted permission for particular kinds of stools to lesser chiefs according to their status. The stools were identified not only with the individual but with his office as well (or sometimes her office, as in the case of the queen mother). The Golden Stool thus stood at the center of an elaborate, ritualized hierarchy of secondary stools that anchored the political structure of the kingdom: a practical yet magical embodiment of the king's rule. (The other Ashanti chairs included again adaptations of European models, be it the "praying mantis" variety that was based on a European folding chair or the *Asipim* armless chairs derived from European prototypes.[18]) The Golden Stool became associated with a new set of laws, with a new national ideology, with a new all-Ashanti ruling council, and with a new capital city. In this way the Ashanti economy of stools may well be the most striking example from this period of a royal figure consolidating absolute power over his subjects through the agency of a physical throne.

And yet the affinity between the Ashanti case and the others we have seen in this chapter is suggestive. In a dozen different locations across three continents, within the space of a few decades in the second half of the seventeenth century and leading up to the decade of the *Throne of the Great Mogul*, we find new thrones being created with considerable investment and taking on an enhanced role as embodiments of personal rule. Few direct links can be shown between these different cases. Each one of them, taken in isolation, can be situated satisfactorily in its own cultural and political context, as has on occasion been done. Considered together, however, these dozen different throne events, from contexts that are indeed wide apart, appear too many to be explained away as mere coincidence. Rather, they raise the possibility that in this moment in the history of the Eastern Hemisphere, collectively and more or less simultaneously, *thrones mattered*, as embodiments and agents of the power of the rulers seated on them (or standing next to them).

Furthermore, it is suggestive that the European role as a driving force in this "throne moment," while not all-encompassing and while serving often only as a catalyst for local developments, nevertheless appears to be disproportionate. The pattern that has emerged here, after all, is more or less simultaneous with one of the more familiar narratives of early modern history in a European context, peaking in the second half of the seventeenth

century and indeed shaping much of the previous discussion of Augustus the Strong and the Holy Roman Empire around 1700: the Age of Absolutism. That is to say, this was the period in which absolute rule—rule embodied in the person of the ruler, who at least ideally was the fount of all power and law and whose legitimacy was divinely sanctioned—emerged in different parts of Europe as a logical outcome of long-term processes of centralization and state formation. And yet our whirlwind tour of thrones up and down the Eastern Hemisphere may lead us to wonder whether the cross-continental pattern that has emerged with regard to the role and meaning of rulers' thrones during this period—in Asia and Africa as well as in Europe—directs our attention to a broader historical phenomenon: namely, the possible *global* connections between seventeenth-century rulers with regards to embodiments and practices of rule. Is this "throne moment," then, embodied so well in Dinglinger's *Thron des Großmoguls*, a historical consequence of the convergence between two major historical developments, the European so-called Age of Absolutism on the one hand and a much broader, early modern age of globalism on the other?

That this may indeed be the case, and that the worldwide seventeenth-century interest in thrones as embodiments of rulership was not mere coincidence, is reinforced by the fact that similar transcontinental patterns can be shown for other practices and embodiments of rule precisely at the same time. For instance crowns, or more broadly princely headgear.

In chapter 2 we saw that Dinglinger replaced the turban and aigrette on the Great Mogul's head with a European-style crown. Soon thereafter Dinglinger also designed for his Saxon ruler a pair of beautiful Eastern-style aigrettes, thus fitting Augustus, in addition to his crown, with the headgear of sultans. Dinglinger was not the only European court jeweler to have done so. Earlier in the seventeenth century Arnold Lulls, a Dutch jeweler working in the court of James I, had already experimented with designs for several Eastern-style aigrettes, presumably based on copied drawings of Mughal *jighas*, as a potential addition to the English king's regalia and perhaps also as gifts to the Mughal court. And from the Mughal court itself, Bichitr's painting of Jahangir preferring the wisdom of a Sufi sage to the company of James I and others (plate 18) shows James with an aigrette-shaped jewel, perhaps the Mughal painter's rendition of one of the king's famous jewels called *The Feather*, which itself was similar to Lulls's aigrette designs.[19]

Conversely, in the second half of the seventeenth century we find the English court busily sending European-style crowns to rulers across the globe, signaling a recognition of their status and suggesting to local rulers what would be an appropriate embodiment thereof. For instance, in 1664 a crown was sent to the ruler of the kingdom of Ardra in an attempt to secure valuable trading privileges. In 1671 a velvet-and-silver crown went to Cockacoeske, the ruler of the Pamunkey Indians in Virginia, with her status as queen inscribed (in English) on a silver frontlet next to that of King Charles, intended to replace her native princely wampum headgear, which one contemporary Englishman dismissed as a mere "imitation of a crown."[20] And again, in 1709 the English court sent to West Africa a crown that cost thirty pounds for the young King Huffon in Whydah in yet another attempt to secure a trade monopoly, which as we have seen failed against the competition of a French gift of a throne.[21] In the case of the crown intended for the king of Ardra, it so happened that the ship carrying it to Africa was intercepted by the Dutch, and thus both the crown and the accompanying letter found their way into the collection of the Rijksmuseum in Amsterdam. This rare survival provides us with an unusual window into the English perspective on the presentation of regalia to foreign rulers, through a gaping disparity between rhetoric and practice. In rhetoric, the richly ornamented missive on parchment from the brother of the king and head of the Royal Africa Company to the king of Ardra explained that "WEE haue so great a Value for Your Person and Dignity, that wee haue Sent You a Present of a Crowne, which is the Badge of the highest Authority." In practice, while the actual object has the appearance of a typical European crown—golden and bejeweled with fleurs-de-lis around the bottom and an orb and cross on top—and indeed was probably modeled after Charles II's own newly minted crown following his restoration in 1660, it was in fact designed for the African ruler on the cheap. The seeming gold was really gilded brass, and what looked like precious stones were in truth mere colored glass.[22]

This seventeenth-century pattern of rulers' cross-cultural exchanges and adaptations of regal headgear extended further around the world. For our purposes here it is sufficient quickly to demonstrate its broad extent. An early example was "the headgear [*taç*] belonging to kings, which they [Hungarians/infidels] call *krona*" that the Ottoman Sultan Ahmed I sent in 1605 to his anti-Habsburg ally István Bocskay, ruler of Hungary and Transylvania.[23] Others pile up fast: the Persian-style aigrette or *jigah* that was sent

by Shah Abbas I to the Mughal emperor Jahangir as a sign of friendship; the similarly friendly exchange of turbans between Shah Jahan and Maharana Karan Singh of the Rajasthani kingdom of Mewar; the highly ornamented version of a *taj,* or turban, that the Persian shahs themselves began using from the second half of the seventeenth century, which was in fact a hybrid of an Asian turban and a European crown; and the even more striking hybridity of Queen Njinga of the Ndongo and Matamba kingdoms in present-day Angola, who in the middle of the seventeenth century presented herself on ceremonial occasions not only sitting on a throne with a European-style crown but also in regal robes of silk, velvet, and brocade imported especially from Portugal, all the while skillfully wielding the traditional royal symbol of the battle axe.[24] Occasionally such a regal object could also fail to transcend the cultural and political differences. A crown that the Dutch sent in the opening years of the eighteenth century as a gift to an important ally, the king of Eguafo (also in present-day Ghana), was not brought into use and finally melted down a few years later, reportedly because "this manner is not in practice among the natives."[25]

This mind-swirling phantasmagoria of bejeweled headgears criss-crossing the world between seventeenth- and early eighteenth-century rulers and their agents—and this is but a partial list—coincided with the parallel worldwide interest that we have already seen in potentates' thrones. If we consider together these emerging patterns in the cross-continental history of thrones and crowns—the two most obvious embodiments of personal rule, for which they serve as metonymic substitutes (as in "the power of the crown" and "ascending to the throne")—we confront an interesting possibility. The evidence grows that this period witnessed in many places distant from one another an intensified cross-cultural preoccupation with manifestations of absolute rulership, generating dynamics of mutual exchange in multiple directions between rulers and courts: dynamics of curiosity, of emulation, of currying and bestowing favor, of partial adoptions and adaptations. Never before, perhaps, did rulers the world over thus observe each other (and believe others should observe them), learn of each other's modes of embodying and practicing power, and adapt some of those selectively while anchoring them in local conditions and traditions.

Observing each other is meant here also literally. Rulers of this period exchanged and observed actual portraits of themselves and their foreign counterparts. We have already seen this in the case of James I and Jahangir,

and could similarly have mentioned the exchanges of portraits between Louis XIV and the kings of Ardra or of Siam, or the late seventeenth-century rajas of Rajasthan who modeled their own portraits after those of the Mughal emperor.[26] As a Persian envoy to the court of Siam reported of King Narai in 1685, "He was eager to learn about the other kings of the inhabited world, their behavior, customs and principles. . . . [He] sent everywhere for pictures depicting the mode of living and the courts of foreign kings."[27] The king of Siam famously exchanged embassies with Louis XIV in Versailles, thus adding greatly to his knowledge of foreign kings. But while such diplomatic exchanges among the many potentates we have encountered were the exception rather than the rule, the cumulative outcome of all these numerous discrete events ("events" here understood inclusively as any form of material, observational, or informational exchange about practices and embodiments of *Herrschaft*) was a gradually emergent seventeenth-century lexicon of absolute rule shared by more and more rulers across the globe.

In understanding why thrones and crowns were so central to this emergent lexicon of absolute rule, it bears repeating that in early modern polities rulership was anchored, articulated, and instantiated in externalized embodiments of the ruler's power. Ceremonies, rituals, portraits, and objects were not merely symbolic but constitutive of power. This was especially true of rulers who claimed an absolute personal status that distinguished them from their subjects. Since this was a difference not manifest in physical features, the unique status of such rulers was defined through external, visible means—regalia, dress, ritual, entourage, and architecture. Thus, for instance, a further investigation of this global historical phenomenon might ask whether it is a coincidence that the rebranding of personal rule for so many of the potentates mentioned in these pages involved the creation of a new city in which to house their seats of rule: Kumasi as a new Ashanti capital for Osei Tutu; Shahjahanabad (present day's old Delhi) for Shah Jahan; the Safavid Shah Abbas's earlier rebuilding of Isfahan, centered on the famous Naqsh-e Jahan (literally "Image of the World") Square; the rebuilding of King Narai's Thai palaces that were described as Versailles for Siam; the late seventeenth- and early eighteenth-century redesigning of Abomey, capital of the kingdom of Dahomey, with a cosmologically derived plan centered around the king's house; the vision to rebuild the mythical and largely abandoned capital of Mbanza Kongo as key to the Princess Kimpa Vita's turn-of-the-eighteenth-century vision for the revival of the Kongo kingdom; and in

Europe the newly designed seats of rulers during the same period, which included not only Louis XIV's Versailles but also the transformation of Turin as the Savoy capital centered on the royal palace, the remaking of Berlin as a capital city for the newly crowned Friedrich III/I, the radical founding of St. Petersburg by Peter the Great, and, closer to our own story, a redesigned Saxon royal capital in Dresden as well as a projected redesigning of a Polish royal capital in Warsaw for Augustus the Strong.

The patterns we have seen in this chapter suggest a cross-continental phenomenon in the seventeenth and early eighteenth centuries, one that historians have previously not noticed or conceptualized as a significant historical formation. In referring to these examples as instances of an emergent shared global lexicon of absolute rule, the words "absolute rule" invoke of course the historical narrative of what we call the European Age of Absolutism. The links to European absolutism are not only those of simultaneity of the timeframe but are also evident in numerous identifiable historical threads. And therefore, although the historical weight of the Western Age of Absolutism within this broader global configuration remains to be empirically determined, I have chosen to retain the terminology of absolutism, using the term flexibly and cross-culturally to denote personally embodied rulership with claims to omnipotence and divine sanction. For the broader cross-continental phenomenon discussed here I would like to suggest the term "global absolutism."[28]

It is obviously beyond the scope of this book to provide a comprehensive account of the global age of absolutism, thus unfolding the historical consequences of the convergence between the Age of Absolutism and the early modern age of globalism. And yet it should already be clear, now that we return to our main inquiry, that the seventeenth- and early eighteenth-century phenomenon I call here global absolutism is an essential plank in the full understanding of Johann Melchior Dinglinger's and Augustus the Strong's *Throne of the Great Mogul*: its logic, its contents, its intricacy, its timing. In the broadest sense, this emergent lexicon of global absolutism was the big picture from which crowns, thrones, and other representations and physical embodiments of rulers drew their force at this historical moment. Global absolutism is the context in which we can situate and understand the considerable investments of the transcontinental society of princes of this period in such objects and such representations. Global absolutism is the context in which we can situate and understand the increasing interest of princes during this period in

observing what other rulers—often in distant, faraway lands—were doing, not only in order to learn about these other princes' standing but also in order to learn about the uses and power of their modes of embodiment and self-representation in buttressing their personal rule. In the resulting exchanges and partial adoptions we find time and again hybrid objects and performances of rulership that combined elements from different cultural origins into new arrangements, the interpretation of which depended on this emergent, shared global lexicon of absolute rule. And nowhere perhaps was all of this more pertinent than for the *Throne of the Great Mogul*.

To be sure, Dinglinger and Augustus were unaware of the lion's share of the cross-cultural and cross-ruler throne and crown events that fill the pages of this chapter. They did not know that the *Throne of the Great Mogul* belonged to these patterns of global absolutism, which by the first decade of the eighteenth century were longstanding and widespread. And yet, when Dinglinger chose the Mughal court as the mirror for his Saxon prince; when he invested together with his two brothers and other collaborators such inordinate amounts of time, effort, and resources in the unprecedentedly rich details of this miniature court, an investment that sometimes aspired to ethnographic accuracy and other times wallowed in cultural hybridity; when he focused on the person of the Great Mogul and on the most momentous public performance of his power; when he remained confident that Augustus the Strong would understand the need for all these efforts, appreciate the outcome (while probably providing earlier encouragement along the way), and be willing to pay for it; and, more specifically, when Dinglinger insisted on the peacock that identified Shah Jahan's Peacock Throne and when he deliberately replaced the Great Mogul's turban and sword with a European crown and scepter, and similarly when Augustus donned an oriental aigrette in his Polish coronation images and had Dinglinger design such Asian-looking feather jewels for him—in all these choices and actions Augustus and Dinglinger, the highly attuned and well-connected prince and his court jeweler, proved to be immersed in the global cultural-political context of their times. They were certainly receptive to the impulses emerging from the patterns of global absolutism I have suggested in this chapter. Every now and then they even showed flashes of awareness of its existence.

Our quasi-global round of suggestive interconnections among rulers far and wide in the period of the *Throne of the Great Mogul* is almost complete. I

would like to bring our focus back to Dinglinger and Augustus in Dresden via the one ruler contemporary of Augustus whose weight and influence in the European Age of Absolutism was greater than any other's, and yet whose presence in these pages has been relatively minor so far: Louis XIV of France.

Every account of Augustus the Strong rightly notes his wish to imitate the ways of the court of Louis XIV ever since Augustus's almost nine-month-long sojourn as a young duke in Paris in 1687–1688, during which he visited Versailles no less than sixteen times. As elector and king Augustus kept an agent in Versailles who informed him of new developments to watch for. Thus, for example, François Girardon's ten-and-a-half-meter equestrian bronze statue of Louis XIV in 1699 prompted Augustus to commission from Girardon or his workshop a similar equestrian bronze statue, an exact mini-ature measuring a tenth in size (105 cm), with its facial features reworked to look like himself. For the rooms redesigned in 1715 to hold his *Schatzkammer* treasures (the future Grünes Gewölbe) Augustus ordered Parisian wall mirrors. At the peak moment of the 1709 celebrations for the Danish king Frederik IV, we recall, Augustus put on Dinglinger's sun mask, made espe-cially for the occasion in imitation of Louis XIV's famous appearance in the guise of Apollo early in his reign. A decade later, for the event that would signal the most significant political achievement of his career, the wedding in 1719 between his son and the daughter of the Holy Roman Emperor, Augustus requested from his agent in Paris a copy of the outfit that Louis XIV, by now already dead, had worn on his wedding day almost seventy years before.[29] In this preoccupation Augustus, even if somewhat excessive, as was his wont, followed the well-trodden path of many princes in the Holy Roman Empire and across Europe, imitating Louis XIV and his Versailles court as the model for absolute rule. As Friedrich the Great summed it up in the middle of the eighteenth century, looking back in disdain, "all of Europe sought to imitate the France it admired," "enthused by the magnificence which Louis XIV impressed on all his actions, by the sophistication of his court."[30]

The shadow of Louis XIV can also be found in Dinglinger's *Throne of the Great Mogul*. The wall mirrors that surround the Great Mogul's court would have brought to a contemporary viewer's mind the Galerie des Glaces in Versailles, just as the huge sun above the Mogul immediately invoked the imagery of the Sun King. To be sure, in both cases these elements had a

Mughal source: the halls of mirrors in the Mughal palaces (though these were mirror mosaics of many small pieces, rather than large mirror panes) or the sun as a Mughal symbol, as we have already seen in Wouter Schouten's engraving of the Mughal emperor's throne. And yet these elements obviously resonated for European observers with Louis XIV and his court, and indeed would have reinforced the sense that great rulers in faraway places drew on a shared material and visual lexicon. By contrast, the most deliberate and carefully executed homage to the French court in Dinglinger's ensemble was a subtler gesture, likely to have been overlooked by an uninformed observer. This is a water basin that Dinglinger modeled after a design print by Jean Lepautre, one of the main French court designers and printmakers whose 2,200 prints, and especially his ornamental inventions, were influential in the spreading of the Louis XIV style across Europe.[31] The unusually large water basin (13 cm high; see frontispiece and plate 2, right behind the scales), eye-catchingly enameled by Georg Friedrich Dinglinger and placed centrally at the front of the ensemble, happens to be the only court object in Dinglinger's ensemble that was adapted wholesale from another European princely setting.

All this is hardly surprising. And yet in other ways Louis XIV does not fit well into the picture that has emerged from the last few chapters. Consider, say, his throne: Louis had indeed a luxurious silver throne made in 1681, albeit somewhat hurriedly, and before he ordered it to be melted down a mere eight years later as a contribution to military expenses. More significantly, this throne did not command much respect or reverence at Versailles and was used only rarely. As historian Peter Burke has pointed out, Louis wheeled out his special throne for the audiences given to the Moroccan and Algerian envoys in 1681 and 1684, the Siamese envoys in 1686, and the Persian envoys in 1715 (on another throne that Louis himself downplayed as a simple armchair, "*un fauteuil à l'ordinaire*"). From this list one may reasonably conclude that Louis XIV saw in his throne simply a way of impressing foreign visitors from exotic, distant lands.[32] The same was also true of Louis XIV's personal crown, which, surprisingly, was plain and unembellished with precious stones. It was only in 1722 that Louis XV commissioned a magnificent crown for the French king, set with the richest stones from the royal collection.[33]

An especially suggestive illustration of the complexity of Louis XIV's self-presentation as monarch is his state portrait in full regalia that was

painted by Hyacinthe Rigaud in 1701. With the king donning his fleur-de-lis ermine robes and the sword of state, holding his scepter with his crown close by, this portrait is famously taken to be the epitome of the self-representation of an early modern absolute monarch, one that gazes at the (nonroyal) spectator rather than the other way around. But this widely shared view of Rigaud's portrait requires us to dismiss with an uneasy laugh an incongruity at the center of the composition that seems quite inappropriate for a regal state portrait. Oddly, Rigaud's larger-than-life Louis XIV is holding his scepter upside down, leaning on it as if it were a walking cane.[34] How can such a playful gesture be explained or accommodated within a display of *majesté?* A similar playful nonchalance is evident in Antoine Morand's clock that was installed in Versailles in 1706. The clock's action for marking time— its cuckoo function, if you will—was the parting of clouds and the appearance of Fame, ready to crown a small statuette that reemerged every hour on the hour, representing the king himself.[35] In a palace dominated through and through by representations of the absolute king, this particular use of the king's image was again playful rather than majestic, presumably making the observer smile rather than stand in awe.

These peculiarities in Louis XIV's modes of display as ruler highlight his particular place within the map of European absolutism. Louis, as expressed in the title of an eponymous 1698 fairytale that will be of interest to us later, was "Sans Parangon," without equal. Somewhat earlier a court historiographer, having written a book titled *Parallèle de Louis le Grand avec les princes qui ont été surnommés grands* (Parallel Between Louis the Great and [Other] Princes Who Have Been Called Great), made the point as clearly as possible: "Louis resembles all the Great princes, although none of these Greats resemble him, because only he is similar to himself, and the Great prince par excellence. In one word the Incomparable."[36] If Louis was "incomparable," then semblance could not be a two-way street. To be sure, we know that Louis played the game of competitive absolutism just as avidly as other princes, and often better. But at the same time, as the examples above suggest, he could also entertain transgressions from the expectations of this game, transgressions which demonstrated that his own superior status as absolute ruler—at least in Europe—was indeed unique.[37]

Nothing demonstrated this singularity more poignantly, especially in terms of our earlier discussion of mirrors for princes, than a transgression that took place in miniature and was visible only for people in the know. The

location of this transgressive self-representation of Louis XIV, rediscovered in recent years following restoration work in Versailles, could not have been more significant. Charles Le Brun, the king's leading painter, placed it at the heart of the central ceiling painting in Versailles's Hall of Mirrors, the symbolic and political center of French absolutism. The famous painting *Le roi gouverne par lui-même* of 1661 celebrated the moment Louis XIV came into his own through an image of the king about to be crowned by Minerva, Mars, and an allegory of glory. What is of interest to us happens very close to Louis XIV's face. Minerva's polished shield serves in the painting as a mirror: one can see in it a clear image of the king (plate 20). Hall Bjørnstad, who has spent more time than anyone studying this unusual image, has shown that Le Brun planned this mirroring effect with deliberate care and changed previous designs to accommodate it. So what does one see in this mirror for the prince? As we have come to expect from the behavior of mirrors next to princes, this shield-mirror does not merely reflect but rather presents a quite different visage than the face it supposedly reflects. In contrast to the standard usage of a mirror for a prince, however, which we expect to show the exemplum or ideal, in this case exactly the reverse is taking place. The king in front of Minerva presents the ideal face of a king, with perfect Grecian features, complete poise, and no emotion. But his reflection in the mirror is coarser, earthier, full of emotion and perhaps even desire.[38] Other princes need mirrors to show them their ideals and exempla to which to aspire. But if you are Louis XIV, the singular absolute ruler who already embodies his own ideal, then the mirror for the prince—and one that is intended really only for him—can perform a very different function. The hidden mirror portrays a moving image of the real, feeling Louis XIV—the always-hidden human side of the "incomparable" king's two bodies.[39]

We ended up with a miniature mirror embedded in the ceiling of the Hall of Mirrors that in its unusual features displayed Louis XIV's superiority over other absolute princes. This unexpected twist allows me to end this chapter by going back to the miniature mirror in the *Throne of the Great Mogul* with which I began the exploration of this artwork's connection to contemporary absolutism, and by allowing Dinglinger himself an ironic final word. For even if Louis XIV was Europe's superior absolute king, whose relationship with other European rulers like Augustus the Strong was decidedly asymmetrical, the latter could still take comfort in small triumphs.

Once again, one needed to be in the know, in this case, to know something about the history of mirror-making.[40] The Galerie des Glaces at Versailles, opened in November 1684, was celebrated rightly as an unprecedented feat in the use of mirrors, with its more than three hundred mirrors from blown glass arranged in seventeen false window casements. But it so happened that the main technological breakthrough in large-scale mirror-making took place in France a few years *after* the completion of the Hall of Mirrors, namely, the invention of casting glass on a flat table, which allowed for the production of mirrors much larger than could have been achieved even by the most experienced glassblowers. A Jewish glassmaker from Orléans, Bernard Perrot, was the first to present the invention of a cast-glass mirror to the French Academy of Sciences in 1687, though it took the royal glassworks another decade to turn this radical breakthrough into a dependable monopoly. The English naturalist and fellow of the Royal Society Martin Lister recorded his astonishment at his visit to the Paris glassworks in 1698: " 'Tis certainly a most considerable addition to the Glass-making. For I saw here one Looking-glass foiled and finisht, 88 inches long, and 48 inches broad; and yet but one quarter of an inch thick. This, I think, could never be effected by the Blast of any Man."[41] In 1691 the king was presented with four 2.1-meter mirrors; by 1700 the glassworks factory followed with a cast pane of glass almost 2.7 meters tall and more than 0.9 meters across. The mirrors in Versailles's Galerie des Glaces, by contrast, measured only 66 to 86 centimeters. A whole new era in the history of mirror-making had begun.

So now let us take another look at the freestanding mirror in Dinglinger's *Throne of the Great Mogul* (see fig. 3, plate 2L). The mirror stands twice the height of its attendant, but once we take into account the dimensions of the frame, it appears to represent a mirror of a single sheet of glass of about one and a quarter human size, or about 1.8 to 2.1 meters, with a width of perhaps 1.6 meters. In order to appreciate the radicalness of this particular form of mirror we must place ourselves firmly within the horizons of the knowable and the imaginable for a viewer of the first decade of the eighteenth century. Unlike other objects represented in Dinglinger's *mise-en-scène*, a mirror of this size was the most cutting-edge innovation, a breakthrough technology that had just entered the highest end of the European luxury market. Dinglinger's miniature presented to the viewer something that a mere decade before had not existed and could not have been easily imagined outside fairytales or Rabelaisian fantasies.[42]

The fact that Dinglinger conjured up so precisely the appearance of the human-size mirrors about to hit the high-end luxury market was no coincidence. News of the revolutionary new type of mirror arrived in Dresden in 1702, and by 1704 Augustus has already acquired through his Paris agents several extra-large French flat mirrors. These *"grands miroirs"*—thus named in the invoices detailing their enormously high prices—measured up to two meters in height.[43] Dinglinger, a highly informed court jeweler with a constant interest in technical innovations in decorative arts, was surely aware of, and perhaps involved in, this exciting purchase. Indeed, I suggest later the identity of the Dresden expert on mirrors who witnessed the birth of larger-than-life mirrors at the French glassworks during those very years, and who is likely to have been both Dinglinger's and Augustus's informant. We should also note that Dinglinger's letter of 11 October 1707, in which he offered Augustus the Strong the *Throne of the Great Mogul*, specifically singled out the freestanding mirror and described it as a "large mirror [*ein Großer Spiegel*]," precisely the same term used in the French invoices for Augustus's purchases of 1704.[44]

Was there an ironic pleasure in drawing Augustus the Strong's attention to Dinglinger's "large mirror"? Recall that due to the vagaries of historical timing, Louis XIV's great Galerie des Glaces, for all its mirror fame, was completed shortly before Perrot's invention and thus did not include the revolutionary type of larger-than-human-scale mirror. So when such a mirror was now on prominent display in Augustus's court of the Great Mogul—echoing the new and expensive purchases that had just arrived from Paris to the Dresden court—was Dinglinger playfully offering his prince a small private triumph-in-miniature over the great Louis XIV, a point scored in the incessant competition between rulers?[45]

5. Scales (or, Figuring Miniatures in Princely Courts)

Dinglinger's *Throne of the Great Mogul* contains an additional meaningful gesture to the seventeenth-century exchanges between the Mughals and the Europeans. It is an object two centimeters long: a miniature book that today lies visible at the center of the lower level of the Mogul's court among the gifts unpacked from the treasure chest that stands beside it. The small book is encased in a gold binding with gem and enamel ornaments. I have not seen it opened, nor have the current curators of the Grünes Gewölbe in Dresden. But Erna von Watzdorf, an art historian who was active in the Grünes Gewölbe between 1928 and 1945 and wrote a two-volume biography of Dinglinger, described the small book as containing hand-painted continents. The text that Augustus received from Dinglinger together with his purchase in 1709 indeed specifies precisely the nature of this book: *Der kleine Atlas*—a miniature atlas.[1]

Like globes, atlases were an early modern Western invention helping to organize visual knowledge of the world, in this case in book form. Shortly after such books began to appear in the second half of the sixteenth century, the term "atlas" was applied to them by the renowned geographer and cartographer Gerardus Mercator in his last book of maps, published posthumously in 1595. Some two decades later Mercator's work made a grand entry into the Mughal court through the hands of the British ambassador Sir Thomas Roe. Roe reported that on one occasion he found himself without an appropriate gift for Emperor Jahangir, "which made mee venture upon a

faire Booke well bound, filleted and gilt, Mercators last Edition of the Maps of the World." Roe wrapped his gift with diplomatic flair, presenting it to the Mughal emperor "with an excuse that I had nothing worthy, but to a great king I offered the world, in which he had so great and rich a part."[2]

What made this exchange more loaded and interesting is what happened next. The first hint came a week later, when Jahangir "questioned [Roe] about the Booke of Maps." Two weeks later Roe reported how, in another audience at court, the Great Mogul "sent for the Map-booke, and told me he has shewed it to his *Mulaies*, and no man could reade nor vnderstand it; therefore if I would, I should haue it againe. I answered: At his pleasure; and so it was returned."[3] If we believe Roe's account, the Mughals, who as we have seen enthusiastically "Mughalized" Western globes as representations of the world for their own purposes, at the same time found the diagrammatic and more abstract form of an atlas less comprehensible. Roe's chaplain, Edward Terry, added some more details in his own published account of this incident. According to Terry, Roe explained to the Mughal emperor "that that book described the four parts of the world, and all the several countreys in them contained," upon which Jahangir asked to be shown where his own lands were represented. The emperor then turned the pages, "and finding no more to fall to his share, but what he first saw, and he calling himself the Conqueror of the world, and having no greater share in it, [he] seemed to be a little troubled," and thus handed back the atlas.[4]

Regardless of Terry's gratuitous condescension at the supposed comeuppance of the Mughal emperor who "feeds and feasts himself with this conceit, that he is Conqueror of the World," it is clear that this gift and its ultimate rejection constituted a loaded moment in the exchanges between Thomas Roe and Jahangir. With this in mind, let us look again at the miniature book in the *Throne of the Great Mogul*. After all, this book set up as a gift to Dinglinger's Mogul is an atlas containing the continents of the world. Furthermore, it is a world atlas that is well-bound, gilt, and filleted—that is, ornamented with lines on a book cover—precisely as Thomas Roe had described the atlas he presented to Jahangir. Is this a fortuitous coincidence or a knowing reference to that loaded exchange between the English ambassador and the Mughal emperor? The latter, to my mind, is much more likely. Indeed, we know from a (somewhat later) inventory of the Saxon palace library that one could find in Dresden a copy of Samuel Purchas's *Purchas His Pilgrimes* of 1625, a compilation in which Thomas Roe's account of the

incident involving the atlas was first printed.[5] It is therefore plausible to assume that during Dinglinger's preparations for his big project he had become acquainted with this particular story about Europeans at the court of the Great Mogul. On Dinglinger's part, the miniature atlas was then a rather subtle gesture. On the one hand, it reinforced the global reach of the gifts for the Great Mogul. On the other hand, given the incident with Roe, the atlas also alluded to the limits of the Mogul's reach and to the edge that a European ruler maintained over his Asian counterpart.

By this point, the reader may object with frustration that I am missing the whole point of this object. After all, surely it makes a difference that what we are looking at is not simply an atlas but a *miniature* atlas measuring only two centimeters, with even smaller miniature drawings therein. Similarly, the previous chapter ended on an almost comical note, suggesting a comparison between the mirrors of Augustus the Strong and Louis XIV that is all about *size*, when the actual object that in my interpretation signaled the Saxon advantage with larger-than-human-size mirrors is again a miniature standing a mere nine centimeters tall. The competition between rulers in both cases was enacted in a miniature world. Indeed, the very throne of the Great Mogul is a miniature, and yet the previous chapter placed it and its miniature owner in a seamless historical picture next to human-size thrones created for life-size rulers across the globe. It is therefore high time to talk about the *scale* of these objects, and to try to understand how they could carry such big statements, inversely correlated with their actual physical size. This is a key point. Grasping the import of miniature objects at the turn of the eighteenth century is essential to fully explain the enormous investment in the *Throne of the Great Mogul*, an ensemble of so many tiny objects that together created a miniature court of a great distant ruler occupying a table less than a meter and a half wide.

Size matters. It matters to us all the time. In daily experience we expect people we meet to be more or less our size, dogs to be significantly smaller, buildings to be significantly bigger. Misalignments of scale therefore carry a frisson: they can frighten, they can amuse (as evident, say, in the evocative contemporary street art of Slinkachu), they can befuddle, they can arouse wonder, but they cannot fail to draw one's attention.[6] Things out of scale are things out of place and in need of a narrative.

On one level, it is undoubtedly the case that a fascination with Lilliputian things is a staple of human culture that is found in ancient and modern societies around the world. Claude Lévi-Strauss wondered many years ago whether the small-scale model or miniature "may not in fact be the universal type of the work of art." Its special quality, he explained, is that "in contrast to what happens when we try to understand an object or living creature of real dimensions, knowledge of the whole precedes knowledge of the parts." This effect, even if it is an illusion, gratifies the human intellect as well as the aesthetic sense; the miniature works universally by renouncing what Lévi-Strauss called the "sensible dimensions" in favor of "intelligible dimensions." As Susan Stewart has written in one of the most evocative essays on this subject, miniaturization is by definition a cultural procedure: "There are no miniatures in nature; the miniature is a cultural product, the product of an eye performing certain operations, manipulating, and attending in certain ways to, the physical world."[7] Miniaturization is a cognitive faculty, a particular way for humans to interact with their world and understand it.

On the other hand, it is also the case that like many other universal human traits *in potentia*, their expressions are resolutely historical and can vary across a wide spectrum of possibilities. Humans may well be inherently attracted to miniature (or gigantic) objects, and yet there are specific cultural contexts and particular historical moments in which alterations of scale become especially meaningful. The goal of the present chapter and the next is to show that the period from the middle decades of the seventeenth century through the beginning of the eighteenth century was precisely such a moment: a historical conjuncture in which miniature objects in the West proliferated in distinctive forms and were invested with cultural resonance. What follows, therefore, identifies certain characteristics of the miniature objects of this period and links them back to the specific historical contexts from which they emerged, shows the particular ways in which this cultural trend entered the world of courtly taste and princely collections, and establishes this particular configuration in the history of miniature objects as an essential context for the creation and understanding of Dinglinger's *Throne of the Great Mogul*. In the previous paragraph I used the word "Lilliputian" as a well-established synonym for miniature. Another way to put my argument is that it was not a coincidence that Jonathan Swift, a trendsetter of Western culture, brought Lilliput and Gulliver into existence precisely in the early eighteenth century, suffused with perceptive insights about the

consequences of alterations of scale, following a period of intense European preoccupation with, and investments in, scale-altering objects.[8]

In this chapter we begin with the society of princes and princesses. In April 1692 Anna Maria Luisa de Medici had a miscarriage. The last princess of the Medici family, she had married the previous year the Elector Johann Wilhelm von der Pfalz. (A decade later, we recall, she would thus almost become the queen of Armenia.) Although their betrothal, as I have mentioned before, was a political move in the competition for quasi-royal honors between Italian and German princes, it led to a harmonious and affectionate marriage. The electoral couple took mutual pleasure in turning the new Palatine capital of Düsseldorf into one of the major centers of arts and collecting in Europe at the turn of the century.[9] A major disappointment, however, clouded their marriage: Anna Maria Luisa was unable to bear children (which is why she went down in history as the last princess of the Medici).

In 1695, perhaps following a second miscarriage, Johann Wilhelm sent his "adored and beloved Electress" Anna Maria Luisa a gift from Amsterdam (plate 21). It was an exquisite miniature cradle of gold filigree, measuring forty-nine by fifty-five millimeters. In it, resting on top of a miniature blanket in blue silk embroidered with small pearls, lay two freshwater pearls that together create the shape of a newborn baby. Unusually, the miniature is actually documented in a letter from a craftsman or agent in Amsterdam to Johann Wilhelm, dated 1695, reporting the expedited shipment to Düsseldorf of "the oriental pearl portraying a baby and the cradle." The cradle is engraved with the words "*auguror eveniet*," meaning more or less, "I predict that it will come to pass."[10]

What a moving object. It embodied with crystalline clarity the electoral couple's ardent yet fragile hopes for an heir, their conjugal love and mutual need for consolation, as well as their anxiety about the dynastic succession that was exacerbated by the increasing concerns of those around them. But why pack all this emotional freight into a painstakingly made miniature object of five and a half centimeters? It seems to me insufficient to say, as one creative scholar of the cognitive aspects of material culture has done, that "miniatures have certain physical and semiotic properties" that endow them with a universal tendency "to bear meaning in an intensified fashion."[11] While this may be true, it does not get us very far in explaining Johann Wilhelm's individual choice at that particular moment, nor the

broader historical or cultural patterns in which this particular choice was situated and with which it resonated.

On one level, the explanation for the Elector Palatine's choice of gift is obvious: the electress loved miniatures. Next to the official art collection that she and her husband amassed in their palace in Düsseldorf, Anna Maria Luisa also cultivated her own private collection, set in two private "cabinet rooms." Pride of place in her collection went to her *galanterie gioiellate*, that is to say, her precious little things. This term comes from a 1743 inventory, taken shortly after her death, which enumerated for this category no less than 789 objects. It may well have been the richest such collection in Europe during this period, described in her own words already in 1697 as "one of the most beautiful things that are in Germany." While Anna Maria Luisa inherited many pieces of jewelry, the taste for freestanding miniatures was her own, leading to multiple acquisitions in the late seventeenth and early eighteenth centuries, such as the turn-of-the-century elephant and camel illustrated here (plate 22, top). Furthermore, given that most of the pieces were gifts from her doting husband, or purchases they made together on occasions such as the Frankfurt Fair, it is reasonable to assume these small objects played a not insignificant role in the intimacy of their marital relationship.[12] This impression is strengthened by the existence of a highly unusual miniature figurine of Johann Wilhelm himself, humorously portrayed as Mars, dating to 1704, which was certainly a private piece authorized by the elector and may well have belonged to his wife's miniature collection (plate 23).[13] Considering Anna Maria Luisa's passion for miniatures, then, and the role of miniatures in her relationship with her husband, the choice of the pearl baby in the gold filigree cradle as a gift for that especially loaded moment of intimate consolation seems to fit right in.

A broader look at European courts reveals that such a gift would have fitted in well with the purchasing habits of other late seventeenth-century princes and especially princesses. Women were often the collectors of miniature *pretiosa* (precious objects), though men like Johann Wilhelm von der Pfalz or, as we shall shortly see, Augustus the Strong were avid participants as well. In Sweden, for instance, the formidable Hedwig Eleonora, in turn queen from 1654 to 1660, dowager, sometime regent, and for more than half a century the Swedish court's most powerful woman, became the most important collector in Swedish history until her death in 1715 (next to Queen

Christina, who at her abdication dispersed her collections). Hedwig Eleono-
ra's many-sided collecting, like Anna Maria Luisa's, included a deliberate
investment in a large number of miniature objects, such as the twenty-five
miniatures she purchased in 1685 from her Dutch agent, a converted Jew by
the name of Carl Christian Mandel. Her jeweler-made miniatures included
such pearl and enameled gold objects as a monkey playing a fiddle that is
twenty-two millimeters tall (including the base), a miniature pearl-belly frog
on an agath pedestal (one of the items commissioned in 1685), a tiny Bacchus
riding a barrel, and an unusual cylindrical gold box measuring only eight
millimeters that holds several small-denomination coins (plate 22, bottom).[14]

The lid of the miniature coinbox in the Swedish royal collection sports
an electoral hat of the Holy Roman Empire and a monogram: "J G 3." This
is the cypher of Johann Georg III, elector of Saxony from 1680 to 1691. The
box also bears his Latin motto, and the coins themselves, worth one-eighth
of a ducat, are Saxon coins from his reign. We are suddenly back in Dresden.
Not that this is very surprising. For one, Hedwig Eleonora was partly Saxon.
Granddaughter of an earlier Saxon elector, Johann Georg I, she grew up in
the German court of Gottorf where her mother, Marie Elisabeth of Saxony,
was highly influential in developing a rich cultural milieu and not least a
Kunstkammer filled with *pretiosa*, itself modeled after her own experience of
the Dresden *Schatzkammer*.[15] Second, and more importantly, Saxony was a
major center for the collecting as well as the making of miniature objects.
Take for instance an ebony, gold, and gemstone camel with two African
figures that belonged to Friederike Elisabeth von Saxony-Eisenach, consort
of Duke Johann Georg of Saxony-Weissenfels, a family with close relations
to the Dresden Wettins, or an ivory, brass, and gemstone camel with an
African figure that belonged to Christiane Eberhardine, wife of Augustus the
Strong (plate 24).[16] Interestingly, each of these camels, in turn at eighteen
and sixteen centimeters, looks much like a blown-up version of Anna Maria
Luisa de Medici's minute, five-centimeter camel figurine, likewise accompa-
nied by an African attendant. Miniature objects often traveled in packs.

Unsurprisingly perhaps, few had a stronger attraction to small-scale
precious objects—one might say obsession—than Augustus the Strong
himself. He collected them all his life, whether from his own court jewelers
and artists or through purchases in venues such as the Leipzig and Frankfurt
Fairs, which he made personally or through agents. When Augustus later in
his reign set up the Grünes Gewölbe, the intimate space within it called the

"Corner Cabinet," dedicated to the small-scale and miniature works of art he had amassed, boasted close to five hundred pieces. "Especially note-worthy," wrote a visitor shortly after the display was arranged, is "a small cabinet" in which one finds "various figures, not longer than a finger."[17] That Augustus might have imagined this calling already at the beginning of his reign is suggested by a one-of-a-kind miniature object in his collection (plate 25). At almost fifteen centimeters high this is not an especially small object, but it is a complex one. It shows in miniature an elegant cabinet or wall piece with diamond-ornamented consoles for the purpose of display. These are occupied by a tea set, complete with minute cups and saucers measuring a few millimeters and a teapot 1.2 centimeters tall. The electoral hat on top indicates that this piece entered Augustus's collection when he was still elector but not yet king, that is, in the mid-1690s, which makes this the earliest datable piece acquired by Augustus for his *pretiosa* collection. At that time such a display arrangement with consoles, which three decades later was going to be adopted across the Grünes Gewölbe, was not yet common: Augustus may have remembered it from his visits to Versailles as a young prince.[18] Be that as it may, the piece itself is as unique as it is revealing. It is what art critics call a *mise-en-abyme*, which can be explained as a self-referential mirroring of meaning in a work of art operating on two hier-archically ordered levels. Here, Augustus had a precious miniature, itself representing a displayed collection of *pretiosa*, or, we might say, a representa-tion or even a kind of self-portrait of a miniature collector—recall the elec-toral hat—in collectible miniature form.

We have already seen another self-portrait of a court miniature collector that matched form with content by being itself a miniature: the figurine of Elector Palatine Johann Wilhelm as the god Mars (plate 23). As a princely self-portrait, it is virtually unique.[19] But at the same time this figu-rine is actually an excellent example of how miniatures traveled in packs. Johann Wilhelm's figurine belongs to a specific genre of late seventeenth- and early eighteenth-century miniatures that spread among courtly collec-tors in Europe during a relatively short period. What is common to this particular genre of freestanding figurines is the irregular, misshapen, often lumpy pearls around which the figure is designed, in this case the pearl consti-tuting the elector's torso. Such pearls were rare and highly valued. They are known as "baroque pearls" or "barroco pearls," preserving the Portuguese origin of this term, which is also one of the etymologies often suggested for

the term "baroque" as a whole. While they could not really stand out as beautiful gems on their own, they turned into unique and valuable pieces once an imaginative jeweler conjured up from them a three-dimensional figure in often surprisingly creative ways, which—when successful—seamlessly harnessed their irregularities.

Baroque pearls already had an earlier spate of popularity in the sixteenth century, when an influx from the American coasts spawned a wave of unusual jewels created for European courtly circles: pendants (typically) that combined the natural qualities of these pearls with jewelers' creative fantasies. After having gone out of fashion for about a century, baroque pearls came back. What was new and catching in this second wave of jewelers' creations with baroque pearls from the late seventeenth century was their form. They were now incorporated into freestanding figurines, each one creating a narrative specifically tailored to the uniqueness and irregularity of the misshapen pearl. Such figurines of animals and humans, often grotesque, spread in considerable numbers across courts in the Germanic sphere, like the figurine of Johann Wilhelm von der Pfalz or the baby in the crib he sent to his wife in 1695. Anna Maria Luisa de Medici and Johann Wilhelm collected altogether no less than twenty-seven baroque pearl miniatures. Augustus the Strong acquired what was almost certainly the largest collection in the world of baroque pearl miniatures, of which we know about seventy pieces.[20] One of them, as it happens, was of a striking camel shaped from a monstrous pearl (plate 24, bottom left). The camel is attended by two Africans who resemble closely the attendant of Anna Maria Luisa's miniature camel. A single miniature, it turns out, could travel in more than one pack.

From the point of view of the cultural historian, beyond their unusual creativity, what is interesting about these freestanding baroque pearl figures is that they suddenly appeared as a distinctive art form, which was specific to a particular time, a particular place, and a particular clientele, and then disappeared again. With almost no exceptions, the many dozens of figurines that have survived, and those of which we know from written documents, emerged in the Holy Roman Empire beginning in the 1690s and continuing through the first couple of decades of the eighteenth century. Always unsigned, they appear to have been made by several jeweler artists, centered in a few workshops, and sold competitively and exclusively to princely collectors. The courts in which they ended up are all in the Germanic sphere

or otherwise close to it and influenced by it (St. Petersburg, Stockholm, Copenhagen). A central figure in this trade was a mysterious merchant with a jeweler's training by the name of Guillaume Verbecq, who lived in Frankfurt from 1696 to 1707 and was involved in many purchases of baroque pearl figures. Verbecq appears in Augustus the Strong's inventories in connection with these purchases no less than sixteen times.[21]

For our purposes here, what is most significant is that *Perlfiguren*—to use the German name for a Germanic art form—are a particular genre of miniatures, typically of five to eight centimeters in size (not including their often highly ornate mini pedestals). They all represent in small scale human figures and animals, typically coming together as a genre scene or visual narrative. The popularity of this genre for a short period of some twenty to thirty years captures for us the cultural moment of the miniature figure in courts in and around the Holy Roman Empire in the late seventeenth and early eighteenth centuries. This of course was precisely the moment in which Johann Melchior Dinglinger and his brothers created the unusual set of miniature figures that together constituted the *Throne of the Great Mogul*, the miniature ensemble purchased by Augustus the Strong, Europe's greatest amasser of baroque pearl figurines. The force of this historical moment is further revealed in an inventory entry in the Dresden court archive. Augustus, it turns out, actually requested that four Renaissance pieces of jewelry with baroque pearls, which had already been part of the Dresden collections, be taken apart, reworked, and placed on miniature pedestals as freestanding figures: a new design intended to satisfy the new taste for storytelling figurines that Augustus had acquired by the turn of the eighteenth century.[22]

Baroque pearls, however, were hard to come by. A jeweler might have seen such giant pearls suitable for figure-making once or twice in a lifetime, or if a court jeweler with privileged lines of supply, perhaps once every few years. (The Dresden collection actually has a natural cluster of baroque pearls still in their shell, presumably awaiting their jeweler.[23]) Moreover, each misshapen pearl was different, and thus its artistic outcome impossible to plan ahead. Because of these limitations, the new courtly taste for storytelling figurines could hardly rely on the serendipity of this occasional art form. It is therefore not surprising that next to them we find in court collections in the decades on either side of 1700 other intricate, valuable miniature figures in different artistic forms. In Munich, for instance, there are four enigmatic late seventeenth-century figurines ("herms"), possibly belonging

originally to the collection of the Electors Palatine. Measuring thirteen to seventeen centimeters (without the base), each of them is made of a medley of polished gemstones brought together to form a pair of European aristocrats and a pair of American Indians. Interestingly, just as Augustus requested to "update" into miniature form several of the Renaissance baroque pearl pendants in the Dresden collection, here too the heads of all four herms were actually late medieval pieces of sculpture that were repurposed at the turn of the eighteenth century by placing them on top of newly made bodies to form freestanding human figures.[24]

A more prolific series of miniatures representing jeweler-created human figures were made of ivory, with added diamonds, gems, and colored glass for eyes, buttons, and other details. Augustus the Strong's collection of ivory miniatures was again perhaps the largest of all, with some fifty pieces. Typically under ten centimeters tall (not counting their pedestal or base), these included miniature dwarfs, genre types, and street vendors, whose life positions and occupations—similar to the grotesque figures made of the rare baroque pearls—stood in unmissable contrast to the expensive materials and painstaking workmanship. A particularly notable example is the miniature scissors- or knife-grinder (plate 11, bottom). This figure existed in multiple versions in different princely collections—with pride of place to those of Augustus the Strong and of Anna Maria Luisa and Johann Wilhelm von der Pfalz—and thus demonstrates the dense connections between the courts in the Germanic cultural sphere. The most likely origin of the knife-grinder figurines was the workshop of Johann Heinrich Köhler in Dresden around 1710. It has also been suggested, however, that this repeated theme had a connection to a particular entertainment in the Brandenburg court in 1690, an occasion for which the court poet Johann von Besser wrote a poem celebrating the scissors-grinder, which may have spawned the princely taste for this particular design.[25] Regardless, the point to note is that the ivory miniatures of this genre could be found in the same German and German-influenced courts as the baroque pearl figures and occupied the same visual universe. So much so, in fact, that the account of a visit to the Grünes Gewölbe shortly after it opened that I quoted before failed to tell apart the two genres but rather conflated them.[26] Further evidence of an affinity between these genres of miniatures is the very similar knife-grinder figurine found in St. Petersburg, belonging to the same moment and the same vogue, but this one made of two large baroque pearls. In short,

these ivory figurines join the others I have discussed in this chapter as examples of the penchant of princely collectors in and around the Holy Roman Empire for expensively wrought miniatures, and especially for freestanding miniatures of human and animal figures, in the decades on both sides of the turn of the eighteenth century.

For a final demonstration of the attraction of miniatures to princes and princesses at this particular moment in time we can return to an object we have encountered earlier. Recall the surprise egg with a sequence of nesting miniatures that Liselotte von der Pfalz sent to Caroline of Ansbach: once again an intimate gift in miniature, once again a moving gesture involving princesses that were raised in Germanic courts. The message of that ivory egg was singular, of course, a bond forged through the political successes of the two women, signaled by the electoral and royal crown hidden within. But in fact this egg itself, once again, was not singular. We know of six such ivory eggs that emerged in the circles of imperial princes at the opening decades of the eighteenth century. One is in the Habsburg collections in Vienna, secreting a ducal coronet and its own personalized message, the meaning of which is now lost: a golden-wire arrow piercing a heart next to the number 3, presumably a wordplay on the German "drei" sounding like "treu" ("true"). The others are now lost or in private hands. One egg hiding a diamond crown and enameled portrait was owned by the margravine of Baden-Baden, Sibylla Augusta, an early romantic interest of Augustus the Strong and Anna Maria Luisa de Medici's sister-in-law, whose collections also included an ivory knife-grinder. Another, with a nested hen enclosing a motto with small diamonds, belonged to Anna Sophie, the second wife of Frederik IV of Denmark, for whose visit in 1709 Augustus set up the display of the *Throne of the Great Mogul*. Predictably, Augustus the Strong himself also owned such an egg, which he acquired at the Leipzig Fair in 1705: "a golden egg in which is placed a golden hen and in the hen a little, diamond-embellished crown." In 1725 Augustus was also offered the sixth documented ivory egg, formerly belonging to the duchess of Saxony-Coburg-Meiningen, in which the hen enclosed "a royal crown garnished with brilliant cut diamonds and pearls, in the crown a ring with green heart-shaped roses."[27] To be sure, each one of these intricate objects with its tiny details—all but Augustus's belonging originally to women—held its own specific, personal, intimate message. And yet, at the same time, these eggs all belonged to the same pack, resembling each other in appearance and design, created almost certainly by

the same ivory artist (probably a Frenchman). Each of them served in its own way the personal-cum-political desires and ambitions of their princely owners: think of Augustus the Strong's yearning for the Polish crown that he had just lost when he purchased his own crown-secreting egg in 1705. And they all did so in miniature.

The last few pages have portrayed the princely taste for miniature scale-altering objects as it spread in courtly circles in and around the Holy Roman Empire in the late seventeenth and early eighteenth centuries, with a particular passion for freestanding figurines. To be sure, this was not a completely new phenomenon, nor was it an exclusive courtly one. As the following chapters make clear, it was one manifestation of a broader cultural trend, a trend that broke with earlier precedents to develop distinctive qualities and become especially pronounced at this historical moment. And yet the courtly expression of this development is a coherent historical phenomenon in and of itself. Princely collectors of decorative objects, as the example of the multiple knife-grinders shows so well, were closely connected, constantly observing each other, and often relying on the same jewelers and decorative artists to provide them with collectible pieces in miniature comparable to those of their competitors. As I have put it earlier, miniature objects often traveled in packs, especially among princes and princesses. This remained true, often ironically, even as all princely collectors worth their mettle made an effort to outclass the others with singular works of art that made their collections stand out from the rest.

As we have seen throughout Augustus's career, from his early acquisition of the singular *mise-en-abyme* miniature of a collector's cabinet to the assembly of the Grünes Gewölbe's unparalleled "Corner Cabinet" with its almost five hundred micro-objects, no prince played a more conspicuous role in the rise of the court miniature. Agents, suppliers, middlemen, and of course jewelers and artists working in different materials were all well aware of the opportunity that an unusual scale-altering creation could present with Augustus, turning a profit and gaining a powerful patron, including, of course, Johann Melchior Dinglinger. Together with his brothers, Dinglinger was well aware of the creative trends of his time and familiar with fashions in Germanic courts, not least the predilections of his prince. This does not mean that Dinglinger participated in every such trend. For instance, despite much wishful thinking from twenty-first-century museum curators across Europe,

there is no evidence that Dinglinger produced baroque pearl figures, and indeed they do not appear to have suited his taste.[28] And yet, overall, it remains true that most decorative artists with hopes of currying favor in Augustus's court, especially in the first decade of the eighteenth century, were involved in the making of miniatures. Dinglinger's younger brother, for instance, the jeweler Georg Christoph, sold Augustus two complex miniature figure groups, possibly on the occasion of the 1709 visit of Frederik IV of Denmark: two blackamoors driving an intricate sleigh drawn by a beautifully caparisoned horse and a *Turmelefant* with an African rider (the elephant carrying a castle being the symbol of the Danish Order of the Elephant). His colleague Johann Heinrich Köhler made at the beginning of the century the miniature arrangement of the pyramidal obelisks and a triumphal arch that we have already seen, then the ivory knife-grinder in 1708, and many miniatures subsequently. Another resident jeweler, Gottfried Döring, contributed statuettes of two Africans with feather headdresses carrying a white lady on a jewel-encrusted sedan chair. At the (apparently quite fruitful) Leipzig Fair of 1705, Augustus's agent bought from the important Dresden court sculptor Balthasar Permoser two small ebony figurines of Africans, specified in the purchase bill as "Hottentots." Permoser and Johann Melchior Dinglinger were frequent collaborators. Among their earliest collaborations in the Grünes Gewölbe, from around 1700, are two more pairs of miniature figurines, designed by Permoser, adorned and accessorized by Dinglinger: African warriors in the midst of vigorous movements with their bows and arrows, and African musician riders. A further collaboration between Permoser and Dinglinger around the turn of the century produced the camel with two Africans that belonged to Friederike Elisabeth von Saxony-Eisenach (plate 24, top left).[29]

All in all, then, miniature-making was a busy preoccupation in Dresden: all decorative artists at the top of their trade, all miniatures of genre scenes measuring typically less than twelve centimeters, almost all displaying exotic, non-European figures (especially Africans, reminiscent of the costume that Augustus chose for the festivities of 1709).[30] Considering this intense activity in and around the Dresden court, and indeed keeping in mind this trending fashion in the aspiring courts of the Holy Roman Empire, we can now see how the scene was set for Dinglinger's grand entry into the world of miniature.

On one level, it is evident that the *Throne of the Great Mogul* belonged to the same world as these other miniatures, replete as it was with free-standing figurines of humans and animals that captured a genre scene or a

Figure 11. Dinglinger's Turkish camel in the *Throne of the Great Mogul* (plate 24) next to the
Turkish camel drawing by Melchior Lorch, 1576

moment in a narrative. Take each of the two camels in Dinglinger's court of
the Great Mogul, say, and place them next to the other camel miniatures we
have seen from the same period: they will fit right in (plate 24, top right).
This remains true even if Dinglinger's camels were more extravagantly
bedecked, an indication of the extra mile to which Dinglinger was willing to
go in pursuit of ultimate miniaturization. The ten-centimeter-tall camel in
Ottoman style illustrated here was closely based on a late sixteenth-century
camel drawing by a man who had lived in Turkey (fig. 11), Melchior Lorch.[31]
Not only does it boast a luxurious caparison and saddle but the saddle is itself
adorned with its own miniature bells equipped with tinier-still clappers that
are tied by a golden rope to a bejeweled and tasseled knotted cover, below
which one can find the almost invisible enameled star pattern on the side-
saddle itself. No other camel miniature came even close to such intricacy on
multiple levels of smallness.

That Dinglinger was invested in pushing miniaturization further and
further can be seen by returning one more time to Wouter Schouten's
engraving of the Great Mogul on his throne. We have seen that Dinglinger
relied closely on Schouten's engraving in designing the scene while allowing
himself to deviate on certain details that he deemed important for his own
purposes: the substitution of a crown and scepter for the Great Mogul's

turban and sword, the addition of the peacock under the canopy. One other deviation from the engraving deserves notice. Schouten's engraving shows at the bottom left of the staircase leading to the throne two men crouching next to gifts that they have brought for the Mogul. One is holding a birdcage, the other is unloading several valuable chalices, plates, and necklaces from an open treasure chest that lies on the ground with a raised cover. In most respects, Dinglinger set up a faithful three-dimensional reproduction of this scene: two men crouching next to a filigreed treasure chest with a moveable cover.[32] (He also retained the birdcage but elsewhere, with another figure.)

But when it came to the contents of the chest, Dinglinger changed direction. Instead of valuable crockery and vessels, Dinglinger placed in the five-and-a-half-centimeter chest a set of miniature objects that in turn hid within them further feats of even smaller miniaturization. These include no less than nine minute weapons: a rifle, six pistols, and a pair of daggers (plate 26). A further surprise awaits those who carefully pick up these objects: the tiny firearms all have even tinier moving mechanisms, while the needle-thin daggers can actually be drawn from their scabbards.[33] Next to the weapons, the chest holds the two-centimeter-long atlas that opened this chapter, which in its bejeweled and ornamented binding holds minuscule maps of the continents. Dinglinger's alteration to Schouten's treasure chest, in short, was designed to showcase his remarkable skill at making intricate miniature objects, on increasingly smaller scales, descending from the filigree chest to the miniature weapons and atlas to the surprises they contained within. For those in the know, that is to say, whomever Augustus the Strong allowed close-up examination, these feats of miniaturization were intended to elicit astonishment. This astonishment, we may add, had no inherent connection to the theme of the *Throne of the Great Mogul*.

Considering the jeweler's skillful acts of scale alteration across the *Throne of the Great Mogul* as a whole, we also realize an inherent inconsistency: different objects are created to different scales. Take for instance the porcelain-like coffee service that Dinglinger introduced into the court of the Great Mogul (plate 27). This was an unmistakable self-reference to his earlier celebrated *Goldenes Kaffeezeug*, which he had completed for Augustus the Strong just before beginning his work on this project. At 9.7 centimeters from side to side, the Mogul's coffee service, with its fourteen carefully designed pieces, including cups and saucers, coffeepot, and sugar containers that like their bigger model imitated in enamel the appearance of porcelain,

is an admirable, carefully crafted miniature. But had it been consistent with the scale of the figures or the architecture, the miniature coffee service should have been six or even eight times smaller, which would have made all these details harder to enjoy. Similarly, the coins on the scales are wonderful feats of tiny design, measuring no more than six millimeters in diameter yet sporting clear signs of writing. Relative to the human figures next to them, however, the coins are still some ten times bigger than they should be were they created to scale. The outcome across Dinglinger's creation is a kind of optical illusion that depends on the viewer's capacity to ignore or tolerate inconsistent sizes, a familiar phenomenon sometimes referred to as "scale error."[34] Dinglinger engaged in multiple feats of miniaturization rather than in modeling the court of the Great Mogul fully to scale, and yet succeeded in creating an aesthetically pleasing, harmonious whole.

This final observation draws our attention to a fundamental quality that sets apart the *Throne of the Great Mogul* from the other late seventeenth- and early eighteenth-century scale-altering objects we have encountered in this chapter. It is a *miniature ensemble*, a composition of numerous autonomous miniatures that together creates a complex, busy scene. While individual miniatures and small-scale figurines repeated themselves in many princely courts, the scale and complexity of the *Throne of the Great Mogul* rendered it a unique piece (though we shall shortly see partial parallels in other cultural contexts). This relationship of Dinglinger's work to the world of miniatures in the courts of the Holy Roman Empire was of course well aligned with Augustus the Strong's own ambitions in the first decade of the eighteenth century, namely to be part of the society of princes and at the same time to claim a unique standing among them.

Our quick tour of the fashion for freestanding miniatures in princely society began with Johann Wilhelm von der Pfalz and his wife, Anna Maria Luisa de Medici, a couple who repeatedly turn up as counterparts to Augustus the Strong in the market for unusual micro-objects. I would like to return to their court in Düsseldorf in order to close this chapter with a unique piece of evidence for the attraction of miniaturization at the turn of the eighteenth century—evidence in verse.

The Palatine electors, like other German electors and princes at the turn of the century, wanted to manifest their political ambitions through the erection of a new palace. In 1695 they appointed as their court architect

the well-traveled Venetian Matteo Alberti, who in 1699–1700 presented the plans for the projected Neues Schloss—a hunting palace—with the aid of a wooden model. The Palatine court secretary, Giorgio Maria Rapparini, honored Alberti's planning with a sonnet, which merits quoting in full:

> A building model, for forest-covered heights
> small in size, but sublimely conceived,
> the famous Architect from the Adriatic offers,
> which impresses real marvel in the sight.
> The building itself is erected squarely
> from the ground level to the adorned tops;
> compacted and accurate in perfect measures
> it expresses every angle, every space to the eye.
>
> This Earth in which we are, if from time to time
> we feel its body tremble in open precipices,
> it is because Jove created it on shaky poles.
>
> For, had he first made it in a small, full relief model
> with the Daedalian hand of the great Alberti,
> the world would now be firmer, and more perfect.[35]

This is a surprising poem, and a revealing one. It is not a song of praise that one might have expected for the new and inspiring architectural edifice which was soon to honor the princes who commissioned it. Rather, these verses from beginning to end are a paean to Alberti's *miniature model*. It is the model that could not fail to strike the marveling beholder in being "small in size, but sublimely conceived," "compacted and accurate in perfect measures." So much so, muses the writer, that had Jupiter himself begun the creation of the universe with such a miniature model, the earth would have been better than the world we live in. Rapparini's poem was an all-out song of praise for the sublime art of miniaturization.

Architects' building models had not always looked like this. Alberti's fifteenth-century namesake, Leon Battista Alberti, gave this advice to practitioners in architecture: "Better then that the models are not accurately finished, refined and highly decorated, but plain and simple, so that they demonstrate the ingenuity of him who conceived the idea, and not the skill of the one that fabricated the model." The many architectural models that have survived from the fifteenth through the seventeenth centuries attest that

Alberti's advice, to render building models plain and unadorned so as to convey the general idea of a structure but not to direct attention to the modeling itself, was well heeded. In 1624 the English architect Sir Henry Wotton closely echoed Alberti when he insisted that building models should "bee as plaine as may be, without colours or other beautifying, lest the pleasure of the Eye preoccupate the Judgement."[36] Thus, when a Baroque architect like the second Alberti became so invested in the finish and detail of an architectural planning model, this was quite a revolutionary change in practice. Johann Wilhelm's and Anna Maria Luisa's court secretary's poetic panegyric, composed in the Düsseldorf court just as in the Dresden court Dinglinger was beginning the work on the *Throne of the Great Mogul*, captured not only the resonance of the miniature object for its beholders in the Palatine court around 1700 but also the innovative effort at aesthetically satisfying miniaturization that was now undertaken by the architect himself.[37]

6. Miniatures (or, The Early Modern Moment of the Micro-Object)

The discussion of miniaturization as a backdrop to the *Throne of the Great Mogul* can stop here, it seems, since we have now a clear picture of the significant role attained by miniature objects in princely collections—and consequently in the work of top jewelers and artists—at the time of Augustus the Strong. This understanding, in turn, gives further weight to Dinglinger's choice of this particular scale-altering form for the greatest and most complex project of his career.

Stopping here, however, would miss the bigger story. Across Europe, in multiple social and cultural settings, we find during this period a broad cultural pattern—much broader than courtly circles—involving a particular investment in micro-objects. This significant historical phenomenon, heretofore little noticed, is a key context for understanding the making of the *Throne of the Great Mogul*. In the pages of this book I can only gesture at this wide-ranging cultural development and leave its full unfolding for another occasion. But in the next few pages I suggest that this broader picture, in which Dinglinger's creation was situated, can help explain some of its singular characteristics, not least its particular form, namely a miniature ensemble showing a highly complex scene composed of a multitude of free-standing miniature parts.

We can take our cue once again from the cradle with baby that Johann Wilhelm von der Pfalz sent from Amsterdam to his wife, Anna Maria Luisa de Medici, in 1695 (see plate 21). The emotionally loaded gesture was personal,

intimate, unique. At the same time, we also know that the use of the rare baroque pearl for the baby placed this gift in an exclusive group of miniature objects from the turn of the eighteenth century limited to a narrow circle of princely collections. The miniature cradle itself, however, was a different matter. In its materials—gold, pearls, silk—and with its fine filigree work, it was an unusual and expensive piece. But its form would have been immediately familiar from a much larger group of objects. Amsterdam in 1695 was a major center for the production of distinctive miniatures of domestic items, not least of which was a significant number of cradles (fig. 12). Typically made of silver, the miniature cradles imitated the common wicker baby accessory, often appearing uncannily similar to Anna Maria's unusual golden one.

The Dutch miniature manufacture from the second half of the seventeenth century (and continuing through the eighteenth century), of which these cradles were but a fraction, was one of the most significant and surprising episodes in the history of small-scale objects in Western Europe. It was also an often-overlooked yet highly creative artistic expression of the Dutch golden age. Picking up around 1650, and more in earnest from around 1670, we suddenly find what can only be described as mass production of thousands of collectible miniature objects and figures in hundreds of designs. Although miniatures were also made in materials such as wood, tin, and lead, those that survived are predominantly in silver. Dozens of silversmiths in Amsterdam and elsewhere employed new casting and assembling techniques that facilitated production in large quantities, such as Dirk van de Graeff from Haarlem, whose stock inventory in 1702 included no fewer than 462 different miniatures. The Dutch even had their own generic term for such objects of small scale, a term also found in contemporary inventories: *poppegoet*. Thematically, Dutch silver miniatures were primarily of two kinds: interior furnishings and household items—a three-dimensional complement to the unprecedented abundance of domestic interiors in seventeenth-century Dutch art—and human figures in work or at play. The variety and detail are bewildering: seemingly every possible piece of furniture, a proliferation of kitchen utensils, lamps and candleholders, spinning wheels and linen presses, minutely made wicker baskets, baby rattles, and of course an array of baby cradles. The spectrum of miniature figures designed in daily routines is no less astonishing: sleigh and carriage riders, boatmen, a shepherd, a wine-taster, a pair of tennis players, acrobat tightrope walkers, riders on a merry-go-round, children flying kites or throwing dice, an ice skater, a

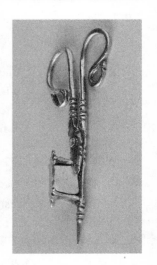

Figure 12. Dutch silver miniatures, late seventeenth century, measuring 4–8 cm. The form of the cradle (top left) resembles the gold filigree cradle that Anna Maria Luisa de Medici received from her husband in 1695 (plate 21)

pair bowling hoops, a hunter with his dog shooting a bird, a dog peering out of its kennel, and, interestingly, several examples of scissors- and knife-grinders, which immediately bring to mind their ivory counterparts that appeared in Germanic courts around the same time.[1]

The maker of the silver knife-grinder in figure 12 (center-left) was the Westphalia-born Wessel Jansen, who like many other German silversmiths emigrated during the Thirty Years' War to Holland and from 1642 to 1696 was active in the Amsterdam guild. It is tempting to assume a thread connecting the knife-grinder of this German-Dutch craftsman with those we have seen in costlier materials in Dresden and the other courts in and around the Holy Roman Empire. Perhaps. But it is also true that German silversmiths produced miniatures similar to the Dutch ones, as did English silversmiths in larger numbers from the 1680s, calling them "silver toys."[2] Gold- and silversmiths traveled, as did their wares. According to surviving evidence, Dutch miniatures were sold in northern Germany, Poland, Scandinavia, Russia, and perhaps elsewhere.

There is more. Some of these Dutch miniature objects ended up in what was probably the most elaborate cultural genre celebrating the miniature form in the late seventeenth and early eighteenth centuries: Dutch dollhouses. From the second half of the seventeenth century, wealthy Dutch women created and furnished at great expense large collections of miniatures, put together into model house interiors over several floors. The term "dollhouse" is rather misleading since these were not children's toys, nor primarily a scenery for playing with dolls, but rather elaborate displays that have been aptly described as female cabinets of curiosities. Several well-known examples of this Dutch high-class fashion survive, set up meticulously with hundreds of miniature objects made by craftsmen working with multiple materials and replicating interiors in their fullest diversity.[3]

Take as an example the oldest surviving dollhouse, that of Petronella de la Court, wife of a brewery owner in Amsterdam, who began assembling her ensemble of miniatures around 1674 and continued to her death in 1707. The eleven mini-rooms contain some 1,600 small-scale objects (!), from furniture through domestic necessaries to every possible house item one can imagine—objects made of ivory, amber, silver, blown glass, different kinds of woods, imitation porcelain, wicker, copper- and tin-ware, and of course many textiles for the costumes of the twenty-eight wax and resin dolls. To grasp a single room we can look at the art gallery or *Kunstkammer*,

furnished in the 1670s and 1680s, measuring under half a meter from floor to ceiling and inhabited by three wax figures carefully bedecked in contemporary clothing (plate 28). In it we find miniature paintings signed by well-known contemporary artists in carved and gilded frames, patterned ivory and wood parquet floor, an ornate fireplace, minute relief-carved ivories, a carved amber table, oriental porcelains, portrait busts, seashells, celestial and terrestrial globes, leather-bound books (some holding sixteenth-century German engravings), and so on, all pieces miniaturized to a scale of several centimeters. The art gallery also sports its very own miniature cabinet of curiosities, which when opened reveals collectibles on an even tinier scale, from minuscule coins through carved cherry pits to carefully identified minerals and gems (plate 28, bottom). Once again we observe a collector's *mise-en-abyme*, bringing to mind Augustus the Strong's miniature collector's cabinet. This self-referential move is playfully acknowledged through the design of the mini-cabinet's distinctive spiral-turned legs, which echo precisely the legs of the larger dollhouse cabinet in which the miniature cabinet of curiosities is housed.[4]

Although Dutch dollhouses are the best known from early modern Europe, and the most complex and sumptuous, parallels can be found elsewhere. In southern Germany we find another, distinctive tradition of dollhouses, which developed from the early seventeenth century as a representational format for large urban households in miniature. The German dollhouses were typically not quite as luxurious as the Dutch ones, and often equipped with pewter and copper utensils. By the turn of the century the fashion spread; the first recorded dollhouses in England and in Sweden both date from around 1700.[5]

My goal in these few paragraphs, however, is not to give a full map of the European production and spread of miniature objects but simply to present sufficient evidence for the widespread wave of interest and investment in miniaturization from the second half of the seventeenth century and accelerating toward the turn into the eighteenth century. A fuller account, which must wait for another opportunity, would include, *inter alia*, the genre of lampworked glass miniatures, a particular technique of glassmaking that originated in Italy and flourished from the second half of the seventeenth century in the French city of Nevers, which ranged from freestanding figurines to complex, three-dimensional scenes and even complete interiors resembling dollhouse rooms (see plate 33).[6] It would also include further

types of miniature genre figurines made from other materials, exemplified by a highly detailed thirteen-centimeter-tall south German lime- and cherry-wood miniature carriage from the 1680s reproduced with mindboggling precision; a thirteen-centimeter Dutch mid-seventeenth-century boxwood beggar with a wooden leg, perhaps inspired by Jacques Callot; or thirteen-centimeter red-stone figurines—also Dutch, circa 1700—of ape-faced barber-surgeons with their clients, shaving or pulling teeth.[7] It would refer to the seventeenth-century qualitative leap in the number of European minia-ture books, culminating in the smallest book ever to be printed before the late nineteenth century, the Dutch 1.3-centimeter *Bloem-Hofje* of 1673, beauti-fully bound with gilt-tooled red leather capped with a minuscule gold clasp.[8] And although they are objects of a somewhat different type, an account of the early modern wave of European miniatures must also take notice of the making of miniature ship models, a highly skilled scale-altering genre with various decorative and personal as well as professional and political uses that began to be developed in the seventeenth century, especially from the 1660s and 1670s. "Among the most remarkable objects" in the apartments of James, duke of York, the excited Cosmo III of Tuscany reported in 1669, were "inclosed in glass cases, some miniature models of men of war." Such minia-ture ships were often given as princely presents, including one that the city of Danzig proudly presented to Augustus the Strong.[9]

I would like to give the final word in this quick jaunt through the mini-ature landscape of Europe around the turn of the eighteenth century to a south German observer who made it his mission to document the world of manufacture and professions around him. Christoph Weigel from Nurem-berg, by profession an engraver and art dealer and by training also a gold-smith, published in 1698 a compendium of visual and textual illustrations of guilds, arts, and crafts. One section is devoted to "*Der Dockenmacher von Silber / Holz / Alabaster / Wachs.*" *Docken* was a word for dolls, but during this period it developed also as a broader reference to miniatures and toys: a usage that together with its derivatives *Dockenmacher* and *Dockenwaren* had the generic meaning encompassing this whole class of miniature objects, analogous to the Dutch seventeenth-century word *poppegoet*.[10] In the descrip-tion of this miniature/toymaker, working with silver, wood, alabaster, or wax, Weigel observed, "There is hardly a handicraft in which the things usually made big are not often seen to be manufactured in small models and miniatures [*Docken-Werck*] to play with: this applies especially to so-called

dollhouses [*Docken-Häusern*] which contain everything necessary for the household and for its pride and ornament, daintily and sometimes preciously imitated."[11] Weigel saw it all: the miniatures imitating and modeling every kind of life-size object, as well as the houses for dolls or for miniatures in which micro-ensembles emerged, composed of more miniatures. Note Weigel's use of "so-called" (*sogenannten*): the terminology for this wave of miniaturization was still quite new, describing a phenomenon as yet in the process of becoming. Finally, it is worth noting that when Weigel provided examples of uses for such miniature objects made in imitation of life-size ones, he placed them twice in the educational program of "princes of high potentates" or of the heirs "of a crowned head" (*gekrönter Haupt*).[12] In Weigel's view—a view that put *Docken-Werck* in a rather different sociocultural context than the *poppegoet* of the Netherlands—the miniature objects he encountered in southern Germany belonged most naturally to the society of princes.

The princely collections of miniatures around 1700 that were the focus of the previous chapter, we now realize, were part of a broader European cultural trend from the second half of the seventeenth to the early eighteenth century, a trend that proliferated freestanding miniature objects and figures, with an increased investment in practices of miniaturization in multiple forms. This was a particular cultural taste across many parts of Europe precisely when Dinglinger was planning and executing the *Throne of the Great Mogul*. A versatile jeweler at the top of his trade, Dinglinger kept a constant eye on what was trending in the market for decorative art objects and what was fashionable among collectors. Keeping up to date in Dresden was made easier by the periodic visits to and reports from the Frankfurt and especially the Leipzig Fairs. (Although he was not thinking directly of miniatures, Gotthold Ephraim Lessing captured well this effect of the Saxon fair when he wrote to his mother at midcentury, "I am traveling now to Leipzig, where one can see the whole world writ small, as it were."[13]) The Dutch miniatures—the most richly varied European art genre of freestanding miniature figurines—were in demand in northern Germany and presumably vied for attention in these trade fairs with their German counterparts. Dinglinger's familiarity with the latter may well have been reinforced by his close relationship with his neighbor and (since 1697) father-in-law, Leonhard Schorer. Schorer, with whom Dinglinger was possibly also in business,

was a merchant with close connections to the luxury trade in Augsburg, a major south German center for miniature production.[14]

This broader culture of miniaturization can help us explain a puzzling feature of Dinglinger's work. As objects, miniatures are expected to be handled: picked up, played with, cupped in one's hand, studied at close quarters, turned to be viewed and touched from all sides, arranged and rearranged, sometimes opened to reveal further layers. We have encountered miniature objects that were highly personal and intimate, like the messages hidden in the nesting eggs or in Anna Maria Luisa de Medici's cradle, or some of the dollhouses that had items inscribed with their owners' names and histories. But in truth the experience of *every* miniature is an intimate one, demanding an encounter up close and personal. (This is why museum displays of miniature objects inevitably fail to convey their appeal.[15]) The close encounter is even more significant in the case of those costly miniatures made of rare materials combined together, like the baroque pearl figurines or the figurines composed from multiple gems. Here the touch of the different stones—moving one's fingers around them, caressing them, sensing their different textures and the ingenuity of the craftsman who welded them seamlessly together—is key to the appreciation of the artwork as a whole. Taking pleasure in miniatures is ultimately an interactive, haptic experience.

In the case of Augustus the Strong, we have a rare firsthand testimony of how he, an obsessive collector, took pleasure in his miniatures. The account by the court official in charge of the collections, Johann Georg Starcke, dates from the time of Augustus's greatest political troubles, when he lost the Polish crown and moved back to Dresden in 1704–1705. Augustus ordered a "Praetiosen Cabinet" to be set up in the closest proximity to (*unmittelbar neben*) his personal quarters, in which he then arranged the valuable pieces brought back from Warsaw with his own hand. Starcke reported, "From that day on, His Royal Majesty kept the keys to this *Praetiosen Cabinet* with himself at all times. The keys always remaining sealed in the desk in his bed chamber, he sometimes went there by himself, frequently also with ladies and gentlemen, to view his precious things, and allowed himself to linger, rearranging or changing their mounts."[16] A precious image: the crownless king confining himself with his miniatures and other valuable small objects, taking his time to hold them, play with them, rearrange them—an intimate, personal, tangible relationship.

So now let us go back to the *Throne of the Great Mogul*. One of its puzzling aspects is the fact that Dinglinger chose for it an unusual form, that

of a huge number of small, freestanding pieces on a theater-like set. Why?[17] This choice is counterintuitive in two different ways. First, the arrangement of the Great Mogul's court is intended to reproduce a precise hierarchy of the various dignitaries with their retinues and gifts, a hierarchy physically enacted in their spatial positioning up and down the three levels of the court, closer or further away from the Great Mogul. The free placement of the pieces, however, allows for deviations from this strict hierarchy and thus creates a space for play within what is otherwise supposed to represent an absolute order at the court of the Great Mogul. Dinglinger, indeed, made an effort to circumscribe this space for play by writing down the correct order of the dignitaries and their placement in the text that he handed Augustus the Strong with his creation. The text, however, only underscores the fact that leaving the components of the *Throne of the Great Mogul* unattached ran against the logic of the piece. Furthermore, this choice also ran against the logic of Dinglinger's trade. As art historian Carsten-Peter Warncke has pointed out, allowing pieces of a composite creation to stand freely was counter to the best practice of a jeweler or a goldsmith. Rather, the typical procedure of the goldsmiths' art is to fasten, solder, or screw their creations into mounts. So we can ask again: why did Dinglinger choose to deviate from standard practice as well as from the thematic requirements of his composition?

The most persuasive answer, it seems to me, is precisely the interactive, haptic experience of miniatures. Dinglinger left it possible for each individual piece of the *Throne of the Great Mogul* to be picked up. He thus encouraged the appreciation of single components through close observation, together with the tactile feeling of the different materials and their joining in a seamless finish. For Dinglinger, in other words, next to the grand ensemble, each of the individual pieces needed to be appreciated in its own right. This choice is thus also an instance where Dinglinger interwove his own agenda into the work even when it did not fully square with that of Augustus the Strong. In leaving his figures freestanding and unattached the jeweler prioritized the playful miniaturization that required touch and intimate observation over the rigidly fixed court hierarchy that would have better served the political agenda of the prince.

Ironically, Dinglinger's efforts at miniaturization, combined with his decision to leave the figures freestanding, may have also undermined his own professional goals. The small scale of the figures made their feet tiny and

consequently rather unstable. Today we see damage to the enameling of many individual pieces, resulting from the delicate figures repeatedly falling over. This design flaw was evident already during Dinglinger's lifetime. When the Grünes Gewölbe was rearranged as a museum in 1724, Dinglinger's colleague, the court jeweler Johann Heinrich Köhler, was asked to attach "small flat pieces of silver-gilt" to the feet of some of the figures, "in order to allow them to stand." These corrective feet-widening plates are still visible today for some figures in the *Throne of the Great Mogul* (e.g., the feet of the accounting bureaucrat in plate 7, top left), a barely visible sign of how Dinglinger prioritized miniaturization over functionality.[18]

A dollhouse—the *Docken-Haus*, or house of miniatures—is structurally parallel to Dinglinger's *Throne of the Great Mogul* in that it constitutes an ensemble of a large number of freestanding miniatures, both of objects and of figures. These come together in multiple independent scenes, scenes that are combined once more into a unified *mise-en-scène* with an overall meaning by means of an overarching architectonic structure—a house interior—that lends the whole ensemble specific connotations. This is also quite an accurate characterization of the *Throne of the Great Mogul*: an overall architectural structure with specific connotations—a court—giving a unified meaning to so many individual miniature pieces arranged in narrative groups.

For the most part, I cannot draw a direct line connecting late seventeenth-century dollhouses to Dinglinger or to Augustus the Strong. There may be an exception, however, that was unusual in more ways than one. Its protagonist was Augusta Dorothea of Brunswick-Wolfenbüttel, a princess married since 1684 to Count Anton Günther II of Schwarzburg-Sondershausen, one of Augustus's feudal underlings in a small principality west of Dresden. The count was elevated to the level of an imperial prince just as Augustus became king of Poland, whence began a decades-long effort to shake off Anton's and his heirs' obligations to the Saxon elector, which certainly drew attention in Augustus's court. Augusta Dorothea, for her part, embarked soon after her marriage and more in earnest from the 1690s on a unique, lifelong project: amassing a collection of dollhouses in her residence in Arnstadt. These she meticulously arranged as detailed miniature princely and courtly tableaus, often featuring dolls of herself and her family in various daily activities. By the end of Augusta Dorothea's life in 1751, her collection consisted of no less than eighty-two miniature scenes in seventeen

wooden cabinets, with some one thousand figures (of which some four hundred still exist).[19] She called it *Mon Plaisir*, My Pleasure.

Mon Plaisir, then, was a dollhouse—or rather a combined set of multiple dollhouses staging together an even bigger unified theme—that as a court enterprise under indirect Saxon rule was socially, geographically, and politically quite close to Dresden. Augusta Dorothea had the personal protection of Johann Wilhelm von der Pfalz—a friend of her father's—while her younger brother may well have had an affair with Aurora von Königsmarck before she became the mistress of Augustus the Strong. In 1716, when Johann Wilhelm died, Augusta Dorothea turned to Augustus to request protection. It is quite likely, therefore, that she and her miniature passion were known to both Augustus and Dinglinger, at least by reputation. Perhaps they encountered Augusta Dorothea while patronizing the miniature sellers at the Leipzig Fair, where she is recorded in 1697 purchasing "doll-related items" (*poppen ʒeug*).[20] Augusta Dorothea and Augustus, then, were moving in the same circles, partaking of the same cultural fashion for staging miniatures through narrative scenes in courtly programs. *Mon Plaisir*—in the 1690s and early 1700s still an emergent work-in-progress—was a unique bridge between the broader European penchant for miniaturization and the simultaneous courtly fashion for fancy miniatures, bringing them together as close as we can get to Johann Melchior Dinglinger as he was conceiving and designing the *Throne of the Great Mogul*.

7. Magi (or, Miniatures Between Sacrality and Play)

Once more I would like to pause and acknowledge a reader's possible objection. Surely, you are likely to say, all that the previous chapter describes is not especially new: can one not marshal earlier instances of scale-altering miniature objects before the alleged European wave of miniaturization of the late seventeenth century? The simple answer is yes, and on one level this objection is correct. Therefore, in order to make my point about what *was* new and different by the late seventeenth and early eighteenth centuries, I wish to address this objection from two perspectives: methodological and historical.

Thinking about the history of culture for most of my professional life, I find myself often in need of clarifying the methodology of delineating cultural patterns. Identifying a cultural trend as one that in a particular time and place raises a certain cultural phenomenon—in this case, miniaturization—to a distinctive level of prevalence that it did not have previously does not require this phenomenon to be a novel one. On the contrary, the historical finding is even more significant if a particular cultural phenomenon had been around and available but could be found only occasionally, and then suddenly it picks up and resonates in an unmistakable leap across numerous forms—many of them new—and numerous social locations. Whether we can or cannot explain *why* an existing yet sporadic cultural form suddenly becomes a wide-ranging resonant trend, we have identified a meaningful historical phenomenon.

The existence of precedents, in and of itself, is relevant insofar as it provides a possible origin for the cultural forms that erupt and reverberate at

a particular moment. When we take a longer historical look at miniaturized objects, such precedents are not hard to find. Yet what stands out in these precedents is that they are few and far between. Before a certain point, in contrast to what was to come later, they stand out precisely for being rather rare. Take for instance silver miniatures, which as we have seen became a widespread trend from the second half of the seventeenth century, led by the Dutch but also in Germany, England, and elsewhere. Victor Houart, who literally wrote the book on this subject, tells us that as far as is known from material or documentary evidence, very few silver miniatures were produced by European craftsmen before the middle of the seventeenth century. The only earlier examples on record are sporadic miniatures made by special order for princes and aristocrats, most famously, the silver miniatures that Louis XIII had as a child at the beginning of the seventeenth century, some of which then passed into the hands of Louis XIV.[1] Or take dollhouses: we know of two sixteenth-century examples, both made to order for German princes and princesses—the miniature four-story palace *Dockenhaus* created with expensive materials in 1558 for the *Kunstkammer* of Duke Albrecht V in Bavaria, and a toy kitchen with 275 miniature pieces gifted to the princesses of Saxony in 1572.[2] Albrecht's brother-in-law Archduke Ferdinand II had in his remarkable collection in Schloss Ambras a sixteenth-century set of 255 tiny miniature objects from daily life—from house tools to kitchen utensils, sorted out by the materials of which they were made—that is the most remarkable precedent for the seventeenth-century silver miniatures I have come across.[3] All in all, these represent a sparse trickle of singular examples that do not coalesce into a cultural trend. (This remains true even if the historical record is patchy, as it inevitably is. Unless one assumes a particular process of destruction of miniatures, had there been many such examples, it is reasonable to assume that more of them would have left a trace in the material and historical record.)

Most interesting, however, are not singularities but rather earlier clusters of miniaturization that in fact did coalesce into significant cultural phenomena in their own right, that is to say, precedents in the sense of previous patterns of miniaturization that were themselves resonant and meaningful. (I am talking about earlier clusters with direct historical links to the same European cultural sphere, not in places like ancient Egypt or China, which as parallels and analogs can be revealing but cannot be linked historically to early modern European developments.) I am getting now to the

second response to the "what's new" objection—namely, the *historical* argu-
ment about precedents for miniaturization before the second half of the
seventeenth century, and how they were different from the latter wave of
miniature objects at the time of Dinglinger. This argument, in turn, high-
lights an aspect of the *Throne of the Great Mogul* that has so far remained
unexplored: its relationship with the divine.

Consider, for instance, the early sixteenth-century object in plate 29. A
sphere carved from boxwood with gothic tracery on the outside hides within
it two delicately carved scenes with numerous figures arranged in several
receding levels. At 6.5 centimeters from side to side, this is as remarkable a
miniature artwork as any we have already encountered. And like them, it is
one example of a genre of similar objects of which many dozens are known.
This genre, which has in recent years generated much attention, peaked
around 1500 to 1530 in Netherlandish workshops, but also with some German
exemplars with their own distinctive forms.[4] Ranging from 3 to 6.5 centime-
ters in diameter, they are usually called "prayer nuts," or *Betnüsse*, due to
their more or less walnut size and to the religious scenes minutely staged
inside them—crucifixions, scenes from the passion, and the like. They are
also sometimes called prayer beads or paternosters, since some of them origi-
nally hung on rosaries. The prayer nut illustrated here depicts the queen of
Sheba visiting King Solomon in one hemisphere, and the three magi visiting
Christ in the other: a material embodiment of the prefiguration of the gospel
in the Old Testament. The boxwood micro-carving genre extends to other
miniaturized objects as well. Sometimes described as "aids to prayer," these
are similar in execution but can be even more elaborate, such as miniature
altarpieces and multistory tabernacle towers. The feats of miniaturization in
the boxwood micro-carvings can be bewildering: a tiny movable ring, only
1.5 millimeters in diameter, which is hanging gratuitously on a wall behind a
depicted scene, or a *mise-en-abyme* of minuscule prayer beads hanging on the
prayer nut's inner wall next to the adoration of the magi.[5]

Prayer nuts with their skilled miniaturizing work were valuable, rare
collectible possessions. These qualities elevated them above mere objects of
private devotion, as attested by the fact that few of them show signs of wear
from routine use. And yet, as several scholars have pointed out, in the context
of religious artistic practices of the fifteenth and sixteenth centuries—
comparisons have been suggested, for instance, with early sixteenth-century

paintings with minute and almost invisible religious scenes—the very play-fulness embodied in the miniaturized scenes intensified the devotional experience. The crowded and hard-to-discern tiny details demanded intense immersion and patient deciphering, and in turn rewarded their beholders with a particularly animating visual sensation, stimulating them to contemplate Christ's passion with the "eyes of the heart." A similar experience was created by another group of rare late sixteenth-century or early seventeenth-century devotional objects, in the form of transparent rock-crystal pendants displaying minutely carved religious scenes, typically three to four centimeters tall. In the words of Frits Scholten, the foremost student of the genre of boxwood micro-carvings, "The very combination of the playful and the devotional was a mainspring behind the development of new, ingenious devotional objects like prayer nuts."[6]

There are other late medieval and early modern manifestations of the impulse to combine devotion with playful miniaturization. Two centuries before the wave of miniature ship models of the mid-seventeenth century, we find already ship models as devotional ex-voto offerings in churches across Europe. Likewise, some two centuries before the playful Dutch miniature cradles, young nuns and devout children handled little clay cradles, typically equipped with miniature baby dolls, as stand-ins for the Christ child. Historian Virginia Reinburg has emphasized the effect of the small size of illuminated images in devotional books of hours of the fifteenth and sixteenth centuries, which allowed their viewers to imagine themselves as if magically entering and manipulating the tiny scenes. In the Counter-Reformation Bavarian court, with its self-proclaimed mythology as the protectors of Catholicism, the most exquisite anti-Protestant object was a 14.2-centimeter "World Turned Upside-Down" automaton from the 1560s with miniature figures and even tinier accessories that ridiculed Protestant preachers. Or take the Netherlandish painters in the early sixteenth century, notably Joachim Patinir and Herri met de Bles, who developed the art of tiny religious scenes with almost imperceptible figures at the sidelines of landscape paintings. The very search for these tiny scenes in their work enhanced the religious experience of viewing, in a manner similar to the immersion required by prayer nuts.[7] God was in the details, literally.[8]

Perhaps most familiar are the late medieval and early modern portable altars and altarpieces, allowing for the celebration of mass on consecrated ground while traveling or at home. These small-scale house altars, made by

jewelers and artists for private devotions, abound with miniaturized religious scenes. The Munich *Schatzkammer* collection, for example, has several interesting ebony, gold, and enamel portable altars from the late sixteenth century, mostly from Augsburg, that are rich with miniature figures. One of the most suggestive among them dates to around 1600 from the Benedictine monastery of Andechs (plate 30, left). As is typical of the genre, the multilevel architectural setting boasts several scenes in miniature: the annunciation, the crucifixion, and at the apex the resurrection of Christ. What makes this particular house altar remarkable is its extension into a dynamic scene in three dimensions. Leading up to the structure are gold-plated steps that create a spatial depth resembling a theatrical stage, on which are positioned freestanding gold and enamel figures of the three kings or magi bearing gifts, tiny figures measuring some 2–3 centimeters with elaborate dress and colorful accessories. Small wonder that Erna von Watzdorf long ago singled out this particular miniature altar as a possible precedent for Dinglinger's *Throne of the Great Mogul.*[9]

But now compare the miniature Andechs altar of circa 1600 to another in the same Munich collection dating to around 1700 (plate 30, right). Made of precious materials—silver-gilt, gold, silver, enamel work, precious and semi-precious stones—and adorned with minute paintings, it is a slim altar with a tiny crucifix and tiny candles. Standing eighteen centimeters tall, it is much smaller than the almost half-meter-high portable altar of 1600 or the other house altars around it.[10] More importantly, conceptually and functionally it is a completely different object. It is not a small-scale altar that in principle at least preserves the function of its large-scale counterpart, providing a sacred space for the ritual of the mass. Rather, it is a *miniature* of an altar, a plaything that is intended to *represent* an altar rather than stand in for one. One can picture this miniature altar alongside the furnishings of a dollhouse, something that is not imaginable with the Andechs altar. This later piece is a miniature object belonging to the rich world of miniatures around 1700, together with the many other examples we have encountered in these pages, such as Augustus's miniature collector's cabinet (plate 25). Interestingly, the provenance of this miniature altar is from the Palatine collections that arrived in Munich via the Palatinate court in Mannheim. It is not unlikely that its original owners were Johann Wilhelm von der Pfalz and his wife, Anna Maria Luisa de Medici, avid collectors of miniature objects at the time it was made.

A second miniature altar makes the point even more forcefully (plate 31). This object is preserved together with its protective leather case in the Habsburg collections at the Kunsthistorisches Museum in Vienna and has never been studied or displayed. Similarities to other artworks date it to around 1700, probably from Vienna.[11] The miniature altar, twenty centimeters high, is made of gilt-silver worked in an open filigree-like manner, richly decorated with enamel and many precious stones. It is carefully laid out for liturgy with minute candleholders, water and wine cruets on a tray, a tiny missal, and most prominently the chalice for the mass. What makes this particular miniature unusual is the striking fact that next to the altar stands a 5.6-centimeter-tall tonsured priest in liturgical vestments. The human figure is now part of the miniaturized scene. The interactive narrative staging of the altar is underscored by the removable veil (or cover) of the chalice, allowing the user to choose whether to represent the priest as preparing for the mass or during the performance of the mass, and indeed to move back and forth between the two stages of the action. Moreover, a drawer below the altar presumably held other small parts that could be used to complement the scene. Far from being a devotional object with possible sacral uses, this Viennese altar-cum-priest miniature from the end of the seventeenth century is manifestly an object of play.

In the same Habsburg collection in Vienna, next to the miniature altar with the attending priest, is stored another miniature work of art that likewise has not yet attracted scholarly attention (plate 32). Visual and stylistic similarities place it in the same environment as the miniature altar, in Vienna of around 1700.[12] It is an annunciation, one of the most familiar and often repeated themes in European art. But it is an unusual annunciation. Mary and the archangel are two small enamel figurines, enclosed in a 20.5-centimeter-tall glass box with silver filigree pillars on a gilt-silver base studded with gems. The inside of the box is Mary's room, furnished with miniatures in enamel: Mary's bed, the desk with her writing box and the book she is reading, a wall cabinet, a round table, a wardrobe, a stool, a spindle, and even a dog. One side of the glass box is a wide door that opens to allow for the rearrangement of the room with its many pieces of freestanding furniture. Once again there is a drawer at the bottom of the box, presumably for storing small objects that could be used in setting up the scene. In short, while the theme of this work of art is the annunciation, the form and interactive

handling are those of a dollhouse. The content of the scene is a religious one; the logic of the object is that of play, giving it a very different feel.

Indeed, it seems that the domestic setting of the annunciation made this particular Christian theme attractive to the makers of small tableaus during this period, as they geared up their miniature production. The antique market in recent years has offered at least three additional examples of miniature three-dimensional annunciations from this period, made of different materials. The most intricate, in French lampworked glass from Nevers, has a wonderful room setting with sumptuous Baroque furniture, two wall mirrors, and a minute porcelain vase on a decorated mantelpiece. It resembles again nothing more than a dollhouse interior (plate 33). Two others, furnished more sparsely, are made of carved bone (from Italy or France) and of coral (from Trapani, Sicily).[13] All of these, however, pale in comparison with the no-longer-extant *Petite maison de la sainte-vièrge* that belonged to the House of Guise in France, a mid-seventeenth-century miniature model of Mary's house in Nazareth as it was represented in the pilgrimage site of Loreto in Italy. Made of exotic gold-plated wood and studded with diamonds and rubies, its enameled gold furnishings and wooden figurines were listed in an inventory from 1688: Mary's bed, chairs and tables, chest and wardrobe, many vases with fruit and flowers, lamps and baskets, fireplace and tiny bellows, stove and kitchen utensils. These and many other tiny objects carefully enumerated created a detailed staging not only of the Virgin and the announcing archangel but also of Joseph at the lathe and the boy Jesus sweeping up the shop. The *Petite maison* was a material expression of the House of Guise's deep and longstanding Marian piety. At the same time, it has also been plausibly described as the world's most expensive dollhouse.[14]

Like the *Petite maison de la sainte-vièrge*, the object in plate 34 is also an unparalleled singularity from the middle of the seventeenth century, and like it this product of miniaturization speaks volumes about religiosity and play. The carefully carved ivory shoe was stored in the Louvre Museum for decades, appreciated for its craftsmanship—a miniature summary of the history of salvation in numerous compartments, from Adam and Eve through the passion cycle to St. Francis, and on the outside an intricate embroidery with tiny images of secular luxuries (a ship, weapon trophies, even a prancing king)—before its true secret was revealed. A secret tiny latch opens a hidden compartment from which two minute figures of demons violently spring forth, carrying a condemned person to the mouth of the

Leviathan. Other secret compartments reinforce the effect. Since the demons are fully painted, they have a stronger presence than the rest of the decoration, not to mention the surprise when they pop out. In short, although this object dating from 1650 contains the full story of salvation, it has moved the whole nine yards from sacrality to play—and all that in just under nine centimeters.[15]

These unusual objects direct us to the heart of my argument about the changing meaning of miniaturization in early modern Europe. The miniature altars of the end of the seventeenth century differed from earlier portable altars in their relationship to the divine. While the latter miniature altars of course continued to draw on religious themes and practices, in and of themselves they were no longer sacral objects. As their form and smaller scale attest, the latter miniature altars served a playful purpose rather than a liturgical or devotional one. The same is true of the miniature annunciations, and more broadly of the diverse creative efforts at miniaturization from the second half of the seventeenth century. What made them different from their sixteenth-century counterparts was a crucial shift in the *balance between sacrality and play*. I choose this formulation advisedly: a shift in balance does not require a binary reversal. The Dutch historian Johan Huizinga, a trailblazing explorer of play in human culture, pointed out long ago that sacrality and play are fundamentally intertwined. Their respective weight and relative roles, however, can vary widely in different configurations between these two poles. Thus, playfulness was an integral aspect of the early sixteenth-century prayer nuts, as we have seen, but it was subservient to their devotional purpose. Conversely, late seventeenth-century miniatures could still draw on religious themes or models, but their sacrality was now more often subservient to their playfulness. This, of course, occurred in addition to the many new genres of miniatures that evolved alongside them with no apparent relationship to the divine at all. With some poetic license we can borrow Stefan Laube's suggestive formulation and say that miniature objects by the later seventeenth and early eighteenth centuries traveled a significant distance along the path *von der Reliquie ʒum Ding*: from relics, or objects with primary religious and devotional meanings, to playful things.[16]

In a broader perspective on European history in the early modern period, moreover, this transformation in the meaning and uses of miniatures was the tip of a rather large iceberg, namely a fundamental shift in the role that god was assigned in the world. For many Europeans, sometime in or

around the second half of the seventeenth century the Christian god moved to the back seat. As Jonathan Sheehan and I have argued in a recent book, this was not a triumph of secularism but rather a reorientation of the domains of responsibility of a still very present god. God's providential hand was no longer necessarily understood as directing each and every occurrence in the world or each and every human action. To be sure, god was the primary cause and ultimate purpose of everything. But in between the first and final causes, Europeans from the second half of the seventeenth century began to imagine a *space for play*. What characterized this intermediate space for play was a certain degree of freedom for the workings of human agency and choice, in which they were unencumbered by divine decree. The consequences of this historical development were legion: from new understandings of the working of divine providence, through new ways of imagining human agency and indeed human identity, to revolutionary new understandings of the origins of order in a world in which god's hand did not determine every occurrence, as well as to new, quasi-anthropological ways to view religion itself as a bounded domain of human life.[17] And to get back to the realm of the present book, the changing playfulness of miniature objects—a playfulness that at first accompanied objects of religious devotion but then increasingly became a goal of its own—was a material and artistic manifestation of this broader transformation.

One of the most telling expressions of the shift in the balance between sacrality and play in miniature objects can be seen in the evolution of an especially rich vernacular art form: the nativity scene or crib.[18] This genre of decorative art—the German *Krippen*, the French *crèches*, and the Italian *presepi*—has been described, in the form that it took from the late seventeenth century, as the Catholic counterpart to the largely Protestant dollhouses.[19] Late medieval and early modern nativity scenes first developed as three-dimensional representations of the biblical story, with several freestanding figures that were typically half to full life-size: statuettes of mother and child, Joseph and angels, perhaps shepherds and a couple of animals, and in bigger sets also the three kings or magi (plate 35, top). From the sixteenth century, more or less in parallel with the prayer nuts, we also find a miniaturized form called "Bethlehem": a small-scale representation of the nativity scene with fixed miniature figures, often made of valuable materials and set in a box, intended to be exhibited on an altar on Christmas. From the late seventeenth and

through the eighteenth century, however, a decisively new form of the nativity crib emerged. This new type of nativity scene moved far along the axis from devotion toward play, and at the same time from courts and religious institutions also to domestic settings. Given the many local traditions across much of Catholic Europe—with major centers in the German Alpine regions and in Bavaria, Sicily, Naples, and Genoa, as well as Portugal, Spain, and even New Spain—it is beyond the scope of the next few sentences to provide a comprehensive account of this cultural form. But regardless of local variations, the main contours of the shift are clear. It was a shift so radical that perhaps we should view the late seventeenth- and eighteenth-century nativity scene as a new genre rather than an evolution of the earlier one.[20]

The radical innovation of the Baroque period was an extensive enlargement of the nativity scene, of its scope of representation, and of its population (plate 35, bottom). No longer designed to represent only the biblical story, the nativity scene now expanded to display the living community in which it took place, in the form of a miniature theatrical staging of a busy townscape. The town typically resembled more the contemporary setting in which the nativity scene was put together than that of biblical Bethlehem. The baker, the butcher, the shoemaker, the flower girl, the fruit seller, the innkeeper, the tavern, and so on: every local lay figure was now the basis of a small genre vignette, represented in his or her own setting with meticulously miniaturized accessories and props (*finimenti*). In Sicily, for example, this popular art form reached a peak around 1700 under the influence of the *presepe* maker Giovanni Antonio Matera (1653–1718), with carved figures dressed in the distinctive *kaschiert* technique (clothes soaked in glue, then shaped and colored on the figure).[21] To be sure, Mary and the infant Jesus were still always present, commonly placed next to architectural ruins, and approached by the magi who entered the scene with ever-more-elaborate retinues. But now the observer might have required a moment or two to find them, sidelined as they were by so many figures and so much secular activity.

Italian political philosopher Giorgio Agamben wrote a perceptive essay about the genre of the *presepe*, which since the late seventeenth century has held a special place in Italian culture. What the *presepe* shows us, Agamben suggested, "is the world of the fable precisely at the moment when it wakes from enchantment to enter history." In stating that in the nativity scene "all ritual traces dissolve into the economic innocence of the quotidian,"

Agamben perhaps overstated the extent to which enchantment was suddenly sidelined by history. Rather, in the formulation I have been employing here, it may be more productive to think about the *presepi* since the late seventeenth century as having moved decisively along the axis from sacrality to play, all the while retaining their original devotional *raison d'être*. "The key to this profane liberation from enchantment," Agamben noted further, "is *miniaturization*."[22] The numerous freestanding, small-scale figures crowding the nativity crib in its new form, for the most part in domestic settings (although most of the surviving large-scale examples displayed in museums originated in aristocratic households or religious establishments), turned the *presepe* into an interactive playful activity: annually, by setting up the miniatures for the holiday season, and over time, by adding figures and changing the staging from one year to the next.

Let us now return to the *Throne of the Great Mogul*. On one level, the Baroque nativity scenes join the variety of cultural forms we have encountered in the previous chapters as another innovative genre of miniature scenes that fit well within the broad context of the experimentation with miniaturization in Europe in the late seventeenth and early eighteenth centuries. Indeed, they exhibit notable structural parallels with Dinglinger's work. Like the *Throne of the Great Mogul*, the playful versions of the nativity scenes were populated by a large number of reduced-scale figures and objects that came together as ensembles of mini-vignettes with an overarching narrative, placed in an architectural setting with a deliberate meaning. This remains true even though Baroque *presepe* figures were scale-altered but not always miniaturized in the stricter sense, often reaching thirty to forty centimeters in height. Some variations were even closer: one of the earliest Neapolitan *presepe* recorded with numerous lay figures was a jeweler-made ensemble displayed by the Congregation of Goldsmiths in 1661, with jewel-studded miniature figurines that were probably not unlike Dinglinger's later creations.[23]

The parallels between the nativity scenes and Dinglinger's work, however, extend also to a second, topical level. The expanded *mise-en-scène* of the Baroque nativity included typically two distinctive types of figurines, stemming from two different worlds. One was the local townspeople in their sprawling variety, designed with the greatest possible verisimilitude. The other, drawing less on observation than on a common stock of tropes and

images, was the retinues of the three magi or wise men from the East, leading
convoys laden with oriental luxuries as gifts for the infant Christ (plate 36).
For early modern Europeans, the most likely source for a mental image of an
African or Asian man, or of a camel, was nativity scenes, together with
paintings of the adoration of the magi.[24] So it makes sense, for instance, that
the closest parallels to the miniature camels in the court of the Great Mogul—
as well as the array of other miniature camels in the collections of the Dresden
court—can be found in contemporary nativity scenes. The same is true for
other details, sometimes to an extent that gives one pause. Consider for
instance the uncanny similarity between the treasure chest with its load of
tiny weapons in the Great Mogul's court and a treasure chest from a Neapol-
itan *presepe*, likewise containing miniature firearms (fig. 13). I do not know
which of these two miniature props came first, and doubt that one was
directly influenced by the other. At the same time, the resemblance between
them, one in Dresden and the other in Naples (and such examples can be
multiplied), does make one wonder how widely a shared stock of quite
specific images traveled among miniature-makers across Europe.[25]

The three magi and their convoys, furthermore, carried a deeper signif-
icance for the *Throne of the Great Mogul*. The magi, after all, combined two
themes that were at the heart of Dinglinger's *mise-en-scène*: oriental wealth
and the presentation of gifts as tributes. The magi, especially in their
expanded visual and material presence in Baroque nativity scenes, brought
with them the untold wealth of the East. As such, they were the main cultural
vehicle for introducing the Orient and its exotic riches into a Western setting.
This of course was precisely the logic of the Great Mogul's court in the
Dresden court of Augustus the Strong, reinforcing the impression of the
untold and exotic wealth of the oriental ruler in content and form. Moreover,
the magis' providential purpose—their whole *raison d'être* in the biblical
story—was embodied in their *gifts*: gifts that were signs of their submission
to the infant Christ as well as diplomatic tributes from foreign kingdoms.
The three magi, therefore, as the ultimate embodiment of gift-giving in the
Christian tradition, provided a natural counterpart to the miniaturized court
of the Great Mogul in which the presentation of gifts as tributes from the
mightiest figures in the land was the main storyline.

Dinglinger, I have little doubt, was well aware of the relevance that the
vaunted theme of the three magi presented for the *Throne of the Great
Mogul*.[26] I would like to go even further and propose that Dinglinger, a

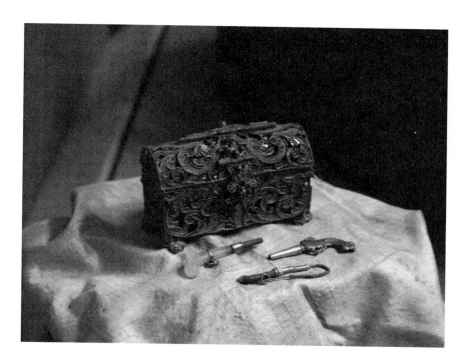

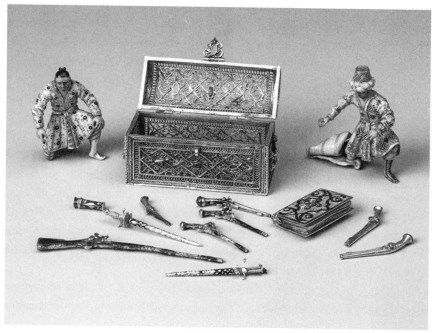

Figure 13. Top: miniature treasure chest with firearms from an early Neapolitan *presepe*.
Bottom: miniature treasure chest with firearms in the *Throne of the Great Mogul*

Protestant jeweler serving a Catholic prince, devised an ingenious way to invoke the magi right at the center of his design but in an oblique, subtle way. This claim is somewhat speculative, so allow me to explain.

The action in front of the Great Mogul includes four groups of dignitaries of the court, approaching the throne with their servants, two from each side. We know who they are because the text that Dinglinger provided Augustus the Strong identifies them, and two lesser figures next to them, as the top officeholders of the Mogul Empire. The second section of the text is dedicated to naming and describing each one, together with his accoutrements and gifts to the Great Mogul, assigning titles and ranks that follow verbatim the Dutch writer Olfert Dapper (although failing to acknowledge the source): Chan Channon, the prince of princes; Mir Miron, the emir of emirs; Chani Alem, the prince of the people; and the primo vezier, the chancellor of the realm. Chan Channon and Mir Miron have Chinese features. Their high positions in the empire of the Great Mogul, as well as the dignitaries' gifts that are explicitly foreign (one camel is listed as in Turkish style, another in Persian style; a Turkish horse led by a moor; and so on), all confirm the Great Mogul's status as a world leader receiving homage from far and wide.[27]

Something very interesting happens, however, when we shift our attention from the dignitaries to their retinues, each consisting of several small figurines of attendants (plate 37). Mir Miron's attendants, cast uniformly at 5.5 centimeters in height, are Chinese. This is plausible, since he himself has a Chinese appearance. What is less expected is that Chani Alem's attendants are uniformly Black Africans. Chani Alem is not Black. And the primo vezier, himself wearing a very impressive aigrette, is surrounded by servants who all wear turbans that identify them as Turkish or Persian. The fourth group, that of Chan Channon, is less distinctive in appearance, and with his own odd headgear that resembles the hat that the Mogul wears beneath his crown is probably intended to represent local figures, that is, Mughal. Together, what we see in the foreign convoys is three groups of servants accompanying dignitaries bearing exotic valuable gifts: one retinue from the Far East (China), one from the closer Muslim East (Persia or Turkey), one from Africa.

Here, then, is the key interpretive point. None of this is necessary or prescribed by the intended scene. Dinglinger's insistence on retinues that are ethnically identifiable and uniform, each one distinct from the others, is not derived from or indeed connected to the overall narrative of the fictive court

of the Great Mogul. If anything, the visual attribution of a distant foreign origin to the three groups of attendants appears to subvert the explicit narrative set up in the accompanying text with regard to the roles of these dignitaries at the domestic hub of the Mogul Empire. Which raises the question: why did Dinglinger make this deliberate effort to introduce a gratuitous twist into the presentation of the *Throne of the Great Mogul*?

The likely explanation for the three foreign retinues is that they evoked allusions to the three magi or wise men from the East. The African attendants of Chani Alem are especially suggestive here. Ever since the fifteenth century it was *de rigueur* to represent one of the magi as a Black African, a trope that originated in German lands; indeed, his Blackness became one of the most immediately recognizable traits of the three magi tableau. However, whereas in the late Middle Ages the three magi had been taken to represent the three continents, including Europe, and were often understood to be kings, by the seventeenth century they largely reverted to being the three wise men from the East, leaving learned scholars to argue over their precise Eastern origins.[28]

So, three miniature convoys of dignitaries in motion approach the center of the action in order to present gifts and pay homage. They are marked unmistakably—and, it bears repeating, unnecessarily—as originating from three distinct geographic origins in Asia and Africa. At the beginning of the eighteenth century, the allusion would have been hard to miss. It must have been even more immediate for a goldsmith who was actually named after one of the magi, Melchior. (This realization also brings to mind the camel Dinglinger created for Friederike Elisabeth von Saxony-Eisenach [plate 24, top left], led by two Africans and carrying enameled chests for precious objects, on which he collaborated with another artist named after another magus, Balthasar Permoser.[29]) Dinglinger invoked the magi in the *Throne of the Great Mogul* precisely because of their affinity to key themes of the ensemble. And yet, since they were but a subtext to the main storyline of the Great Mogul's court, Dinglinger introduced them with deliberation but *sotto voce*, at the level of the dignitaries' retinues.

In the Holy Roman Empire and in Saxony, moreover, the theme of the three magi or kings had a special resonance. Ever since their relics had arrived in Cologne in 1164, the veneration of the magi became an integral part of the Holy Roman Emperor's coronation ceremonies.[30] By the early modern period, this particular imperial ritual had waned, but the political relevance

of the three magi/kings lived on. It so happened that their local significance was reaffirmed with fanfare precisely at the same time that the *Throne of the Great Mogul* made its first public appearance.

Augustus the Strong, we recall, put the *Throne of the Great Mogul* on display to honor King Frederik IV of Denmark during his month-long visit to Dresden in June 1709. On 28 June the two royals signed a treaty, and two days later they arrived together in Potsdam for what came to be known as the *Dreikönigstreffen*: the meeting of the three kings—Augustus, Frederik of Denmark, and Friedrich I of Prussia. Much was made at the time of the fact that there was no precedent for a king meeting simultaneously two other crowned heads, and thus the protocol had to be invented anew. Much attention was also given to the symbolic happenstance that all three kings were named Frederick (Augustus was Friedrich Augustus, after all), and that they brought into harmony all three religions of the Holy Roman Empire. More than anything, what made the comparison to the three biblical kings or magi inescapable was the fact that during this royal congress Friedrich I's son's wife was expected to give birth to his first grandchild, and that when it finally arrived—a baby girl—she was baptized in the presence of the three kings and named Friederike after them all. As the Baron von Pöllnitz recounted, one poet "presented verses to the [Prussian] King in which he compared the new-born Princess to the Child Jesus, and the three monarchs who were present at her baptism to the three Magi." There were in fact at least two texts produced for the event that offered this comparison, one emerging anonymously from the close circle of the Prussian court, the other in French verses presented to the Prussian king by the Marburg City Council member Karl Wilhelm von Meisenbug. While the Christian world has always celebrated the memory of the three biblical kings in the middle of winter, Meisenbug exclaimed, here was the first time the celebration of the three kings was to take place in the middle of summer, as is suitable to northern climes. The modern three kings, he added, were in truth more powerful than the biblical ones, who had ruled only "what we today call the kingdomlets (*Roitelets*) of India." Meisenbug actually presented his verses to the king a week before the *Dreikönigstreffen*, in anticipation of the actual event, when Frederik IV was still in Dresden enjoying the hospitality of Augustus the Strong, not least at the house of Johann Melchior Dinglinger.[31]

Augustus himself, then, was being likened to one of the three biblical magi. One wonders whether the same association came to mind three days

before Meisenbug's presentation of his poem, during the "Carousel of the Four Continents" of 19 June, that grand entertainment inspired by the court of Louis XIV and carefully planned by Augustus himself with Dinglinger's help. In the Dresden Carousel, we recall, Frederik took on the role of the king of the Europeans next to Augustus who, memorably, blackened his face to assume the role of the African king. Were they also alluding to Melchior and Balthasar? Perhaps. Regardless, it is clear that the theme of the three magi/kings retained its immediacy in the Saxon and neighboring courts at the beginning of the eighteenth century. It was readily comprehensible for Augustus the Strong. It was readily available to Dinglinger, who took some license with the design of the court of the Great Mogul in order to invoke the magi through the African, Chinese, and Persian/Turkish retinues of the three dignitaries.

Finally, both Augustus and Dinglinger were surely aware of a precedent for the presentation of a Saxon elector as one of the three biblical magi, a precedent that was a prize object in the Dresden *Kunstkammer* collection. It was a Bethlehem—a miniaturized, box-size, gilded-bronze nativity—made by the late sixteenth-century Augsburg clockmaker and goldsmith Hans Schlottheim while he was sojourning in Dresden, and presented on New Year's Day 1589 as a gift from the Electress Sophia of Saxony to her husband, Christian I (fig. 14). What made this particular Bethlehem—a Protestant one—singular was that it combined the miniaturization of the biblical scene with the playfulness of an automaton. A mechanical device set the adoration of the three kings or magi in motion. The kings, each followed by two attendants, paraded in a circle around the nativity scene itself, pivoted to face the infant Christ, and continued to present their offerings in a never-ending cycle to the sound of a Lutheran hymn. While the kings were all represented in contemporary courtly garments, the first one donned a mantle and collar with the recognizable ermine fur of an elector of the Holy Roman Empire: this miniature magus represented Elector Christian I himself.[32] The presence of this valuable musical automaton in Augustus's collection reinforces our sense of the resonance that the theme of the three magi held in the Saxon court, not least in relation to rulership. Indeed, we may wonder whether for Dinglinger, a century after Schlottheim's Bethlehem, the presence of an object with multiple miniature figures of magi and attendants, in which the many parts—figures, scenes, and numerous architectural elements—were rendered in a variety of techniques befitting a top-notch goldsmith, was as

Figure 14. Hans Schlottheim's automaton nativity, or "Bethlehem," Dresden, 1589 (detail): the moving figures of the three kings

close as the Baroque jeweler could possibly have had to a *Vorbild*—a model, a precedent, an example, a forethought—for his own *Throne of the Great Mogul*.

With Schlottheim's Bethlehem this chapter completes a full circle, returning to the playfulness in devotional objects that characterized the sixteenth-century prayer nuts, and which subsequently became stronger and more independent as god and the sacral moved in some key senses to the sidelines. We have seen multiple playful manifestations of the wave of miniaturization that entered so many branches of decorative arts from the late seventeenth century. The *Throne of the Great Mogul* is an extraordinarily playful example in numerous ways, not least Dinglinger's subtle introduction of the Christian motif of the three magi from the East, buttressing his intentions in the work as a whole but without allowing the religious narrative to take over.

And yet Dinglinger's preoccupation with religion in the *Throne of the Great Mogul* went much deeper, and in a strikingly original direction. The

space for play that opened up in so many domains of European culture from the seventeenth century, through the circumscription of the realm of the sacral and the partial distancing of god's direct involvement in human affairs, allowed Dinglinger a radical experiment in what we may call today comparative religion. This unexpected layer of meaning interwoven into Dinglinger's *Throne of the Great Mogul*, a tactile exploration of religion as a scholarly humanist subject that is set within a quasi-global framework, is the subject of the following chapters.

Before going there, however, I wish to end this chapter with a note of caution regarding the purported shift along the axis from transcendent sacrality to mundane play, in particular with regard to miniature objects. The historical narrative informing this chapter, namely the gradual weakening of the early modern belief in the supernatural involvement of god in daily affairs between the sixteenth and the early eighteenth centuries, has been diagnosed by scholars ranging from historian Keith Thomas to sociologist Max Weber and philosopher Marcel Gauchet as the early modern "disenchantment of the world."[33] We have seen Giorgio Agamben mobilize the same framework in discussing the nativity crib. It is well-known, however, that this disenchantment and the concomitant decline of magic were long, drawn-out, and uneven processes, never fully successful in driving out magical ways of being in the world. Historians have often emphasized the coexistence of science and alchemy in the seventeenth century, or of astronomy and astrology. In early modern terms it was not at all incongruous or unusual that Augustus the Strong was at the same time a patron of science who attracted learned scholars to his court and a believer in astrology and alchemy, domains of knowledge that often influenced his policy decisions. The idea of the *Throne of the Great Mogul* itself may have been related to a prophecy that Augustus had pored over already in 1696, according to which a Saxon prince named Augustus was going to become king of Poland, then Holy Roman Emperor, and then add to his conquests the Ottoman Empire and parts of Asia. Recall the astrological chart that proudly accompanied Augustus's printed portrait upon his coronation in 1697, when the first stage in this prophecy came true (see fig. 9).[34]

Miniature objects in particular were a cultural form in which the ascent of play did not necessarily entail the disappearance of magical efficacy. An obvious example is Johann Wilhelm von der Pfalz's gift to Anna Maria Luisa de Medici. When the elector commissioned for his wife the miniature golden

cradle with the baroque pearl baby, a typical specimen of a rich and playful Dutch manufacture, he had the filigree engraved with the inscription "*auguror eveniet*": "I predict that it will come to pass." Was this simply a comforting phrase, or did Johann Wilhelm also think of the miniature cradle as a kind of charm with talismanic powers to induce the outcome it augured, as miniature cradles are known to have been used elsewhere?[35] Or recall the ivory shoe in the Louvre: was this shoe simply a playful miniature jack-in-the-box, or was there something menacing and perhaps efficacious about the demons popping out from its tiny hidden compartments? Did the frisson of early modern miniaturization retain vestiges of the uncanny?

Keeping such possibilities in mind, now in the context of magical thinking in the Saxon court, let us speculate a bit further about the possible effect of the *Throne of the Great Mogul* itself. Playful and non-sacral as Dinglinger's creation was, when the Great Mogul and his court in all their splendor were miniaturized onto a tabletop and tamely enclosed in the depths of the prince's vault, and when the Great Mogul himself—a contemporary potentate of untold power—was rendered tiny enough to be held helplessly in the prince's hand, could this radical scale-alteration have induced in Augustus the Strong certain expectations regarding his own power over and against the mighty Mogul?

8. Hands (and Frogs and Pyramids)

This chapter begins with two groups of elements in Dinglinger's *Throne of the Great Mogul* that are so surprising, indeed each in its own way so inexplicably out of place, that one's immediate reaction, once one realizes what they are, is to scratch one's head and say *this simply cannot be*. Such incredulousness may account for the fact that these elements—and indeed the further components of Dinglinger's ensemble into which they lead us, forming together a major subtext of the *Throne of the Great Mogul*—have not been analyzed or explained before, if noticed at all. As we follow these components in the unforeseen directions necessary to understand them, they turn out to provide rare access to the jeweler's own private agenda in this project, a far-reaching agenda for which nothing we have seen so far has prepared us in the least.

The first is a group of delicate, unobtrusive engravings on gilt silver that are almost indiscernible for an unsuspecting observer, and have thus escaped attention for the past three hundred years. Located as they are in the most densely ornamented part of the court of the Great Mogul, that is to say, in the immediate surroundings of the throne, they are outshone by an abundance of more conspicuous colorful ornamentation. These engravings are on the two golden pilasters that frame the throne and its baldachin, demarcating the central and most important part of the *Throne of the Great Mogul* (see plate 4). The pilasters are punctuated by screws, of the kind that Dinglinger used throughout the work to hold the whole set together. In between the screws, on the gilt, and easier to see when the light falls at the right angle, are engraved five pairs of figures, facing each other from both sides (fig. 15; also discernible in plate 4). The sitting frog is the first to hit

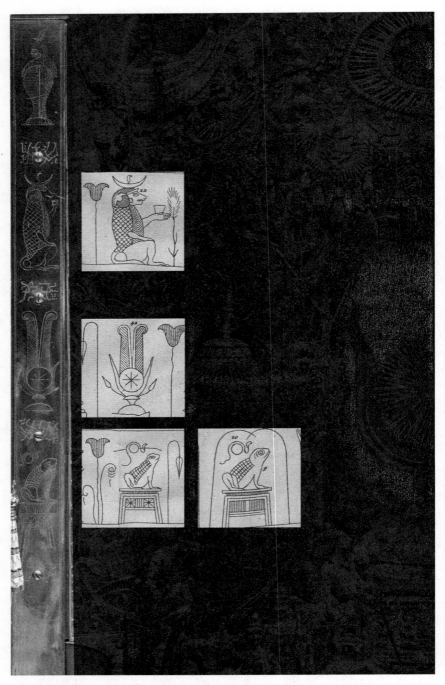

Figure 15. Etchings on the throne's pilaster in the *Throne of the Great Mogul*, paired with details of the *Mensa Isiaca* from the borders of Lorenzo Pignoria's folio plates of 1669. Note that Dinglinger's frog on the pedestal combines elements from two different frogs in Pignoria's plates

one's eye. Below the frog is a harder to discern viper. Above it, from bottom to top, are a vase with plumes, a humanoid animal figure sitting with a crescent on its head, and another standing figure in the shape of a mummy. As the ending of the previous sentence makes explicit, these images do not look Asian. Rather, their appearance is distinctly Egyptian.

As it happens, their reticent presence in the *Throne of the Great Mogul* does not betray the significance of their source. The origin of these faint engravings was the most famous Egyptian antiquity in early modern Europe, an inlaid bronze tablet known as *Mensa Isiaca*. This tablet, discovered in Rome in the sixteenth century and published by the Padua-based antiquarian Lorenzo Pignoria in 1605, together with drawings of its many scenes and figures, became the touchstone for seventeenth-century efforts to penetrate Egyptian culture and interpret hieroglyphs. (Today we know that the *Mensa Isiaca*'s iconography, centered on the goddess Isis, was not in fact hieroglyphic, and was probably not Egyptian, but rather an imperial Roman imitation.) As can be seen in figure 15, which pairs them together, the engravings on the pilasters at the sides of the Great Mogul's throne were carefully rendered copies of certain motifs in the *Mensa Isiaca*. These motifs are not central ones but rather drawn from a string of small images that constitute the borders of the ancient tablet. The frog, furthermore, combines elements from *two* frogs in the original tablet drawing: the one contributing the engraved frog's distinctive eye and arched back as well as the shape of the snake above its head, the other the distinctive geometric pattern of its pedestal.[1] The superimposition of two Egyptian frog drawings to achieve the required effect, like the borrowing from minor border figures, is a sign of studious design. But why introduce these figures next to the throne of the Great Mogul in the first place? And to make things more puzzling still, why are the Egyptian figures on the throne pilasters separated from each other by what appear to be (unpersuasive) imitations of Chinese writing?

The second set of elements we want to focus on here is as conspicuous as it is mysterious. In the parade of gifts for the Great Mogul are included two upstretched golden hands, represented as so large that they require their own ornamental barrows on which two pairs of servants wheel them into court. The hands, in actual measure just over seven centimeters tall, are covered on all sides with peculiar symbols in colorful enamel (plate 38). Their layout and details stand out from other objects in Dinglinger's ensemble.

But the real revelation strikes us when we look at the two pairs of images in figure 16. On the left side are Dinglinger's creations. On the right we see two bronze hands housed today in the British Museum, actual archeological artifacts dating from the first to the third centuries AD: these are called Sabazius Hands, cultic objects associated with the worship of the Phrygian and Thracian deity Sabazius. It takes a moment to realize that Dinglinger's colorful gold and enamel creations are not simply *similar* to the Sabazius Hands in the British Museum. In terms of their shape and their idiosyncratic layout of symbols, and if we disregard for a moment the round bases on which Dinglinger's creations stand, the hands made by the Saxon jeweler are for all intents and purposes *identical* to those in the British Museum. This remains true even though the museum exhibits are made of plain bronze and are actually twice the size, at around fifteen centimeters. But how can this be? How did precise, miniaturized replicas of archeological findings find their way into Dinglinger's court of the Great Mogul?

The initial steps in solving this puzzle require some bookish legwork but are not very difficult. Unlike Dinglinger's silent borrowing from the *Mensa Isiaca*, in this case the text that Augustus the Strong received together with the *Throne of the Great Mogul* actually names the missing links. Both distinctive bronze hands in figure 16 emerged into the public eye for the first time in the seventeenth century, independently of each other. One was dug up in the area of Tournai near today's French-Belgian border, and the other turned up in Rome and was acquired by the art patron and collector Cardinal Francesco Barberini. They were published in the form of short, dedicated antiquarian tracts. One was published in 1624 by Lorenzo Pignoria, the same Pignoria who also published the *Mensa Isiaca*. The other was announced to the world in 1649 by the Paduan scholar Giacomo Filippo Tomasini, with the help of Cardinal Barberini's secretary, the famous Roman patron, collector, and antiquarian Cassiano dal Pozzo.[2] The three scholars are all named in Dinglinger's text. Both tracts included detailed drawings of both sides of the bronze hands (fig. 17). These drawings were the sources for Dinglinger's three-dimensional reconstructions of these ancient objects in the court of the Great Mogul, down to the smallest details (plate 39).

We can also reconstruct with a high degree of certainty how and in what form these specialized publications by Italian antiquarians reached our jeweler in Saxony. Long after their authors died, these tracts attracted the attention of the Amsterdam-based publisher Andreas Frisius (or Fries).

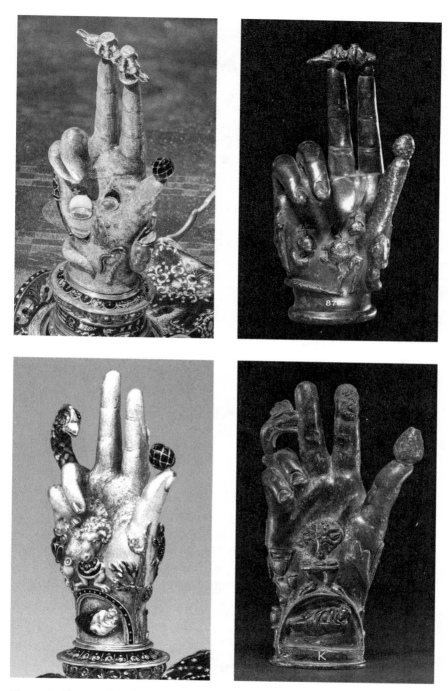

Figure 16. The two golden hands covered with symbols in the *Throne of the Great Mogul*, next to two ancient Sabazius Hands from the British Museum (right)

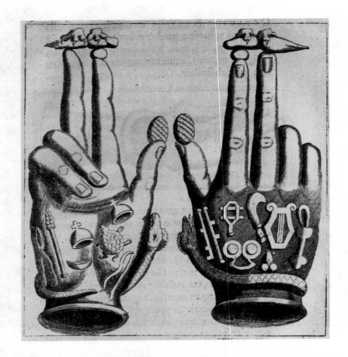

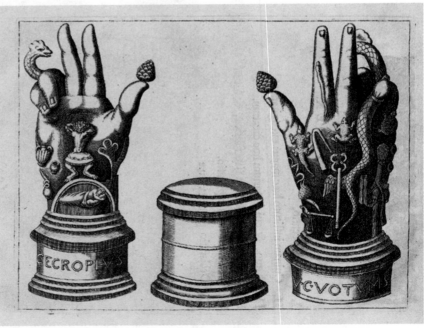

Figure 17. Printed drawings of two Sabazius Hands discovered in the seventeenth century, from antiquarian tracts by Lorenzo Pignoria (1624) and Giacomo Filippo Tomasini (1649)

Frisius, a humanist with a strong Latin education, developed from the mid-1660s a market niche for himself by reissuing works by deceased humanist authors, especially from Italy. He focused on titles in Latin on antiquarian topics relating to the Roman world and ancient Christian history. These he republished with additional materials and scholarly apparatus and marketed internationally at relatively low prices, especially through the Frankfurt book fair.[3] In 1669 Frisius picked up Pignoria's book on the *Mensa Isiaca*, to which he added further plates with enlargements of the string of small images on the borders of the ancient tablet, now all arranged in cartoon-like rows.[4] Next to this work Frisius also selected for republication Pignoria's tract about the ancient bronze hand and paired it with Tomasini's publication about the other bronze hand of the same type. (This choice was perhaps suggested by Frisius's Venice-based half-brother and lifelong collaborator, Giovanni la Nou, who worked as an agent for the librarian of Cardinal Barberini, the owner of this rare antiquity.) Frisius placed the two bronze-hand tracts at the end of his reissue of Pignoria's *Mensa Isiaca*, printed a combined title page for the three works (with some additional text and images of amulets from Athanasius Kircher and others), and circulated them together as a compendium of antiquarian works about ancient objects with unusual graphic symbols.[5]

A close comparison with Dinglinger's material reconstructions of these antiquities confirms that Frisius's was the book he used. The details of the engravings on the pilasters of the Great Mogul's throne, frog and all, can be shown to have been based on the additional plates with the enlarged border figures that Frisius added to the *Mensa Isiaca*.[6] Likewise, in Dinglinger's gold and enamel reconstruction of Pignoria's bronze hand, the conspicuous tongue of the snake enveloping the hand follows the image of the snake in the reissued plate of 1669 but is not a detail visible in the original Venetian edition of 1624. The Dutch publisher, then, was the active agent who brought together these particular texts and enriched them with these particular images. Dinglinger, for his part, with Frisius's single-volume compilation in hand, had in front of him all the visual materials he needed to introduce the Egyptian images and the two Sabazius Hands, all derivations of actual antiquities discovered in the seventeenth century, into the *Throne of the Great Mogul*.

But this analysis only begs the real question: Why did Dinglinger go to all this trouble? Why the insistence on accurate reconstructions of real artifacts

based on their scholarly illustrations—which is a practice quite different from drawing inspiration with considerable freedom from illustrations in contemporary travel books? Why the effort to imagine and recreate peculiar antiquities that bore no relationship to the rest of Dinglinger's project in terms of its theme, geographical focus, or timeframe? The last point is worth dwelling on for another moment. The narrative enacted in the *Throne of the Great Mogul*, as we have been unpacking it up to this point, was insistently about the here and now (taking a quasi-global perspective on "here"): a living Mughal emperor in a weighing ceremony in front of the dignitaries in his present-day court, offered as a model for emulation to a contemporary, early eighteenth-century Saxon prince with immediately pressing claims for a royal crown he had recently gained and lost. In the opening words of the text accompanying Dinglinger's creation, the artwork represented the court of the Great Mogul with its birthday ceremonies *"wie es am Tage ist"*—"as it is today." And if the three magi or wise men from the East in the previous chapter added a whiff of biblical times, this was by way of analogy and prefiguration. But now, by contrast, we find Dinglinger adding to the *Throne of the Great Mogul* a new dimension of ancient and even mythical time.

That this was a deliberate agenda becomes clear when one considers the cylindrical pedestals of Dinglinger's two cultic hands (plate 38). One hand stands on a drum that bears, between two rows of diamonds, a Latin inscription in shiny gold lettering against a black background, *"Cecropius voti compos votum solvit,"* "Cecrops, whose wish was granted, has gratefully fulfilled his vow." This inscription follows the drawing in Tomasini's tract but expands it to spell out words that were abbreviated in the original inscription and completed by Tomasini. Dinglinger's explanatory text reproduced Tomasini's interpretation of these Latin words as a votive offering by a man named Cecrops after the recovery of a sickly child, represented in the symbolic landscape of the bronze hand in the arms of his mother in a cavern on the hand's palm. (Modern scholars of the late-antique world, as it happens, have discredited the authenticity of the Latin-inscribed base of this hand, but Dinglinger of course could not have known this.[7])

But now compare the base of Dinglinger's second hand. Here, between two rows of diamonds similar to those at the base of the Hand of Cecrops, and again in shiny gold on black echoing the Latin lettering, is a series of signs that look like Egyptian hieroglyphs. These faux hieroglyphs constitute apparently another inscription, paralleling the Latin one. In truth, however,

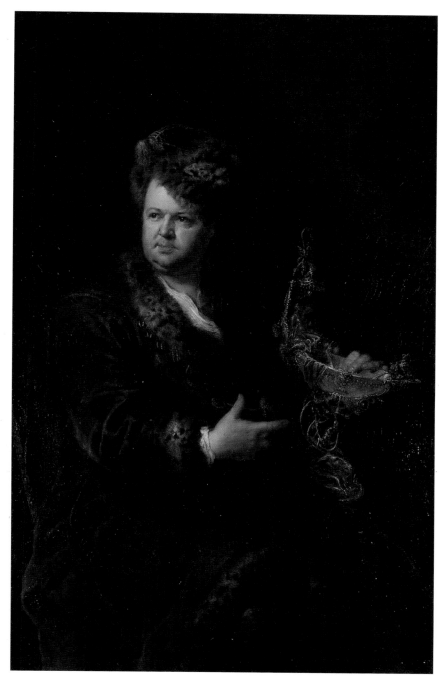

Plate 1. Antoine Pesne, *Johann Melchior Dinglinger*, 1721. Pesne was the Prussian court painter and Dinglinger's personal friend

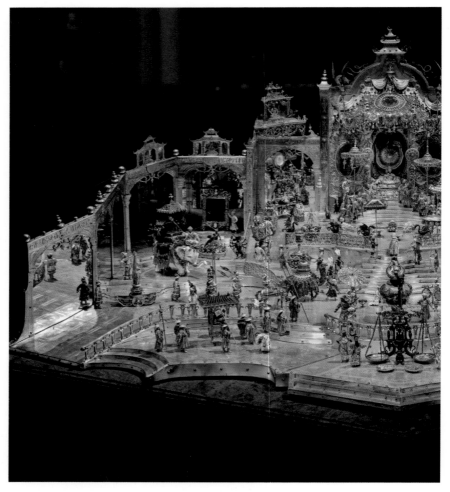

Plate 2. Johann Melchior Dinglinger, *Throne of the Great Mogul*, 1701–1708 (142 × 114 × 58 cm)

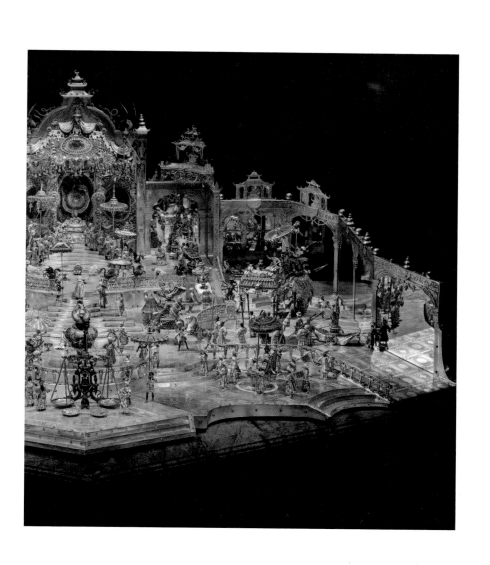

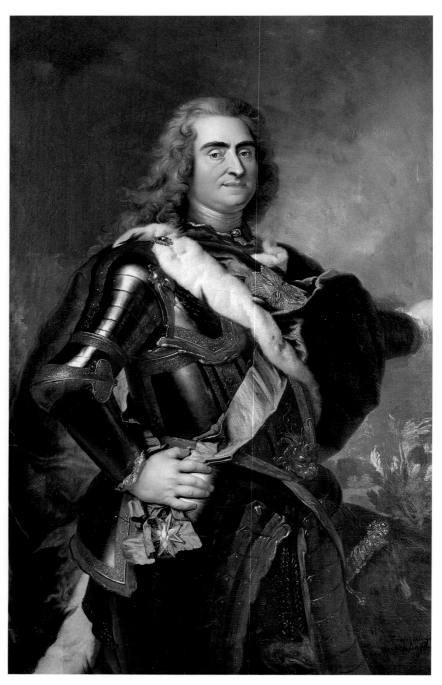

Plate 3. Louis de Silvestre, *Augustus the Strong*, 1718 or later, with the badge of the Polish Order of the White Eagle

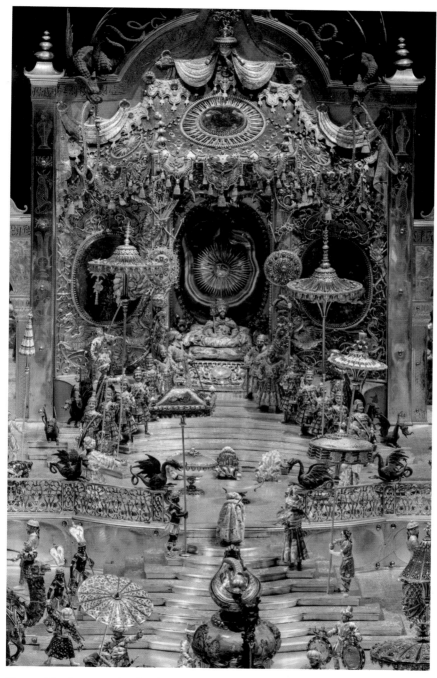

Plate 4. The Great Mogul on his throne in the *Throne of the Great Mogul*

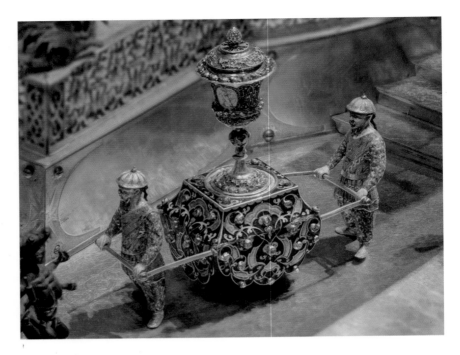

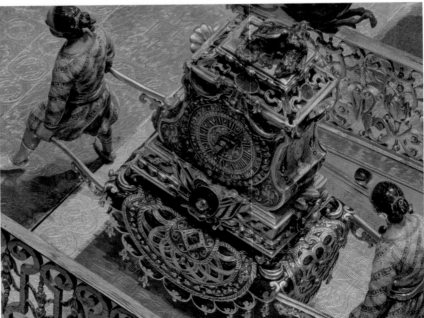

Plate 5. Gifts paraded for the Great Mogul: golden goblet (h. 6 cm); clock with repeater mechanism, signed by the court clockmaker "[Andreas] Fichtner, Dresden" (h. 5.5 cm)

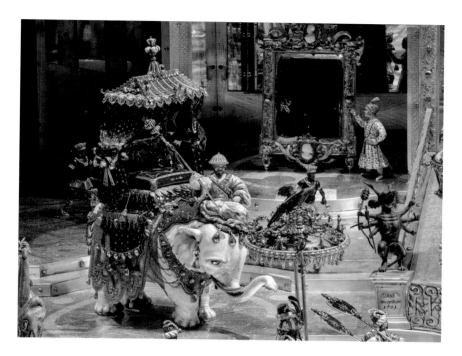

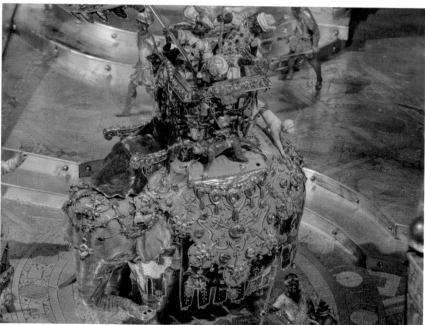

Plate 6. Caparisoned elephants in the *Throne of the Great Mogul*: white riding elephant (top, h. with canopy 18 cm); grey hunting elephant (bottom, h. 21 cm; note the clambering monkeys)

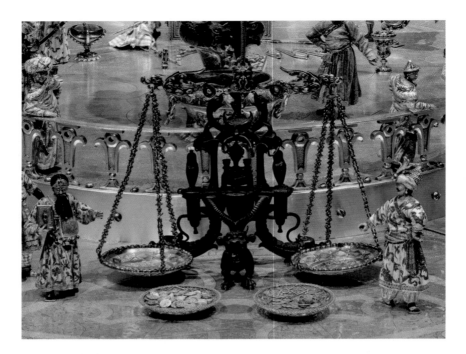

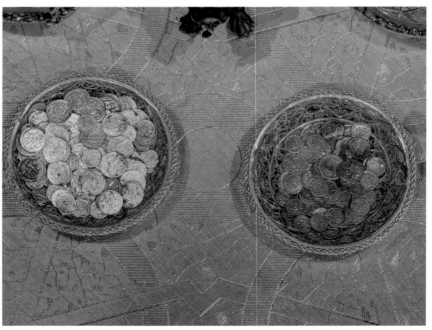

Plate 7. The scales in the *Throne of the Great Mogul* (h. 15.8 cm), with the filigree baskets holding piles of 94 gold and 154 silver coins, each measuring up to 0.6 cm in diameter. Note the accounting bureaucrat recording the results of the weighing

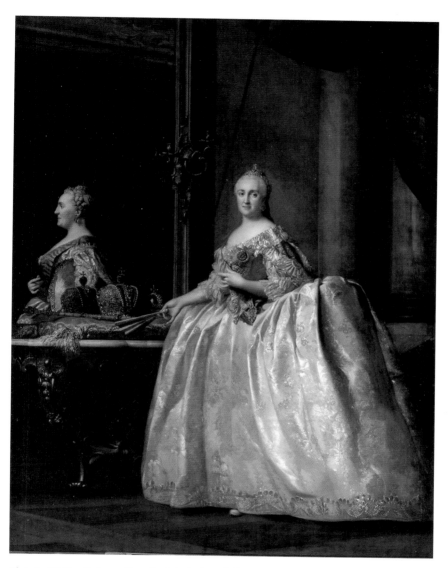

Plate 8. Vigilius Eriksen, *Portrait of Catherine II before a Mirror*, 1762

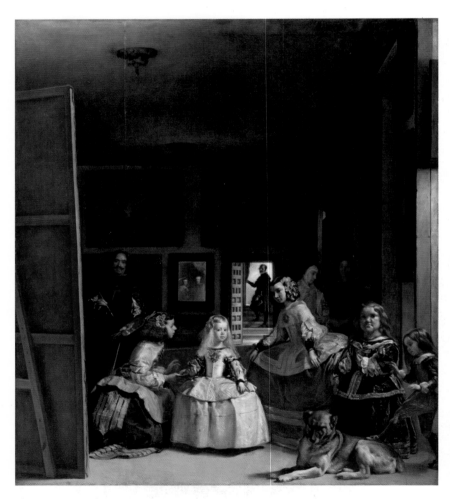

Plate 9. Diego Velázquez, *Las Meninas*, 1656

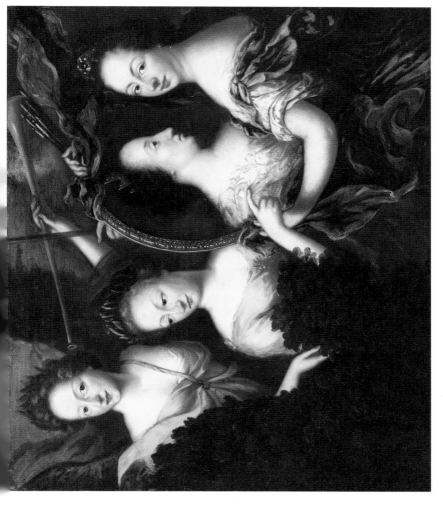

Plate 10. Amalia von Königsmarck, *Allegory with Self-Portrait and Profile Portrait of Ulrika Eleonora the Elder*, 1689

Plate 11. Two works by Johann Heinrich Köhler. Top: triumphal architecture with two crowned obelisks, 1701–1705 (h. 20 and 16.5 cm); bottom: ivory knife-grinder, 1708 (h. 9.6 cm with base)

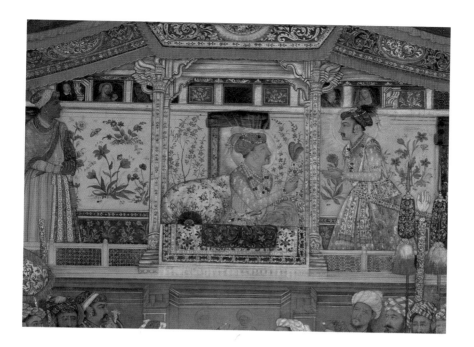

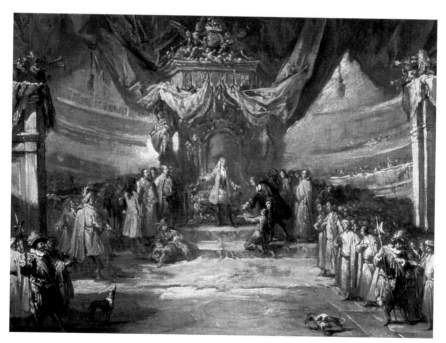

Plate 12. Top: Payag, *Jahangir Presents Prince Khurram with a Turban Ornament*, c. 1640 (detail).
Bottom: Antonio Pellegrini, *The Elector Johann Wilhelm von der Pfalz Being Offered the Crown of Armenia*, 1713–1714

Plate 13. Top: Ivory egg with nested miniatures, sent by Liselotte von der Pfalz to Caroline of Ansbach, c. 1717. Bottom: Johann Melchior Dinglinger, sun mask with likeness of Augustus the Strong, 1709

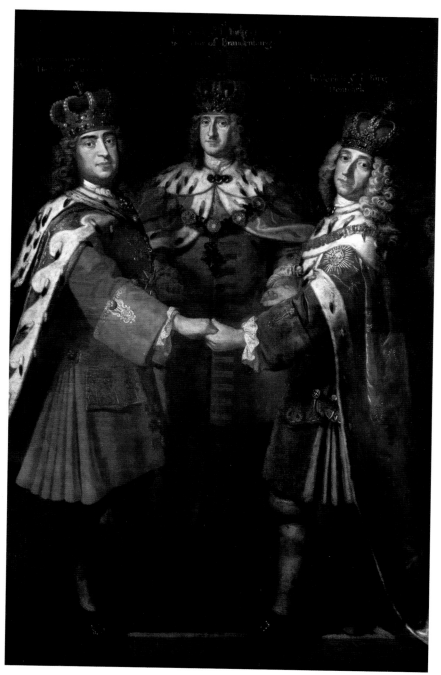

Plate 14. Samuel Theodor Gericke, *The Meeting of the Three Kings Friedrich I in Prussia, Augustus II the Strong and Frederik IV of Denmark*, 1709

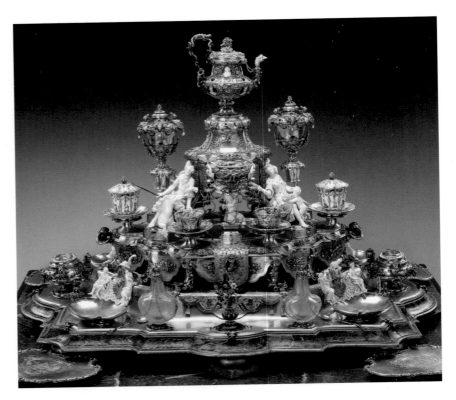

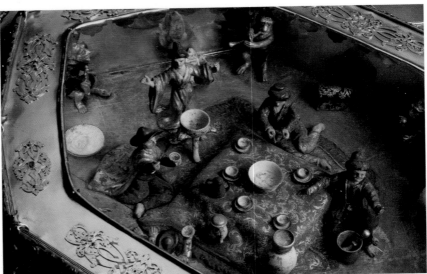

Plate 15. Johann Melchior Dinglinger, *Golden Coffee Service* (*Goldenes Kaffeezeug*), 1697–1701 (96 × 76 × 50 cm). Below, the coffeehouse scene hidden at the base

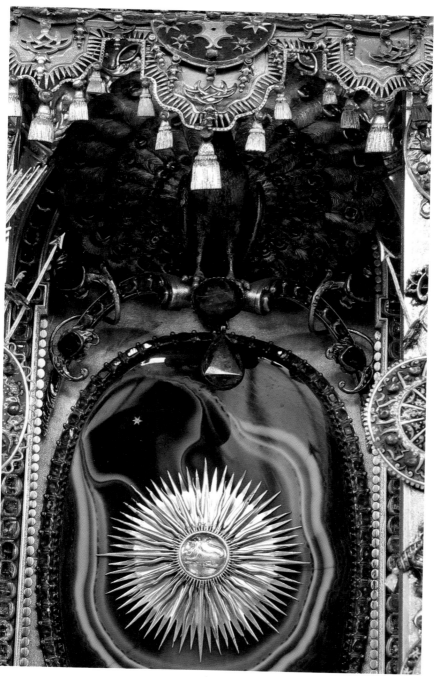

Plate 16. The peacock under the canopy overhanging the throne in the *Throne of the Great Mogul*

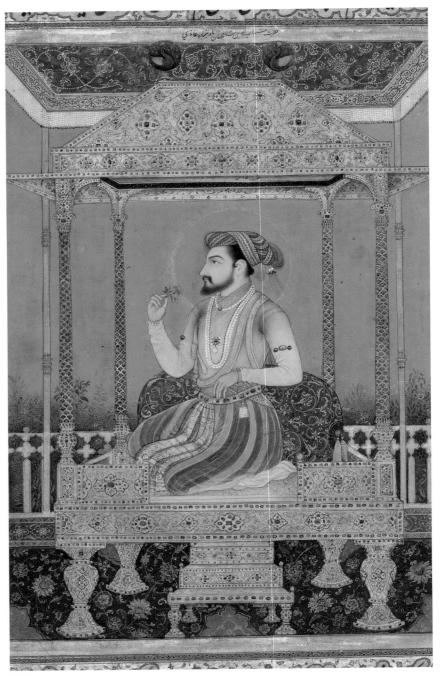

Plate 17. *Shah Jahan on the Peacock Throne*, a nineteenth-century painting based on a contemporary Mughal original. The peacocks are represented as two circles at the top of the throne

Plate 18. Bichitr, *Jahangir Preferring a Sufi Shaikh to Kings*, c. 1615–1618

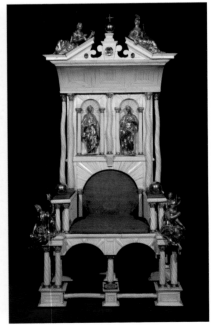

Plate 19. European regal thrones of the second half of the seventeenth century: the Swedish Silver Throne, 1650, bottom left; the Danish "Unicorn Throne," 1671, bottom right; the Holy Roman Emperor's Amber Throne, drawing, 1677–1678, top

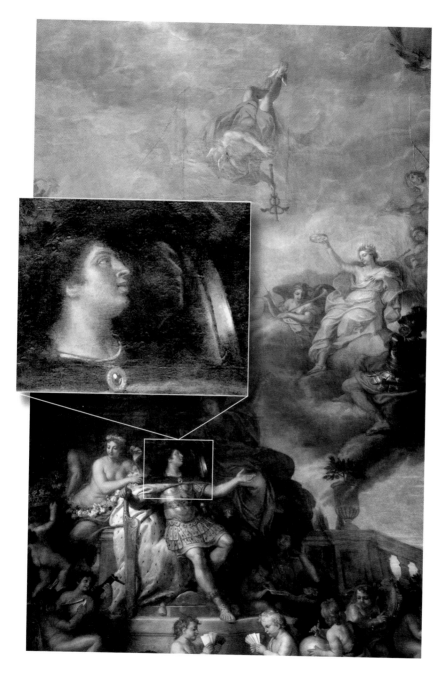

Plate 20. Charles Le Brun, *Le roi gouverne par lui-même*, Hall of Mirrors, Versailles, 1661 (detail). In insert, the king's face mirrored in Minerva's shield

Plate 21. Anna Maria Luisa de Medici's cradle and baby, 1695 (49 × 55 mm)

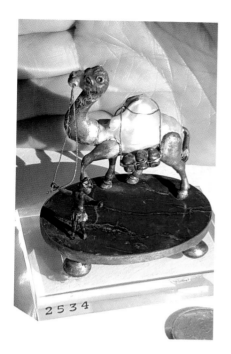
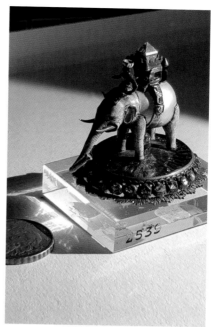

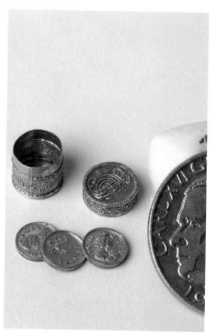

Plate 22. Princesses' miniatures. Top: Anna Maria Luisa de Medici's camel (10 × 44 × 50 mm) and elephant (39 × 37 mm, h. 58 mm with base). Bottom: Hedwig Eleonora's monkey (22 × 20 × 23 mm) and coinbox (h. 8 mm)

Plate 23. Johann Wilhelm von der Pfalz in miniature as Mars, 1704 (h. 19 cm)

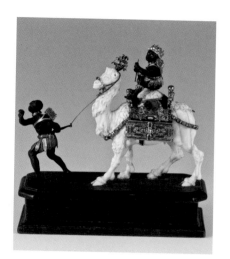

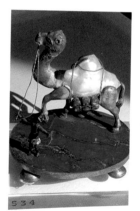
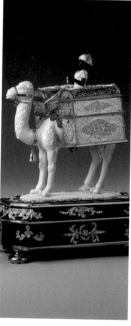

Plate 24. Miniature camels. Friederike Elisabeth von Saxony-Eisenach's (h. 16.3 cm with base; top left), Christiane Eberhardine's (h. 18.2 cm; bottom right), Anna Maria Luisa de Medici's (h. 5 cm; bottom middle), Augustus's made of a baroque pearl (h. 12.3 cm; bottom left), Dinglinger's Turkish camel in the *Throne of the Great Mogul* (h. 10 cm; top right)

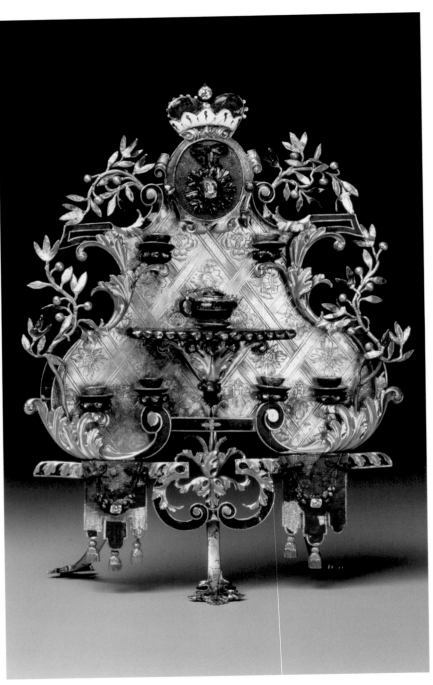

Plate 25. Augustus's miniature cabinet piece with consoles, 1694–1697 (h. 14.8 cm)

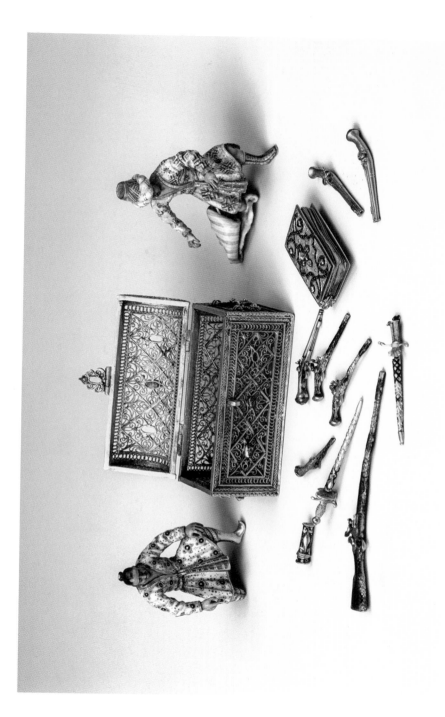

Plate 26. Treasure chest (l. 5.5 cm) with weapons and book in the *Throne of the Great Mogul*

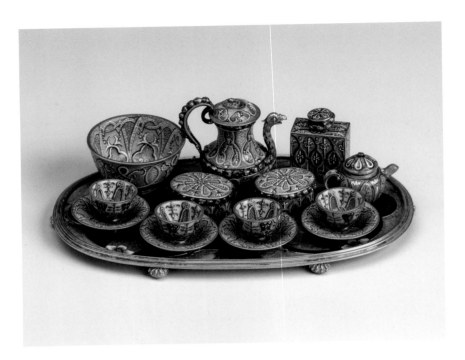

Plate 27. The miniature coffee service (tray l. 9.7 cm) in the *Throne of the Great Mogul*

Plate 28. The art gallery room in Petronella de la Court's late seventeenth-century dollhouse, with its miniature cabinet of curiosities (22.5 × 21.4 × 7.1 cm)

Plate 29. Prayer bead: The queen of Sheba visiting King Solomon and the adoration of the magi, c. 1520 (d. 6.5 cm)

Plate 30. Two reduced-scale altars. Left: the Andechs altar, Augsburg, c. 1600 (the baldachin was a mid-eighteenth-century addition; h. 43.5 cm). Right: miniature altar, c. 1700 (h. 18 cm)

Plate 31. Miniature altar with Dominican priest performing the mass, probably Vienna, c. 1700 (h. 20 cm)

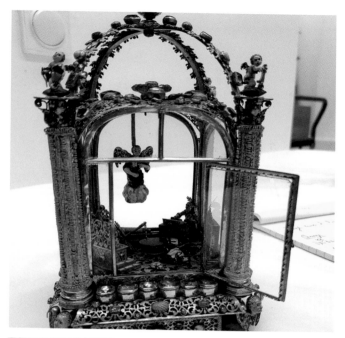

Plate 32. Miniature annunciation scene in glass box, probably Vienna, c. 1700 (h. 20.5 cm)

Plate 33. Miniature annunciation scene in Nevers lampworked glass, turn of the eighteenth century (w. 47 cm, h. 34 cm)

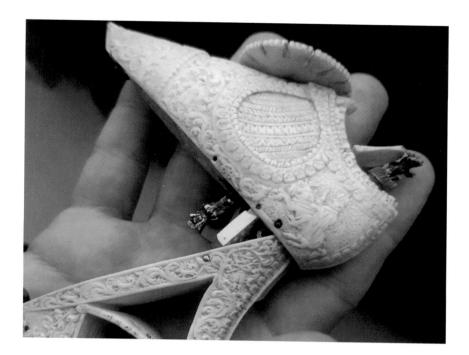

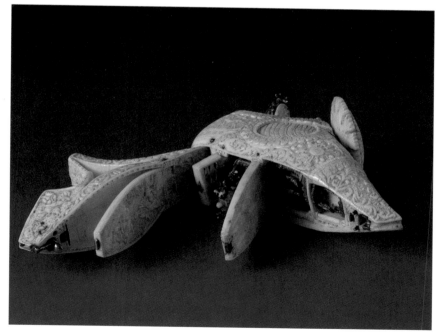

Plate 34. Miniature ivory skating shoe with religious scenes, hidden compartments, and jumping demons, Netherlands/Germany, 1650 (h. 8 cm, l. 6.9 cm)

Plate 35. Top: Nativity scene, Augsburg Cathedral, c. 1590 (three-quarter life-size). Bottom: *Presepe Cuciniello*, Naples, put together by the nineteenth-century playwright Michele Cuciniello (detail). Includes 173 eighteenth-century human figures and over 300 miniature objects

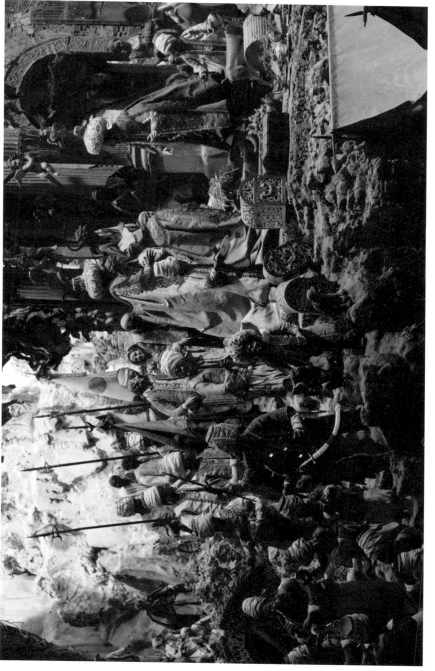

Plate 36. *Presepe Cuciniello*, convoys of the three kings / magi with treasure chests

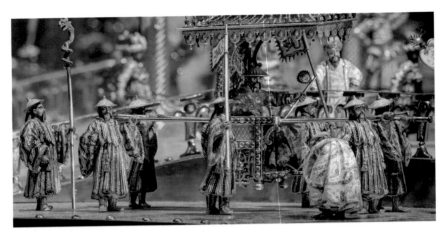

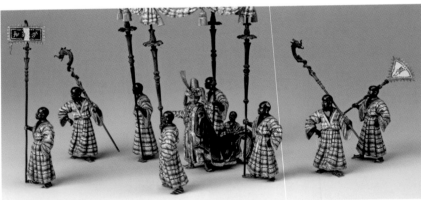

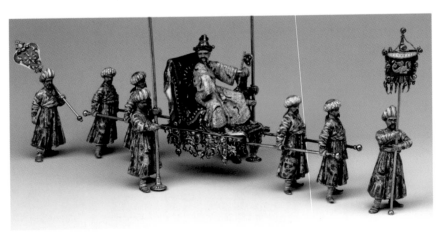

Plate 37. Dignitaries' retinues in the *Throne of the Great Mogul*: the Chinese attendants of Mir Miron, the African attendants of Chani Alem, and the Turkish/Persian attendants of the primo vezier

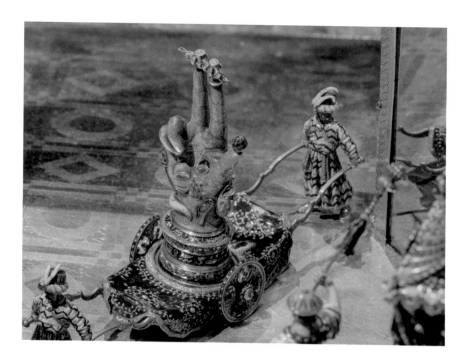

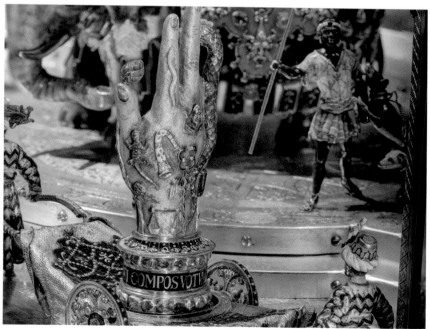

Plate 38. The two golden hands covered with symbols in the *Throne of the Great Mogul*

Plate 39. Dinglinger's golden hands in the *Throne of the Great Mogul*, next to the printed drawings that they meticulously imitated, published in antiquarian tracts by Lorenzo Pignoria (1624) and Giacomo Filippo Tomasini (1649)

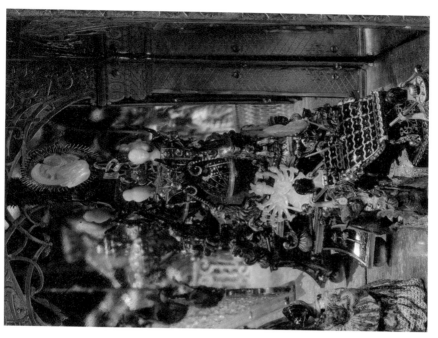

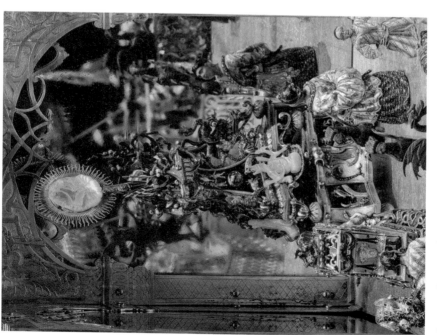

Plate 40. The sun and moon pyramids in the *Throne of the Great Mogul*

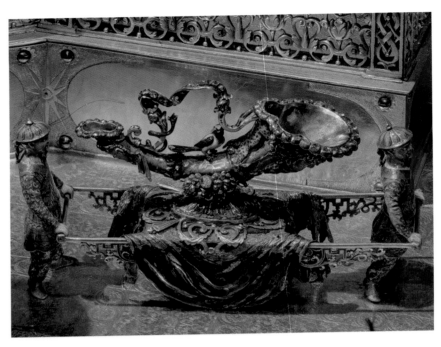

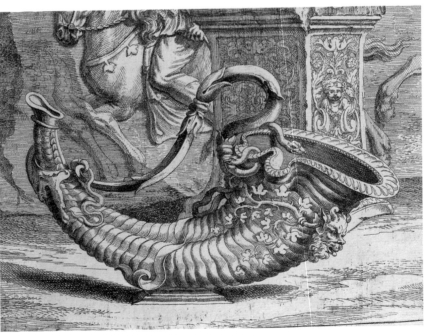

Plate 41. The gift drinking horn in the *Throne of the Great Mogul*, above the Mantuan drinking horn illustrated by Joachim von Sandrart (1679)

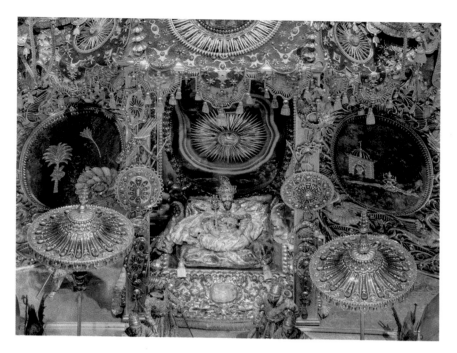

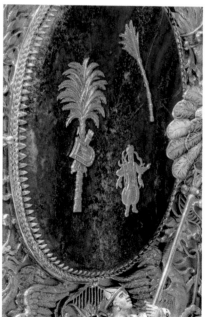

Plate 42. Lapis lazuli discs flanking the throne in the *Throne of the Great Mogul*, with enlargements of both discs

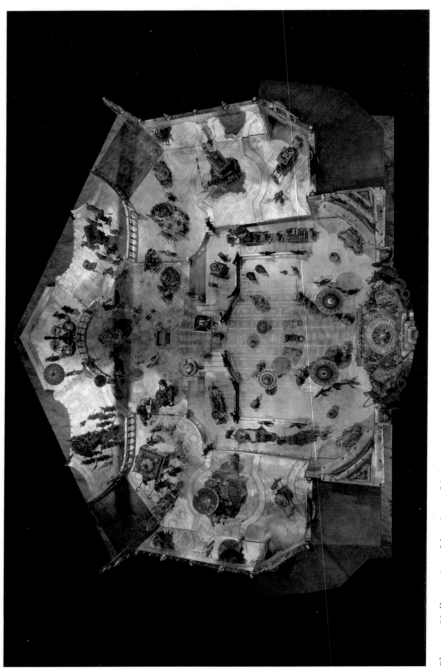

Plate 43. Bird's-eye view of the *Throne of the Great Mogul*

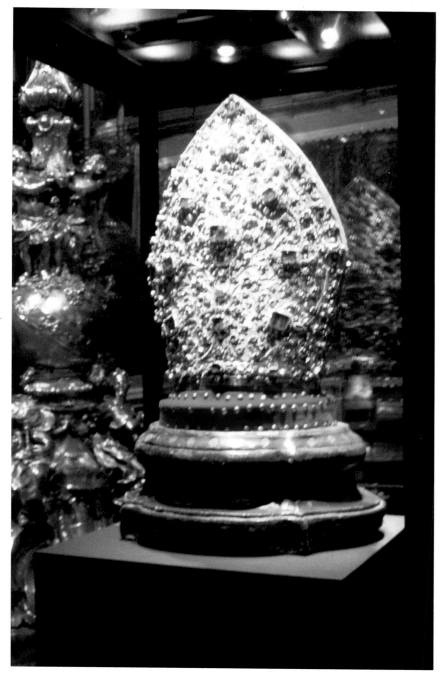

Plate 44. Matteo Treglia, Miter of San Gennaro, Naples, 1713

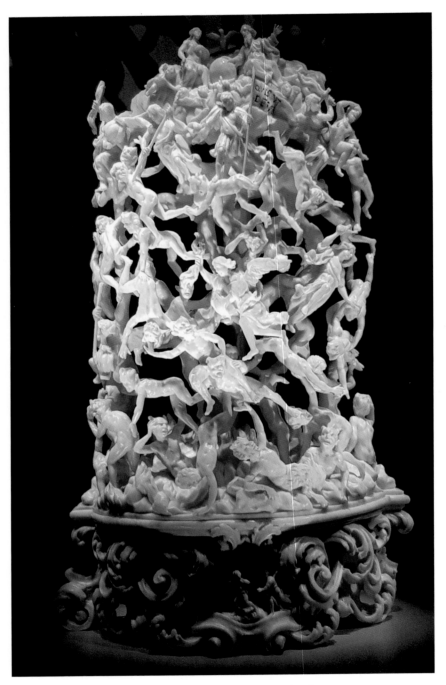

Plate 45. Ivory "tower": *Demons Falling from Paradise*, Naples/Sicily, 1696

gifts, since the others "are not difficult to understand." What makes these specific ones harder to understand is spelled out in the general introduction to the *Short Outline*: they are "secret curiosities . . . most diligently and artfully garnered from antiquity." Herein lies the key: these five artifacts hark back to antiquity, and indeed delve into its hard-to-recover esoteric secrets. Appropriately, the long chapter devoted to explaining them is titled "Discourse on Divers Antique Figures and Their Actual Meaning."[11]

Previous students of the *Throne of the Great Mogul* have concluded from this apparent disconnect between the third chapter and the content and meaning of Dinglinger's ensemble, as well as from a few other plausible but (as I will shortly show) mistaken considerations, that this "Discourse on Divers Antique Figures" was written after the fact by someone else entirely, and thus does not really belong in this story. But in fact, a thorough analysis of this text in relationship to the *Throne of the Great Mogul* proves the opposite. It is precisely here, I want to suggest, in the secret curiosities garnered from antiquity, which required such diligent efforts in the artful creation of the *Throne of the Great Mogul* and that came close to taking over its accompanying text, that Dinglinger's own private and very personal agenda was realized, an additional agenda distinct from his goals that we have seen so far.

To make things more confusing still, internal evidence in the text indicates that the lengthy commentary in the third chapter is in fact a composite of two contributions by two different individuals. As I demonstrate below, one was Dinglinger himself, who appears to have committed himself to this intellectual agenda with much curiosity and enthusiasm. The other was a more scholarly collaborator who was fluent in Latin and contributed a level of academic style with which Dinglinger would have been less familiar. The second collaborator—I later make a tentative suggestion as to his identity, supported by some circumstantial evidence—was responsible for the section of the text that describes the two antique bronze hands. This section, running for seventeen handwritten pages, consists of translations from Latin to German of selected and rearranged passages from the two aforementioned antiquarian tracts by Pignoria and Tomasini. The German writer often appropriated the Italians' authorial voice and reproduced their classical references as if they were his own.[12] Dinglinger did not have the command of Latin required for these translated excerpts. Nor did he require it, since all he used for his gold and enamel reconstructions of the two antique Sabazius Hands were the detailed drawings found in the Latin tracts.

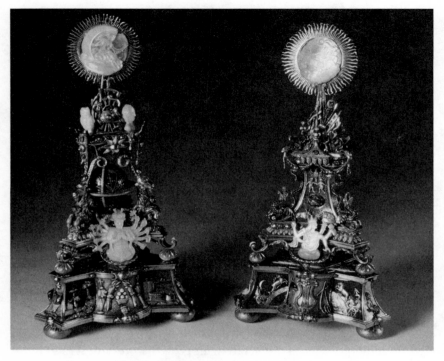

Figure 18. The sun and moon pyramids in the *Throne of the Great Mogul*

The sun and moon pyramids are a completely different matter
(fig. 18, plate 40). In terms of their layout, these two sixteen-centimeter-tall
creations are by far the most complex artifacts included in the *Throne of the
Great Mogul*, and in some ways the most curious. Previous discussions of this
work of art have almost entirely ignored the pyramids, for the same reason that
earlier scholars preferred to distance the "Discourse on Divers Antique
Figures" from Dinglinger's ensemble: they simply do not seem to belong. The
"pyramids" are freestanding, three-sided structures densely packed with
dozens of miniature figures and symbols. Importantly, they are complete inven-
tions. Unlike anything else in Dinglinger's court of the Great Mogul, the pyra-
mids were not based on any model or precedent or reference to an actual object.
Perhaps the example of the symbol-laden bronze hands in the antiquarian
tracts inspired Dinglinger to create such three-dimensional artifacts that could
serve as a lexicon of esoteric symbols, but the choices of how to shape and fill
these visual lexicons were his own from beginning to end. So, what *did*
Dinglinger draw on in creating *ab nihilo* the sun and moon pyramids?

The answer to this question is simultaneously conspicuous and obscured in the "Discourse on Divers Antique Figures"—conspicuous because a full half of the text that accompanied Dinglinger's delivery of the *Throne of the Great Mogul*, constituting thirty-four handwritten pages, is devoted to the sun and moon pyramids; obscured because these pages are far from user-friendly and hide their own origins behind a facade of bookish erudition. They consist of a long list of symbolic elements that are included in the two pyramids—there are several dozen of them—providing each one with a historical and mythical explanation.

We can let one typical example stand in for the whole. The moon pyramid displays three different moon goddesses on three sides, surrounded by numerous moon-related symbols (fig. 19). Underneath one of the goddesses, Hecate, appear a torch and a sistrum, which the text explains as follows:

> The torch may be interpreted thus, that when the Moon shines at night it shows the way for the traveler, therefore it was also called *Hegemony*, a leader and illuminator of the night. The Sistrum doubt-less bears witness to a custom of those ancient peoples who, under the open sky at night-time, made a great din on pots of bronze or iron at times when there was an eclipse of the Moon, with which they hoped to help along the darkening of the Moon, because these foolish people imagined the Moon to suffer great distress through witchcraft, and people could be found among them who boasted that they could bring the Moon down from the heavens by tricks of magic, whereof Virgil treats in the *Pharmacentria* [*sic*].[13]

It is easy to see why curators and scholars of the *Throne of the Great Mogul* have concluded that such an erudite piece of scholarship, weaving a well-informed ethnography with an antiquarian history of customs and beliefs and drawing on a specific reference from Virgil (even if misspelled, at least in the copies that reached us) in order to explain how ancient pagan peoples confronted eclipses of the moon, was not something likely to have been produced by a jeweler. Reasonably, therefore, they have suggested instead that this text—in the recent estimation of an art historian, one of the most detailed and complex descriptions of an artwork that can be found in the German language—must have been the post-factum work of someone else who studied Dinglinger's pyramids and then went back to do the library research.[14]

Figure 19. Detail of the moon pyramid

In fact, however, this passage emerged from a process that was in every sense the opposite of the scenario conjured up by the previous sentence. The description of the torch and the sistrum in relation to the moon, it turns out, was simply lifted from beginning to end from a late seventeenth-century book by the writer and important painter Joachim von Sandrart. To be more precise, the passage quoted here combines two excerpts that were reproduced virtually word for word from Sandrart's German-language 1680 volume on representations of the gods of the ancients, *Iconologia Deorum, oder Abbildung der Götter, welche von den Alten verehret worden*.[15] Even Sandrart's authorial interventions—leaving some room for equivocation in the meaning of the torch, insisting on the lack of doubt in the meaning of the sistrum—were copied without editing into the "Discourse on Divers Antique Figures." The only significant addition of the copying hand was the characterization of the ancients, with their beliefs detailed by Sandrart about the lunar eclipse, as "foolish" (*albern*).

The manner by which this passage was created was completely typical. Modern editors and readers of the "Discourse on Divers Antique Figures" have faced the sprawling, blow-by-blow exposition of every detail in the sun and moon pyramids unaware of its genesis. What they did not realize is that this thirty-four-page-long section of the text—and *only* this section—is a cut-and-paste compilation of multiple excerpts from a small number of contemporary German books, and even within them predominantly from certain circumscribed chapters. Two writers supplied the lion's share of the material: Joachim von Sandrart, with over twenty excerpts from his well-known *Teutsche Academie* and from *Iconologia Deorum*, and Erasmus Francisci. Both of these Nuremberg-based authors were prolific popularizers of historical, artistic, and ethnographic knowledge. Both drew on a wide variety of earlier sources—many of them in other languages—and repackaged this knowledge within a comparative perspective in a more palatable form, in German, for broader consumption. Neither of them, we can surmise in passing, would have been overly troubled by the liberal borrowing from their works, since their own books were themselves compilations that made few claims to originality. Sandrart's *Iconologia Deorum*, the source for the torch and the sistrum as well as a large number of other elements in Dinglinger's pyramids, was actually an augmented translation of a sixteenth-century Italian mythography, Vincenzo Cartari's *Le imagini degli dei degli antichi*, which Lorenzo Pignoria had already extended with additional materials in

1615. Additionally, the opening of the "Discourse on Divers Antique Figures" incorporated several excerpts from the contemporary German translation of a third writer, the Dutchman Arnoldus Montanus, who like Olfert Dapper wrote widely about Asia as well as the New World without ever having left Europe. These lengthy passages, lifted from Montanus together with their scaffolding of biblical and classical authorities, rearranged and lightly edited, were the closest that our text came to a comparative theory about the origins of pagan worship of the sun and the moon.[16]

The composition of this small bookshelf is revealing. We know that in the process of the creation of the *Throne of the Great Mogul* Dinglinger held in his hands the books of precisely these three authors, Montanus, Francisci, and Sandrart. We are certain of this because, as Walter Holzhausen and Erna von Watzdorf already pointed out long ago, from each of them Dinglinger adopted one or more visual elements to incorporate as three-dimensional figures into the Great Mogul's court. From Montanus, Dinglinger extracted—from a busy image of a Japanese temple—the figures of the two grotesque demons that frame the inner court of the Great Mogul, beneath which the Dinglinger brothers signed and inscribed the dates of the beginning and end of the work. (Dinglinger was already familiar with Montanus, having borrowed from him images for the decorations of the *Goldenes Kaffeezeug*.) From Francisci, Dinglinger took the image of the Hindu goddess Bavani (which Francisci himself had taken from Athanasius Kircher) and placed her in a small pagoda-like temple at the top of the court structure (see fig. 24). From Sandrart, Dinglinger took the gift drinking horn which is the fifth object included in the "Discourse on Divers Antique Figures" (plate 41). Dinglinger's brother Georg Friedrich also used several images from Sandrart's books in decorating the enamel water basin in the middle of the Mogul's court.[17] This, in other words, was the Dinglinger brothers' working bookshelf.

We are finally in a position to reconstruct the process by which Dinglinger created the sun and moon pyramids, as a first step in unraveling their meaning and significance. Let us summarize what we now know:

First, the texts describing all the elements in the pyramids existed before the miniature pyramids themselves. Dinglinger's creation was a realization of these textual descriptions, rather than the other way around.

Second, the compilation of this set of textual excerpts—imagine them as a working card index—required a proactive effort with a particular

purpose and principle of selection. This group of books was combed through in order to collect references and symbols relating to the worship of the sun and the moon in different cultures.

Third, the books in which the research was undertaken, all in German, were familiar to Dinglinger, who also extracted from the same books visual images for different parts of the *Throne of the Great Mogul*.

Fourth, unlike other objects in the court of the Great Mogul—in particular, in contrast with the reconstructions of the antique hands to which we shall return shortly—there was no *Vorbild* for the sun and moon pyramids, no visual model to build on. Dinglinger, in making the pyramids, had to design three-dimensional entities and imagine how he might represent visually the contents of every fragment from the topical collection of textual excerpts—every "notecard" in the "card index"—and how they might all fit together.

Fifth, this was a highly involved and self-contained project. The pyramids, independent of anything else in the larger ensemble, incorporate many dozens of small parts that required thematic planning, image selection, and a combined composition into integral creations, creations that moreover worked together as a harmonious pair. One can appreciate the complexity of the pyramids from the fact that a spectator standing in front of the *Throne of the Great Mogul* cannot view all their parts. The only way to see all their components and follow their correspondence to the textual description is to pick them up and rotate them slowly, separating them from the larger setting in order to study each pyramid on its own.[18]

Sixth and finally, the textual description of the pyramids is by far the longest section of the *Short Outline of the Magnificence of the Great Mogul* precisely because it contains all the raw material collected for this specific project, a running record of the textual fragments that informed the making of the sun and moon pyramids.

From these considerations it seems to me impossible to reach any other conclusion than that Johann Melchior Dinglinger was himself behind the project of the sun and moon pyramids from beginning to end: beginning with the conceptualization of the general theme, through the collection of all the textual fragments from his working library, to the detailed design of both pyramids that he invented from what he read and selected in these excerpts, and then to the final compilation of the text that recorded this process. This remains true even if an amanuensis might have helped Dinglinger in this

endeavor, in the same way that a research assistant might have helped me in finding some of the materials for this book. Indeed, this was to become a repeated pattern of Dinglinger's later career, when several times he accompanied complex works in which he was especially invested with detailed textual commentaries.[19] Finally, we should note that no other element in the *Throne of the Great Mogul* or in the *Short Outline of the Magnificence of the Great Mogul* was put together in a similar manner. The pyramids embodied a special intensity of personal commitment, even within a broader ensemble that itself was singular in its level of investment.

All of which brings back to the table the key question that was already raised by the curious antique hands, and again by the Egyptian symbols, but now ever more forcefully: *Why?* Why introduce such an intricate, self-contained, wholly invented project into the court of the Great Mogul? What was its purpose? Why did it elicit from Dinglinger such an unusual level of engagement? And what might be the connection of the pyramids to those other puzzles that opened this chapter, the inconspicuous engravings of Egyptian symbols and the reconstructions of the recently discovered antique hands, each in its own way reaching back deep into ancient history? Given the efforts and aforethought these elements required, what was at stake for Dinglinger in placing them in the *Throne of the Great Mogul?*

Before moving on to the key question of meaning, however, let us complete the analysis of the process that created the third chapter of the text accompanying the *Throne of the Great Mogul*. We discussed two hands and two pyramids but are still missing the fifth object singled out in the "Discourse on Divers Antique Figures," a horn.

I have suggested earlier that the section on the two hands was the work of someone else, a collaborator with proficiency in Latin and a scholarly bent. It stands to reason that this collaborator might have left his mark elsewhere as well. Thus, in a single paragraph toward the end of the pyramids' description, dedicated to the three he-goats surrounding the celestial globe in the moon pyramid, one suddenly gets the sense of a different writing voice. Several unusual things happen in this one paragraph. First, unexpectedly and only this one time, the text acknowledges with fastidious scholarly precision its reliance on "the learned Erasmus Francisci's *Kunst-und Sitten-Spiegel*, fol. 1011." Second, Francisci's own source is reproduced and named, which turns out to be not one about classical, Egyptian, or Eastern customs of the kinds

that fill Dinglinger's compilation but rather, uniquely in the whole text, an early sixteenth-century book about *Prussian* antiquities. And third, the writer augmented the account borrowed from Francisci with a short excerpt with a rare detail that came from another work by one Christoph Hartknoch, the most important recent writer on Prussian history. So, given this sudden interest in German antiquities much closer to home, which did not attract Dinglinger's attention elsewhere, and given the meticulous academic cross-referencing, which stands out from the rest of the long section on the pyramids, can we see in this paragraph the thumbprints of Dinglinger's scholarly collaborator?[20]

Perhaps. The case here is circumstantial. But there is another point in the text in which we find something much closer to a smoking gun, a place where the seam between the contributions of the two collaborators appears unmistakable. This happens in the short description of the drinking horn, the fifth object that concludes the "Discourse on Divers Antique Figures," almost as an afterthought. For the horn's design Dinglinger relied on Sandrart. First, he used as his visual model an illustration from Sandrart of a goldsmith-wrought horn in the Mantuan *Schatzkammer* (plate 41). Second, he borrowed from Sandrart the textual explanation of the horn's details, such as a passage reproduced almost word for word from Sandrart's *Iconologia Deorum* about the meaning of the ivy that Dinglinger accentuated conspicuously around the drinking horn, its Greek etymology, its relation to Bacchus, and a cautionary opinion of the twelfth-century archbishop and scholar Eustathius of Thessalonica.[21] So far so good: this follows Dinglinger's procedure familiar to us from the sun and moon pyramids.

But the beginning of the textual account of the horn tells a completely different story: "Olaus Wormius amongst others makes mention of this in Book I Fastor: Danici:, and also remembers in his Antiquitatibus Danicis a wondrous and artfully wrought Horn which was found on the 20th day of July, anno 1639 in the reign of [the Danish king] Christian IV, by a maiden on common land on the way to Megeltundern, and is preserved in the Danish treasure chamber." This part of the text, it takes a moment to realize, *speaks of an entirely different horn*, a narrow and elongated golden horn replete with ancient symbols that the Danish antiquarian Olavius Wormius had published in the first half of the seventeenth century. The "Discourse on Divers Antique Figures" then veers back to describing the details of the drinking horn in the court of the Great Mogul. The text cannot, however, hide the fact

that the jeweler who made the actual miniature horn—Dinglinger—was interested in a completely different object as his model than was the individual who discovered in Wormius's Latin book the exciting Danish late-antique finding of the early seventeenth century, a Scandinavian counterpart to the two antique bronze hands.[22]

My immediate goal in this somewhat complicated analysis is to point to the one place in the text accompanying the *Throne of the Great Mogul* in which there is an indubitable seam between two individuals who collaborated on the text, each of whom was interested in a different horn, and thus braided together two genealogies for the object that we find in the Great Mogul's court. But however informative this textual fissure is for us in reconstructing the textual history of the "Discourse on Divers Antique Figures," this is not the main story. The more significant story is the very collaboration of Dinglinger and this other scholarly individual on a detailed, highly involved project right in the middle of the *Throne of the Great Mogul*, one that appears to have had nothing at all to do with the Mogul or with his court. We now have enough information to uncover what they were after.

9. Gods (or, The Global History of Pagan Religion)

Let us begin by going back to the opening words of Dinglinger's text. Here they are in full:

> Just as, since time immemorial, divers nations, especially those of the Orient, were wont to venerate their crowned sovereign leaders as Numina, and to demonstrate their most obedient homage and deep humility, not only on the occasion of their coronations, but also on their birthdays, and not merely with all manner of elaborately presented good wishes, but also with precious gifts: so such customs still exist in our time among the East Indian peoples, and are particularly diligently observed among the subjects of the Great Mogul.[1]

The introductory sentence to the *Short Outline of the Magnificence of the Great Mogul, on His Birthday* sets up the theme of the powerful rule of the Great Mogul as expressed on this special occasion. As I have suggested earlier, by invoking the homage paid to *gekrönte souveraine Häupter* this formulation brings the Great Mogul into the contemporary context of European international relations and royal aspirations in the post-Westphalian age. But this sentence also introduces another theme: religious veneration. It speaks of nations who, from time immemorial to the East Indians of the present day, have venerated (*veneriren*) their rulers *as Numina*, that is to say, as divinities. To be sure, in an early modern court the association of an absolute ruler with divine status would not have been surprising. At the same time, however, the

term *Numen/Numina*, which was often used to refer to non-Christian and non-monotheistic beliefs, also resonated with a different contemporary discussion, that of paganism and idol worship.

Dinglinger's text repeats the term *Numen* one more time, in the context of the sun and moon pyramids in the third chapter, highlighting its associations with pagan worship. With regard to the sun pyramid, it states, "One has to know above all else that, albeit the blinded Heathens have become somewhat aware by the light of nature that a Summum Numen or supreme Godhead [*höchste Gottheit*] exists, on which all other things originally depend, they nevertheless do not comprehend the essence of his being." Since the pagans did not possess the holy scriptures, they remained largely in the dark, and yet,

> They could not err so readily if they located this supreme Godhead in the highest place which surrounds the whole world, and because this latter, the heavens to wit, does not possess anything more marvelous than the selfsame excellent sources of light which grace them, and in special the great eye of the world, the sun; thus it came about that these people took it for the highest god, and did it most reverence, next to the moon.

Continuing at length about the awe inspired by the sun, the text mobilizes both biblical and classical authorities to attest to the prevalence of "the idolatry so ancient" that was sun worship, whose practitioners "forgot their true Creator, and worshipped his creation in his stead." Such veneration of the sun was not only a thing of the deep past: "The Chinese, Japanese and other Indian peoples follow [this practice] even to this very day, worshipping the sun in the same manner, under various names and designations."[2]

Indeed, the most substantial engagement with a broad intellectual theme anywhere in Dinglinger's text is this particular discussion of the origins of sun and moon worship. In this it echoed an important seventeenth-century conversation in the European republic of letters in which the stakes could hardly have been higher. How could one account for human diversity, especially in matters of religion? After all, as one English astronomer and antiquarian summed up the state of knowledge of the seventeenth century, there were four religions that together composed the whole world: "Idolatrie, *Mahumetanisme, Iudaisme,* and Christianity," and among them, "*Christians* possesse, neere about a sixt[h] part of the knowne inhabited earth: *Mahumetans,*

a fift[h] part . . . and Idolaters, two thirds, or but little lesse."[3] So given this predominance of idolaters—who included also all the pagan civilizations of antiquity—were they all living in error in complete defiance of god, or were their practices some form of religion? Could the biblical story account for this diversity of worship and belief? The topic was huge and involved theologians defending a biblical narrative, antiquarians and travelers with mountains of evidence, and philosophers who pondered the compatibility of different authorities, the limits of knowledge, and the unity of mankind. For our purposes, suffice it to say that a major outcome of these often heated debates was the transformation of religion from something that only true believers had—that is, monotheists—to a more anthropological concept, something inherent in human nature that was shared also by those almost-two-thirds of the global population who were idolaters. The meaning of idolatry, consequently, changed as well, from an error antithetical to religion to a set of practices understood to be encompassed under the umbrella of religion itself. (Here was another manifestation of the space for play that gradually emerged in the seventeenth century under god's now increasingly more distant eye.) By the second half of the century this scholarly conversation spawned the birth of European comparative religion as a field of knowledge and inquiry. With it, this conversation also animated Dinglinger's private project, which he introduced as a substratum into the *Throne of the Great Mogul*.[4]

Pride of place in this seventeenth-century discussion was given to the worship of the sun and the moon, which was important in sketching underlying parallels between Christian monotheism and pagan religions. As the third chapter of the text accompanying the *Throne of the Great Mogul* pointed out, it was easy to imagine how pagan people naturally fell into such a misconception. These thoughts, as we now know, were not in the main Dinglinger's own but rather borrowed liberally from books on his working bookshelf. In this case, the main source was Arnoldus Montanus's account of his embassy to Japan, in which the Japanese practice of sun worship led the author to broader reflections about precisely this point. "There are scarce any People that have not been guilty, or at least made themselves so, of that Idolatry of worshipping the Sun," Montanus declared in a part passed over by Dinglinger. Montanus therefore proceeded with numerous examples from far and wide, past and present, pooling together biblical peoples, ancient and late-antique Mediterranean cultures from Egypt and Syria to Armenia and Persia, or further afield Africans, Peruvians, West Indians, East

Indians—and also the pre-Christian Germans. (It is worth noting, however, that the Chinese, mentioned in Dinglinger's text next to the Japanese and the East Indians, were not on Montanus's list.)[5]

Other texts that informed Dinglinger's work dwelt on the same themes. The chapter on sun worship in Sandrart's *Iconologia Deorum*, which the jeweler read carefully and used extensively, began with a conjectural history of how the ancients made gods out of the stars, the sun, and the moon. Vincenzo Cartari's earlier book of which Sandrart's was a translation not only included the same narrative but actually opened—in the 1608 edition— with a not very subtle visual illustration of this very point: an engraving of a man praying to the anthropomorphized sun, moon, and stars filling the heavens (fig. 20).[6] The same was true of Lorenzo Pignoria, who prefaced his own augmented edition of Cartari by stating that the worship of the sun, the moon, and the militias of heaven was the oldest form of idolatry in the world. Dinglinger's immediate source for the land of the Great Mogul, François Bernier, likewise described the belief of the local inhabitants "that the sun, moon, and stars are all so many *deiitas*," having explained earlier that *deiitas* are idols, or *Numen*.[7]

In a simple sense, then, this narrative, which reached back to the very origin of religion as a fundament of human culture, was a basic insight that Dinglinger drew from the newly emerging perspective of comparative religion, and that he reproduced in three-dimensional form in the sun and moon pyramids. This was why Dinglinger chose to focus on the sun and the moon, and this was why he packed their "pyramids" to the hilt with signs and symbols that, according to the same learned authorities, were associated in different cultures with solar and lunar worship. So far, so good. But Dinglinger's engagement with the historical narratives of comparative religion actually went much further and became much more interesting.

If we raise our eyes in passing, we find that other Europeans were expressing similar ideas at the beginning of the eighteenth century, although Dinglinger may well have been the only jeweler among them. In 1704, at more or less the moment when Dinglinger was busy designing his miniature pyramids with their much smaller symbolic parts, two very different publications sketched pictures of Asian customs that resonated with Dinglinger's. One was a famous act of fakery: a Frenchman who tried to pass in London as a native of the island of Formosa (today's Taiwan) under the name George Psalmanazar, and who

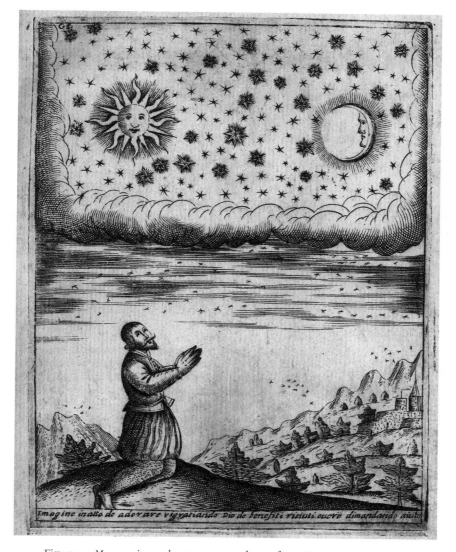

Figure 20. Man praying to the sun, moon, and stars, from Vincenzo Cartari (1608)

published a detailed ethnographic "description" of his alleged native island without ever having set foot in Asia. What is interesting for us in Psalmanazar's audacious invention of a whole culture—one for which he used many travel accounts, and which was taken seriously enough for the Royal Society to invite him to defend it—is the dominant role he assigned in his oriental fantasy to sun and moon idolatry. "The Inhabitants of *Formosa* knew no other Gods

but the Sun and the Moon whom they believed to be Supreme, and the Stars, which they looked upon to be as it were *Semidei*, or Subordinate Gods," a worship in which they persisted even after they had learned of the existence of a single omnipotent god. Psalmanazar supported his account with (completely invented) drawings that showed the altars of the moon and the sun that were allegedly erected next to every city. The Formosans also had a central tabernacle or temple, which had not only the anthropomorphized sun and moon on its roof but also "a little Pyramid upon which is the Figure of the Sun" inside the temple, and "another upon which is the Figure of the Moon." More sun and moon pyramids, then, represented visually: this was apparently quite the trend in imagining idolatry at the opening years of the eighteenth century.[8]

The second publication of 1704 that shared Dinglinger's interests, by another learned Frenchman named La Créquinière, who served as a military officer at the French garrison at Pondicherry, was a much more substantial affair. Historian Carlo Ginzburg has recently rescued it from obscurity as a milestone in Western "proto-ethnography." Titled *Conformité des coutumes des Indiens Orientaux avec celles des Juifs et des autres peuples de l'antiquité* (translated into English the following year as *The Agreement of the Customs of the East-Indians, with Those of the Jews, and Other Ancient People*), its main aim was to compare the customs of the gentiles of India—in this case, not the Mughals but the Tamil Hindus of the Coromandel Coast—to those of the ancient Jews and other nations in antiquity. More than the details of his account (which included, inevitably, the origins of idolatry when "at first the Sun, Moon and the other Stars were ador'd"), what is significant for our inquiry is La Créquinière's broad comparative move. Here was another case of a European writer focusing on contemporary India while seeking parallels and comparisons between idolatrous nations and the familiar narratives of Western antiquity, wheeling in Greeks, Romans, and Egyptians next to the Jews. Once again, had La Créquinière seen Dinglinger's sun and moon pyramids in the middle of the court of the Great Mogul, he would have immediately gotten the point.[9]

Of course, he did not. We can be reasonably certain that Dinglinger, La Créquinière, and Psalmanazar never crossed paths. This makes the similarities among their very different projects, all undertaken in or around 1704, that much more revealing as independent indicators of a particular cultural moment characterized by a particular kind of cross-cultural imagination. It was a moment especially generative in thinking comparatively about religion, both across space between continents and across time between ancients

and moderns. None of the three, we should note, was a scholarly participant in the European republic of letters. Rather, they were all well-read laymen whose comparative thinking along parallel lines drew on a broadly disseminated stock of ideas. In this sense it was a broader cultural moment, which in turn drew on the more scholarly conversation that brought into being European comparative religion in the second half of the seventeenth century.

In an important sense, however, Dinglinger's purpose in his own foray into comparative religion, and the threads that he chose to follow from that seventeenth-century scholarly conversation, were not at all like La Créquinière's. In understanding the difference between them, the most surprising aspects of what I have described as Dinglinger's "private" project underlying the *Throne of the Great Mogul*—including, *inter alia*, the yet-to-be-explained Egyptian engravings and the mysterious cultic hands—finally come into focus.

Cross-cultural comparisons could be marshalled to support different historical narratives. La Créquinière's perspective was encapsulated in the first word of his title, *conformité*. He identified similarities and parallels across cultures but did not assume that such "conformities" indicated possible connections or common genealogies. Rather, his was a theory that can be described as cultural primitivism: an assumption that similar developments must have taken place in similar circumstances, even when those were separated by huge spans of space and time. In this view La Créquinière was pointing ahead toward the eighteenth-century vogue for universal theories of humanity. At the same time he was parting ways with the seventeenth-century antiquarians, for whom what mattered most was a historical narrative that could render religious diversity across the globe commensurable with the biblical story. Dinglinger, on the contrary, drew his inspiration precisely from this earlier scholarly environment. What Dinglinger learned from the seventeenth-century antiquarians is often referred to as the diffusionist theory—the assumption that ancient religious practices traveled from one part of the world to another. The challenge of diffusionist scholars was to trace the global genealogy of idolatry from one ancient culture to the next with the help of textual and material evidence, in a manner compatible with Christian belief.[10] In the next few pages I argue that Dinglinger's "private" project that he embedded in the *Throne of the Great Mogul* amounted to an ingenious, detailed, unmatched affirmation of the diffusionist theory.

I can most readily demonstrate this with a close analysis of a rich example: that of the goddess Pussa. Pussa, Hecate, and Lucina are the deities associated with the moon represented on the three sides of Dinglinger's moon pyramid. In Dinglinger's "Discourse on Divers Antique Figures," Pussa opens the description of the pyramid:

> Thus, on the first side of our [moon] Pyramid, there is to be seen The Goddess Pussa. By whom the Chinese, according to the observation of Piery lib:39. Hieroglyph. c.3, also refer to Isis. She sits above an Egyptian lotus flower with Hands most strangely folded, very modest yet solemn of mien, with 8 separate arms protruding from her right and left side, and each of her hands holds a different object, so that it is difficult to guess whether they be swords, spears, halberds, fruits, wheels, or whatever else. The learned and wise Chinese understand by this Pussa, whom they also depict with 16 arms, nothing other than the strength, force and might of Nature, beneficent in all things, and they claim, as the renowned Athan. Kircher remarks in China Illust: P.III. c.2. f.241, that China in the 1600 years under the protection of this Goddess enjoyed good peace and likewise flowered through 16 golden centuries. The aforesaid Goddess, however, sits on an Egyptian lotus flower, which indicates, since this plant always floats over water, that the natural moisture due to the benevolent influence of the Moon is a prime source of all things, wherein the Chinese and those wise Egyptians think alike, always holding Water to be the beginning of universal being.[11]

A lot goes on in this dense description. It moves back and forth between China and Egypt, between visual description and textual sources, between mythography—the explanation of mythological symbols (the Egyptian lotus flower)—and mythical history (China's sixteen golden centuries). While apparently a messy collection of fragments, this description is in fact carefully put together from excerpts from two of Dinglinger's staple, go-to authors, Erasmus Francisci and Joachim von Sandrart. Much of it was copied from Francisci's compendium about the East and West Indies and China. To this Dinglinger added several carefully chosen words and scholarly references from Sandrart's *Teutsche Academie*, as well as some editorial alterations that were his own.[12]

Francisci, the arch-compiler who without getting too far from his armchair published two works running to four thousand folio pages with

extensive descriptions of Asia and the New World, obtained his information about Pussa from another author. Dinglinger's text dutifully reproduced his reference: the Jesuit scholar Athanasius Kircher, from his *China illustrata*, one of the most influential seventeenth-century works about Asia.[13] Kircher had actually supported his own account of Pussa with an illustration of the goddess, sitting on the lotus flower with her many arms. Francisci, for his part, had Kircher's image of Pussa engraved anew, slightly altered, and published it in his other major book of two years later, *Neu-polirter Geschicht-Kunst-und Sitten-Spiegel*. It was here, in Francisci's second compilation, which Dinglinger knew well, that the jeweler found the visual model for his own Pussa in the *Throne of the Great Mogul* (fig. 21). Kircher, in turn, had been drawn to the visualization of the goddess by Lorenzo Pignoria's reissue of Vincenzo Cartari's *Le imagini degli dei degli antichi*. This, as far as I am aware, was where this chain of transmission began. Pignoria was apparently the first to notice a similarity between the flower on which Pussa sat and the Egyptian lotus flower, from which he deduced a connection between the Chinese goddess Pussa and the Egyptian goddess Isis. Pignoria's discovery then traveled through Kircher to Francisci, and from him to the lotus that Dinglinger designed for Pussa's seat on his moon pyramid.[14]

The reconstruction of this chain of transmission is far more than an arcane exercise, but rather reaches the very core of our inquiry. This is because Pignoria and Kircher were perhaps the two most important champions of European diffusionist theory in the seventeenth century. As such, they hold the key—one might say that they *invented* the key—to the agenda and drive of Dinglinger's "private" project. Pignoria and Kircher provide the explanation not only for Dinglinger's presentation of Pussa but also for his moon and sun pyramids, for the reconstructions of the antique symbol-laden hands, for the Egyptian symbols on the pillars next to the Great Mogul, and for other esoteric elements in the *Throne of the Great Mogul* that can only now come into focus.

In their diffusionist theories, both antiquarians focused on Egypt. Pignoria, ever since his publication of the *Mensa Isiaca* in 1605, and Kircher, notably in his obsessive, four-volume *Oedipus Aegyptiacus* of 1652–1655, spent much of their scholarly lives demonstrating that idolatrous religious practices across the globe originated in ancient Egypt. This genealogy was demonstrable, in their telling of the global history, for pagan practices from the Middle East and the ancient Mediterranean through southern and eastern

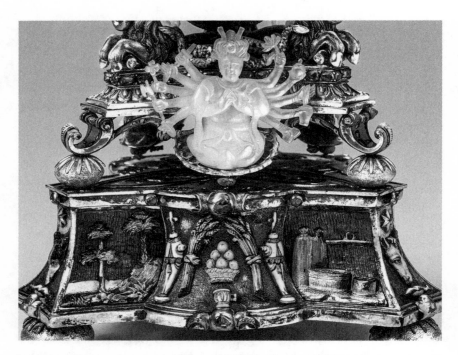

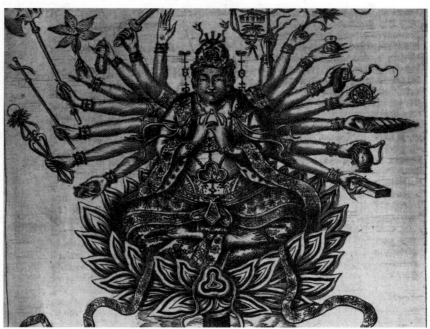

Figure 21. The goddess Pussa on Dinglinger's moon pyramid, above the goddess Pussa from Erasmus Francisci (1670). Note the lotus seat of the many-armed goddess

Asia and even as far as Central America. In terms of how they understood the history of religious *truth*, Pignoria and Kircher were actually wide apart. The former saw in Egypt the source of false and misleading superstition; the latter believed in an antediluvian, pre-Mosaic *prisca theologia*—that is, ancient theology—which was preserved in corrupted form in ancient Egypt and from there migrated to pagans across the globe, carrying with it often obscured grains of truth. But this debate, while of considerable theological import (and reputable Renaissance roots), was for the most part not relevant to the methodology that Pignoria and Kircher offered for reconstructing the global history of heathenism.[15] In order to establish connections between religious practices in different contexts, Pignoria, Kircher, and fellow anti-quarians mobilized ancient and modern texts, images, and, most radically, archeological objects. The more knowledge gathered from objects and texts about the cults of Isis, Osiris, Cybele, Mithras, or Attis, the more they all became grist for the mill.[16] Some princely owners of *Kunstkammern* joined in too, seeking idols for their collections and trying to interpret them in light of these antiquarian speculations. In a notable example in Munich and in Gottorf, a Thai Buddha statuette acquired in 1651 was described by the ethnographer and keeper of the collection Adam Olearius as "an Indian pagode, which to some looks like an Egyptian Isis."[17]

Dinglinger was not a participant in this scholarly conversation. But it reached him, sometimes twice removed, through books he used and read as well as through likely conversations with scholars in the Dresden court, and he was deeply interested. His active engagement with these materials was to continue for many years after the Great Mogul, all the way to his dedication of his last major work, the *Apis Altar*, to a large-scale "illuminat[ion] with a new light" of ancient Egypt's monuments, focusing on Isis and Osiris.[18] But more than anywhere else, it was in the minute details of the *Throne of the Great Mogul* that Dinglinger found the opportunity to imagine, to explore, and to push forward the ramifications of the Egypto-centric diffusionist theory. This agenda shaped in uniquely creative ways many elements that Dinglinger included in the *Throne of the Great Mogul*. This agenda also shaped the compo-sition of that longest chapter in Dinglinger's text accompanying the work, the title of which—"Discourse on Divers Antique Figures and Their Actual Meaning"—can now be appreciated for its full significance.

Let us return to the example of the Asian goddess Pussa, as Dinglinger represented her both textually and visually. In the textual description that I

quoted earlier, Egypt and the Egyptians are mentioned three times. All three mentions, it turns out, were additions that Dinglinger himself inserted into the text borrowed from Francisci.[19] Nor was this the only intervention Dinglinger made in order to "Egyptize" Francisci's original description. Francisci opened his description of Pussa with a comparison to the Japanese goddess Amida. Dinglinger's version omitted Amida and replaced her with the Egyptian Isis, for which purpose he imported from Sandrart's *Teutsche Academie* another ancient authority, "Piery lib:39. Hieroglyph. c.3." This was a reference to Pierio Valeriano's *Hieroglyphica*, the most significant treatment of the subject in the sixteenth century. But Dinglinger took liberties with Sandrart as well. Although Sandrart did indeed rely on Valeriano's book 39 for a discussion of Isis, Sandrart did not mention Pussa or the Chinese in this context. Once again, the hand that connected Egypt and China appears to have been Dinglinger's own.[20]

To be sure, my point is not that Dinglinger invented these connections, connections that he encountered many times in his books that popularized the Pignoria-Kircher line. My point is rather that when Dinglinger saw an opportunity, he proactively took the liberty to drive the "Egypto-genetic" connections forward a notch or two beyond what he found spelled out in his sources. There are many other examples of such interventions by Dinglinger throughout the description of the sun and moon pyramids. These interventions were geared to strengthening the overall conclusion, in Dinglinger's own words, that the Chinese practices of solar and lunar worship were just like those practiced under different names by "the Egyptians /:*from whom they learned most of their idolatries:/.*"[21]

The reader may still remain somewhat skeptical regarding the deliberateness of these textual changes, introduced by a jeweler meddling with excerpts from different books in order to achieve a particular intellectual effect. In order to persuade further that Dinglinger was proactively interested in these details, therefore, let us return to the goddess Pussa for a final look at her actual figure, as Dinglinger designed it on his moon pyramid. After all, Dinglinger was first and foremost a jeweler, and if he wished to highlight a particular storyline, we would expect him to do so first and foremost in his artistic work. And indeed, Dinglinger's most decisive "Egyptizing" move took place in the presentation of the goddess, a move so unwarranted that it attests to his personal choice and intent far beyond the liberties he took with the text in order to achieve the same effect.

Our focus now is the ornamented base on which Pussa sits in her lotus flower (see figs. 21, 22, top). The central panel at the bottom of the moon pyramid that supports Pussa is decorated with two sheaves of corn, a fruit basket above a cup, and two water containers with a curiously distinctive form. The corresponding text is unilluminating, stating only that these are all symbols that "indicate withal the fruitfulness which has its origin in her [Pussa]." Having collected all the visual representations of Pussa in Kircher and Francisci, I realized that this image was not found in their writings on this goddess. Yet the ornamented base, and especially the water containers, appear too particular to have been a figment of the jeweler's imagination. So given my assumptions about Dinglinger's modus operandi with his working bookshelf, I combed through the books that I knew he had consulted. And sure enough, the same image, complete with sheaves of corn, basket of fruit, cup, and water containers, appears in a different context in Sandrart's *Teutsche Academie*. The context is a rather unobtrusive entablature decoration at the top of an illustration of the Egyptian sun god Osiris (fig. 22, bottom left).[22] There seems to be only one way to explain what happened here. Dinglinger, scanning his copy of Sandrart, came across this combination of symbols associated with Osiris. He made the deliberate decision to lift this image, consisting of an elaborate set of symbols, from its architectural position in Sandrart, and transpose it to Pussa's pedestal, reconstructing with precision the same configuration of symbols. It is difficult to see the "Egyptizing" outcome as anything but carefully calculated: the Chinese moon goddess, sitting on a possibly Egyptian lotus flower, was now propped up on top of an ornament that the Saxon jeweler had gratuitously taken straight out of the (imagined) temple of the Egyptian sun god.

Beyond his invention of the sun and moon pyramids with their mélange of Egyptian, Chinese, and Greco-Roman symbols, Dinglinger's commitment to the diffusionist theory of the global history of religious practices informed many other choices in the creation of the *Throne of the Great Mogul*. The remainder of this chapter and the next lay out several examples of such choices, ones that often appear curious, out of place, even mysterious. At times Dinglinger rendered them so inconspicuous as to have escaped notice, and yet when considered together they amount to a key stratum of the jeweler's signal project.

Most conspicuous and already begging for explanation since many pages ago are the two reconstructions of the antique cultic hands with their

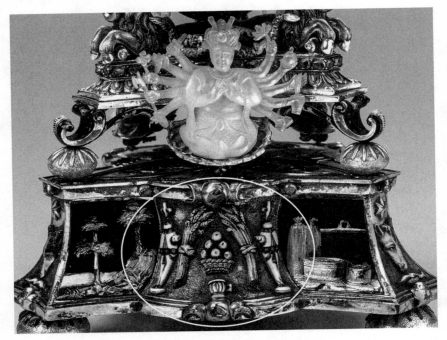

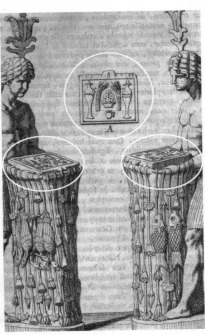

Figure 22. Pussa's moon pyramid pedestal in the *Throne of the Great Mogul*, above detail of Joachim Sandrart's Osiris, 1679 (bottom left) and detail of Athanasius Kircher's Nile god, 1666 (right). The tableau with sheaves of corn, fruit basket, cup, and water containers migrated from Kircher's Nile priest's offering table to the didactic figure in the white space of the page, then to Sandrart's Osiris's architectural entablature, and finally to Dinglinger's pedestal

mysterious symbols (see figs. 16, 17, plates 38, 39). Why did Dinglinger choose to reproduce them from the drawings he found in the antiquarian tracts by Pignoria and Tomasini for a scene completely unrelated to them? Why did he design them in such an elaborate form, as two of the most eye-catching objects in the court of the Great Mogul? And why were they singled out for a disproportionately long discussion in the text accompanying the *Throne of the Great Mogul*?

The answers, by now, seem readily at hand. These particular antiquities were perfect real-life illustrations of the historical migration of ancient religious practices that Dinglinger found so intriguing. The section in the "Discourse on Divers Antique Figures" on the "Hieroglyphic Hands," following Pignoria, identified the first hand as the "Hand of Attis" and linked it to Phrygian sun worship processions, especially in the feasts of the mother goddess Cybele—who, Dinglinger knew from Francisci, was another manifestation of the goddess Pussa. The cult was Phrygian, and yet the bronze hand was discovered in "Tornai" in the Netherlands. Subsequently a second hand "exactly like that of Attis in character and shape" turned up in Italy, "dug up in the old chapel of Holy Gregorius in Rome." One could not easily imagine better physical proof of the migration of religious practices across time and space.

Furthermore, the connections of religious worship across time and space were literally inscribed on the very surface of the two antique hands. One finds there a whole trove of sacred and mythological symbols that Pignoria had already explained, drawing on multiple religious and linguistic traditions. Phrygians and Gauls, Greeks and Romans; Cybele, Attis, Marsyas, Apollo, Osiris, and Adonis; the sun and the moon; even a hint of Christianity through the gesture of the fingers "in almost the same way in which our priests are wont to bless the people"—all of these and more found their place on the miniature Hand of Attis.[23] The attraction for Dinglinger must have been great. In the best manner of the diffusionist methodology, here were exciting archeological artifacts, recently discovered, through which the ancients bequeathed to posterity an actual historical compendium and narrative of migratory religious history, precisely like that which Dinglinger tried to create *ab nihilo* in the sun and moon pyramids.

Once Dinglinger opted to recreate these hands in the court of the Great Mogul, moreover, his choice opened up a space for creative license. As we have seen him do with Pussa, when the opportunity presented itself, he was glad to lend a helping hand in order to reinforce the message an extra notch.

Recall the (faux) hieroglyphic inscription that Dinglinger added to the cylindrical base of the Hand of Attis. It was his invented counterpart to the Roman inscription around the base of Tomasini's Italian hand, which spelled out its religious function as a votive offering by one Cecrops. The accompanying text, translated from Tomasini, explained that the offering must have been directed at Ammon and Asclepius, Isis, Cybele, and Jupiter—Cecrops presumably needed all the help he could get. The same paragraph also insisted on the similarity between the two antique hands. So when Dinglinger proceeded to complement the Latin inscription on the Hand of Cecrops with a parallel inscription on the Hand of Attis, set in precisely the same manner in gold on black between two rings of diamonds but in Egyptian hieroglyphs, the implication was a parallel in devotional function. Dinglinger was in a sense setting up, of his own accord, the two bookends of religious history. One hand he equipped with pointers to ancient Egypt, the ur-beginning point of the Pignoria-Kircher global history of the spread of religious practices. The other hand with its Latin inscription, conversely, pointed to Rome, where its discovery at the literal foundations of a Christian chapel indicated the endpoint of this imaginary historical development.

The next chapter picks up Dinglinger's hieroglyphs as a starting point for uncovering yet another aspect of the diffusionist narrative of human civilization that the jeweler cleverly inserted into the *Throne of the Great Mogul*. But I want to end this chapter, titled "Gods," with a nod to the other bookend just mentioned, that of the Christian god. In and of itself, Christianity was not a big concern for Dinglinger in recreating this religious history in the *Throne of the Great Mogul*. And yet there is one suggestive visual link to Christian symbols in the details of Dinglinger's recreations of pagan religious objects, in a juxtaposition between two antiquities from contexts unrelated to each other, that may well be more than a coincidence.

In order to see it, let us look once again at figure 22, which sets side by side Dinglinger's tableau on Pussa's pedestal with its origin in Sandrart's temple of Osiris. In the full plate in Sandrart (not reproduced here), a sharp eye can notice that the entablature decoration above the figure of Osiris, that which Dinglinger copied, is mirrored, inexplicably, in the offering tables held by two Nile-god figures that stand to the right and left of the Egyptian god. We know that Sandrart was himself a compiler who borrowed materials from others. In this case, he copied this element and the Nile-god figures from an

illustration that appeared in another of Athanasius Kircher's Egyptological works, reproduced in figure 22 at the bottom right.[24] It takes only a moment to realize that Sandrart corrupted the image and transformed Kircher's didactic diagram floating in the middle of the white of the page (marked "A"), which showed the Nile-god's offering table from above, into an integral part of the architecture in a now illogical Egyptian scene. But however revealing this transformation is for understanding Sandrart's mode of operation, what is of interest to me here is a smaller detail. Sandrart, or perhaps his engraver, also added to the lids of the water containers distinctive crosses that did not appear in Kircher's original version. These crosses appear prominently in Dinglinger's rendition of this tableau on Pussa's pedestal in the moon pyramid.

Now look again at the Hand of Attis (plate 38, top). It sports two conspicuous hats topped with crosses, which were there in Pignoria's drawing and faithfully reproduced in Dinglinger's version. One then realizes that the tops of the hats on the Hand of Attis are echoed in the distinctive tops of the Egyptian water containers in the tableau that Dinglinger borrowed from Sandrart. The unexpected appearance of two pairs of miniature crosses among the ancient pagan symbols meticulously reproduced by Dinglinger is suggestive. It also raises the question of whether the visual correspondence between two pairs of crosses was a factor in Dinglinger's choice of that particular Egyptian decorative element, an element he found associated with Osiris and wholly unrelated to Pussa, as the ornament for her pedestal.

Indeed, it is not only to the present author that the distinctive affinity between these two sets of crosses seems suggestive, and not only to Dinglinger that it may well have appeared as historically meaningful. Joseph-François Lafitau was a learned Jesuit missionary in the first half of the eighteenth century, an early theorizer of comparative anthropology and the last great proponent of the global diffusionist theory of comparative religion in the tradition of the seventeenth-century antiquarians. A decade after the completion of the *Throne of the Great Mogul*, Lafitau, who almost certainly knew nothing of Dinglinger's work, paired together precisely these two specific antiquities with their conspicuous crosses: Pignoria's Hand of Attis and Kircher's Nile-god's offering table. In Lafitau's opinion, this pairing provided incontrovertible visual proof, based on archeological evidence, that the holy cross had been long revered among ancient pagans.[25] Dinglinger, we can now speculate, may well have spotted this first.

10. Scripts (or, Framing the Mogul in the Global History of Writing)

Dinglinger, I have suggested, invented a string of pseudo-hieroglyphs for the base of his Hand of Attis, in order to strengthen its Egyptian genealogy. We have yet to understand the full significance of this particular choice. In the world of those antiquarians who espoused the Egypto-genetic theory of global religion, hieroglyphs held a special place. Athanasius Kircher in particular was convinced that Egyptian hieroglyphs secreted the key to ante-diluvian Adamite wisdom, and therefore devoted much of his life to a gigantic effort to decipher them (an effort that, as a string of commentators from the eighteenth century to this day have enjoyed pointing out, was completely misguided). In Kircher's view, ancient paganism and systems of writing spread together.

Next to his diffusionist history of the global spread of pagan idolatry, therefore, Kircher also developed an Egypto-centric theory of the diffusion of languages, and in particular of forms of writing. By his last publication of 1679, titled—what else—*Turris Babel*, or *Tower of Babel*, Kircher had developed an ambitious and often far-fetched world-historical reconstruction of the spread of idolatry in relation to the biblical dispersal of tongues. Kircher thus pointed to similarities found across the globe in religious practices, in names of divinities, and in writing systems, as testimonies to the common origin of all human cultures. Kircher was convinced that both pictographic and alphabetical scripts had their roots in ancient Egypt. He tried to demonstrate how Chinese characters were descendants of Egyptian hieroglyphs (based on a

perceived similarity that earlier Europeans in China, like the famous Jesuit Matteo Ricci, had already commented on), and that a similar genealogy could be shown for Aztec ideograms. In parallel, Kircher claimed with the aid of a detailed table in *Turris Babel* that Egyptian Coptic writing, an alphabetical system, was the origin of all alphabets.[1] The frontispiece to Kircher's first large-scale effort at hieroglyph decipherment, *Obeliscus Pamphilius* of 1650, made the point suggestively by juxtaposing two piles of books flanking a scroll of hieroglyphs: a stack of books of wisdom and philosophy going back to ancient Egypt, and a second stack of books in different scripts, including Hebrew, Greek, Arabic, and Coptic. Whether in pictographic or alphabetical form, writing and religion traveled hand in hand.

In and of itself, the fact that Dinglinger called the cultic hands "Hieroglyphic Hands," while also designing a ring of hieroglyphs under the Hand of Attis, does not necessarily mean he was aware of Kircher's theory. And yet what follows shows that Dinglinger was interested in the theory that linked the history of religion to the history of writing. Indeed, we will see how Dinglinger mobilized the genealogy of writing systems with careful deliberation in order to bring his "private" project, which in my telling so far has been limited only to the pairs of pyramids and cultic hands, right back to the Great Mogul. Dinglinger did so "privately," however, in the sense that his choices were left silent and unexplained, and consequently unaccounted for by observers of the *Throne of the Great Mogul* for the past three hundred years.

We get a sign that Dinglinger was well aware of this side of Kircher's theory already in the moon pyramid. A sign in a literal sense: a letter-based sign that Dinglinger placed on the base of the pyramid, accompanied with an explanation taken from Sandrart (see fig. 19, right side). This sign, the text explains, "properly belonged to the secret signs of the Egyptians" signifying well-being and life, before it was transformed by the Greeks and the Romans into the letters T and Θ, signs of life and death. This of course was an excellent demonstration of the migration of sacred symbols and letters from their source in ancient Egypt. As we have seen often, Dinglinger added to Sandrart's words an elaboration of his own: "from whence it was carried over to other peoples."[2] Here then was Kircher's logic of the cross-cultural transmission of sacred signs and letters, originating in Egypt, in a nutshell.

But Dinglinger's more intriguing engagements with the diffusionist theory of writing and religious practices lay elsewhere, and they came with

no explanation at all. As we shall see, Dinglinger's Great Mogul was literally framed by them.

The first manifestation of this framing we have already seen but did not yet understand. On the gold pilasters to the right and left of the Mogul we identified several Egyptian figures, copied from the *Mensa Isiaca*. Seventeenth-century students of the *Mensa Isiaca*—none more so than Kircher himself—mistook these images to be hieroglyphs pregnant with meaning. Next to each supposed hieroglyph on the Great Mogul's pilasters Dinglinger placed an incongruous imitation of Chinese characters. So here, lightly engraved next to each other, were jeweler-enacted representations of the two major ancient pictographic writing systems of the Eurasian world, (mistaken) Egyptian hieroglyphics and (faux) Chinese characters, inter-mixed together. Framing the throne of the Great Mogul on both sides, they distilled Kircher's ideas about the evolution of pictographic ideograms. Recall furthermore that the Egyptian images Dinglinger chose for the pilas-ters were not derived from the central scenes of the *Mensa Isiaca* but rather from its smaller-size, unobtrusive border. Whatever these supposed hiero-glyphs meant, what was good for framing the Egyptian goddess was appar-ently appropriate also for framing the Great Mogul.

Several years ago I wrote about an Anglo-Dutch painter named Edward Collier who worked during the same decades as Dinglinger and who had curious habits of playing with minute details as an idiosyncratic means to explore larger questions. In order to preempt incredulous eyebrows for what could easily seem like coincidental findings and over-the-top interpretations, I proposed what I called the *rujum* rule of thumb for recognizing intention-ality. A *rujum* is a small pile of stones with which a Bedouin unobtrusively marks a trail or a water source in the desert, laying three little stones on top of each other. One stone on top of another can be a coincidence, moved by the wind or kicked by a goat, but three must be a deliberate human contrivance. If you identify a surprising phenomenon once, perhaps you misinterpret it or mistake a coincidence for a meaningful choice. Find it repeated again, and perhaps even once more, and your confidence increases that you have actually identified a consistent pattern that, just like the Bedouin's *rujum*, marks an intentional trail. Of course, as in the desert, you may have no idea where the trail is going, but you have at least managed to demonstrate deliberate intent.

With this preamble, the scene is set for a second framing of the Great Mogul between signs of the diffusionist theory of writing. This second

example draws not on pictographic but on alphabetical writing genealogies. To the right and left of the Great Mogul, on the inner golden pillars, we find hanging two large blue and gold shields (see plate 42, top). They are not identical. To the viewer's left is an oval shield with an outer ring decorated with eight animals that seem like zodiac signs. For our purpose, however, I wish to focus on the circular shield to the viewer's right, where instead of zodiac signs, on the blue outer ring, one finds an assortment of odd characters. Characters that look like writing. Figure 23 juxtaposes these characters with the table from Kircher's *Turris Babel* that demonstrates the affinities between ancient alphabetical writing systems. As one looks at them together, the realization gradually suggests itself that Dinglinger's shield is chockfull of characters from different columns in Kircher's table, the table that provided an empirical basis for a diffusionist genealogy of alphabetical scripts.[3] We have found, it seems, an additional stone in Dinglinger's *rujum*: a rendition of Kircher's storyline about the spreading of alphabetical scripts from ancient Egypt, one that messes up the linear organization of an orderly table by jumbling it up in circular form. The Great Mogul is thus framed twice through two surprising choices, each confirming the logic of the other, each making the other seem less like a coincidence. Without the "hieroglyphs" from the *Mensa Isiaca*, I may well have not known where to search for inspiration for the strange characters on the shield. Without identifying the table of ancient alphabets in *Turris Babel*, I would have been less confident in interpreting the alternating Egyptian and "Chinese" pictographic characters on the pillars. Without Dinglinger's "private" project in the pyramids and the cultic hands, we may well have not had a clue where to begin.

As it happens, Dinglinger left behind several more stones piled on top of each other. Since he left no guide to their meaning, some of them are today only partly decipherable (or require better sleuthing). This may well be the case with the oval shield on the other side of the Great Mogul, the one with the zodiac symbols. Kircher actually spent much time and effort in *Turris Babel* and elsewhere on the zodiac symbols of different peoples, which in his hands became more grist for his diffusionist mill. Although I have been unable to find the reference point for Dinglinger's zodiac shield with its peculiar insistence on reptiles and amphibians, the very choice of a zodiac is fully in line with this broader goal, and I am confident that this puzzle has a solution, even if it has eluded me.

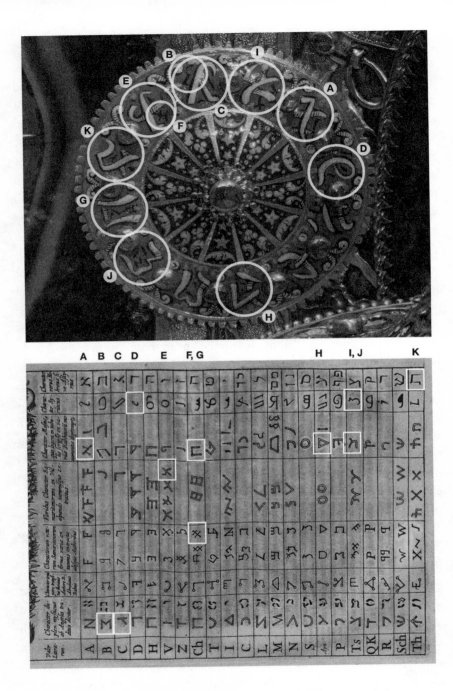

Figure 23. Hanging shield in the *Throne of the Great Mogul*, above a table from
Athanasius Kircher's *Turris Babel* (1679) displaying affinities between ancient alphabetical
writing systems. A through K mark correspondences between symbols on Dinglinger's shield
and characters in Kircher's table

In one instance, however, Dinglinger actually broke the silence about the elements with which he chose to frame the figure of the Great Mogul, and provided a hint of his overall scheme and intent. Chapter 1 of the *Short Outline of the Magnificence of the Great Mogul* includes a description of the upper edge of the ensemble, where there are "two particular cells or chapels, in which a certain goddess with four arms called Bavani is sitting on a rose." Dinglinger took the description of a Hindu goddess named Bavani or Bhavani from Olfert Dapper, but her visual appearance from Francisci (fig. 24), who himself had lifted it from Kircher (who had actually gotten it completely wrong).[4] Dinglinger's text continues: "And finally, still further in front, to either side, two other similar cells can be seen, in each of which a Chinese idol [is] sitting on tapestries." Indeed, among the most conspicuous elements in the architecture of the *Throne of the Great Mogul* are six pagoda-like structures at the top rim that literally frame the whole scene. Two accommodate figures of the Hindu goddess, and four house her Chinese counterparts. Of course they are not the same, any more than hieroglyphs and Chinese characters are expected to be. Rather, the Great Mogul is flanked from both sides by Chinese and Indian idols that are deliberately set next to each other, in similar structures and poses, so that what is highlighted is their family resemblance.

The Chinese and Hindu idols overlooking the throne were thus another tier in the growing pile of gestures at religious diffusionism framing the Great Mogul. In this case, the deliberate pairing pointed to religious genealogies within Asia. According to Kircher, however, the form of the pagoda itself had actually evolved from the Egyptian pyramid.[5] Perhaps it also resonated for Dinglinger with his choice to present sun and moon worship in the form of pyramids. But it is the next pebble that topped Dinglinger's carefully stacked *rujum* which may well be the most telling of all. It has also been one of the most difficult to penetrate.

Let us take another look at Dinglinger's Great Mogul on his throne. On the throne structure itself, next to the two hanging shields we already know, the Mogul's most remarkable framing takes place between two striking, blueish ovals to his right and left, lapis lazuli discs a full nine centimeters tall (plate 42). Their empty dark blue surface contrasts with the very busy gold and silver surroundings, and the sparse cast-gold reliefs with their distinctive motifs and unusually dispersed composition stand out. Erna von Watzdorf,

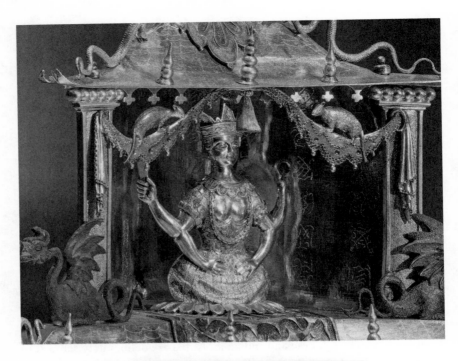

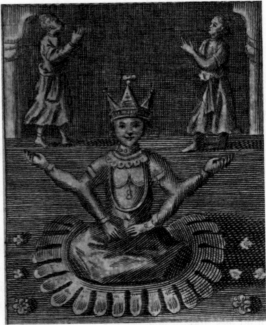

Figure 24. The Hindu goddess Bavani on the upper edge of the *Throne of the Great Mogul*, above the goddess Bavani from Erasmus Francisci (1670)

who studied the *Throne of the Great Mogul* and Dinglinger's career more closely than anyone, singled out these two discs with their fine ornamentation as extraordinary displays of unparalleled skill in which Dinglinger outdid himself. On the left disc one sees a sumptuously dressed man with a bow, and a palm tree from which hangs a quiver full of arrows. It is the right disc, however, that signals its connection to the present inquiry. Its foreground shows a female figure seated on a palm branch, who in her pose and with her multiple arms appears similar to Dinglinger's idol Bavani, seated in her pagoda structure close by. Similar, but not quite identical. Behind this figure on the lapis disc is a highly specific structure from which emerges a large crowned head with sunrays around its neck, balanced by a moon crescent at the top of the dome.

Previous scholars who investigated the visual sources of the *Throne of the Great Mogul*, from Walter Holzhausen and Erna von Watzdorf through Joachim Menzhausen and Dirk Syndram, were not able to identify a source for this image. And yet, given the distinctive features of the image on the lapis disc that indicate a specific source, and given what we already know about how Dinglinger combed through his working library in search of *Vorbilder* or models for details of the artwork, it seemed likely that this was a riddle with a discoverable solution. I therefore went back to scanning the illustrations in every book I knew Dinglinger had used in this project, and once again this crude methodology produced an answer. Unexpectedly, however, it came from a completely different part of Asia.

Dinglinger found the visual he was looking for in Jean-Baptiste Tavernier's travel account, which in its German translation was a major source for his knowledge about the Mughal Empire. Perhaps the most peculiar image in Tavernier's book is a purported view of the temples and pagodas of the Tunquin heathens next to their idols (fig. 25, bottom). Tunquin is Tonkin, in northern Vietnam, a region that Tavernier had never visited and that was not included in the first French edition of his travels. After learning about it from hearsay, allegedly from his brother, he proudly added a "new and unique account of the Kingdom of Tonkin" with multiple illustrations.[6]

It takes a minute to realize that this busy copperplate was indeed the source for Dinglinger's delicate miniature figures in their spread-out composition on the blue lapis (fig. 25, top). The connection is most readily identifiable in the structure with the ribbed dome roof and the arch from which the idol is oddly peering out, next to which stands the multiarmed female

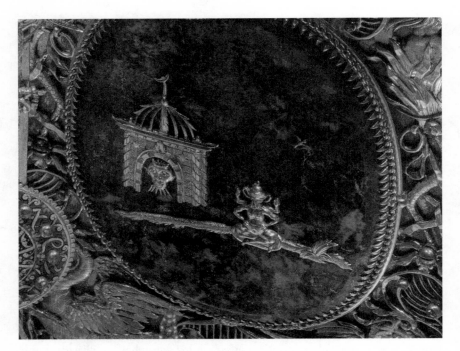

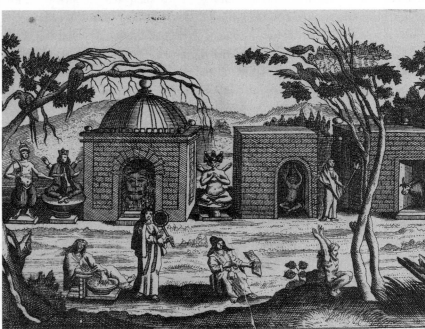

Figure 25. Top: the lapis lazuli disc to the Mogul's left in the *Throne of the Great Mogul*. Bottom: illustration of the temples and pagodas of the Tonkin heathens next to their idols, from Jean-Baptiste Tavernier (1681). Dinglinger's reliance on the illustrated rib-domed structure, with the idol peering out of its open arch and the multiarmed goddess to the side, is unmistakable

goddess. Two goddesses, actually. Furthermore, once the relationship between Tavernier's copperplate and Dinglinger's lapis disc on the right is established, it takes one further mental effort to realize that the man with the bow on the other lapis lazuli disc on the left (plate 42) is actually fashioned from the half-naked archer to the left in Tavernier's image—note the position of both arms, the bow, and the puffed pants—though his proximity to the Mogul, presumably, required his dress code to be upgraded.

Now that we have identified Dinglinger's visual source for the lapis lazuli discs, it remains to explain why this small finding is in fact so telling. Dinglinger studied his Tavernier well, and while he was working on the *Throne of the Great Mogul* must have perused his copy multiple times. (We will see another extraordinary piece of evidence for this at the beginning of the next chapter.) A likely scenario is that once Dinglinger happened across Tavernier's image of the temples and pagodas of Tonkin, he noticed the similarity of the goddess figures in it to the Bavani illustration in Francisci. Or perhaps it was the other way around. What we can be certain of is that Dinglinger then made the deliberate, proactive decision to reproduce both figures, from two completely unrelated contexts, in close proximity to each other in the decorations surrounding the Great Mogul.

Take a moment to appreciate the significance of this choice. In this particular instance it was Dinglinger himself who, scanning his bookshelf for usable images for his great work, discovered what appeared to him as visual evidence supporting the diffusionist theory of the spread of pagan worship in Asia. Borrowing a page from the comparative-religion book of the seventeenth-century antiquarians, therefore, he took these idolatrous practices of two places distant from one another and placed them in his tableau side by side. In so doing—in a manner prefiguring that which I use throughout this book in composite illustrations, juxtaposing different objects to highlight their affinities—Dinglinger drew attention to the similarities between the images of the Hindu and Tonkinese idols and thus to their supposed common genealogy. What a Pignoria or a Kircher or a Francisci would have done with words and printed illustrations, Dinglinger achieved in his own *métier*, in a move perhaps unparalleled in the annals of jewelers, in this work of decorative art.[7]

Once again, moreover, even as Dinglinger added a third parallel idol from the *Tunquinischen Heyden* to the two he juxtaposed from India and China, he took certain artistic liberties with other details. Note the unusual head peering from inside the structure with the ribbed dome roof. In

Dinglinger's version, the enigmatic head sports sunrays around its neck, while the structure from which it peers out is topped with a moon crescent. These details, both inventions not to be found in the original printed illustration, echo once more the theme of the worship of the sun and the moon, which in Dinglinger's presentation was so central to demonstrating the continuities in the global spread of idolatry. Finally, Dinglinger added to Tavernier's image one more detail that is likewise suggestive: on the disembodied head under the arch the jeweler placed a crown. This might have been an insignificant aesthetic choice barely noticeable in its minute scale. Or, perhaps it was an element added to the golden head on the lapis lazuli disc as another *rujum* stone, indicating intentionality through repetition: an echo of the other crown that Dinglinger chose to add of his own accord, that which he placed on the head of the Great Mogul himself, a mere few centimeters to the left. That crown, we recall, was one of the more meaningful alterations the jeweler made to his visual sources for the *Throne of the Great Mogul*.

Much of the analysis and interpretation in the last few chapters depends on a close reading of small details. The intellectual agenda of the *Throne of the Great Mogul*, however, also provides a framework for understanding an apparent incongruity of the whole. At first glance, after all, the broad overview can be perplexing in its eclecticism. The Great Mogul sits under two Chinese dragons holding the curtain ropes in their mouths, copied directly from a report from China published by Olfert Dapper. His inner court is guarded from below by the two multiarmed demons that are Japanese, copied from a Japanese temple in Montanus (and themselves perhaps yet another counterpart to Bavani or to Pussa). The frieze at the top of the whole structure of the Great Mogul's court carries from side to side a long string of Chinese pseudo-writing, this time composed of actual Chinese characters carefully copied without an effort to create a meaningful sequence. What are all these pan-Asian elements doing in the court of the Great Mogul? Sanjay Subrahmanyam, a leading historian of this period, has taken Dinglinger to task for "his incapacity or lack of desire" to differentiate Mughals from Chinese from ancient Egyptians.[8] But we now know better. Far from creating an ignorant or undiscerning orientalist mishmash, these design choices, like the others we have seen across many objects and details in the *Throne of the Great Mogul*, served to advance a consistent and far-reaching intellectual program. This program, Dinglinger's "private" project, was an unparalleled

effort to enact in gold, jewels, and enamel a theory of global history and comparative religion that with hindsight can be seen perhaps as ill-conceived but at the time had exciting explanatory power and a reputable provenance.

We should not lose sight of how peculiar a project this was, however, and how surprising it is to uncover it as the subtext of the *Throne of the Great Mogul*. Dinglinger's Great Mogul is surrounded by numerous elements that have nothing to do with the Mogul, with his court, or for the most part with his mighty empire, the ostensible topics of the presentation. These elements also had little to do with the needs and interests of the prince who was the intended audience and patron of this work of art. Conversely, the prince's benefits and political payoffs from the overall spectacle effect of the ensemble were presumably what allowed the jeweler a free hand to fill in so many of the details as he pleased. So the jeweler tuned into a quirky conversation among seventeenth-century antiquarians who benefited from the space created by the partial retreat of god from certain cultural domains in Christian Europe; antiquarians who explored new ways of thinking about religion and in particular about idolatry in a global perspective. Much of this scholarly speculation focused on Asia, and thus Dinglinger's *magnum opus* celebrating the Court of the Great Mogul offered him a rich opportunity to mobilize his own medium and skill to reenact and even advance these speculations. The astonishing scope of Dinglinger's "private" project becomes evident when one lists its multiple manifestations in quick succession: the two pyramids with their many dozens of carefully wrought and explained components spanning ancient Egypt, Greece, Rome, China, and Japan; the meticulous reproductions of the two antique cultic hands with their numerous unusual symbols and their Latin and hieroglyphic bases; the Hindu and Chinese idols in pagoda-shaped structures all around the rooftops; their echo in the lapis lazuli discs that replicated idolatrous scenes from the remote region of Tonkin; the preoccupation with the cultural migration of forms of writing and ancient scripts, imitating hieroglyphs and copying other Egyptian symbols, interspersing them with Chinese characters, as well as reproducing multiple characters from the comparative table of ancient alphabets. All in all, this was a prodigious effort that demonstrated an extraordinary level of commitment to visual and material enactments of the diffusionist history of religion and writing.

Oddly, and reflecting this disconnect between the ostensible subject of the artwork and its substratum, one place that remains largely secondary in Dinglinger's "private" project is India. In his text, as if suddenly becoming aware of this absence, Dinglinger at one point interjected an editorial correction to a text borrowed from Montanus, insisting that contemporary idolatry included "the Chinese, Japanese *and other Indian peoples*."[9] Explicitly, the only invocation of Hindu religion in Dinglinger's work is the goddess Bavani in her Chinese-looking pagoda. And yet one of the most mysterious elements in the *Throne of the Great Mogul*, which I left for last, was designed, I believe, as a playful gesture to the antiquity of Hindu religion and the Hindu script. To see it we need to look past Bavani. I mean this literally: a close look at the top of figure 24, looking past the goddess on the wall to her left (i.e., to our right), reveals two columns of written characters etched on the wall. They are unlike any other we have seen.

Because they are quite difficult to discern—they are much more clearly visible in this close-up photograph than for an observer facing the actual artwork—no one to my knowledge has ever paid attention to these characters. Yet they are deliberately etched, and given Dinglinger's interest in forms of writing, surely meaningful. So after failing to find anything similar in any of Dinglinger's sources, I sent this photograph to some dozen experts on different kinds of writing. I came up empty-handed: none of them had ever seen anything like it. This puzzle was to remain unsolved.

But just as I had given up, I came across this description in Bernier's account of the Mughal Empire: "Two leagues from the city [Delhi], on the Agra road, in a place which the Mahometans call Koia Kotub-eddine, is a very old edifice, formerly a Deüra, or Temple of idols, containing inscriptions written in characters different from those of any language spoken in the Indies, and so ancient that no one understands them."[10]

Now imagine reading this description as a jeweler at the beginning of the eighteenth century who is going through Bernier for relevant details for the Great Mogul, and who is at the same time a devotee of Kircher's diffusionist theory of religious history with the significant role it assigns to ancient scripts. And then think about what you see in figure 24, in a pagoda that the jeweler designed for the goddess Bavani. It is a temple of an Indian idol that contains an inscription written in characters different from any others that no one understands, just as Bernier says. Could this writing on the wall be anything else but Dinglinger inventing an indecipherable script in

order to stage, privately and playfully, Bernier's encounter with the antiquity of Indian religion?

One last question remains as we conclude this foray into Dinglinger's intellectual interests and the manner in which he introduced them into the *Throne of the Great Mogul*. Who were Dinglinger's interlocutors in this endeavor?

To begin with, we need to remind ourselves that the *Throne of the Great Mogul* involved three Dinglinger brothers, not only the one. We know little in this context about the youngest brother, Georg Christoph. But as for Georg Friedrich, the enamellist who was Johann Melchior's closest collaborator, the surviving inventory of his rich library demonstrates that he was interested in many of the same topics and owned many relevant books, including works by Jean-Baptiste Tavernier, Olfert Dapper, Erasmus Francisci, Cassiano dal Pozzo, and some of Athanasius Kircher's scientific writings.[11] One can assume that the brothers spoke often of the details of their joint project. We cannot know how often an attribution of an artistic choice in the making of the *Throne of the Great Mogul* to Johann Melchior actually enfolds in it the influence of Georg Friedrich.

But I have also suggested that Dinglinger had a scholarly collaborator, someone with academic training who wrote certain sections of the text that accompanied the *Throne of the Great Mogul* and contributed to its intellectual grounding. I wish to end this chapter by proposing a possible name, identity, and context for this collaborator.

The one seventeenth-century writer whose ideas influenced Dinglinger's conceptualization of his "private" project more than any other was Athanasius Kircher. Kircher died in Rome in 1680. His relevant works did not exist in German, and his ideas reached Dinglinger indirectly. There was however one person in early eighteenth-century Dresden who had known Kircher and had personal scholarly exchanges with him. This was Ehrenfried Walther von Tschirnhaus, a descendant of Saxon nobility who was in turn a mathematician, mechanical scientist, and philosopher. Tschirnhaus's study travels brought him into the circles of the Royal Society in London; made him from 1682 the first German member of the French Académie des sciences; earned him the friendship of Leibniz, Huygens, and Spinoza; and allowed him to create a broad network of learned correspondents across Europe. Between 1677 and 1680 Tschirnhaus lived in Rome, and during this period sought the company of the aging Kircher and worked with him. In

Dresden, Tschirnhaus built a well-stocked library—according to surviving inventories, about four times the size of Georg Friedrich Dinglinger's—and was well connected with the local intellectual and scientific community.[12] He was also well connected in court. Already in 1692 Tschirnhaus entered the service of the Saxon elector as a court councilor at the invitation of Elector Johann Georg IV. In 1696 Augustus the Strong charged Tschirnhaus with the task of finding and developing deposits of gemstones in Saxony, upon which he even established a short-lived grinding and polishing mill. Such tasks, it stands to reason, involved regular exchanges with the court jeweler.[13]

Given Tschirnhaus's close connection to Kircher in Rome, then, and subsequently his presumed regular contact with Dinglinger in Dresden, was he a colleague with likeminded interests who could discuss with the jeweler the German Jesuit's findings and theories? Such a scenario is certainly plausible. And if so, what about the next step: could Tschirnhaus have been the scholarly collaborator who translated for Dinglinger parts of the Latin tracts by Pignoria and Tomasini—both from the 1669 volume that also included a contribution by Kircher—and helped in the overall production of the *Short Outline of the Magnificence of the Great Mogul*? There are some circumstantial arguments to support such a conjecture. The catalog of Tschirnhaus's library is suggestive. Next to Kircher's scientific works he also had on the shelf, among some sixty geography titles and more than one hundred history books, both of Erasmus Francisci's relevant works, Olfert Dapper's description of Asia, a range of other travel books to the East, as well as Olearius and several other authors on European *Kunstkammern*. Tschirnhaus even owned a copy of the opera-ballet *Le triomphe de l'amour* with the frontispiece that might have inspired the overall arrangement of the court of the Great Mogul as a mirror for a prince.[14] Also suggestive is the precise timeline. The only illustration that Dinglinger drew directly from a Kircher publication seems to be the alphabet table from *Turris Babel*. This book was published in 1679, when Tschirnhaus was in Rome, and thus he might have discussed it with Kircher or brought a copy to Dresden. In addition, there is a curious standalone correction in the *Short Outline of the Magnificence of the Great Mogul* that may point to Tschirnhaus. In a passage borrowed from Montanus, the latter explained the ancients' sun worship in their awe at the speed of the sun, which "runs ten hundred thousand miles in an hour." Dinglinger's text rephrased this datum as the sun traversing "16666 2/3 miles in one

minute." Did this unnecessary and oddly finicky correction bear the thumb-print of the mathematically inclined hand of a natural scientist?[15]

In the usual course of historical research, this speculation would end here. Without a smoking gun—a copy of *Turris Babel*, say, with Tschirn-haus's *ex libris* and even better Dinglinger's marginalia—it would remain hanging as an appealing yet ultimately indemonstrable conjecture. But a surprising twist allows us to push this conjecture one step further. In order to see it I need to take you back one more time to the first object that opened our investigation of the *Throne of the Great Mogul*, the freestanding mirror.

Earlier I suggested that the Great Mogul's mirror—what Dinglinger described as "a large mirror"—was designed to represent in miniature an exciting, unprecedented contemporary innovation, the larger-than-human-size mirrors made by casting glass on a flat table. This process was first presented to the French Académie des sciences in 1687 and then developed by the end of the century into a French royal monopoly. Augustus, I further noted, became aware of this technological-cum-decorative breakthrough in 1702 and had his agents procure for him several early *"grands miroirs"* for unusually high prices. I now wish to add one more link in this chain of events: the Dresden-based authority who witnessed firsthand the production of these large-scale mirrors in Paris and transmitted back to Augustus and Dinglinger the excitement of this extraordinary event. This person was Tschirnhaus.

Tschirnhaus's passion was lenses and mirrors. He was well known for his experiments with mirrors and the invention of gigantic burning lenses, some of which were used by the likes of the duke of Orléans and Antoine Lavoisier. The reason Tschirnhaus traveled to meet Kircher in Rome was first and foremost to discuss mirrors, yet another topic in which the polymath Jesuit was interested and on which he had published only a short while before. In Dresden in 1697 Tschirnhaus sent a letter to Augustus the Strong boasting of his ability to produce mirrors more beautiful than those from Venice, as a result of which he was allowed to establish in 1700 a mirror and glass manufacture. In 1701–1702 Tschirnhaus made his last trip abroad, a combination of trade mission and industrial espionage across Holland and France. Inevitably, his itinerary included a visit to the new cutting-edge mirror factory in Paris, which, as he later reported in detail, was secret and inaccessible. Eventually he did succeed in getting in: "In the Fauxbourg St. Antoine is the large mirror manufactory. . . . There are over 600 persons

constantly working here. . . . The largest mirrors are 3 yards and a few inches. Not many of them are made, however, because they are often ruined in the manufacture."[16]

Tschirnhaus, in other words, a Dresdener scholar with a deep professional and personal interest in mirrors, made considerable efforts to visit the new French factory with its futuristic production line and reported back in Dresden on the exciting, cutting-edge mirrors with which the French had been experimenting, not without difficulties. And then, lo and behold, two things happened almost overnight. One: Augustus had his agents purchase several such mirrors, apparently at almost any cost, for the Dresden court. Two: Dinglinger designed a miniature model of precisely such a cutting-edge mirror and placed it in a prominent position in the *Throne of the Great Mogul*. (The completed work actually sported two large mirrors: it is likely that the second one was added after Augustus's first viewing of the ensemble, since its addition is the only alteration recorded at this late stage.[17])

Tschirnhaus's report, then, was undoubtedly what triggered the interest of both Augustus and Dinglinger in the innovative oversized mirrors. This of course does not prove that Tschirnhaus had an active role in encouraging the introduction of such a mirror into Dinglinger's court of the Great Mogul or in designing its details. And even if he did, this does not prove that the two men discussed other aspects of this complex project. And even if they did, this does not prove that they talked about the diffusionist theory of religion and writing forms propagated by Kircher, Tschirnhaus's former host in Rome, or pored together over the alphabet table in Kircher's *Turris Babel*. And even if they did, this does not prove that Tschirnhaus reviewed Dinglinger's text and made suggestions, such as adding mathematical precision to the supposed speed of the sun. Finally, even if Tschirnhaus did do much of the above with Dinglinger, it still does not prove that he also shared Dinglinger's interest in the cultic hands published by Pignoria and Tomasini and collaborated with him by translating excerpts from Latin into German. And yet the highly specialized common ground that joined together Tschirnhaus's personal excitement about a technical innovation and Dinglinger's unusual choice to display this exciting innovation in the *Throne of the Great Mogul* makes these possible interactions that much more likely.

11. Uniqueness (or, Accounting for the Unaccountable)

In the introduction, I used the image of a child-drawn flower with many petals around it to describe the structure of this book. At the center stands the *Throne of the Great Mogul,* and the petals going out and coming back in are the chapters, gradually accumulating its understanding from different angles, topics, places, and historical questions. We are now a couple of petals away from the end of this sketch. We know a lot about the agenda of the prince/king as it was served by this project, and a lot about the agenda of the jeweler, sometimes dovetailing with that of his prince, sometimes veering in independent directions. We know how the Great Mogul became entangled in both agendas. And we know how these different aspects are all embodied in the different parts of the Dinglinger brothers' intricate work, often in minute details. The present chapter, although it begins with an extraordinary detail that has escaped the attention of commentators for three hundred years, is in the main not about the components nor about the specific thematic content of the artwork. It is rather more of a meta-observation about the *Throne of the Great Mogul* as a whole: an analysis of a meta-goal shared by both prince and jeweler, though for different reasons. That goal was the achievement of *uniqueness.* But first, in order to penetrate what uniqueness meant for both of them, we should begin with a few thoughts about *value.*

The detail that leads us into the question of value—and the last element in the *Throne of the Great Mogul* to be examined closely in this book—is in fact

the most explicit sign of the rule of the Great Mogul in the whole ensemble. In a very real sense, it is the Great Mogul's signature. And yet, although this signature is centrally positioned, it needed to wait for this late stage because several other petals in the book-flower needed to be in place in order to appreciate it.

Figure 26 shows an enlargement of a coin from the piles of gold and silver coins in the baskets next to the scales' pans at the front of the Great Mogul's court. The first thing to appreciate is the feat of miniaturization: two 4-centimeter-wide filigree baskets hold 94 tiny gold coins and 154 tiny silver coins, varying in size up to 0.6 centimeters in diameter (see plate 7).[1] It is because of this small scale, probably, that the second thing distinguishing these coins has been overlooked: they all bear inscriptions. Resonating with Dinglinger's interest in experimenting with scripts and writing characters, real and imaginary, here the inscriptions are in a script that we have not yet encountered in the *Throne of the Great Mogul*. The coins are inscribed with what was a real effort to reproduce Arabic—or, in this case, Persian—characters.

Coins, obviously, carry a particularly loaded type of representation. They are intimately bound with sovereignty, and in the context of absolute rule with the person and power of the ruler. Mughal coins were designed with the names of the emperors in Persian characters. The details of coin design and the authority to use them mattered greatly. In 1692 the British in Bombay decided to mint rupee coins with the names of the English royals William and Mary transliterated into Persian, rather than with the name of Aurangzeb as they had done previously in Madras. The Mughal emperor considered this act such an infringement of his sovereignty that he threatened to invade Bombay unless the rupee "with the unholy name of their king" was withdrawn. The Europeans complied.[2]

Dinglinger may well have known nothing of this. And yet as court goldsmith he was well aware of the meaningfulness of coins and of coin design. The message of coins was all the more important in a *mise-en-scène* intended to enact absolute power, that of the Great Mogul and that of Augustus the Strong mirrored in the rule of the Asian potentate. This is why Dinglinger chose to place the Mogul's coins at the center of the action, taking the place of the Great Mogul on the scales that were intended to weigh his body. And this is why the coins had to imitate the authentic writing that represented the Great Mogul.

Figure 26. A coin from Dinglinger's coin baskets next to the scales (flipped right-left), showing the correspondences to two distinctive sequences of Persian writing in Jean-Baptiste Tavernier's illustration of Mughal coins

The artist, however, may well have never seen an actual Mughal coin. Instead he relied on the fellow jeweler Jean-Baptiste Tavernier, who inserted into his travel account a drawing of several coins of different Mughal emperors with their respective "arms or seals."[3] As figure 26 demonstrates, Dinglinger carefully copied sequences of Persian-Arabic writing from the arms or seals on two different coins in Tavernier's plate. For this side of the miniature coin he chose two segments from Tavernier's Mughal coins that were visually distinctive and at the same time clear in reproduction on a minute scale. These segments then got reversed in the process of casting. Dinglinger of course could not read the Persian-Arabic script, any more than he could read the Chinese characters he copied along the top of the court's architecture, and thus his "letters" are incorrect. Nevertheless, even among the numerous extraordinary elements we have already encountered in the *Throne of the Great Mogul*, one cannot but be astonished at the considerable length to which Dinglinger went in order to produce two piles of authentic-looking tiny coins with pseudo-Mughal signatures.

As a side note, we may wonder whether this signature of the Great Mogul also doubled as a subtle signature for the jeweler himself. On the one hand, the piles of coins are indeed the closest the *Throne of the Great Mogul* gets to a form of the ruler's signature and a stamp of his power. They are thus placed together with the scales at the front and center of the ruler's court. On the other hand, the scales in Dinglinger's design do not really bring to mind the heavy weighing machine hanging from a beam that was required to weigh a human being. In creating the upper beam of the scales, Dinglinger actually followed closely the ornate ceiling beam holding the heavy Mughal balance in Bernier's illustration of this event (fig. 27). And yet the miniature scales look more like the delicate scales of a jeweler or goldsmith, that with which the craftsman weighs the precious materials of his art.[4] Perhaps, therefore, there is another message behind the fact that what occupies the scales, where the mighty ruler should have been, are two piles of minutely ornamented objects of gold and silver, the main materials and artifacts of the jeweler's *métier*. After all, we now know that Dinglinger often asserted his own presence and his own agenda in this artwork next to that of the prince and the Mogul. Could this then be another such case of double purpose in which the Mogul's signature and stamp of authority at the center of his court also double as a subtle signature and stamp of the authority of the jeweler at the center of his artwork?

Coins and scales are devices for representing and measuring equivalences of *value*. The coins represent the abstract interchangeability of value that is introduced with the use of money, a value disembodied from the specific qualities of whatever is being measured and exchanged in monetary value terms. The scales measure an equivalence of weight, which is then translated through predetermined criteria—think of the goldsmith weighing gold— into a measurement of value. Both coins and the scales are instruments of *commensurability*, that is to say, the possibility to substitute one material or commodity for another through their exchange value. Coins also store value in and of themselves. Unlike modern money, in the early modern period gold and silver coins did so by holding their value (more or less) in the weight of the precious materials from which they were minted. The act of weighing precious metal coins on the scales represented in the *Throne of the Great Mogul*, therefore, merges the two modes of commensurability offered by scales and coins.

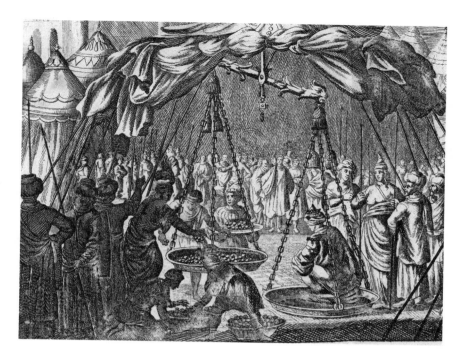

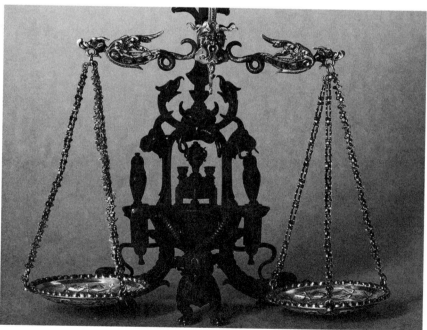

Figure 27. The scales in the *Throne of the Great Mogul*, together with the illustration of the weighing of the Great Mogul from the travels of François Bernier (first published 1699; here from the edition of 1723–1724). The central beam in Dinglinger's scales follows closely the beam in the printed image

Now contrast these general considerations about how coins and scales function in the measuring and accounting for value with their particular function in the scene in front of us. In the ceremony of the weighing of the Mughal emperor, the festive occasion that Dinglinger recreated in the *Throne of the Great Mogul* and for which purpose both scales and coins are placed at the forefront of the tableau, the meaning and function of value were completely overturned. The weighing of the Mughal emperor was a celebration of *incommensurability*. The Mughal was weighed against gold or silver or rice—an accounting procedure embodied in Dinglinger's artwork in the figure of the bearded bureaucrat with the ornamented account book who is charged with writing down the precise measurements (plate 7, top left). But obviously whatever was written in this account book did not in any way measure the ruler's "value," a fact underscored by the use of a series of differently valued weights or "currencies" for measuring the ruler—gold, silver, rice, and by some accounts also other commodities such as silk, perfume, copper, iron, butter, starch, salt, and grains.[5] Instead of participating in an economy of exchange value, the Mughal emperor's weight in these different "currencies" was distributed as charity, that is, transposed into a different economy of gifts, directed by a ruler whose beneficence cannot be quantified. This transmutation was embodied in the very coins distributed to the crowds during the weighing ceremony. As Jean-Baptiste Tavernier explained, these were not regular coins but rather tokens minted especially for such occasions, inscribed with the Great Mughal's name, which were distributed as "*Geschenck-Stucken*" or gift-pieces; the French original had them as "pieces of generosity."[6] Only then did they enter circulation as exchangeable currency, but one that always wore on its sleeve the special occasion of its inception. Tavernier's account illustrated a selection of these "*Geschenck-Stucken*," noting (wrongly) that Aurangzeb did not mint any of his own, and it was the writing on these festive tokens that Dinglinger then copied for his gold and silver miniature coins.

This, in short, was the Mughal's paradox. The very act of weighing the Mughal defied the logic and function of scales, of coins, and of gold and silver in an economy of exchangeable value. This defiance was not incidental but rather a fundamental public lesson of this famous ceremony. The Great Mughal, by his essence and status, exceeded any measurement of value and existed only as a figure of immeasurable magnanimity, an actor in an

economy of gifts and grace. He was a figure that embodied the literal meaning of *invaluable*.

It had to be so. The invaluableness and incommensurability of the Great Mughal were not simply an aggrandizing narrative device: conceptually they were a precondition for imagining him as an absolute ruler. "Invaluableness" is braided with "absoluteness" in two ways. First, the incomparability of the absolute ruler: there can be only one, and there is—in theory—nobody and nothing to which the absolute ruler can be compared. We have already seen this logic in the words of a French royal historiographer who in 1685 promised to compare Louis XIV with other princes titled "Great" but then veered in the opposite direction: "Prodigy of Greatness! Louis resembles all the Great princes, although none of these Greats resemble him, because only he is similar to himself, and the Great prince par excellence. In one word the Incomparable." Hall Bjørnstad, in a recent analysis of Louis XIV's "exemplarity" or singularity, pairs this text with another of two years earlier by André Félibien, a key figure in Louis's court, in which a conventional *paragone* debate between poetry and painting is solved in favor of the latter because of its unique ability to represent the king's deeds "to which nothing in all the histories is comparable." Bjørnstad also adds a fairy-tale from 1698 that I mentioned earlier, by Jean de Préchac, which is a thinly veiled commentary on the life of Louis XIV. This parable on Louis's life is titled simply *Sans Parangon*, "Without Equal."[7]

The singularity of the ruler, furthermore, is absolute also in a sense related directly to value. The value of money, like that of gold and silver, is conventional and relational rather than intrinsic. The value of the ruler, by contrast, is intrinsic and absolute. Absolute value has no limits or boundaries and cannot be diminished or subtracted from; it is in a basic sense infinite. When the Mughal emperor put on heavy ornaments and sat on the scales, to be balanced again and again against commodities handed out to the crowds, it was a public demonstration that his riches could not be subtracted from, in the same way that subtracting any number from infinity leaves infinity. The value of the absolute ruler is singular and incommensurate, and its effect is to remove mundane values from the secular cycle of exchange. "It is, moreover, one of the clearest manifestations of our power," Louis XIV explained his absolutism in his famous memoir to his son, "to give infinite value when we please to what in itself is nothing."[8]

To be sure, not all that applied to Louis XIV's dream of absolutism (the phrase is Bjørnstad's), or to the European fantasy of the Great Mogul, was equally applicable to Augustus the Strong. The latter's aspirations to absolute rule, after all, played out in the arena of the Holy Roman Empire, a scene replete with likeminded aspirants who were unavoidably and incessantly comparable. And yet the imperatives, or fantasies, of absolutism remained. The recognition in the Holy Roman Empire, and indeed in Augustus's immediate vicinity, of the necessity for the absolute ruler to be incomparable became evident, ironically, precisely at the moment that should have highlighted its impossibility: the *Dreikönigstreffen* in Potsdam in 1709. "It is rare that three crowned heads are thus reunited," wrote Karl Wilhelm von Meisenbug before comparing Augustus and the kings of Denmark and Prussia to the three biblical kings. This was because—here Meisenbug directly echoed the French line—absolute majesty is "a kind of singularity, which cannot tolerate anything equal in its vicinity."[9] German princes with absolute aspirations had to negotiate this impossibility as best they could. This may help explain, for instance, the studied excess of the princely *Schatzkammer*, with its accumulation of dozens upon dozens of almost indistinguishable extraordinary art objects: a sea of turned ivories, a whole wall covered with nautilus cups, or shelves upon shelves of baroque pearl figures. Whereas piling them up on top of each other undermined the proper appreciation of any single work of art, the cumulative effect—as any modern visitor to the reconstructed Grünes Gewölbe still experiences—was the same impression of infinitude that was the desired effect of the weighing of the Great Mughal.

The skill of a top court jeweler was to create works for his prince's *Schatzkammer* that stood out even in the midst of all this excess, thus shoring up his patron's special value as well as his own. Dinglinger certainly knew how to create singular works, from the *Goldenes Kaffeezeug* of the closing years of the seventeenth century to the *Apis Altar* at the end of his life. And yet the *Throne of the Great Mogul* enacted its incomparability on a higher and more self-conscious level. Here form matched content. The representation of absolute power in this mirror for the prince embodied in its very execution precisely the two qualities essential for the ideal absolute ruler: infinitude and uniqueness.

Infinitude, on one level, is obvious. The spectator standing in front of the *Throne of the Great Mogul* is dazzled by a phantasmagoria of details that

crowd each other to capture one's attention even for a fleeting moment. The overall effect is remarkably one of limitlessness. This effect is intensified by the small scale—the apparent ability of the viewer to notice all parts of the miniature ensemble at once, even as they elude visual focus—and by the shallow viewing angle, as the artwork set on a table confronts the viewer with all its elements jammed one behind the other. By contrast, a bird's-eye view of the *Throne of the Great Mogul* (plate 43) reveals to one's considerable surprise that the scene is in fact sparsely populated and relatively empty. (This sparseness accounts for the puzzling lightness of the ensemble as a whole, an experiential effect that is impossible to reproduce in a photograph.)

At the same time, I would argue, the deliberate impression of infinitude is enhanced by further, subtle means. That the 164 pieces are almost all freestanding rather than fastened, thus allowing for infinite possible configurations, may have been a coincidental side effect of other considerations rather than a strategy for creating infinitude. But what can be described as the nested-details effect is more likely to have been deliberate.

Consider one more time the gold and silver coins that opened this chapter. First one takes in the scales, then the baskets on the scales, then the piles of coins in the baskets, each a few millimeters wide, and then the minute but quasi-authentic writing on the coins. Every level contains within it a tinier sublevel, creating overall a nesting sequence that continues beyond the actual requirements of the representation and approaches invisibility. Such sequences were in fact a familiar and oft-discussed scenario in the late seventeenth century. Following the development and continuing improvement of the microscope from the 1660s and 1670s, the tiny, the tinier, and the tinier still—but never the *tiniest*—became a hot metaphysical topic of speculation. As the famous learned Frenchman Bernard de Fontenelle put it in 1686, "We see from the elephant down to the mite; there our sight ends. But beyond the mite an infinite multitude of animals begins for which the mite is an elephant, and which can't be perceived with ordinary eyesight." So would there ever be an end to this regress? The quest for the tiny, driven by the developing science of optics together with a clearer understanding of its limits, became a demonstration of god's infinite wisdom in an infinite world.[10]

Dinglinger, a jeweler who engaged in ever more intricate miniaturization, was likely attuned to these conversations about the implications of exploring successive levels of minuteness. Dinglinger repeated the nested-details effect in the coins on the scales, and again in the miniature treasure

chest with its tiny weapons that hid in them tinier working mechanisms, and in the tiny book that emerged from that chest and bound within it minute world maps, and again in the details of the Turkish camel that carried a saddle adorned with miniature bells equipped with tinier clappers and tied by a golden rope to an ornamental cover that hid beneath an almost invisible star pattern, as well as in numerous other details within details throughout the *Throne of the Great Mogul*. In the context of the quest for the qualities of absolute power, therefore, miniaturization may have become more than a demonstration of the jeweler's astonishing skill. It may well have also provided a means to heighten the impression of infinitude.

Even more than infinitude, it is Dinglinger's investment in ensuring the second key requirement of an absolute ruler, incomparable uniqueness, that is the signal quality of the *Throne of the Great Mogul*. The declaration of intent was spelled out in Dinglinger's own words in the letter he handed to Augustus the Strong on 11 October 1707 to introduce the masterpiece he hoped the prince would purchase:

> The extent of the work is all made of silver, but the throne with its figures and gifts is all in pure gold, ornamented with diamonds, emeralds, rubies, and pearls, and executed in the most artful and delicate manner, enameled and smelted with the most attractive colors, that, without unseasonably declaring my own glory, such a work has never yet been offered by any artist, and none will ever occur in times to come, insofar as not many have the ability to produce any such, and even were one to be capable, the great expense and even more the great length of time would prevent such a hazardous undertaking, so that nowhere will such a piece be found in the cabinet of any great ruler.[11]

Before the work on the *Throne of the Great Mogul* was fully completed, Dinglinger was already insisting on its uniqueness: no work like it ever existed nor ever would. Of course, one may wish to read such language as the conventional hyperbole of a top-notch court artist approaching his patron. In this case, however, there are grounds for taking the jeweler at his word.

As Dinglinger himself explained, the uniqueness of the *Throne of the Great Mogul* was guaranteed by a combination of an inordinate outlay of expense and precious materials, an inordinate investment of professional

time and effort by multiple individuals, and an inordinate level of highly skilled detail. Close observation confirms that several qualities of this work of art made it exceedingly difficult to replicate or imitate. These include the expert, multiple-level miniaturization—of every piece, of so many pieces, and in nesting levels; the seamless blending together of so many different materials; and the enamel work of Georg Friedrich Dinglinger. The significance of the last was brought home to me by Dr. Rainer Richter, perhaps the world's leading expert in the restoration of such enamels, who spent a decade on the painstaking restoration of Georg Friedrich's work in the *Throne of the Great Mogul*. When I unfolded my thoughts about the deliberate effort to ensure uniqueness in the making of the *Throne of the Great Mogul*, Richter immediately recognized this imperative from his own perspective. In his experience, Georg Friedrich's contribution to this artwork pushed enamel work to its very limits. This was an unprecedented endeavor with no parallel elsewhere—not in terms of the variety of enamel techniques nor in the sophistication and delicacy of the enamel work nor in its miniaturized scale. The *Goldenes Kaffeezeug* sports impressive enamels, but the *Throne of the Great Mogul* raised them to a wholly different level.[12] We may therefore add that the collaboration of Johann Melchior Dinglinger with others, above all his extraordinarily skilled brother, further shored up the uniqueness of the outcome.

Their efforts were successful. No artist has ever attempted an imitation of the *Throne of the Great Mogul* nor a production of a similar nature or scale—not even Dinglinger himself. When Dinglinger copied one of the Great Mogul's elephants for Friedrich II, duke of Saxe-Gotha-Altenburg, as a present for the duke's wife, the choice to extract a single miniature from the whole ensemble demonstrated how far this single elephant was from a design to recreate a similar overall effect.[13] As the jeweler had said, there never was nor was going to be anything like the *Throne of the Great Mogul*, a work of art that wore its uniqueness on its sleeve as a badge of honor.

It was therefore inevitable, perhaps, that the *Throne of the Great Mogul* also went through its own iteration of the Mughal's paradox. What was the value of a singular, unique work of art? Initially, Dinglinger in that same letter priced the artwork, through a detailed account of materials and labor, at exactly 55,584 thalers. Augustus did not accept this precise accounting but rather arrogated to himself the authority of valuing the jeweler's creation by setting the price he was going to pay for it at a round figure of 60,000 thalers.

He thus replaced the jeweler's pricing rationale, based on an item-by-item reckoning, with the prince's generic round price that signaled extraordinary value with an order of magnitude.[14] Once purchased, the *Throne of the Great Mogul* quickly became, like the prince or the Mughal on the scales, "invaluable": a priceless, unique work of art. When Dinglinger handed Augustus his letter announcing the historical singularity of this particular piece, in short, he meant it literally and deliberately, and his language resonated immediately in the prince's ear. Infinitude, uniqueness, invaluableness: the *Throne of the Great Mogul* was the ultimate absolute work of art for the wishful proclamation of absolute rule.

The context of early modern absolutism, then, in which the mirroring relationship between the Great Mogul and the Saxon prince was a playful enactment of the fantasies of absolute rule in two courts halfway around the globe, appears fully sufficient to situate and explain the Dinglinger brothers' investment in the uniqueness of the *Throne of the Great Mogul*.

But the aspiration to uniqueness of this work of art can also be interpreted in another light. I would like to shift focus for a moment to a very different perspective on this investment in uniqueness in the opening years of the eighteenth century, one that takes us away from the context of absolutism and places the jeweler himself front and center. It is a perspective that highlights resonances with other extraordinary works of art created across Europe at the same historical moment, notably by jewelers and goldsmiths. It brings to the fore desires driven not by political ambitions but by artistic ones, and thus requires us to consider how artists like Dinglinger and some of his contemporaries perceived broader developments in European art in their lifetimes. From this perspective, it turns out, at this particular juncture, Dinglinger's commitment to the uniqueness of the *Throne of the Great Mogul* was not all that unique.

Consider, for example, the rare Dutch print in figure 28, of which only one copy is known. The oversized broadsheet, datable through external evidence to 1688, advertised for sale in Leiden a miniature architectural model of a court-like arrangement of buildings and gardens, set on a wooden stand and enclosed in a glass box, itself topped with a crowned clock. The full ensemble rose 2.7 meters high. Its many features were listed in the text printed below the image: structures and towers; pergolas and railings; pedestals with "silver statues and pyramids, all to a correct scale"; an ingenious

Figure 28. Jacobus Jancke's print advertising his unique miniature architectural
model (Leiden, 1688)

grotto made of small shells, stones, crystals, and fine pearls; a miniature garden "full of flowers, fruits, plants and trees, even including small birds, all made of silk, as naturalistic as possible," and so on.[15]

The relevance of this artwork for our purposes manifests itself most clearly in the preamble to the accompanying text:

> [It] is made known to all curious amateurs, who have a mind to buy an exceptionally rare piece of workmanship which Sr Jacobus Jancke, living in Leiden, has constructed, which is so excellent, rare and ingenious, that the like has never been seen or made, as will be attested by all who have seen it; neither will it ever be made anymore, as the said Sr Jacobus Jancke has worked on it for more than ten years ceaselessly with great application and effort, and has skillfully assembled in it many rarities. The wonderful details and parts are so numerous that (if one should want to describe them all) one should need a whole book and even then it would be impossible to explain everything.

A miniature model the likes of which has never been seen before nor will ever be made again—a formulation closely prefiguring Dinglinger's, penned a little over a decade before the commencement of the work on the *Throne of the Great Mogul*. Nor do the parallels between this creation and Dinglinger's stop there. Jacobus Jancke, the creator, was, like Dinglinger, a jeweler and goldsmith. Although working in Leiden, he was in fact German-born—from Schleswig, in the cultural sphere of the Gottorf court with its famed *Kunstkammer*—and German-trained. The one identifiable influence in his model—the clock—was modeled after the work of a German clockmaker. Little of Jancke's work is known, other than one documented silver medal and this printed testimony to the lost masterpiece. Like Dinglinger, Jancke worked on his masterpiece on his own initiative painstakingly for many years, an inordinate investment of time and effort that in his eyes guaranteed it could never be repeated. Like Dinglinger's, this model represented in miniature an architectural setting with a seemingly endless multitude of small and smaller details. Like Dinglinger, Jancke appended a partial explan-atory text. And perhaps surprisingly for an artwork made in the Dutch republic—Jancke's wealthy German wife had been in the service of the dame d'honneur to the dowager princess of Orange—his miniature model, according to the key in the text, was "crested with a curiously wrought crown

(N) set with rare stones." The crown notwithstanding, the cultural sphere for Jancke's unique creation was of course completely different from Dinglinger's Dresden. Having completed his personal project of many years in capitalist-bourgeois Holland, not in a German court, therefore, Jancke advertised it for sale to the highest bidder. And yet, despite the different circumstances, the parallels between these two miniature model projects, each claiming uniqueness on similar grounds, are uncanny.

Let us now move forward a few years and southward to the other side of Europe. In 1712 the Deputation of the Chapel of the Treasury of San Gennaro (Januarius) in Naples commissioned a leading local goldsmith, Matteo Treglia, to create within a year an extraordinary gift for the city's patron saint. By getting their permission to enlist other local craftsmen to help, Treglia met the deadline with a piece that claimed, once again, to be unprecedented and unique (plate 44). In part, this was due to its inordinate cost, raised through contributions from numerous donors from local citizens all the way to the Holy Roman Emperor. The total amounted to some 20,000 ducats, which, it is worth noting, was more or less the equivalent of 60,000 thalers: perhaps a benchmark value for a unique, complex work of decorative art about to become "invaluable." In part, the uniqueness was due to the design. What Treglia offered the saint—after proudly affirming the incomparability of the piece in front of the viceroy, the cardinal, and "the many virtuous people"—was a goldsmith-made model of a bishop's miter (to complement a bust that Charles II of Anjou had donated in the thirteenth century). The miter was made with a gilt-silver base, shaped with a thick coat of silver flowers and leaves, and bedecked with thousands of gemstones. Or, to be as precise as the officials who recorded the donation: 3,328 diamonds, 164 rubies, and 198 emeralds.[16]

To be sure, the circumstances for the making and reception of Treglia's Miter of San Gennaro and of Dinglinger's *Throne of the Great Mogul* could hardly have been more different. One belonged to the cultural-political world of the *Schatzkammer* of a wannabe absolutist court in the Holy Roman Empire, the other to the communal-devotional world of a powerful Italian religious institution that over centuries amassed one of the richest treasuries in the world. And yet it is against these different backgrounds that the similarities in the making of these objects, within five years of each other, stand out. Both were made by top-rank jewelers who were pushing the envelope of what jewelers—even the very best ones—were expected to deliver. Both

were intended to stand out in spaces of excess in portable art, that is to say, treasuries chockfull of precious objects. Both, each in its own environment, were claimed (rightly) to be unique and unprecedented, and remained unparalleled thereafter. For both the uniqueness was a combined consequence of an excess of value—each sporting a base of gold and silver augmented with thousands of gemstones, the number of which was precisely declared—together with their singular artistic theme, composition, and detail. Both were models or remediations: a reproduction of something in a different form—be it different material and/or different scale.

Add to these Jacobus Jancke's architectural model under glass from yet a third very different cultural context, that of the bourgeois-capitalist milieu of the Dutch golden age, and a picture begins to emerge. To be sure, there are many differences: Treglia's masterpiece was not an architectural miniature like the other two, Jancke's creation did not require such an outlay of expensive materials as Treglia's and Dinglinger's, and so on. Differences, however, are what one would expect. The more striking finding is a possible pattern that appears to have been repeated in three quite distant places, in three European settings that socially, culturally, and politically could hardly have been wider apart, by three ambitious master jewelers who were unlikely to have known of each other's work.

A historical pattern like the one tentatively sketched here, composed of multiple independent and unrelated events, emerges at first as a fuzzy possibility in which repetition gradually pushes one to consider whether the recurrence of the observed pattern is more than a coincidence. The fuzziness exists on two levels. First, the pattern itself is a matter of interpretation: are the elements I chose to highlight sufficiently salient characteristics of these three unrelated works of art to justify connecting them with one underlying pattern? Second, unlike the *rujum* rule of thumb I proposed above, such a pattern does not reveal the increasingly likely intentions of a single agent but rather a confluence of multiple unrelated events at a particular historical juncture. These then may indicate an underlying logic shared unknowingly by agents acting independently of each other, a logic that in this case crossed geographical, political, and cultural lines. Obviously, therefore, one strengthens the case by adding more events that can be shown, *mutatis mutandis*, to have belonged to the same proposed pattern.

Given the scope of this book, exploring the different interpretive doors opened by Dinglinger's *Throne of the Great Mogul*, I can only briefly point to several additional instances of this emergent pattern. I then also propose a possible explanation, linking this pattern to certain concerns regarding artistic practices at this juncture which I believe were on Dinglinger's mind as well as on the minds of some others.

Dinglinger's, Jancke's, and Treglia's artworks were unrepeatable, once-in-a-lifetime, highly complex projects. One notch below them stood works of art that were extraordinary, singular in their own way, but at the same time an integral part of how their makers made a living. As it happens, the same period at the turn of the eighteenth century witnessed several new genres of decorative art, typically short-lived, that strove to manufacture uniqueness through rare materials, ingenious skill, and unprecedented design. One example of this apparent oxymoron, a genre of unique pieces, we have already encountered in the baroque pearl figurines. These, we recall, belonged to a short-lived, highly exclusive genre of which altogether no more than 150 examples are known, mostly from the Germanic cultural realm between the 1690s and the 1720s (see plates 21–24). Each one of these free-standing miniatures mobilized with great ingenuity the irregular form of a singular lumpy pearl—itself a rare find—to create a unique cabinet piece. In the only known description of the making of a baroque pearl figure, from the workshop of a jeweler in Strasbourg who set the misshapen pearl as the backside of a man pulling down his trousers, the jeweler did so on his own initiative and free time and then had difficulties locating a buyer willing to pay the high price.[17] In the end, it was nature itself that guaranteed that every baroque pearl figure, regardless of its generic affinities with others, was in fact specifically unique and impossible to reproduce.

Nature was also a factor in a second small group of artworks in ivory from southern Italy—Sicily or Naples (Treglia's city)—also dating to the years around 1700 (see the example from 1696 in plate 45). These are extraordinarily skilled ivory carvings, beginning with an elephant tusk sawn down the middle, with scores of minute figures in complex arrangements as if hanging in the air, representing devotional scenes such as the last judgment or the fall of the rebel angels from heaven. I am aware of a dozen extant examples that are obviously closely related, though they have hardly been studied as a group.[18] The intricate excess of each of these freestanding works, often consisting of more than one hundred tiny figures hanging and twisting

from one another like a never-ending filigree, showcased the virtuosity of the ivory carver while guaranteeing the irreplicability of the work. Its uniqueness also relied on the individual qualities and shape of the elephant tusk, which the carvers deliberately left to be seen. It has been suggested more broadly that this period witnessed a shift from bronze to ivory "towers" or complex creations precisely because of the appeal of an animal's tusk as a singular natural object that could not be replicated, unlike bronzes.[19]

My third example of a group of virtually irreproducible decorative artworks from the decades on either side of 1700 comes from a little-known father and son team who worked in another medium altogether: wax. Johann Baptist and Nikolaus Engelbert Cetto lived in the town of Tittmoning in the archdiocese of Salzburg. Their specialty was a new and unprecedented genre of three-dimensional relief tableaus in wax, miniaturized with mindboggling detail. They formed complex scenes with perspectival depth through multiple layers of images, outlined filigree-like with the thinnest wax lineaments imaginable, with the help of pig bristles, rabbit hairs, fish bones, and tiny natural branches. No other artist is known to have succeeded in replicating their feat, and modern attempts to reconstruct it have failed. The father, Johann Baptist (1671–1738), used his wax micro-technique for religious scenes, such as the miniature nativity illustrated here (plate 46), though a photograph cannot begin to capture the intricacy of the tiny details. The son, Nikolaus (1713–1746), moved the genre into secular themes. It so happened that the pinnacle of this particular art form, shortly before it died out, took place in 1738 in Dresden. These were four spectacular miniature wax reliefs by Nikolaus Cetto that were presented on the occasion of the wedding of the daughter of Augustus III to the young king of Naples and later Spain, showing views of Naples, Madrid, ancient Jerusalem, and of course Dresden itself.[20] Unlike my other examples, the south German Cettos carried on with their signature art form for several decades. But the father does belong to the pattern that I have suggested for the years around 1700, having developed then another mini-genre of decorative art that relied on extreme miniaturization and excessive detail to ensure uniqueness.

Dinglinger, then, was not unique in his striving for uniqueness. Instances of the proposed pattern in the late seventeenth and early eighteenth centuries that have accumulated so far from different parts of Europe, all independent of each other, include three top-rank jewelers with explicit aspirations to

incomparable and unrepeatable singularity, as well as three types or mini-genres of decorative art in different media that displayed a particular investment in their own irreproducibility, achieved through excessive detail, miniaturization, and the reliance on the singularity of natural forms. Had this been the central goal of my book, I could have readily expanded the list. It would have included a consideration, for instance, of a miniature model of the Temple of Solomon completed in Hamburg in the early 1690s after many years of work, with "richness in gold, silver, carving and figures," as well as "6700 pillars, 1500 chambers," and so on, which—thus was the claim of a 1724 description—"has not its like in the universe."[21] Another example to explore is the extraordinary wafer-thin, translucent ivory reliefs by Ignaz Elhafen, who at the pinnacle of his ivory sculpting career was working at the court of Augustus the Strong's persistent collecting competitor Johann Wilhelm von der Pfalz.[22]

But does a handful of examples indicate a possibly meaningful historical pattern, that is, an underlying logic shared by multiple unrelated agents in late seventeenth- and early eighteenth-century Europe? We need to proceed with caution. First, the array of examples is relatively small, only from certain parts of Europe, and can only be taken as suggestive of possible connections rather than as strong "evidence" of an underlying pattern. Second, we must tread carefully because in every generation one can expect to find jewelers and likeminded decorative artists who strove at some point in their careers to create a singular piece. One need only think of an artwork like the virtuosic mid-sixteenth-century ode-to-the-earth table centerpiece at the Amsterdam Rijksmuseum, created by the extraordinary Nuremberg-based goldsmith Wenzel Jamnitzer, in which Mother Earth is surrounded by fragile silver leaves, twigs, and tiny creatures, all made in silver through highly skilled life-casting. Once again, the uniqueness of natural forms bolstered the uniqueness of the goldsmith's creation.[23]

And yet this was not necessarily the imperative behind the work of even the greatest jewelers and goldsmiths. Nothing shows this better than the next display case in the Rijksmuseum, where, facing Jamnitzer's masterpiece, stands a twenty-five-centimeter-tall silver ewer of 1614 made by the silversmith Adam van Vianen. Nominally a ewer, it sported an ambiguity of form that looked like nothing else in the history of silversmiths' work, with indistinct areas without ready description and a daring level of molten movement. The singularity and ingenuity of this ewer were immediately recognized and led to a wave of imitations among silversmiths as well as artists in

other media, not least by van Vianen himself. Here then was a singular virtu-
osic silversmith's small-scale artwork that self-consciously launched a new
artistic style or movement, named *Kwab* (literally, flabby fold of thickening
of a human or animal body, often likened to an ear lobe), that was a distinct
contribution of the Dutch golden age.[24] Similarly, when Queen Elizabeth
sent a "curiously wrought" silver cup to the Russian tsar Ivan the Terrible,
she instructed her ambassador to recommend it "for the rarity of the fashion,"
assuring the tsar that "we do send him the same rather for the newness of the
device than for the value, it being the first that was made in these parts of that
manner." The key phrase in the queen's instructions is "the first": the piece
was singular and thus valuable because it was unprecedented, but was
expected to be followed by others.[25] The mark that jewelers wished to make
with their most spectacular pieces was often in creating innovations that
would then trigger new trends.

Proceeding with caution, therefore, I would like to propose that the
concentration of efforts to achieve irreproducible uniqueness in the late
seventeenth and early eighteenth centuries was not coincidental but rather an
indication of a European cultural pattern broader than the aspirations of a
single jeweler or artist. This goal played a part in Dinglinger's agenda—and
is likely to have been shared by his brother Georg Friedrich—in the making
of the *Throne of the Great Mogul*. It also stayed with him later: when
Dinglinger sold Augustus the Strong in 1722 his other large-scale *Gesamt-
kunstwerk* celebrating the status of his ruler, the *Obeliscus Augustalis*,
Dinglinger again repeated the claim that this highly skilled work with its
multiple precious stones was "a great unicum [*ein gr. Unikat*]."[26]

If indeed we see here glimpses of a distinctive cultural pattern that is
specific to the period, can I also explain why it emerged then and why it took
the form it did? Why, in other words, was the achievement of artistic unique-
ness especially pressing for some artists at this historical moment? Again
proceeding cautiously, I would like to raise the possibility that this pattern
was a reaction to a particular trend in the world of art during this period. The
pressing issue that may have spurred this drive for singularity was the emer-
gent fashion for producing multiples in works of art.

I first encountered an artist actively engaged with the consequences of
multiple reproduction when I studied the unusual—indeed almost unique—
trompe l'oeil paintings of the Dutch-English painter Edward Collier. From
the early 1690s to about 1708—that is to say, at the very moment Dinglinger

was working on the *Throne of the Great Mogul*—Collier became obsessed in dozens upon dozens of paintings with repetition and its fault lines. He painted in multiples while leaving signs that he was thinking about seriality. On a second level—for example, in trompe l'oeil paintings of printed portraits of Erasmus or Charles I supposedly attached to boards—Collier reflected on the fate of the artist's work as it moved from unique oil-on-canvas paintings to mass-produced prints, and then back again into oil paintings but now painted serially. Collier paid special attention to new methods developed from the 1680s that increased the potential of prints as a reproductive medium, and in particular the invention of the mezzotint, a technique that seemingly enabled the unmediated reproduction of oil paintings. I argued then that long before Walter Benjamin and his famous (and often misinterpreted) statement about the work of art and its endangered "aura" in the age of mechanical reproduction, Collier was already exploring the idea that, in an age of increased mass production of images, the reproducibility of print as well as of the painted canvas compromised the uniqueness of art. In his idiosyncratic paintings he tried both to draw attention to the new possibilities opened up by multiple and serial production and to resist their more unwelcome consequences.[27]

Rembrandt was another visual artist who is known to have been engaged with this question. In producing multiple etchings, Rembrandt experimented with added smears of ink on his copperplate, smears that he altered between individual sheets of paper so that every impression turned into a unique original.[28] Yet Dinglinger belonged to the world not of painting and printmaking but of three-dimensional, decorative art. In this world too, one can identify trends that may well have led a jeweler like Dinglinger to reflect on the uniqueness of works of art, works not that different from his own.

In 1695 Massimiliano Soldani Benzi, one of the finest bronze casters in Europe in Dinglinger's lifetime, was negotiating a commission from the art collector Prince Johann Adam Andreas I of Liechtenstein. The latter desired copies of several famous marble statues in the Medici collection in Florence, which he wished to be made in bronze so as to withstand the vicissitudes of transport. To this Soldani Benzi replied that the prince's preference was excellent, but for a more significant reason. Marble statues cannot be copied in marble while maintaining their "softness, and grace of contours." The Florentine statues, he wrote, are "things which in the world are unique [*singolari*], insofar as the King of France has nothing other than copies of

them, but in marble, which copies are not nor could they ever be as exact as these bronze ones will be." By contrast, Soldani Benzi proclaimed that the bronze copies he was offering the prince would be the first of their kind, an unprecedented feat of faithful replication.[29] In a brilliant rhetorical move, Soldani Benzi insisted on the uniqueness of the ancient marble originals while at the same time appropriating it for his own bronze casts, the likes of which had not been seen before. And yet, being casts made with molds, they were replicable. In 1707, the same year Dinglinger offered Augustus the Strong the *Throne of the Great Mogul* with an insistence on its uniqueness that echoed Soldani Benzi's, the latter sold to Augustus's collecting rival Johann Wilhelm von der Pfalz several bronze casts of the same Florentine marbles. A couple of years later Soldani Benzi cast them again for the duke of Marlborough's new Blenheim Palace in Oxfordshire, a commission that had been placed earlier by the English Queen Anne herself. Soldani Benzi worked on this commission together with Pietro Cipriani, who would also go on to a career of casting copies noted for their faithfulness to the originals.[30]

The technical knowledge for creating multiple bronze casts was not new. The process that allowed for the production of multiples, known as indirect lost-wax casting—as opposed to the direct method in which the mold does not survive the casting process—was an ancient one. It was rediscovered in the Renaissance, probably first by the Mantuan court sculptor known as Antico, and then used variously, notably in the late sixteenth and early seventeenth centuries in Giambologna's well-known workshop. Its early uses, however, were not necessarily focused on replication. As sculpture curator Claudia Kryza-Gersch has suggested, fifteenth- and sixteenth-century small bronzes, from Antico onward, were typically produced in the indirect method for purposes of quality improvement and control, rather than as a means for reproducing multiple objects.[31] In the middle of the sixteenth century, the Italian sculptor Leone Leoni used the indirect lost-wax casting technique to make multiple bronze busts of Emperor Charles V. Although "it would have been possible to cast two hundred of them," as one of the emperor's ministers wrote, only three were actually made, each one rendered unique through varying decoration.[32]

What gradually changed, then, was less the casting techniques than the cultural uses to which they were put. From Giambologna and through the seventeenth century, small-scale sculptures occupied a significant place in European *Kunstkammern*. By the early eighteenth century they multiplied, in

both senses that the phrase implies here, extending their reach from the connoisseurs' cabinets of curiosities to wealthy households. As Soldani Benzi suggested in 1695, by the end of the seventeenth century the faithful replication of original artworks was a cutting-edge goal of its own. Malcolm Baker, perhaps the foremost student of European multiple production of small-scale sculpture, has summarized the consequences: "While making more widely known the masterpieces of European sculpture, and celebrating and perpetuating the reputations of those who invented them, the small-scale sculptural reproduction also made it possible for such images to be used decoratively and appropriated in ways that diminished the status of both the artist and the original work."[33]

Baker offers a second example of the production of an artwork in multiples, in a different medium or actually in several media, which brings these quick observations right back to Dinglinger's own backyard. Around the years 1709–1711 (and perhaps earlier) a small ivory carving (12 x 10 cm) was in the hands of the Dresden court artists. This was the relief *Judith with the Head of Holofernes* (today in Edinburgh), made in the 1680s by the Netherlandish ivory sculptor Francis van Bossuit, whose softness of touch had earned him the reputation of being able to "work upon [ivory] as if it were wax." We know this because several copies of Bossuit's ivory relief were made in Dresden while it sojourned there. Most experimental was an unusually large group of *Judith*s press-molded in the newly developed material soon to be named "Böttger stoneware," which was an early step in the development of porcelain. Six Böttger stoneware copies of *Judith* are known today, but in 1711 no less than seventy-five were reported in an unfired state with twenty-four more in the kiln and twelve in the ceramicists' quarters. In addition, several replicas in ivory were also made, apparently from the ceramic copies rather than from the original, and perhaps some others in wax. Bossuit himself, it may be noted, had made at least five different ivory versions of *Judith with the Head of Holofernes* before his death in 1692, but unlike the multiples created in Dresden in the early eighteenth century, each of his own versions was different.[34]

Johann Melchior Dinglinger was close by and could not have been ignorant of these goings-on. In the 1670s in Italy, Bossuit had been in close relationship with the sculptor Balthasar Permoser, Dinglinger's longtime associate. (This may explain Bossuit's connection to Dresden, as well as the involvement of Permoser's assistant, the ivory carver Paul Heermann, in the

production of several of the ivory copies of Bossuit's relief.) At that time Johann Friedrich Böttger, the maker of the Böttger stoneware, also had a relationship with the Dinglinger brothers, as we shall see shortly. Indeed, this was a small, closely knit group of artists: Böttger also worked on modeling some of Permoser's ivories in his stoneware. Shortly following the Danish king Frederik IV's visit in 1709, during which the *Throne of the Great Mogul* was unveiled and the king dined in Dinglinger's house, the king received a gift of early porcelains from the Dresden court, including one of the Bossuit replicas.[35] In short, it is very likely that Dinglinger was aware of the intensive reproductive activity surrounding Bossuit's small-scale ivory carving across several media in the Dresden court, whether in Heermann's handmade variants in ivory or in Böttger's multiple mold-shaped reproductions. And we can assume that Bossuit's *Judith* was not the only such experiment in the reproduction of multiples that took place in Dresden at the time.

Dinglinger may well have also noticed that the ceramic copies of Bossuit's *Judith* had actually lost in the process of casting some of the subtler features of the ivory relief. Likewise, he may have shared Baker's conclusion, that "the process of dissemination of the image [of *Judith*] seems to have involved a diminution, a loss of significance, at least as far as authorship of the original was concerned." Baker demonstrates his point through the appearance of Heermann's initials on two of the ivory copies, indicating a certain claim to authorship on a design invented by Bossuit.[36]

A full picture of the extent of this trend in the late seventeenth and early eighteenth centuries requires a more systematic survey than I have been able to gesture at in the last few paragraphs. But what we have seen is sufficient to put forward the following suggestion. The contemporary drive to replicate works of art in the production of multiples—not yet quite mass-production but moving in that direction—was plausibly what pushed Dinglinger to invest so much—in effort, skill, time, and money—in the uniqueness of the *Throne of the Great Mogul*, a breathtaking, inimitable singularity. The resistance to the trend for replication may well have also been what drove Dinglinger's brother, and the jewelers Treglia and Jancke, as well as the Cettos, Ignaz Elhafen, the makers of the baroque pearl figures, the carvers of the complex ivory "towers," and the designer of the Hamburg miniature Temple of Solomon. It drove all of them, more or less at the same time, to push the envelope as far as it could go, typically with the aid of extreme miniaturization and excessive detail, in order to create such art

objects that could not be replicated. This suggestion is certainly speculative. Yet it appears increasingly likely when we observe such a concentration of manifest and sometimes self-consciously declared efforts to create unique-ness that took place during the same decades of intensifying experimentation with the creation of high-quality multiples. And nowhere was this more the case than in Dresden itself, which witnessed at precisely the same moment the beginnings of a brand-new medium—we just got a first taste of it with Bossuit's *Judith*—that was about to elevate replication of multiples to a whole new plane: *porcelain*.

12. Epilogue

The Prince, the Alchemist, and the Emperor of China (or, How Dinglinger and the Großmogul *Lost the Battle with Modernity)*

Johann Friedrich Böttger would probably have been surprised by the example that introduced him at the end of the previous chapter. How can the dozens of replicas of Bossuit's *Judith with the Head of Holofernes* constitute an example of an *erosion* of the uniqueness of art objects, when they were made of a revolutionary new material, never before molded in European hands? After all, give an alchemist the challenge of producing uniqueness, and his solution would be grounded in a singular material more than in design. Precisely such a singular material had been developed only a couple of decades earlier in neighboring Brandenburg by one of Böttger's mentors before his arrival in Dresden, the alchemist and glassmaker Johann Kunckel. Kunckel invented gold ruby glass, an unprecedented type of glass for making striking and unduly expensive decorative vessels. For a short period (c. 1685–1705) gold ruby glass was held in as high esteem as was about to be conferred on hard-paste porcelain. Böttger himself also experimented with ruby glass, and even reported in 1713 that he had succeeded in inventing a new variety that was "the first that was ever made."[1] The chase after uniqueness was ubiquitous. But gold ruby glass for Böttger was a sideline. Böttger's main focus in the latter years of the first decade of the eighteenth century—once it had become clear he was unlikely to produce the gold for which Augustus the Strong abducted him from Brandenburg to practical imprisonment in Saxony—was Böttger stoneware, the beginning of European porcelain.

Porcelain by the end of the seventeenth century had developed into some-
thing of a courtly collectors' obsession, a highly desirable luxury that princes
in the Holy Roman Empire and across Europe imported at great expense
from China and Japan. Böttger stoneware was the first step in the radical
breakthrough of porcelain made in Europe, and thus full of promise for a
huge boost to Augustus's credentials as a patron of the arts as well as to his
state coffers.[2]

Böttger stoneware is somewhat of a misnomer. The discovery of
porcelain owed at least as much to another figure in the Dresden court with
chemical and alchemical knowledge: our acquaintance Ehrenfried Walther
von Tschirnhaus. We encountered Tschirnhaus as an expert on mirrors who
probably provided Dinglinger with the information and incentive for
including the larger-than-human-size mirror in the *Throne of the Great
Mogul*, and who is also a plausible candidate for Dinglinger's collaborator
and scholarly guide in his foray into contemporary antiquarianism. Tschirn-
haus's many pursuits had included since at least 1693–1694 a persistent quest
for the recipe for porcelain, for which purpose he melted Chinese porcelain
with powerful burning lenses of his own invention. In fact, his correspon-
dence with Leibniz reveals a nascent interest in this problem already in the
1670s and 1680s, before Böttger was even born. In March 1702 Tschirnhaus
met Böttger and gradually redirected his attention from the unsuccessful
attempts to create gold through transmutation toward experiments in
ceramics. After Böttger's failed escape from Augustus's imprisonment in
1703, the king assigned Tschirnhaus to closely supervise Böttger's work. By
1706 they saw their first successes in the creation of porcelain, and in
December 1707 Böttger was finally able to present to Augustus a small porce-
lain teapot, which, he wrote, was "made with the help of Herrn von Zschirn-
hausen."[3] Unfortunately for Tschirnhaus, he died within a year and thus
never witnessed the ultimate triumph of their joint discovery (a "discovery,"
we should not forget, reinventing a wheel that the Asians had perfected
centuries earlier). In March 1709, Böttger stretched the truth somewhat
(white porcelain was still some distance away) by announcing to Augustus
the Strong that he was now able to make porcelain "equal to that of the East-
Asians [Chinese], if not surpassing them."[4] By January 1710 the alchemist
was already director of the new Saxon royal porcelain factory at Meissen,
and a public launching of its wares took place in the Easter Leipzig Fair of
that year.

For the reader (and author) of this book, what is most remarkable about this oft-told story is the precise unfolding of its timeline. Böttger sent a letter to Augustus the Strong on 3 June 1707 drawing his attention to his forthcoming success in the invention of porcelain. On 11 October Dinglinger sent Augustus his own letter with the detailed offer of the *Throne of the Great Mogul* as an unprecedented unique creation. As we know, the jeweler's letter was hurried to its addressee before the ensemble was actually completed. In the letter Dinglinger invited the prince for an hour-long visit to observe the singularity of the *Throne of the Great Mogul* with his own eyes. Böttger's presentation of the porcelain teapot took place some ten weeks later, in late December, and it too gave the prince an experiential demonstration of the unprecedented qualities of the new creation. Böttger dramatically pulled the teapot out of the white-hot oven and threw it into a pail of cold water, thus proving its resistance to thermal shock—the coveted physical quality that distinguished Asian porcelain from all other types of ceramics. Subsequently, Augustus finalized the purchase of the *Throne of the Great Mogul* on 6 February 1709, and within ten days had it installed as the new *pièce de résistance* of his rearranged *Schatzkammer*, creating a major new display ahead of the all-important visit of Frederik IV of Denmark. And sure enough, here was Böttger again, sending Augustus his rather premature memorandum about the success in creating porcelain equal or superior to that of the Chinese on 28 March 1709, some six weeks after the final triumph of Dinglinger's *Großmogul*. Then, in June King Frederik IV arrived. Together with his visit to Augustus's treasury room, now centered on Dinglinger's elaborate miniature ensemble, and his dinner with Augustus in Dinglinger's roof garden, the Danish king was also given the honor of the first viewing of Böttger's new Saxon porcelain. This was followed shortly thereafter with the first recorded royal gift of Meissen porcelain, which was sent to Frederik in Copenhagen, including a Böttger stoneware copy of Bossuit's *Judith*.[5]

A novelist could hardly have sketched a picture of a tighter competition between two masters of their trade than the one emerging from the unfolding of these events. Let us consider again the bigger picture. The period was auspicious. The occupying Swedish forces had just departed Saxony. Augustus was sitting tight in Dresden looking at a brightening political future, a grand royal comeback that would become manifest during the visit of Frederik IV. Both Böttger and Dinglinger had been working for the past several years on big breakthrough projects reshaping their careers, and both

saw now a promising opportunity to capitalize on their efforts. It is likely that Augustus, for his part, was leaning on both of them to produce results.

Furthermore, Böttger and Dinglinger must have known quite a lot about each other's work. This busy activity, after all, was taking place within a small circle of scientists and artists in the Dresden court. One of its major figures, Tschirnhaus, was simultaneously involved with both projects. Some sources suggest that Böttger and Dinglinger had a direct working relationship.[6] It is likely that in the early stages of Böttger's experiments with his stoneware he collaborated with Dinglinger's brother Georg Friedrich on several distinctive enameled porcelain plates, though this path did not prove fruitful.[7] Indeed, for the earliest designs of Meissen porcelains Böttger recruited one of Dinglinger's colleagues at court, the silversmith Johann Jakob Irminger, since it was among the craftsmen of precious metals in Dresden that the greatest cache of skill was to be found. Böttger and Dinglinger also had shared interests. Böttger had some exposure to goldsmithery, while Dinglinger was interested in alchemy, as he demonstrated years later in his now-lost *Mons Philosophorum*.[8] And let us not forget that Dinglinger's first large project for Augustus, the *Goldenes Kaffeezeug*, was actually the first ingenious imitation of porcelain produced in the Dresden court (though for visual effect only, unable to sustain thermal shock). In short, Dinglinger's and Böttger's work was like a double helix, circling around each other in close proximity. Doubtless they had regular information about each other's progress. And now, when their parallel projects were both getting closer to materializing, and when the tides turned for their patron in a way most promising for their futures as well as his, we find the goldsmith and the gold-maker dancing a *pas de deux* with very similar moves three times within two years: both seeking the favor of their king for their singular creations, each time hastening to act within mere weeks of each other, and each one willing to declare success prematurely when the other had gotten there first. This was truly a race to the photo finish.

In this race, Dinglinger and the Great Mogul lost, twice and thrice over. This outcome was slow to emerge. In 1710 there was no comparison between the level of artistry, skill, and intricacy of the *Throne of the Great Mogul* and anything made in Meissen. And yet it soon became clear that the *Throne of the Great Mogul* represented the past, defensively asserting a greatness that was bypassed by the rather different future embodied in porcelain.

Augustus the Strong, although he was to become world-renowned for his *maladie de porcelaine* (the diagnosis, unexpectedly, was his own), was not the first European ruler to have become invested in this exotic medium. The lion's share of Asian porcelain in seventeenth-century Europe was imported by the Dutch, and it was they who transformed porcelain from rare, individual pieces in *Kunstkammern* into luxury objects collectable in large quantities and increasingly indispensable as a hallmark of courtly prestige. Porcelain cabinets or chambers were first owned by prominent women in the Dutch House of Orange and spread with them as they married princes across Europe, from the Holy Roman Empire to London.[9] From the 1690s porcelain collections became also the domain of princes, not least imperial electors who were vying with each other for royal status. In Versailles already in 1670 Louis XIV had set an idiosyncratic example with his *Trianon de Porcelaine*, a fanciful structure he built for his mistress, the marquise de Montespan, which was covered from the outside with what was supposed to look like Ming porcelain. Although the *Trianon* was in fact covered with European faïence (enameled earthenware) made to look like Asian porcelain, and although it was already falling apart and dismantled by the late 1680s, it did herald the connection between porcelain and royal glory.[10]

In Germany, nobody was more attuned to this new desideratum for royalty than Friedrich III/I, himself on his mother's side a proud descendant of the House of Orange. His first experiment in the 1690s was with a small porcelain room in Caputh, capped with a painted ceiling that showed exotic Asian porcelain next to a Prussia equipped with both an electoral hat and a (premature) crown. Subsequently Friedrich built two more such rooms, unprecedented in scale and design, in Charlottenburg and Oranienburg, in which massive amounts of porcelain were integrated into the architecture. Porcelain also played a conspicuous role in Friedrich's coronation ceremonies in 1701. Johann von Besser, master of ceremonies to the Prussian court, described the new king's triumphal arrival in Oranienburg en route to Berlin: "The triumphal arches were adorned, among other ornaments, with orange trees and large porcelain vessels, which trees and vessels announced even at a distance the palace where they stood, namely Oranienburg with its porcelain room, the elegance of which put the magnificence of the greatest cities to shame." Porcelain, together with orange trees, became a proclamation and testimony to the glory of the new king.[11]

Augustus the Strong encountered the Prussian king's collection of porcelain—almost certainly the most extensive in the Holy Roman Empire

at that point—during the *Dreikönigstreffen* in 1709, when Friedrich took his royal guests to visit the palaces of Oranienburg, Caputh, and Charlottenburg. A major highlight were the porcelain rooms, displayed with what curator of Prussian collections Samuel Wittwer has described as the "highly political iconography of sovereignty" and located in each palace behind the state bedroom, thus emphasizing the special status of porcelain within the codes of royal access.[12] Augustus of course was no novice to porcelain. Only a few months earlier the pieces of porcelain that had previously entered the Dresden *Schatzkammer*, some as early as the sixteenth century, had been put on display in the *Geheime Verwahrung* as an Asian backdrop to the new centerpiece of the presentation, the *Throne of the Great Mogul*.[13] But the impact of the Prussian experience on Augustus appears to have been considerable, and synchronized perfectly with the new horizons that could now be imagined in the wake of Tschirnhaus's and Böttger's discoveries. Within a few years Augustus was actively amassing the largest collection of porcelain in northern Europe, both Asian and Meissen. If in 1709 the *Schatzkammer*'s porcelain collection was arranged in a supporting role around the *Throne of the Great Mogul*, within less than a decade Augustus wished his new obsession to have its own dedicated space: an extravagantly designed palace for porcelain, the "Japanese Palace."

Stepping inside the Japanese Palace—a partly imaginary step since it was never completed—would have made it immediately evident that Dinglinger and the Great Mogul had been left behind. Two iconographic designs, one in a pediment on the outer facade and another (never completed) in the ceiling of the main gallery leading to the throne room, portrayed the main competition to which the whole palace was dedicated—between Far East Asian and local Saxon porcelains. The projected ceiling of the throne gallery was described in detail in 1735 by its designer and architect, Zacharias Longuelune: "The middle [section] will represent Saxony and Japan in the presence of Minerva, competing for the preference and the perfection of their porcelain manufactories. . . . The goddess will put the crown, or the prize of the dispute, into the hands of Saxony. And Jealousy and Chagrin will make a sign to suggest to Japan that they should put back their porcelain vases onto the ships that had brought them." The message was not a subtle one. Saxony was now on par with Japan and China—the two Far Eastern countries were referred to interchangeably—and Augustus the Strong was measuring himself in his own eyes against the emperor of China. Meissen porcelain, a

eulogy for Augustus at his death in 1733 declared, "made the Chinese blush with shame."[14] In the scripts of the age of porcelain, the Great Mogul was no longer even an imaginary reference point.

Nothing made this point with more visual force than the throne designed for the Japanese Palace (and never executed). The architectural placing of the throne at the end of a long gallery extending over an entire wing of the building was unusual, probably designed to echo Louis XIV's long gallery at the Galerie des Glaces in Versailles. At one end of the gallery—underneath the ceiling portraying the triumph of Saxon over East Asian porcelains—was planned a carillon of porcelain bells. The throne itself would have faced it at the other end. It was designed as a majestic eight-meter-tall throne made entirely of Meissen porcelain. The throne, flanked by the figures of Justice and Minerva, was projected to stand under a domed canopy with a palm tree that echoed precisely the pediment in the building's facade, which again celebrated the triumph of Meissen over Asian porcelain.[15] Literally as well as figuratively, and with all the excessive symbolism that thrones carried in the contemporary world of German rulers, the imagined porcelain throne for the king of Saxony completely eclipsed Dinglinger's miniature *Throne of the Great Mogul*. To paraphrase a Shakespearean line from Humphrey Bogart, porcelain was now the stuff that royal dreams were made of.

Although it is seductive to assign much meaning to this symbolic changing of the guard, or in this case of the throne, in fact it reflects actual historical events only up to a point. The Great Mogul had been overshadowed first and foremost by virtue of being dead since 1707, with his empire thereafter falling into decline. Dinglinger, for his part, went on to have an illustrious career all the way to his death in 1731, punctuated with new pieces that continued to showcase the ingenuity and originality of his jewelry-cum-goldsmithery work. The reputation of the *Throne of the Great Mogul* as a singular wonder— in the words of a mid-eighteenth-century British traveler, "the piece of the greatest curiosity" in the Grünes Gewölbe that was created "with extraordinary art and labour"—was not in doubt.[16]

And yet it was in a more fundamental and historically significant way that the art form distilled so memorably in Dinglinger's *Throne of the Great Mogul* did indeed lose out to the possibilities offered by porcelain. Porcelain was a material and a genre conducive to the production of *multiples*. This was true not only in terms of the technical processes of production but also

in terms of the culture of porcelain as imported from East Asia, and, as the Meissen factory was about to figure out before long, in terms of the economic logic of manufacturing the new "white gold."

Porcelain's entry into the cultural politics of the court did not show at first its propensity to encourage multiples. In the admittedly extreme case of Louis XIV's *Trianon de Porcelaine*, the goal was the explicit opposite, namely to be unique. Its singularity was spelled out in Jean de Préchac's fairytale of 1698, *Sans Parangon*, unfolding the feats of Louis XIV in allegorical fashion. The tale's central narrative device is the love of the king "without equal" for "the princess of China who was without question at once the most beautiful and the proudest princess of the world." Its expression is the construction of an unprecedented palace made of porcelain, which the princess inevitably judges to be superior to that in her homeland.[17] More to the point were the early desires of Augustus the Strong: when the royal factory in Meissen came into its own with high-quality porcelain creations, Augustus planned to order large one-of-a-kind porcelain pieces and then break their molds, thus maintaining the edge of a unique collection. He did this most famously in his 1730 order for a fantastical menagerie of large-scale and in part life-size porcelain animals, which is still the pride of the Dresden palace porcelain collection.[18]

But in fact Augustus's royal desires for unique porcelains ran counter to the nature of porcelain production and to the cultural logic of the medium. This was already evident in the porcelain imported from China in the seventeenth century, which was produced and shipped to Europe in mass-produced multiples. Asian multiples dominated not only vessels and tableware but also porcelain figurines, such as the popular figure of Guanyin, the Chinese goddess of mercy and compassion, who in some forms resembled Mary and the child. The Dresden collection had several examples of multiply produced porcelain figures of Guanyin.[19] Porcelain rooms—think of the spectacular (today reconstructed) *Porzellanzimmer* in Charlottenburg Palace—turned seriality and repetition into a well-developed aesthetic.

In Meissen, from the very beginning of the Saxon royal factory, we find experimentation with making casts of Chinese figurines for the production of multiple copies in porcelain. Even before the factory opened, on 28 November 1709, Augustus the Strong had already sent to Böttger eight Chinese porcelain figurines for copying. Porcelain figures based on Asian examples included some cast in molds that were themselves made after Chinese carved soapstone

figurines, a significant number of which were available in Augustus's Asian collections. Similarly, Chinese models were the basis for the most common figure made in multiples in Meissen during those early years, the seated, pot-bellied "Pagod," as well as for the Böttger stoneware figure of Guanyin, copied from a Chinese white porcelain figure. Early Meissen figurines often carried over designs that had been court favorites in other mediums, such as the baroque pearl figurines. Some Pagod figures, perhaps intended as chess pieces, even sported crowns and scepters, echoing the Great Mogul on his throne.[20]

With hindsight, at least, the endpoint seems predetermined. After some initial resistance driven by the perceived needs and desires of Augustus the Strong, the Meissen factory moved full throttle into the production of multi-ples. This was the only plausible outcome of the material, cultural, and economic imperatives that shaped the making of Saxon porcelain. Multiple production took over not only service sets but also figure sculptures. Porce-lain, it turned out, was well suited for the creation of complex, small-scale figurines rich in details and accessories. These new possibilities were demon-strated spectacularly by the Meissen modeler Johann Joachim Kaendler, who with his nine hundred different designs took this art form to a completely new level. Strictly speaking, these were multiples that were not mass-produced: the technical process of their making guaranteed variations between different exemplars, and their cost placed a limit on numbers.[21] Nevertheless, the essence of porcelain figure design was predicated on replication, not singularity.

The gold-maker and the goldsmith, working side by side in Augustus the Strong's Dresden court, thus sketched two paths along two sides of a major historical divide. On the one side you had the reproducible, serial, expandable, and spreadable qualities of porcelain manufacture; the didactic transparency of even the most complex porcelain figurines; and the wealthy patrons who would gradually become accustomed to placing them on their mantelpieces and dining tables. On the other side you had the infinite intri-cacy and minute layering of hidden meanings in Dinglinger's *Throne of the Great Mogul*; its successful claim to nonreplicable uniqueness, grounded in inordinate value and inordinate investment; and its placement as the center-piece of a closed and excessively crowded princely *Schatzkammer*. In the Meissen porcelains one hears the early, tentative footsteps of the Enlighten-ment. In Dinglinger's *Throne of the Great Mogul* one sees in its fullest glory the ultimate artwork of the Baroque.

Notes

Introduction

1. Allison Stielau, "In Tribute: Dinglinger's 'Court of Delhi' in the Grünes Gewölbe, Dresden," unpublished paper, 2010. I am grateful to Allie Stielau for sharing this paper.

2. Transcribed in Erna von Watzdorf, *Johann Melchior Dinglinger: Der Goldschmied des deutschen Barock*, Berlin, 1962, 2:388 (emphasis added). The full text is discussed in chapter 11 below.

3. That judgment is Baron von Pöllnitz's in 1729: *Mémoires de Charles-Louis Baron de Pöllnitz*, new edn., Liège, 1734, 1:154. These topics are discussed in greater detail below. For general background on Saxony and Augustus during this period, see Karl Czok, *August der Starke und seine Zeit*, Munich, 2010 (orig. 1989), and Helen Watanabe-O'Kelly, *Court Culture in Dresden from Renaissance to Baroque*, Basingstoke, U.K., 2002, chap. 7.

4. Augustus paid 60,000 thalers for the *Throne of the Great Mogul*. This sum was equivalent to the value of Pillnitz Castle, an edifice Augustus gave his mistress Anna Constantia von Cosel in 1706. See Dirk Syndram, " 'Der Thron des Großmoguls' und der Preis der Kunst," *Dresdener Kunstblätter* 58 (2014), 4–13, and Dirk Syndram and Jörg Schöner, *August der Starke und sein Grossmogul*, Munich, 2014, 6, 23n5, including the claim that this was the single most expensive artwork of the Baroque. For Peter the Great's interest in Dinglinger, which according to some led the tsar to imitate the jeweler's house in Saint Petersburg, see Watzdorf, *Johann Melchior Dinglinger*, 1:34, and Dirk Syndram, *Juwelenkunst des Barock: Johann Melchior Dinglinger im Grünen Gewölbe*, Munich, 2008, 38–39.

5. Several years ago, the Dresden photographer Jörg Schöner developed a photographic procedure for the *Throne of the Great Mogul* that combines multiple shots from gradually altered field depths with digital "photo-stitching." The resulting images have an unprecedented level of magnification and focus

sharpness in which details never before photographed can be seen. See Yvonne Fritz, "A Microcosm in the Macrocosm: Jörg Schöner's Macrophotographic Documentation of the Grünes Gewölbe at the Museum of Islamic Art in Doha," in Dirk Syndram and Claudia Brink (eds.), *The Dream of a King: Dresden's Green Vault*, Munich, [2012], 61–65. I am grateful to Jörg Schöner for giving me access to his photographic archive.

6. For general descriptions, see Watzdorf, *Johann Melchior Dinglinger*, 1:131–178; Joachim Menzhausen, *At the Court of the Great Mogul*, Leipzig, 1965; Dirk Syndram, *The Throne of the Great Mogul in the Green Vault in Dresden*, Leipzig, 2013; and Syndram and Schöner, *August der Starke und sein Grossmogul*.

7. Watzdorf, *Johann Melchior Dinglinger*, 1:38, 135, 2:361n84; Eleonora Höschele, "Von 'gunst zur wahrheit angetrieben': Leben u. Werk der Dresdner Hofzeichnerin Anna Maria Werner," *Jahrbuch der Staatlichen Kunstsammlungen Dresden* 28 (2000), 33–46, esp. 35, 37. See also Syndram, *The Throne of the Great Mogul in the Green Vault*, 26, as well as 7–8 for a 1725 inventory that enumerates thirty-three gifts rather than the thirty-two counted today. The gap is probably due to a second freestanding mirror now missing.

8. Aurangzeb reputedly retired the weighing ceremony some ten years into his reign but also recommended it to his grandson, and travelers' reports are inconsistent about its subsequent use: see Audrey Truschke, *Aurangzeb: The Life and Legacy of India's Most Controversial King*, Stanford, CA, 2017, 41–43, 98–99.

Chapter 1. Mirrors

1. Erin McBurney, "Art and Power in the Reign of Catherine the Great: The State Portraits," PhD diss., Columbia University, 2014; Luba Golburt, *The First Epoch: The Eighteenth Century and the Russian Cultural Imagination*, Madison, WI, 2014, 293n71.

2. McBurney, "Art and Power," 135–137; Golburt, *The First Epoch*, 59–62. The locus classicus for the medieval theory is Ernst Kantorowicz, *The King's Two Bodies: A Study in Mediaeval Political Theology*, Princeton, NJ, 1957.

3. The Islamic world had a rich parallel tradition to the Western one, though there are few demonstrable direct links between these two worlds. Linda Darling, "*Mirrors for Princes* in Europe and the Middle East: A Case of Historiographical Incommensurability," in A. Classen (ed.), *East Meets West in the Middle Ages and Early Modern Times*, Berlin, 2013, 223–242.

4. Petrus Belluga, *Speculum principum*, Brussels, 1655.

5. J. A. Emmens, "Les Ménines de Velásquez: Miroir des princes pour Phillipe IV," *Nederlands Kunsthistorisch Jaarboek* 12 (1961), 50–79; Joel Snyder, "Las Meninas and the Mirror of the Prince," *Critical Inquiry* 11 (1985), 539–572.

6. On this painting, today at Le Mans, France (Musée de Tessé), see Emmens, "Les Ménines de Velásquez," 63–65, and Hall Bjørnstad, *The Dream of Absolutism: Louis XIV and the Pre-Modern Logic of Modernity*, Chicago, 2021, 103–105. To my knowledge, the only scholar who has noticed the divergence between the scene and its mirror reflection is Thomas Gaehtgens, "Begegnung von Herrschern," in Martin Warncke et al. (eds.), *Handbuch der politischen Ikonographie*, Munich, 2011, 1:127–128.

7. Nationalmuseum, Stockholm, inv. no. NM 7060.

8. Sylvia Krauss-Meyl, *"Die berühmteste Frau zweier Jahrhunderte": Maria Aurora Gräfin von Königsmarck*, Regensburg, 2006, 42–43, 144–149, 227.

9. Jutta Kappel and Ulrike Weinhold, *The New Grünes Gewölbe: Guide to the Permanent Collection*, Dresden, 2007, 50–51; Jessica Keating, *Animating Empire: Automata, the Holy Roman Empire, and the Early Modern World*, University Park, PA, 2018, 52–57; Baron von Pöllnitz, *Mémoires de Charles-Louis Baron de Pöllnitz*, new edn., Liège, 1734, 1:151–152.

10. This is a large parade bowl (Grünes Gewölbe inv. no. VIII 304), on top of which is a figure of Hercules overcoming the Nemean lion. Behind Hercules is a miniature crowned mirror, seemingly oddly positioned to reflect the back of Hercules but in fact returning the reflection of the spectator combined with a frontal view of the heroic demi-god. Lest the intended viewer remain in doubt, the back of the mirror, underneath the crown, bears an enameled portrait of Augustus made by Georg Friedrich Dinglinger. Cf. Erna von Watzdorf, *Johann Melchior Dinglinger: Der Goldschmied des deutschen Barock*, Berlin, 1962, 1:191–200, and Kappel and Weinhold, *The New Grünes Gewölbe*, 207–208. For Augustus as Hercules, see Jerzy Banach, "Kurfürst, Halbgott, König: August der Starke als Hercules Saxonicus," *Jahrbuch der Staatlichen Kunstsammlungen Dresden* 19 (1987), 39–52.

11. Sebastian Neumeister, *Mythos und Repräsentation: Die mythologischen Festspiele Calderóns*, Munich, 1978, 270ff; Marvin Carlson, *Places of Performance: The Semiotics of Theatre Architecture*, Ithaca, NY, 1989, 140–141; Jaime Cuenca, "The Princely Viewpoint: Perspectival Scenery and Its Political Meaning in Early Modern Courts," in Sven Dupré (ed.), *Perspective as Practice: Renaissance Cultures of Optics*, Turnhout, Belgium, 2019, esp. 165–166. I am grateful to opera stage director Krystian Lada for his helpful insights.

12. Cf. Jonathan Brown, *Velázquez: Painter and Courtier*, New Haven, CT, 1986, 259, about *Las Meninas* as a private painting intended for an audience of one, the king, even as it was seen by many.

13. Earlier, during the prologue to the performance, this idealized mirroring effect was matched by another apparition on center stage, an allegorical vision of the apotheosis of Leopold, who appeared as a vigorous equestrian statue. See the contemporary account quoted in A. A. Stanley, "Cesti's *Il pomo d'oro*," *Papers and Proceedings of the Music Teachers' National Association* 1 (1906), 143–144, and Cuenca, "The Princely Viewpoint," 165, color plates 15–16.

14. Neumeister, *Mythos und Repräsentation*, 278–283, 282 (quotation; I am grateful to Efrain Kristal for help with the translation); J. E. Varey, "The Audience and the Play at Court Spectacles: The Role of the King," *Bulletin of Hispanic Studies* 61 (1984), 399–406; Varey, "L'Auditoire du *Salón Dorado de l'Alcázar* de Madrid," in J. Jacquot (ed.), *Dramaturgie et société*, Paris, 1968, esp. 91.

15. *Le triomphe de l'amour. Ballet, dancé devant sa Maiesté a S. Germain en Laye le 21. jour de Ianvier 1681*, Paris, 1681, frontispiece; Joseph Gregor, *Kulturgeschichte des Balletts*, Vienna, 1944, 215, plate 68. This publication was in the Dresden library of Ehrenfried Walther von Tschirnhaus: *Catalogus und Specification unterschiedener gebundener und ungebundener Bücher . . . des Hrn. Raths von Tschirnhaus*, [Görlitz], 1723, no. 57. For Tschirnhaus's relationship with Dinglinger and his project, see chapter 10, below.

16. Frederick M. Link, "Introduction," in John Dryden, *Aureng-Zebe*, Lincoln, NE, 1971, esp. xvi–xx; George McFadden, *Dryden: The Public Writer, 1660–1685*, Princeton, NJ, 1978, 181–202. See also Peter Craft, "Dryden's Transformation of Bernier's *Travels*," *Restoration: Studies in English Literary Culture* 33:2 (2009), 47–55, and Mita Choudhury, *Interculturalism and Resistance in the London Theater, 1660–1800*, Lewisburg, PA, 2000, 136–137.

17. John Dryden, *Aureng-Zebe, a Tragedy. Acted at the Royal Theatre*, London, 1676, 12. The performances took place in November 1675. Cf. Samuel Johnson, *The Lives of the English Poets*, London, 1826 (orig. 1779), 1:231: " 'Aureng-Zebe' (1676) is a tragedy founded on the actions of a prince then reigning, but over nations not likely to employ their critics upon the transactions of the English stage. . . . His country is at such a distance, that the manners might be safely falsified, and the incidents feigned."

18. François Bernier, *Histoire de la derniere revolution des états du Grand Mogol*, Paris, 1670; Bernier, *Suite des memoires*, Paris, 1671; Faith Beasley, *Versailles*

Meets the Taj Mahal: François Bernier, Marguerite de la Sablière, and Enlightening Conversations in Seventeenth-Century France, Toronto, 2018.

19. Jean-Baptiste Tavernier, *Beschreibung der sechs Reisen, . . . in Türckey, Persien und Indien*, Geneva, 1681, book 1, sig. 4–2.

20. Jean-Baptiste Tavernier, *Vierzig Jährige Reise Beschreibung. Worinnen dessen durch Türkey, Persien, Indien . . . In Dreyen Theilen*, Nuremberg, 1681, 2:83. Translation based on V. Ball (ed.), *Travels in India by Jean-Baptiste Tavernier*, 2nd edn., New Delhi, 1995, 1:260. For the illustration Dinglinger used from this same page, see chapter 11, below.

21. For an interpretation of the *Throne of the Great Mogul* that gives pride of place to the image of a ruler rich in jewels, and to the jewels as a metonymy for the abundance of India, see Kim Siebenhüner, *Die Spur der Juwelen: Materielle Kultur und transkontinentale Verbindungen zwischen Indien und Europa in der Frühen Neuzeit*, Cologne, 2018, chap. 2, esp. 68–79.

22. It was also somewhat out of date, since by the first decade of the eighteenth century Aurangzeb's rule was in decline. Given the distance and scarcity of information, however, the news was not yet much noted in Europe, not least in Dresden.

23. François Bernier, *Voyages de François Bernier, . . . contenant la description des états du Grand Mogol, de l'Hindoustan, du Royaume de Kachemire, etc.*, Amsterdam, 1699, 1:319–320. Translation based on Bernier, *Travels in the Mogul Empire, A.D. 1656–1668*, revised edn., transl. Irving Brock and Archibald Constable, London, 1891, 236, 238.

24. See, for example, Stanley Tambiah, "What Did Bernier Actually Say? Profiling the Mughal Empire," *Contributions to Indian Sociology* 32 (1998), 361–386, and Beasley, *Versailles Meets the Taj Mahal*.

25. Bernier, *Voyages de François Bernier*, 1:268. The English translation omits the denial of "barbarian": Bernier, *Travels in the Mogul Empire*, 199.

26. Tavernier, *Vierzig Jährige Reise Beschreibung*, 2:34 (English translation in Ball [ed.], *Travels in India by Jean-Baptiste Tavernier*, 1:111); Bernier, *Voyages de François Bernier*, 2:55–56.

27. Watzdorf, *Johann Melchior Dinglinger*, 1:96ff; Dirk Syndram, *Das Goldene Kaffeezeug Augusts des Starken*, Leipzig, 1997; Syndram, *Juwelenkunst des Barock: Johann Melchior Dinglinger im Grünen Gewölbe*, Munich, 2008, 20–23; and see further chapter 3, below. Augustus had in fact already sent for 120 objects from his *Schatzkammer* to impress the Poles when he was campaigning for his election in 1697: cf. Jutta Bäumel, *Auf dem Weg zum Thron: Die Krönungsreise Augusts des Starken*, Dresden, 1997, 67–73.

28. Syndram, *Juwelenkunst des Barock*, 26–27; Dirk Syndram and Jörg Schöner, *August der Starke und sein Grossmogul*, Munich, 2014, 10–11.

29. Jacob Heinrich Graf von Flemming, "Portrait d'un Roi. Eine Charakterstudie Augusts des Starken," in *Jahrbuch der Staatlichen Kunstsammlungen Dresden* 33 (2006–2007), 23. Cf. Jean Louis Sponsel, *Der Zwinger, Die Hoffeste und die Schloßbaupläne ʒu Dresden*, Dresden, 1924, esp. 99–100. I am grateful to Peter Heinrich Jahn for help on this point.

30. This curious resemblance is noted in Carsten-Peter Warncke, "Johann Melchior Dinglingers 'Hofstaat des Grossmoguls'—Form und Bedeutung eines virtuosen Goldschmiedekunstwerkes," *Anʒeiger des Germanischen Nationalmuseums* (1988), 173. Cf. Walter Hentschel, *Die sächsische Baukunst des 18. Jahrhunderts in Polen*, Berlin, 1967, 1:91–92, 2:fig. 104, and *Unter* einer *Krone: Kunst und Kultur der sächsisch-polnischen Union* (exh. cat.), Leipzig, 1997, 397. No less curiously, a similar plan resurfaced in Luneville for the palace gardens of Stanisław Leszczyński, the Polish claimant to the throne whom Augustus the Strong would defeat in 1709: Emmanuel Héré, *Receuil des plans . . . des chateaux . . . que le Roi de Pologne occupe en Lorraine*, part 1, Paris, [1750–1753], "Vue en perspective de la cascade et du pavillon en bout du canal des jardins de Lunéville" (n.p.). Joachim Menzhausen has suggested that the architectural layout of the *Throne of the Great Mogul* also influenced the design of the most important achievement of the Augustian Baroque, the Zwinger in Dresden: Joachim Menzhausen, "Pöppelmann und Dinglinger," in Harald Marx (ed.), *Matthäus Daniel Pöppelmann: Der Architekt des Dresdner Zwingers*, Leipzig, 1989, 196–198.

31. Dirk Syndram, *Renaissance and Baroque Treasury Art: The Green Vault in Dresden*, transl. D. Kletke, Dresden, 2005, 112–113; Dirk Syndram and Claudia Brink (eds.), *The Dream of a King: Dresden's Green Vault*, Munich, [2012], cat. no. 36. The close association of triumphal arches with royalty is evident in Johann von Besser's account of the 1701 coronation of Friedrich III/I of Prussia in which the description of the ephemeral arches erected for the event overshadows all other discussions of architecture in his works; cf. Kristoffer Neville, "Royal and Roman in the Rebuilding of Berlin c. 1700," in Jeffrey Chipps Smith (ed.), *Visual Acuity and the Arts of Communication in Early Modern Germany*, Burlington, VT, 2014, 208–210, and 212–214 for the telling incorporation of enormous triumphal arches into the design of the new royal palace in Berlin. *Preussen 1701: Eine europäische Geschichte* (exh. cat.), Berlin, 2001, 1:154–156. For the triumphal arches erected for Augustus's coronation in Krakow, see Bäumel, *Auf dem Weg ʒum Thron*, 113.

32. This may have been a pattern for Augustus. There is another example from the same years of two Dresden jewelers—Dinglinger and his brother-in-law Gottfried Döring—producing two very similar ornate vessels, seemingly independently of each other but surely not coincidentally. Syndram, *Juwelenkunst des Barock*, 26–27.

33. Christian Reuter, *Schelmuffsky Curiose und Sehr gefährliche Reisţebeschreibung ţu Wasser und Land*, St.-Malo, France, 1696. See also Joachim Menzhausen, *At the Court of the Great Mogul*, Leipzig, 1965, 15–16 (his translations). Note that Schelmuffsky's name has a German root, *Schelm* (rogue), fitted with Polish suffixes: a wordplay that might have appealed to the Saxon-prince-turned-king of Poland. Ernst Gehmlich, *Christian Reuter, der Dichter des Schelmuffsky*, Leipzig, 1891; *Unter einer Krone*, 353–354; Christoph Schweitzer, "Christian Reuter," in J. Hardin (ed.), *German Baroque Writers, 1661–1730*, Washington, DC, 1996, 342–349.

Chapter 2. Crowns

1. The following paragraphs draw on Karl Czok, *August der Starke und seine Zeit*, Munich, 2010 (orig. 1989); Czok, "Ein Herrscher—zwei Staaten: Die sächsisch-polnische Personalunion als Problem des Monarchen aus sächsischer Sicht," in Rex Rexheuser (ed.), *Die Personalunionen von Sachsen-Polen 1697–1763 und Hannover-England 1714–1837: Ein Vergleich*, Wiesbaden, Germany, 2005, 103–119; Jacek Staszewski, "Die sächsisch-polnische Union," in *Unter einer Krone: Kunst und Kultur der sächsisch-polnischen Union* (exh. cat.), Leipzig, 1997, 15–19; Helen Watanabe-O'Kelly, *Court Culture in Dresden from Renaissance to Baroque*, Basingstoke, U.K., 2002; and Elisabeth Tiller, "Augustus the Strong's Polish Spaces of Representation," in Piotr Salwa (ed.), *Polish Baroque, European Contexts*, Warsaw, 2012, 95–125.

2. "Je n'aurois pas cru que cet Electeur eut poussé si loing cette idée chimérique": Janson Forbin, French envoy to Rome, to Abbé de Polignac, 21 June 1697, in Paul Haake, "Die Wahl Augusts des Starken zum König von Polen," *Historische Vierteljahrsschrift* 9 (1906), 52–53n.

3. The same was true also in Lithuania. In 1701, for instance, a "fake news" declaration was circulated there, supposedly claiming that the rights of the nobility were annulled in favor of the absolute rule of Augustus and his Wettin descendants of whatever gender, a scare-tactic document intended to generate resistance. *The Saxon Electors—The Grand Dukes of Lithuania* (exh. cat.), Vilnius, 2018, 40, 96.

4. Liselotte to Electress Sophia of Hanover, 1 August 1697, in Paul Haake, *August der Starke im Urteil seiner Zeit und der Nachwelt*, Dresden, 1922, 6–7. See Jutta Bäumel, *Auf dem Weg zum Thron: Die Krönungsreise Augusts des Starken*, Dresden, 1997, 8, 32–33. And compare the ditty in Richard Burridge, *The Apostate Prince; or, a Satyr against the King of Poland*, London, 1700, 12, mocking Augustus: "Power you've none; for the Republick Rules / As it thinks fit; Crowns are but lent by Poles" (quoted in Watanabe-O'Kelly, *Court Culture in Dresden*, 197). The "Republick" refers to the Rzeczpospolita, the Polish-Lithuanian commonwealth.

5. For the chronology of Augustus's movements, see *Unter einer Krone*, 49–53. Augustus was absent from Dresden from early June 1697 to late August 1699 and frequently thereafter.

6. Inter alia, Augustus's conversion induced in 1700 a biting parody from the pen of the irrepressible Christian Reuter, included in a comedy about a real-life favorite of Augustus, which may have caused the author of Schelmuffsky to lose favor himself, leading him to move shortly thereafter to Berlin: cf. Christoph Schweitzer, "Christian Reuter," in J. Hardin (ed.), *German Baroque Writers, 1661–1730*, Washington, DC, 1996, 347–348.

7. For the tensions produced by Augustus's conversion with his wife, Christiane Eberhardine, who consequently never set foot on Polish soil and was never crowned, see Helen Watanabe-O'Kelly, "Religion and the Consort: Two Electresses of Saxony and Queens of Poland (1697–1757)," in C. C. Orr (ed.), *Queenship in Europe, 1660–1815: The Role of the Consort*, Cambridge, 2004, 252–275, and Silke Herz, *Königin Christiane Eberhardine—Pracht im Dienst der Staatsraison*, Berlin, 2020, 40–44. The absence of women in the *Throne of the Great Mogul* is accentuated when viewed against the backdrop of the two-dimensional backside of the ensemble, probably added by another artist, which displays female figures prominently (see plate 47). This absence is particularly noteworthy given Bernier's detailed account of the unusually prominent role women held in the Mughal court. A further difficulty with the presentation of women in Dinglinger's court of the Great Mogul might have been the fact that from 1701, Augustus's mistress was a dark-skinned Ottoman woman (a former captive of war), known by the name of Fatima, later Maria Aurora von Spiegel.

8. *Wouter Schoutens Oost-Indische voyagie*, Amsterdam, 1676, 3:opposite 74; Walter Schultzen, *Ost-Indische Reyse*, Amsterdam, 1676, 2:165 (smaller-size illustration). The Dutch title page specifies that the illustrations were based on drawings made by Schouten himself in India. It is unclear from the text

whether this illustration was supposed to represent the Mughal's birthday or the New Year celebration, though the editor of the modern edition assumes the latter: Michael Breet, *De Oost-Indische voyagie van Wouter Schouten*, Zutphen, Netherlands, 2003, 14, 379.

9. Walter Holzhausen, "Die Rolle der Graphik im Werk Johann Melchior Dinglingers," *Die graphischen Künste* 4 (1939), 100; Allison Stielau, "In Tribute: Dinglinger's 'Court of Delhi' in the Grünes Gewölbe, Dresden," unpublished paper, 2010. See also Corinna Forberg, "Copying the World's Emperor: Dinglinger's Great Moghul and the French Model of Absolute Power," in C. Forberg and P. W. Stockhammer (eds.), *The Transformative Power of the Copy*, Heidelberg, 2017, 385. For the connection of the hanging weapons and Tavernier, see Dirk Syndram and Jörg Schöner, *August der Starke und sein Grossmogul*, Munich, 2014, 20.

10. V. Ball (ed.), *Travels in India by Jean-Baptiste Tavernier*, 2nd edn., New Delhi, 1995, 1:295.

11. François Bernier, *Travels in the Mogul Empire, A.D. 1656–1668*, revised edn., transl. Irving Brock and Archibald Constable, London, 1891, 268; Milo Beach and Ebba Koch, *King of the World: The Padshahnama*, London, 1997, 201–203; René Brus, *Crown Jewellery and Regalia of the World*, Amsterdam, 2011, 36; Christiane Hille, "Gems of Sacred Kingship: Faceting Anglo-Mughal Relations Around 1600," in C. Göttler and M. Mochizuki (eds.), *The Nomadic Object: The Challenge of World for Early Modern Religious Art*, Leiden, 2018, 309–314.

12. Bernier, *Travels in the Mogul Empire*, 268. On the Mughal emperors' not wearing crowns, although such items were not unfamiliar to them, see Lucien de Guise, *Jewels Without Crowns: Mughal Gems in Miniatures* (exh. cat.), Kuala Lumpur, 2010, 25–26, 95. Note also 34, 40–41, 106–107, for the mythical "Timurid crown" depicted in several Mughal miniatures as passed on from one ruler to another. It is always shown hand-held, not worn, and has the appearance not of a crown but of an ornamented cap, topped again by an aigrette. In several mixed-style miniatures one also finds Western angels holding an incongruous European-style crown in the sky high above the turbaned Mughal emperor: cf. Stuart Cary Welch et al., *The Emperor's Album: Images of Mughal India* (exh. cat.), New York, 1987, 96–97, 206–209, and Guise, *Jewels Without Crowns*, 72.

13. Dinglinger made both aigrettes before 1719. Dirk Syndram, *Juwelenkunst des Barock: Johann Melchior Dinglinger im Grünen Gewölbe*, Munich, 2008, 48 (including a drawing of an aigrette in Dinglinger's hand), 156–157.

14. Corinna Forberg, "What Does the Emperor of India Look Like? European Representations of Indian Rulers (1650–1740)," in P. Malekandathil (ed.), *The Indian Ocean in the Making of Early Modern India*, New Delhi, 2016, 217.

15. Daniel Fulco, *Exuberant Apotheoses: Italian Frescoes in the Holy Roman Empire*, Leiden, 2016, 148–149; Karl Theodor Heigel, "Ueber den Plan des Kurfürsten Johann Wilhelm von der Pfalz, die armenische Königskrone zu gewinnen (1698–1705)," in *Sitzungsberichte der philosophisch-philologischen und der historischen Classe der koeniglischen bayerischen Akademie der Wissenschaften zu München*, Munich, 1893, 273–319.

16. Ragnhild Hatton, *George I: Elector and King*, Cambridge, MA, 1978, 70–78. Interestingly, none of the fifty-four Catholics ahead of Sophia and Georg in the line of succession chose to convert to Protestantism in order to obtain the crown of England.

17. Christopher Clark, "When Culture Meets Power: The Prussian Coronation of 1701," in Hamish Scott and Brendan Simms (eds.), *Cultures of Power in Europe During the Long Eighteenth Century*, Cambridge, 2007, 14–35.

18. Quoted in Tony Sharp, *Pleasure and Ambition: The Life, Loves and Wars of Augustus the Strong*, London, 2001, 147. In June 1698 Augustus and Friedrich met in Prussian Johannisburg, and it is likely that the latter's coronation project was a topic of discussion. Stepney reported from hearsay a tussle over which prince got to sit in the tall armchair, in a manner that appears to mock their competitive throne seeking: "It is true the Elector has gain'd the point, and *had his arm'd chair*, wch triumph de fauteuil, you may expect, will be placed among the trophies of ye Family": George Stepney to James Vernon, 13 June 1698, quoted in Albert Waddington, *L'Acquisition de la couronne royale de Prusse par les Hohenzollern*, Paris, 1888, 168n3.

19. Clark, "When Culture Meets Power," 27; Karin Friedrich, "The Power of Crowns: The Prussian Coronation of 1701 in Context," in Karin Friedrich and Sara Smart (eds.), *The Cultivation of Monarchy and the Rise of Berlin: Brandenburg-Prussia 1700*, Farnham, U.K., 2010, 4–6; Harold Acton, *The Last Medici*, London, 1980 (orig. 1932), 181–182. Interestingly, the duke of Savoy at the same time passed on the opportunity to claim the Crown of England by converting to Protestantism: Hatton, *George I*, 74.

20. The numerous investments in new and redesigned princely palaces c. 1700 are listed in Peter Baumgart, "Der deutsche Hof der Barockzeit als politische Institution," in August Buck et al. (eds.), *Europäische Hofkultur im 16. und 17. Jahrhundert*, Hamburg, 1981, 27–28. Cf. T. C. W. Blanning, *The Culture of Power and the Power of Culture: Old Regime Europe, 1660–1789*, Oxford, 2003, 60.

21. Hermann Fillitz, *Die österreichische Kaiserkrone und die Insignien des Kaisertums Österreich*, Vienna, 1959, 22–23; Beket Bukovinská, "Zu den Goldschmiedearbeiten der Prager Hofwerkstätte zur Zeit Rudolfs II," *Leids Kunsthistorisch Jaarboek* 1 (1982), 71–82.

22. "Aber wir seindt ja gleiches stoffs undt von churfürstlichen kindern königliche geworden." Liselotte to Luise Raugräfin zu Pfalz, 17 October 1715, in Wilhelm Ludwig Holland (ed.), *Briefe der Herzogin Elisabeth Charlotte von Orleans*, Tübingen, Germany, 1867–1881, 2:652; Mogens Bencard, *The Hen in the Egg*, Amalienborg, Denmark, 1999, 22–23; Joanna Marschner, "The Ivory Egg: Elisabeth Charlotte, Princess Palatine's Gift to Caroline of Ansbach," in J. Bepler and S. Norrhem (eds.), *Telling Objects: Contextualizing the Role of the Consort in Early Modern Europe*, Wiesbaden, Germany, 2018, 233–254, 247, 247n47 (quotations).

23. Sharp, *Pleasure and Ambition*, 184, 198, 214, quoting from the diplomatic correspondence of George Stepney and John Robinson. For historians' assessment of Charles's considerations in the campaign to dethrone Augustus, including critics who "have had much to say on this remarkable ranking of priorities," see J. B. Hattendorf et al. (eds.), *Charles XII: Warrior King*, [n.p.], 2018, 59–60, 78 (quotation), 219, 281–284.

24. Quoted in Clark, "When Culture Meets Power," 26.

25. The following paragraphs are based, first and foremost, on the important work of Barbara Stollberg-Rilinger: "*Honores regii*: Die Königswürde im zeremoniellen Zeichensystem der Frühen Neuzeit," in Johannes Kunisch (ed.), *Dreihundert Jahre Preußische Königskrönung: Eine Tagungsdokumentation*, Berlin, 2002, 1–26; *The Emperor's Old Clothes: Constitutional History and the Symbolic Language of the Holy Roman Empire*, New York, 2015 (German edn. 2008), chap. 3; and "State and Political History in a Culturalist Perspective," in Antje Flüchter and Susan Richter (eds.), *Structures on the Move: Technologies of Governance in Transcultural Encounter*, Heidelberg, 2012, 49–54 ("The Symbolic Construction of Sovereignty"). See also Clark, "When Culture Meets Power," 26–28, and Friedrich, "The Power of Crowns," 5–6.

26. The situation in the second half of the seventeenth century was quite different from that before the Thirty Years' War. When the Palatine Elector Friedrich V assumed the crown of Bohemia in 1619 against the wishes of the Holy Roman Emperor, he provoked the latter to a full-scale military conflict that resulted in Friedrich's deposition from his positions as king and elector within a year, hence his sobriquet "the Winter King."

27. This process is analyzed in detail in Stollberg-Rilinger, *"Honores regii,"* 16–23. It may account for stories that circulated about actual tussles between electors and princes at diplomatic meetings over who got to sit in the higher armchair. In addition to the rumor about such a struggle between Augustus and Friedrich III/I in 1698 (see note 18, above), Baron von Pöllnitz reported a similar armchair dispute between Friedrich and William III of England in 1695: *The Memoirs of Charles-Lewis, Baron de Pöllnitz*, London, 1738, 3:12.

28. Acton, *The Last Medici*, 181–182: Johann Wilhelm and Anna Maria Luisa's betrothal was suggested by the emperor as a consolation prize for the grand duke, following his dismay at the earlier quasi-royal promotion of the duke of Savoy.

29. Thus, in Turin the House of Savoy continued to pursue royal status—a pursuit they had begun in the 1630s with a medieval claim—realizing that only a real crown and kingdom, rather than diplomatic concessions from other rulers, would secure their place in the circle of monarchs. The Savoyard dukes finally attained this goal with the crown of Cyprus in 1713. See Robert Oresko, "The House of Savoy in Search of a Royal Crown in the Seventeenth Century," in Robert Oresko et al. (eds.), *Royal and Republican Sovereignty in Early Modern Europe*, Cambridge, 1997, 272–350.

30. For signs of frustration, see, for instance, the missives of the Brandenburg-Prussia envoy to Vienna, Christian Friedrich von Bartholdi, who on different occasions informed Friedrich III that the dukes of Savoy, Tuscany, and Lorraine had been received as royal highnesses at the emperor's court: Waddington, *L'Acquisition de la couronne royale de Prusse*, 41. Or consider the bitter complaint of the envoy of the Elector Palatine, who during the 1678 peace conference of Nijmegen found himself assigned a high-back chair, lesser than the fauteuils of the ambassadors of the emperor and the "Têtes Couronnées": quoted in Jeannette Falcke, *Studien zum diplomatischen Geschenkwesen am brandenburgisch-preußischen Hof im 17. und 18. Jahrhundert*, Berlin, 2006, 115.

31. "Kurzer Entwurff der Magnificenz des großen Moguls, an seinen Geburths Tage bey Überreichung derer Geschencke," 10026 Geheimes Kabinett loc. 2928/2, f. 659, Hauptstaatsarchiv Dresden; with translation in Joachim Menzhausen, *At the Court of the Great Mogul*, Leipzig, 1965, part 2:8. Regarding Dinglinger's role in the authorship of this text, see chapter 8, below.

32. Gottfried Wilhelm Leibniz, *Germani Curiosi Admonitiones*, 1678, partly translated in Stollberg-Rilinger, *The Emperor's Old Clothes*, 134. Although this was surely not a new phenomenon of the second half of the seventeenth century,

Leibniz diagnosed it to have now acquired a new urgency. Leibniz, "Anhang, betreffend dasjenige was nach heutigen Völcker Recht zu einem König erfordert wird" (1701), in Gottschalk Eduard Guhrauer (ed.), *Leibniz's Deutsche Schriften*, Berlin, 1840, 2:306, 308. The ceremonial essence of the Holy Roman Empire's political structure has been analyzed and explicated by Barbara Stollberg-Rilinger; I am grateful to her for many conversations on the subject.

33. Clark, "When Culture Meets Power," 17–18; *Preussen 1701: Eine europäische Geschichte* (exh. cat.), Berlin, 2001, 1:130–132; Oresko, "The House of Savoy," 279–283. For the crucial significance of crowns and the ceremonial aspects of coronations in this period, see Stollberg-Rilinger, *The Emperor's Old Clothes*, 148, 156, as well as 159 for a public brawl over which elector carried and held the emperor's crown at his coronation in Regensburg.

34. Bäumel, *Auf dem Weg zum Thron*, 124–126; Jutta Bäumel, "Die polnische Krönungsfigur Augusts II., des Starken, in der Dresdner Rüstkammer," in *Jahrbuch der Staatlichen Kunstsammlungen Dresden* 27 (1998–1999), 52, 57–60. In 1705 King Stanisław I could not get access to the authentic Polish crown held by Augustus, and thus his counter-coronation was undertaken with replicas specially ordered by Charles XII for the occasion: Robert Nisbet Bain, *Scandinavia: A Political History of Denmark, Norway and Sweden from 1513 to 1900*, Cambridge, 2013 (orig. 1905), 325.

35. For a detailed chronology of events during the reign of Augustus the Strong, and of Augustus's own movements, see *Unter einer Krone*, 31–36, 49–53.

36. Wilhelm Ernst Tentzel, *Curieuse Bibliothec*, Frankfurt, 1706, 3:79–80; Ulli Arnold, *Die Juwelen August des Starken*, Munich, 2001, 34–39; Syndram, *Juwelenkunst des Barock*, 27–29. The order's name harked back to a defunct medieval Polish order.

37. Stollberg-Rilinger, *The Emperor's Old Clothes*, 127.

38. Peter Baumgart, "Die preußische Königskrönung von 1701, das Reich und die europäische Politik," in Oswald Hauser (ed.), *Preußen, Europa und das Reich*, Cologne, 1987, 77; Friedrich, "The Power of Crowns," 37–40. Two other coveted orders existed for centuries, the Emperor's Order of the Golden Fleece, renewed in 1713, and the English king's Order of the Garter. Augustus's efforts to receive from King William III the Order of the Garter, which had been bestowed on his older brother when he was elector, were frustrated numerous times: cf. Sharp, *Pleasure and Ambition*, 120, 127, 145.

39. The description, from Dinglinger's bill for the first twelve jewels upon their delivery on 18 October 1705, is quoted in Arnold, *Die Juwelen August des Starken*, 34.

40. Quoted in Sharp, *Pleasure and Ambition*, 247; for Altranstädt, see 295n7. For Augustus's clandestine assurances to Poland that he would be back, see Jerzy Lubowski, *Liberty's Folly: The Polish-Lithuanian Commonwealth in the Eighteenth Century, 1697–1795*, London, 1991, 138.

41. Robinson to Harley, Leipzig, 6/17 August 1707, SP 88/17, f. 269, U.K. National Archives (formerly Public Record Office [PRO]), Kew; Robinson to Harley, Leipzig, 13/24 August 1707, SP 88/17, f. 272, PRO; [Wilhelm Ernst Tentzel], *Recht des Chur-Hauses Sachsen auf die Zwey Königreiche Neapolis und Sicilien*, [n.p.], 1707, 22.

42. Upon Leopold's death Augustus became one of the two imperial vicars, together with Johann Wilhelm von der Pfalz. There were rumors of secret negotiations in order to settle the imperial succession on the house of Wettin should Leopold have no legitimate heirs, and even a document apparently written by Augustus the Strong in 1705 titled "Project in fahl das Haus Estraich absterben sohltes": Sharp, *Pleasure and Ambition*, 220, 292–293n6. Augustus's main success in getting the house of Wettin closer to the imperial throne was to come later with the 1719 marriage of his son, later Augustus III, to the daughter of the emperor.

43. Erna von Watzdorf, *Johann Melchior Dinglinger: Der Goldschmied des deutschen Barock*, Berlin, 1962, 2:388; Syndram, *Juwelenkunst des Barock*, 31.

44. The characterization of the Leipzig Fair, from Heinrich Engelbert Schwarz, *Etwas Altes und Neues bestehende in kurtzer Vergleichung der . . . Zwo Städte Jericho und Leipzig*, Leipzig, 1748, 37, is translated and quoted in Yair Mintzker, *The Many Deaths of Jew Süss: The Notorious Trial and Execution of an Eighteenth-Century Court Jew*, Princeton, NJ, 2017, 237. Cf. Karl Czok, "August der Starke und die Leipziger Messe," in Volker Rodekamp (ed.), *Leipzig, Stadt der wa(h)ren Wunder: 500 Jahre Reichsmesseprivileg* (exh. cat.), Leipzig, 1997, 77–84, and Katharina Hofmann-Polster, *Der Hof in der Messestadt: Zur Inszenierungspraxis des Dresdner Hofes auf den Leipziger Messen (1694–1756)*, Stuttgart, 2014, esp. 74–83, and 312ff, for the records of Augustus's visits to the fair.

45. Czok, "Ein Herrscher—zwei Staaten," 114 (quotation). See Czok, *August der Starke*, 161. Throughout this difficult year Augustus continued to transfer sums of money to the Dinglinger brothers in order to put their minds at ease and keep them at work. Syndram, *Juwelenkunst des Barock*, 30–31, and 24 for an image of the dated inscription at the bottom of the figure of the Great Mogul.

46. Jutta Kappel and Ulrike Weinhold, *The New Grünes Gewölbe: Guide to the Permanent Collection*, Dresden, 2007, 71–72; Syndram, *Juwelenkunst des Barock*, 32–35.

47. Iccander [Johann Christian Crell], *Das fast auf dem höchsten Gipfel seiner Vollkommenheit und Glückseligkeit prangende Königliche Dreßden*, 3rd edn., Leipzig, 1726, 72.

48. Syndram, *Juwelenkunst des Barock*, 33–34, 124–127.

49. Jutta Bäumel, "Augustus the Strong as the Sun God Apollo," in *The Glory of Baroque Dresden: The State Art Collections Dresden* (exh. cat.), Jackson, MS, 2004, 27–29.

50. ". . . mit einem Löwen-Kopff, auff demselben eine Crone": from a bill for 718 thalers for the now-lost helmet, a much higher sum than for other parts of the costumes for this event, quoted in Watzdorf, *Johann Melchior Dinglinger*, 1:93. Claudia Schnitzer, *Höfische Maskeraden: Funktion und Ausstattung von Verkleidungsdivertissements an deutschen Höfen der frühen Neuzeit*, Berlin, 2014, 163–165, plates 152–155, for Augustus's notations on the drawings of the African quadrille, based on the earlier engravings from Louis XIV's court. Cf. Schnitzer, "Herrschende und diende 'Mohren' in den Festen Augusts des Starken," in Kerstin Volker-Saad and Anna Greve (eds.), *Äthiopien und Deutschland: Sehnsucht nach der Ferne*, Munich, 2006, 86–101, where she also points out that Augustus had already dressed up as an African leader, in a Warsaw masquerade in 1701. See also Dieter Schaal, "The Dresden Festivities of 1709," *Livrustkammaren*, Uddevalla, Sweden, 1994, 121–130, and C. Schnitzer and Petra Hölscher (eds.), *Eine gute Figur machen: Kostüm und Fest am Dresdner Hof* (exh. cat.), Amsterdam, 2000, 156–168.

51. For the painting that presented the three crowned heads as equals while skillfully hiding the fact that Augustus was taller than the other two royals, see Thomas Gaehtgens, "Begegnung von Herrschern," in Martin Warncke et al. (eds.), *Handbuch der politischen Ikonographie*, Munich, 2011, 1:128–129.

Chapter 3. Thrones

1. Andreas Stübel, *Aufgefangene Brieffe, welche zwischen etzlichen curieusen Personen über den jetzigen Zustand der Staats und gelehrten Welt gewechselt worden*, Wahrenberg [Leipzig], 1699, 1:208–210, plate after 206.

2. See Ewa Łomnicka-Żakowska, *Graficzne portrety Augusta II i Augusta III Wettynów w zbiorach Muzeum Narodowego w Warszawie*, Warsaw, 1997, nos. 19–21, 23–25, 73, 81–84. I am grateful to Anna Grochala of the National Museum in Warsaw for her help with these portraits.

3. For the following paragraph I found two essays in exhibition catalogs especially useful: Adam Zamoyski, "History of Poland in the 16th–18th Centuries," in Jan K. Ostrowski et al., *Land of the Winged Horsemen: Art in Poland,*

1572–1764 (exh. cat.), Alexandria, VA, 1999, 27–37, and Paulina Banas, "Persian Art and the Crafting of Polish Identity," in Axel Langer (ed.), *The Fascination of Persia: The Persian-European Dialogue in Seventeenth-Century Art and Contemporary Art of Teheran* (exh. cat.), Zurich, 2013, 118–135. See also Janusz Tazbir, "La sarmatisme et le baroque européen," in Tazbir, *La république nobiliaire et le monde: Études sur l'histoire de la culture polonaise à l'époque du baroque*, Wrocław, Poland, 1986, 7–27, and Adam Jasienski, "A Savage Magnificence: Ottomanizing Fashion and the Politics of Display in Early Modern East-Central Europe," *Muqarnas* 31 (2014), 173–205.

4. The cultural specificity of this style became evident a few years later when Sobieski gifted this rich piece to the grand duke of Tuscany, who reportedly put it away and marked it in his inventory as "una cosa del barbaro luso" (a thing of barbaric magnificence). Zamoyski, "History of Poland in the 16th–18th Centuries," 36.

5. Jasienski, "A Savage Magnificence," 193–194.

6. The most detailed account, including contemporary sources, is in Jutta Bäumel, *Auf dem Weg zum Thron: Die Krönungsreise Augusts des Starken*, Dresden, 1997, 124–143. See also Karl Czok, *August der Starke und seine Zeit*, Munich, 2010 (orig. 1989), 58.

7. [Philippe Sylvestre Dufour], *Drey neue curieuse Tractätgen: Von dem Trancke Cafe, sinesischen The, und der Chocolata*, Bautzen, Saxony, 1686. A slightly different version of the same image is reproduced in E. C. Spary, *Eating the Enlightenment: Food and the Sciences in Paris, 1670–1760*, Chicago, 2012, 63, and see 62–67. Ulla Heise, *Coffee and Coffee-Houses*, Leipzig, 1987, 16–17, 94, 106, 132. Dinglinger's homage to coffee was not intended for actual use: the cups, made of enamel imitating porcelain, would not have survived the heat of the drink.

8. See Joachim Menzhausen, "Die zwei Fassungen des Goldenen Kaffeezeugs von Johann Melchior Dinglinger," *Jahrbuch der staatlichen Kunstsammlungen Dresden* 4 (1963–1964), 153–162. Menzhausen suggests that when Dinglinger rearranged the ensemble in 1729 he deliberately rendered this lesser quality inner scene invisible. Curiously, the museum curators today appear to follow this line by omitting any mention of this internal scene in their otherwise excellent guidebook: Jutta Kappel and Ulrike Weinhold, *The New Grünes Gewölbe: Guide to the Permanent Collection*, Dresden, 2007, 195–197. See Erna von Watzdorf, *Johann Melchior Dinglinger: Der Goldschmied des deutschen Barock*, Berlin, 1962, 1:100–102, attributing the internal scene to Dinglinger himself, and Dirk Syndram, *Das Goldene Kaffeezeug Augusts des Starken*, Leipzig, 1997, 54–55.

9. Invoice dated Warsaw, 23 December 1701, 10036 Finanzarchiv loc. 33695, Rep. XI Sect II. Lit D no. 18, Hauptstaatsarchiv Dresden; Menzhausen, "Die zwei Fassungen des Goldenen Kaffeezeugs," 159–160.

10. Hanna Widacka, *Lew Lechistanu*, Warsaw, 2010 (following her *Jan III Sobieski w grafice XVII i XVIII wieku*, Warsaw, 1987), includes many examples of the aigrette-topped Sarmatian dress of Jan III Sobieski next to many others with Western European crowns. Compare nos. 32 and 55 with Łomnicka-Żakowska, *Graficzne portrety Augusta II i Augusta III Wettynów*, no. 73 (180–181) and no. 19 (72–73), for instances of royal images with Eastern headdress reused from one king to the next, in one case in mirror image, in the other in a medallion insert. It is also worth noting that one Turkish element was never imitated in Sarmatian dress, namely the turban itself: a fact evident in the Sarmatian portraits of Augustus and Jan Sobieski. See Jasienski, "A Savage Magnificence," 180–181.

11. Stübel, *Aufgefangene Brieffe*, 210.

12. Inv. no. A36691, dated 1675, SKD Kupferstich-Kabinett, Dresden. Note in particular the figures under the throne baldachin and Sobieski's appearance with his canopy and entourage. The print was apparently not based on eyewitness observation and its documentary value is questionable.

13. In fact, Augustus had already appeared in a somewhat comical version of the dress of the Ottoman sultan in a Dresden court masquerade in February 1697, on his return from battles against the Ottomans. Obviously, however, a playful court masquerade was not comparable to sartorial choices taken for Augustus's coronation, the most important event of his life as a ruler, or to his royal portraiture thereafter: Claudia Schnitzer and Petra Hölscher (eds.), *Eine gute Figur machen: Kostüm und Fest am Dresdner Hof* (exh. cat.), Amsterdam, 2000, 68–70, 136. For a more general surge in Turkish influences on art and architecture in Dresden after Augustus's coronation, see Friedrich Reichel, "Die Türkenmode und ihr Einfluss auf die sächsische Kunst," in *Im Lichte des Halbmonds: Das Abendland und der türkische Orient* (exh. cat.), Leipzig, 1995, 263–271.

14. Jean-Baptiste Tavernier, *Beschreibung der sechs Reisen, . . . in Türckey, Persien und Indien*, Geneva, 1681, book 2, 86.

15. Jean-Baptiste Tavernier, *Vierzig Jährige Reise Beschreibung. Worinnen dessen durch Türkey, Persien, Indien . . . In Dreyen Theilen*, Nuremberg, 1681, 2:92, 99. Translation based on V. Ball (ed.), *Travels in India by Jean-Baptiste Tavernier*, 2nd edn., New Delhi, 1995, 1:284, 303–305.

16. See the comprehensive discussion in Susan Stronge, "The Sublime Thrones of the Mughal Emperors of Hindustan," *Jewellery Studies* 10 (2004), esp. 64,

with further sources there, and 67n55 for the few known contemporary visualizations. Also contrast François Bernier, *Travels in the Mogul Empire, A.D. 1656–1668*, revised edn., transl. Irving Brock and Archibald Constable, London, 1891, 268: "I cannot tell you with accuracy the number or value of this vast collection of precious stones [on the Peacock Throne], because no person may approach sufficiently near to reckon them."

17. Stronge, "The Sublime Thrones of the Mughal Emperors," 62–64. See also Abdul Aziz, *The Mughul Court and Its Institutions*, vol. 2, *Thrones, Tents and Their Furniture Used by the Indian Mughuls*, Lahore, n.d., 29–59.

18. François Bernier, *Voyages de François Bernier, . . . contenant la description des états du Grand Mogol, de l'Hindoustan, du Royaume de Kachemire, etc.*, Amsterdam, 1699, 2:53; cf. Bernier, *Travels in the Mogul Empire*, 269.

19. E. D. Maclagan, "Four Letters by Austin of Bordeaux," *Journal of the Punjab Historical Society* 4:1 (1916), 3–17, 17 (quotation). Augustin is frequently misnamed "Austin."

20. Jahangir in his memoirs described Hiriart as "unrivalled as a goldsmith, metal engraver and jeweller, and in all sorts of other skills." For these quotes, together with a full discussion of the sources, see Stronge, "The Sublime Thrones of the Mughal Emperors," 57–59. See also R. Nath, "Augustin of Bordeaux and His Relations with the Mughal Court (1612–1632)," in R. Nath, *Some Aspects of Mughal Architecture*, Delhi, 1976, 112–119, and Ebba Koch, *Mughal Art and Imperial Ideology*, Oxford, 2001, 110, who has already suggested the involvement of the French jeweler in the early stages of the Peacock Throne. Cf. Jonathan Gil Harris, *The First Firangis: Remarkable Stories of Heroes, Healers, Charlatans, Courtesans and Other Foreigners Who Became Indian*, New Delhi, 2011, 136–146. Aziz, *The Mughul Court and Its Institutions*, 2:42–45, makes a valiant if unpersuasive effort to discredit the possibility of a foreigner's involvement. I am grateful to Susan Stronge of the Victoria and Albert Museum for helpful exchanges on this subject.

21. Thomas Roe, *The Embassy of Sir Thomas Roe to the Court of the Great Mogul, 1615–1619*, ed. William Foster, Wiesbaden, Germany, 1967 (orig. 1899), 213–214, 224–225. For the Mughal emperor's continuing interest in European paintings and in copying them, see 119, 143, 253–256, 386, 394, 488, xxv. On the Mughal interest in European paintings, see also Ania Loomba, "Of Gifts, Ambassadors, and Copy-Cats: Diplomacy, Exchange, and Difference in Early Modern India," in Brinda Charry and Gitanjali Shahani (eds.), *Emissaries in Early Modern Literature and Culture: Mediation, Transmission, Traffic, 1550–1700*, Farnham, U.K., 2009, 52–65; Mika Natif,

Mughal Occidentalism: Artistic Encounters Between Europe and Asia at the Courts of India, 1580–1630, Leiden, 2018; and the sources in the following notes.

22. The Persian cartouches explain, "Although outwardly kings stand before him, inwardly he always keeps his gaze upon the dervishes." The bottom left figure is an anonymous Hindu. This rich image by the painter Bichitr, c. 1615–1618, is discussed in detail in Richard Ettinghausen, "The Emperor's Choice," in M. Meiss (ed.), *De Artibus Opuscula XL: Essays in Honor of Erwin Panofsky*, New York, 1961, 98–120; Milo Cleveland Beach, *The Grand Mogul: Imperial Painting in India, 1600–1660*, Williamstown, MA, 1978, 156; Beach, *The Imperial Image: Paintings for the Mughal Court*, Washington, DC, 2012, 28–29, 126–128; Kavita Singh, *Real Birds in Imagined Gardens: Mughal Painting Between Persia and Europe*, Los Angeles, 2017, 63–66; and Ursula Weekes, "A Closer Look at Mughal Emperor Jahangir Depicted on the Hourglass Throne," British Academy (blog), 5 April 2018, https://www.thebritishacademy.ac.uk/blog/closer-look-mughal-emperor-jahangir-depicted-hourglass-throne.

23. Sumathi Ramaswamy, "Conceit of the Globe in Mughal Visual Practice," *Comparative Studies in Society and History* 49:4 (2007), 751–782; Ebba Koch, "The Symbolic Possession of the World: European Cartography in Mughal Allegory and History Painting," *Journal of Economic and Social History of the Orient* 55 (2012), 547–580; Natif, *Mughal Occidentalism*, 125–135.

24. Contemporary Christian observers often mistook the Mughal appeal to Jesus and Mary, driven by their own understanding of the chain of prophets and by their needs for legitimation, as signs of a perhaps secret wish to convert: Ebba Koch, "The Influence of the Jesuit Mission on Symbolic Representation of the Mughal Emperors," in Koch, *Mughal Art and Imperial Ideology*, 1–11; Gauvin Alexander Bailey, *The Jesuits and the Grand Mogul: Renaissance Art at the Imperial Court of India, 1580–1630*, Washington, DC, 1998, esp. 35–40; Bailey, *Art on the Jesuit Missions in Asia and Latin America, 1542–1773*, Toronto, 1999, 134–137; Azfar Moin, "Akbar's 'Jesus' and Marlowe's 'Tamburlaine': Strange Parallels of Early Modern Sacredness," *Fragments* 3 (2013–2014), 1–21; Natif, *Mughal Occidentalism*, 63–66, 258–260. Curiously, with the significant exception of Bailey, the presence of Jesus and Mary in Payag's important painting is left unnoticed in the sources mentioned here, as well as in the authoritative description in Milo Beach and Ebba Koch, *King of the World: The Padshahnama*, London, 1997, 201–203.

25. Beach and Koch, *King of the World*, 202–203. Thomas Roe presented to Emperor Jahangir a portrait of James I, and on two occasions reported that

he saw European royal and aristocratic portraits hanging close to Jahangir's throne: *The Embassy of Sir Thomas Roe*, 143, 226, 394.

26. Ebba Koch, "Shah Jahan and Orpheus: The Pietre Dure Decoration and the Programme of the Throne in the Hall of Public Audiences at the Red Fort of Delhi," in Koch, *Mughal Art and Imperial Ideology*, 61–129. Another interesting element borrowed from Western paintings was the carpet on the parapet of the emperor's *jharoka* (as in Payag's painting of Jahangir and Prince Khurram): Jeremiah Losty, "The Carpet at the Window: A European Motif in the Mughal Jharokha Portrait," in M. Sharma and P. Kaimal (eds.), *Indian Painting: Themes, History and Interpretations*, Ahmedabad, India, 2013, 52–64.

27. Ebba Koch, "The Baluster Column: A European Motif in Mughal Architecture and Its Meaning," in Koch, *Mughal Art and Imperial Ideology*, 38–60; 43, image 3.7; 54, image 3.18. Koch also extends the possible cross-cultural connections to parallel theories of political rule, in particular Solomonic meanings attached to the Mughal throne, similar to the harking to King Solomon in European thrones of this period. These parallels in her analysis characterize not only the Peacock Throne but also another throne with lions that was probably the work of Augustin Hiriart.

28. On the Mughals' concept and policy of "universal acceptance" or "peace with all" (*ṣulḥ-i kull*), and its significance for their intellectual and artistic syncretism, see Ebba Koch, "Visual Strategies of Imperial Self-Representation: The Windsor Pādshāhnāma Revisited," *Art Bulletin* 99:3 (2017), 93, and Natif, *Mughal Occidentalism*, chap. 1. Cf. Rajeev Kinra, "Handling Diversity with Absolute Civility: The Global Historical Legacy of Mughal Ṣulḥ-i Kull," *Medieval History Journal* 16 (2013), 251–295.

29. The parallels between Shah Jahan (rather than Aurangzeb) and Augustus the Strong are also more broadly striking in their understanding of, and personal involvement in, the political meaning of visual and decorative arts as well as court architecture. The following description of Shah Jahan's daily morning session, written by the historian of his early reign Muhammad Amin of Qazwin, could have been transposed virtually word for word to Augustus in Dresden: "Part of the time [His Majesty] spends in looking at gems and precious objects. And part of the time he examines with care and in detail the masterpieces of artists, such as painters and decorators, carvers and engravers, goldsmiths, enamellers. . . . The superintendents of the imperial buildings together with the masterful architects of excellent abilities bring architectural designs before the exalted sight [of the emperor]. And since his

most pure mind is inclined entirely toward building . . . he attends to it fully by creating most of the designs himself and also by carrying out appropriate changes to whatever the architects have thought out." Quoted in Koch, "Visual Strategies of Imperial Self-Representation," 96–97.

Chapter 4. Rulers

1. Jan Veenendaal, *Asian Art and Dutch Taste*, The Hague, 2014, 48–51; Nira Wickramasinghe, *Sri Lanka in the Modern Age: A History of Contested Identities*, London, 2006, 106–111; Robert Aldrich, "The Return of the Throne: The Repatriation of the Kandyan Regalia to Ceylon," in R. Aldrich and C. McCreery (eds.), *Crowns and Colonies: European Monarchies and Overseas Empires*, Manchester, U.K., 2016, 139–162.

2. Joseph Pearson, "The Throne of the Kings of Kandy," *Journal of the Royal Asiatic Society (Ceylon Branch)* 31 (1929), 380–383. The order for the manufacture of the throne had been placed by van Rhee's predecessor, Laurens Pijl: Veenendaal, *Asian Art and Dutch Taste*, 51.

3. Quoted in Pearson, "The Throne of the Kings of Kandy," 381.

4. The term "kingdom," used regularly for such African polities, is a problematic term introduced originally by Westerners. It is maintained here for lack of an obvious alternative.

5. It is uncertain when precisely this coronation ceremony took place, sometime between 1717 and 1725. It was described with a sketch by Chevalier Des Marchais, subsequently published in Jean-Baptiste Labat, *Voyage du chevalier Des Marchais en Guinée, îles voisines et à Cayenne, fait en 1725, 1726 et 1727*, Paris, 1730, 2:69–72, and plate between 70 and 71. In the print, one can discern behind the king, on the door of a thatched canopy, a piece of cloth with a crowned head. Reproduced and discussed in Robert Harms, *The Diligent: A Voyage Through the Worlds of the Slave Trade*, New York, 2002, chap. 19. For the European gifts to Huffon in the context of the complicated situation during his reign, see I. A. Akinjogbin, *Dahomey and Its Neighbours, 1708–1818*, Cambridge, 1967, 43, chap. 2. I am grateful to Patrick Manning for a helpful discussion of this material at an early stage of this project.

6. Thomas Astley (ed.), *A New General Collection of Voyages and Travels*, London, 1745–1747, 3:69, 82; Christina Brauner, "Connecting Things: Trading Companies and Diplomatic Gift-Giving on the Gold and Slave Coasts in the Seventeenth and Eighteenth Centuries," *Journal of Early Modern History* 20 (2016), 418; Roy Sieber, "African Furniture Between Tradition and Colonization," in Sandro Bocola (ed.), *African Seats*, Munich,

2002, 34, and see 33–36 for a general discussion of this pattern of European chairs spreading in Africa from the early modern period.

7. Olfert Dapper, *Naukeurige Beschrijvinge der Afrikaensche Gewesten*, Amsterdam, 1668, 539; Suzanne Preston Blier, *Royal Arts of Africa: The Majesty of Forms*, London, 2012 (orig. 1998), 206–207; Phyllis Martin, "The Kingdom of Loango," in Alisa LaGamma (ed.), *Kongo: Power and Majesty* (exh. cat.), New York, 2015, 63–64, and see 58, 99, on Dapper's engravings, based probably on eyewitness drawings, as particularly well informed concerning Loango. For a more skeptical view of the reliability of Dapper's African images, see Adam Jones, "Decompiling Dapper: A Preliminary Search for Evidence," *History in Africa* 17 (1990), esp. 187–188.

8. Mary-Louise Bastin, *La sculpture Tshokwe*, Meudon, France, 1982, 251; Lorenz Homberger and Piet Meyer, "Concerning African Objects," in Bocola (ed.), *African Seats*, 27–28. See also Chokwe Chair, Metropolitan Museum of Art, New York, http://www.metmuseum.org/toah/works-of-art/1978.412.619. I am grateful to Z. S. Strother for introducing me to Chokwe chairs.

9. Blier, *Royal Arts of Africa*, 74. Eresoyen's stool-throne is in Staatliche Museen zu Berlin, Ethnologisches Museum, inv. no. III C 20295.

10. The Silver Throne's ornamentation includes two winged angels holding a crowned laurel wreath that originally encircled Christina's monogram. Reputed to be the earliest surviving piece of Augsburg furniture worked entirely in silver, in fact it has a solid core of wood. See *Christina Queen of Sweden: A Personality of European Civilisation* (exh. cat.), Stockholm, 1966, 174; Carl Hernmarck, "Der Silberthron Christinas," in Magnus von Platen (ed.), *Queen Christina of Sweden: Documents and Studies*, Stockholm, 1966, 119–129; and Lorenz Seelig, *Silver and Gold: Courtly Splendour from Augsburg*, Munich, 1995, 24.

11. The Unicorn Throne is not only set between two pairs of meter-long narwhal tusks shooting up from the armrests, as well as many smaller ones, but also, even less plausibly, involves narwhal tusk veneer over rare Brazilian wood. The anointing bishops themselves emphasized that the throne was made of the horn of unicorns, thus besting King Solomon. In the 1680s gilded lions were added, inspired by the biblical description of Solomon's throne. Cf. Guido Schönberger, "Narwal-Einhorn: Studien über einen seltenen Werkstoff," *Städel-Jahrbuch* 9 (1935–1936), 240–243, and Christina Petterson, " 'Nothing Like It Was Ever Made in Any Kingdom': The Hunt for Solomon's Throne," in Roland Boer (ed.), *Postcolonialism and the Hebrew Bible: The Next Step*, Atlanta, 2013, esp. 98–102.

12. *Preussen 1701: Eine europäische Geschichte* (exh. cat.), Berlin, 2001, 1:177–178.

13. Winfried Baer, "Ein Bernsteinstuhl für Kaiser Leopold I. Ein Geschenk des Kurfürsten Friedrich Wilhelm von Brandenburg," *Jahrbuch der Kunsthistorischen Sammlungen in Wien* 78 (1982), 91–138, 95 (quotation, from a letter from the emperor to the elector, 17 May 1678), and see 122–124 for the Chinese views; Susanne Netzer, "Bernsteingeschenke in der preussischen Diplomatie des 17. Jahrhunderts," *Jahrbuch der Berliner Museen* 35 (1993), 233–235; Wilfried Seipel (ed.), *Bernstein für Thron und Altar: Das Gold des Meeres in fürstlichen Kunst-und Schatzkammern* (exh. cat.), Vienna, 2005, 19–20, 76–84; Jeannette Falcke, *Studien zum diplomatischen Geschenkwesen am brandenburgisch-preußischen Hof im 17. und 18. Jahrhundert*, Berlin, 2006, 108–122. Today only fragments of the Amber Throne remain, as well as two detailed drawings.

14. Veenendaal, *Asian Art and Dutch Taste*, 49; Daniel Crowley, "Chokwe: Political Art in a Plebian Society," in Douglas Fraser and Herbert Cole (eds.), *African Art and Leadership*, Madison, WI, 1972, 32. The Siamese throne hall with the mirrors was described by a Persian envoy in 1685: *The Ship of Sulaiman*, transl. John O'Kane, London, 1972, 63. For Narai's order of the Dutch mirrors in 1657, see Bhawan Ruangsilp, *Dutch East India Company Merchants at the Court of Ayutthaya: Dutch Perceptions of the Thai Kingdom, c. 1604–1765*, Leiden, 2007, 141.

15. Guy Miege, *A Relation of Three Embassies from His Sacred Majestie Charles II, to the Great Duke of Muscovie, the King of Sweden, and the King of Denmark. Performed by the Right Hoble. the Earle of Carlisle in the Years 1663 and 1664*, London, 1669, 148.

16. Moscow Kremlin Armory, inv. no. R30; Irina Fedorovna Polynina, *The Regalia of the Russian Empire*, Moscow, 1994, 84–85, 101; Sebouh Aslanian, *From the Indian Ocean to the Mediterranean: The Global Trade Networks of Armenian Merchants from New Julfa*, Berkeley, CA, 2011, 82, 150; Rudolph Matthee, *Persia in Crisis: Safavid Decline and the Fall of Isfahan*, London, 2012, 189–190. And for Europeanizing elements in seventeenth-century Persian art, mediated through the Armenian community, see Amy Landau, "From the Workshops of New Julfa to the Court of Tsar Aleksei Mikhailovich: An Initial Look at Armenian Networks and the Mobility of Visual Culture," in Venetia Porter and Mariam Rosser-Owen (eds.), *Metalwork and Material Culture in the Islamic World*, London, 2012, 413–426 (on the Diamond Throne, see 420–421).

17. Douglas Frasier, "The Symbols of Ashanti Kingship," in Fraser and Cole (eds.), *African Art and Leadership*, 138–142; Blier, *Royal Arts of Africa*,

133–136; Malcolm McLeod, "The Asante: A Brief Introduction," in Roslyn A. Walker (ed.), *The Power of Gold: Asante Royal Regalia from Ghana* (exh. cat.), 2018, 19–26; with McLeod's earlier *The Asante*, London, 1984, chap. 7.

18. Herbert Cole and Doran Ross, *The Arts of Ghana* (exh. cat.), Los Angeles, 1977, 140–143; Malcolm McLeod, "A Note on an Asante Royal Chair of Iberian Origin," in Marion Johnson and Malcolm McLeod, *Akan-Asante Studies*, London, 1979, 21–22; Sieber, "African Furniture Between Tradition and Colonization," 35; Martha Ehrlich, "Asante Regalia," in Walker, *The Power of Gold*, 27–28; Brauner, "Connecting Things," 426–427.

19. The penchant of James I and his consort, Anne of Denmark, for aigrettes is evident from numerous portraits; a striking early example is James's portrait of 1595 attributed to Adrian Vanson. Lulls's aigrette designs, dating probably to the second decade of the seventeenth century, included the most imposing single jewel in his design album (kept at the Victoria and Albert Museum, London), thus presumably intended for a royal hat. Roy Strong, "Three Royal Jewels: The Three Brothers, the Mirror of Great Britain and the Feather," *Burlington Magazine* 108:760 (1966), 350–353; John Hayward, "The Arnold Lulls Book of Jewels and the Court Jewellers of Queen Anne of Denmark," *Archaeologia* 108 (1986), 227–237; Oppi Untracht, *Traditional Jewelry of India*, New York, 1997, 384–385; Christiane Hille, "Gems of Sacred Kingship: Faceting Anglo-Mughal Relations Around 1600," in C. Göttler and M. Mochizuki (eds.), *The Nomadic Object: The Challenge of World for Early Modern Religious Art*, Leiden, 2018, 309–315.

20. This crown was actually one of four crowns prepared at the court of Charles II for Native American kings and queens: see Jewel Office Warrant Book, Lord Chamberlain's Department, U.K. National Archives, Kew, as quoted in Lord Twining, *European Regalia*, London, 1967, 32; anonymous letter of July 13, 1705, describing the events of the Bacon Rebellion of 1675–1676, in Ronald Bayor, *The Columbia Documentary History of Race and Ethnicity in America*, New York, 2004, 31; and René Brus, *Crown Jewellery and Regalia of the World*, Amsterdam, 2011, 186. In 2017 the surviving silver frontlet of this crown was repatriated to the Pamunkey Indians. In a notorious earlier incident, English settlers at the time of James I forced a crown on the head of Powhatan in an effort to subjugate him. This cross-cultural use of a crown, however, based on compulsion rather than gifting or exchange, does not belong to the pattern described here. See David Murray, *Indian Giving: Economies of Power in Indian-White Exchanges*, Amherst, MA, 2000, 60–64.

21. Akinjogbin, *Dahomey and Its Neighbours*, 43. In 1724, when the King of Dahomey invaded Ardra, one Englishman recommended "a Present of a Crown and Sceptre, which must be paid for out of what remains due to the late King of *Ardah*": Bulfinch Lambe (an English factor in Ardra) to Governor Jeremiah Tinker, 27 November 1724, in William Smith, *A New Voyage to Guinea*, London, 1744, 173.

22. Anna Keay, *The Crown Jewels: The Official Illustrated History*, London, 2012, 43; Gijs van der Ham, *Tarnished Gold: Ghana and the Netherlands from 1593*, Amsterdam, 2016, 84–87; Brauner, "Connecting Things," 408–415, 426; Christina Brauner, *Kompanien, Könige und* caboceers: *Interkulturelle Diplomatie an Gold-und Sklavenküste im 17. und 18. Jahrhundert*, Cologne, 2015, 324–337.

23. Grand Vizier Lala Mehmed Pasha to Sultan Ahmed I, n.d., in Cengiz Orhonlu, *Telhîsler (1597–1607): Osmanlı tarihine âid belgeler*, Istanbul, 1970, 114; Kees Teszelszky, "A Bocskai-korona és-koronázás mítosza," *Confessio: A Magyarországi Református Egyház figyelje* 30:3 (2006), 54–59; Teszelszky, "Crown and Kingdom in the Republic: The Cultural Construction and Literary Representation of Early Modern Hungary in the Low Countries (1588–1648)," in Kees Teszelszky (ed.), *A Divided Hungary in Europe*, Newcastle, U.K., 2014, 3:157, 160. I am grateful to Tijana Krstic for translating the Hungarian and Turkish sources. After Bocskay's death the crown was incorporated into the Habsburg treasury as a sign of Habsburg dominance over Hungary: Barbara Karl, "On the Crossroads: Habsburg Collecting of Objects from the Islamic World 16th and 17th Centuries," *Ars Orientalis* 42 (2012), 114–117.

24. Brus, *Crown Jewellery and Regalia of the World*, 36, 44; Molly Aitken, *The Intelligence of Tradition in Rajput Court Painting*, New Haven, CT, 2010, 133; Barbara Schmitz, "On a Special Hat Introduced During the Reign of Shah Abbas the Great," *Iran* 22 (1984), 105–108; Linda Heywood, *Njinga of Angola: Africa's Warrior Queen*, Cambridge, MA, 2017, 62, 196. Another suggestive manifestation of this increased preoccupation with royal crowns may be found in an early eighteenth-century north Indian painting at the Metropolitan Museum, New York (*The Monkey Leader Angada Steals Ravana's Crown from His Fortress*, attrib. to Manaku of Guler, c. 1725, inv. no. 19.24.2), in which the artist added an invented scene to the *Ramayana*, focused on the crowning of a rightful king following the retrieval of a stolen crown, an invention that is reinforced with repetitive visual representations of the royal crown.

25. Brauner, *Kompanien, Könige und* caboceers, 333–335; Brauner, "Connecting Things," 426. As Brauner points out, the rejection of the Dutch gift might have had to do with an assertion of sovereignty: the recipients of these gifts were hardly naive in their understanding of their potential implications.

26. Jahangir also gave his own portrait to King James's ambassador Thomas Roe. Brauner, "Connecting Things," 418, and see 420 for another portrait of Louis XIV given in 1702 to King Acassigny, who ruled at the extreme end of the Gold Coast. Meredith Martin, "Mirror Reflections: Louis XIV, Phra Narai, and the Material Culture of Kingship," *Art History* 38 (2015), 656; Aitken, *The Intelligence of Tradition in Rajput Court Painting*, 115–117, and see 136–142 for the formal role of portraits as diplomatic gifts between Rajput rulers.

27. *The Ship of Sulaiman*, 99. Also see Martin, "Mirror Reflections." The French crown likewise sent its Siam counterpart copies of carpets from the Louvre's "Grande Galerie," carpets themselves made by the French "in the Turkish or Persian manner": Sarah Grandin, " 'Of the Greatest Extent': The Matter of Size in Louis XIV's Savonnerie Carpets," *Studies in Eighteenth-Century Culture* 49 (2020), 267–268, 271 (quotation).

28. The late twentieth-century debate about the precise definition of European absolutism and the so-called myth of absolutism (summarized and refuted in Peter H. Wilson, *Absolutism in Central Europe*, London, 2000) need not concern us here. Among many other contributions, see Johann Sommerville, "Early Modern Absolutism in Practice and Theory," in Cesare Cuttica and Glenn Burgess (eds.), *Monarchism and Absolutism in Early Modern Europe*, Abingdon, U.K., 2016, 117–130. Cesare Cuttica, in "A Thing or Two About Absolutism and Its Historiography," *History of European Ideas* 39:2 (2013), 287–300, has called for conceptualizing multiple "absolutisms," though without extending the leap beyond early modern Europe.

29. Barbara Marx, "From Protestant Fortress to Baroque Apotheosis: Dresden from the Sixteenth to the Eighteenth Century," in Gary Cohen and Franz Szabo (eds.), *Embodiments of Power: Building Baroque Cities in Europe*, New York, 2008, 137; Helen Watanabe-O'Kelly, *Court Culture in Dresden from Renaissance to Baroque*, Basingstoke, U.K., 2002, 205–206, 219; *Unter einer Krone: Kunst und Kultur der sächsisch-polnischen Union* (exh. cat.), Leipzig, 1997, 73, 76; Virginie Spenlé, "Les acquisitions de Raymond Leplat à Paris," in D. Syndram et al. (eds.), *Splendeurs de la Cour de Saxe: Dresde à Versailles*, Paris, 2006, esp. 75; Jutta Bäumel, "Das 'Rheingrafenkleid' Augusts des Starken," *Dresdner Kunstblätter* 41:3 (1997), 91–98; Claudia Schnitzer, "Ein

Cabinet du Roi für Dresden? Frankreichrezeption im Kupferstich-Kabinett Augusts des Starken," *Jahrbuch der Staatlichen Kunstsammlungen Dresden* 31 (2004), 24–25.

30. Quoted in T. C. W. Blanning, *The Culture of Power and the Power of Culture: Old Regime Europe, 1660–1789*, Oxford, 2003, 53.

31. Maxine Préaud, *Inventaire du fonds français. Graveurs du XVIIe siècle. Tome 12: Jean Lepautre (deuxième partie)*, Paris, 1999, 150–151 ("Fontaines et cuvettes"), no. 1530. Anna Maria Werner's 1739 drawing of the *Throne of the Great Mogul* shows this water basin at the very front of the arrangement, in front of the scales (and not behind them as it is today). On Dinglinger's water basin there is an enamel landscape painting copied from Joachim von Sandrart; cf. Walter Holzhausen, "Die Rolle der Graphik im Werk Johann Melchior Dinglingers," *Die graphischen Künste* 4 (1939), 97–98, and Watzdorf, *Johann Melchior Dinglinger*, 1:154, 157, and illus. 205–206, 212–216a, where she points to a second chalice, also derived from Lepautre's designs.

32. To this list we should add the reception for the envoys of the grand duke of Muscovy in 1681. Peter Burke, *The Fabrication of Louis XIV*, New Haven, CT, 1992, 192; Béatrix Saule, "Insignes du pouvoir et usages de cour à Versailles sous Louis XIV," *Bulletin du Centre de recherche du château de Versailles*, colloquium, 1–3 December 2005, https://journals.openedition. org/crcv/132?lang=en#tocto1n1; Saule, "La galerie au temps de Louis XIV: De l'ordinaire à l'extraordinaire," in *La galerie des glaces: Histoire et restauration*, Dijon, France, 2007, 66 (quotation); Stéphane Castelluccio, "La galerie des glaces: Les receptions d'ambassadeurs," *Versalia* 9 (2006), esp. 24.

33. Twining, *European Regalia*, 53–54.

34. The incongruity is even more striking in comparison to another portrait of Louis XIV in armor, painted by Rigaud in 1694, in which Louis holds in a manner very similar to the upside-down scepter a commander's baton ready for battle, naturally right-side-up. Cf. Olivier Chaline, *Le règne de Louis XIV*, Paris, 2005, 1:368–369, and Burke, *The Fabrication of Louis XIV*, 33. The beginning point of any discussion of Rigaud's portrait remains Louis Marin, *Le portrait du roi*, Paris, 1981.

35. Stéphane Castelluccio, *Les collections royales d'objets d'art: De François Ier à la revolution*, Paris, 2002, 99–100. One can sense the unease this object generates in the way that Castelluccio describes the statuette as "a figure with the traits of Louis XIV," not quite the king himself.

36. The translation is based on Hall Bjørnstad, *The Dream of Absolutism: Louis XIV and the Pre-Modern Logic of Modernity*, Chicago, 2021, 152, and see

further discussion there. Note also Louis's frank admission in 1715, on the occasion of the visit of the Persian ambassadors: "His Majesty, whose power and greatness are since many years known in the whole world, being no longer preoccupied as he had been during his youth with parading his magnificence in front of ambassadors"; quoted in Saule, "La galerie au temps de Louis XIV," 66.

37. An interesting counterexample was the French Jesuit Joachim Bouvet's book of 1697, dedicated to the king, which provided a level and often personal comparison between Louis XIV and the Kangxi emperor in China. Once contemporaries looked at rulers outside Europe, new configurations could emerge, as we have seen in this chapter. Joachim Bouvet, *Histoire de l'empereur de la Chine*, The Hague [Paris], 1699 (orig. 1697), 6–7; Laura Hostetler, "A Mirror for the Monarch: A Literary Portrait of China in Eighteenth-Century France," *Asia Major* (3rd series) 19 (2006), 363–368.

38. Bjørnstad, *The Dream of Absolutism*, 140–149. For Bjørnstad the reflection in the shield-mirror "clearly expresses the royal desire for glory" (143), an interpretation he supports with Le Brun's own drawings of faces in tranquility and in desire that repeat some of the same facial features. Although I am less convinced of the role of the desire for glory in this reflection, I believe our interpretations are not incompatible. Bjørnstad also shows that contemporaries were aware of the existence of this reflection, and that even though the painting was restored and thus the details as seen today may be inaccurate, the basic divergence of the mirror image from the king's facial expression was certainly there in the original design. See also Virginie Bar, *La peinture allégorique au Grand Siècle*, Dijon, France, 2003, 206, where this reflection is inexplicably characterized in passing as a "veritable miroir, symbole de prudence et de verité"; Nicolas Milovanovic, "Le portrait du roi: Louis XIV dans le décor de la galerie de glaces," in *La galerie des glaces: Histoire et restauration*, 145–147; and Sandra Bazin-Henry, "Charles Le Brun et les décors de miroirs," *Bulletin du Centre de recherche du château de Versailles* (2017), paras. 28–29, https://doi.org/10.4000/crcv.14600. I am grateful to Hall Bjørnstad for many conversations on this topic.

39. Interestingly, this logic, derived from Louis XIV's uniqueness, may have become unintelligible after his death. A mid-eighteenth-century engraving of Le Brun's painting by Jean-Baptiste Massé clearly shows Louis's reflection in Minerva's shield but corrects the painting in order to have the shield accurately reflect the king's face. Reproduced in Bazin-Henry, "Charles Le Brun et les décors de miroirs," fig. 15.

40. This paragraph draws on Sabine Melchior-Bonnet, *The Mirror: A History*, transl. K. H. Jewett, New York, 2001, chap. 2, as well as on Bjørnstad, *The Dream of Absolutism*, 106–107.

41. Martin Lister, *A Journey to Paris in the Year 1698*, London, 1699, 140. See also Jean-François Belhoste, "La glace dans la galerie et le décor français," in Nathalie Volle and Nicolas Milovanovic (eds.), *La galerie des Glaces après sa restauration: Contexte et restitution*, Paris, 2013, 145–166 (esp. 150–155).

42. Rabelais had imagined human-size mirrors a century and a half before they became reality: Melchior-Bonnet, *The Mirror*, 163.

43. Christiane Ernek-van der Goes, " 'En Bordure De Glace Marquetrie'— Verre Églomisé Mirror Frames from the Royal Palace of Dresden," *Furniture History* 52 (2016), 41–44, and 48–50 for the notes citing the invoices, including prices and sizes.

44. 10026 Geheimes Kabinett loc. 896.2, 14, Hauptstaatsarchiv Dresden; transcript by Erna von Watzdorf, omitted from her partial publication of this letter in *Johann Melchior Dinglinger*, 2:388. I am grateful to SKD curator Ulrike Weinhold for providing me with Watzdorf's transcript of the omitted parts. For more detail on the large mirror see chapter 10, below.

45. Corinna Forberg suggests another such private triumph over Louis XIV in Dinglinger's insertion into the court of the Great Mogul of a figure with a posture with arm on hip, a bodily pose derived from European princely portraiture and ultimately from Rigaud's portrait of Louis XIV, which Dinglinger placed in a minor, secondary, "degraded" position. While I find the focus on body posture in the context of the comparative observation of absolute rulers suggestive, and some other parts of Forberg's analysis excellent, the particular argument regarding this minor figure in Dinglinger's busy ensemble is perhaps less persuasive. Forberg, "Copying the World's Emperor: Dinglinger's Great Moghul and the French Model of Absolute Power," in C. Forberg and P. W. Stockhammer (eds.), *The Transformative Power of the Copy*, Heidelberg, 2017, 375–402.

Chapter 5. Scales

1. Erna von Watzdorf, *Johann Melchior Dinglinger: Der Goldschmied des deutschen Barock*, Berlin, 1962, 1:157 (cf. also Joachim Menzhausen, *At the Court of the Great Mogul*, Leipzig, 1965, 31); "Kurzer Entwurff der Magnificenz des großen Moguls, an seinen Geburths Tage bey Überreichung derer Geschencke," in Dirk Syndram and Jörg Schöner, *August der Starke und sein*

Grossmogul, Munich, 2014, 104. Unfortunately, inexpert gluing of the atlas pages in the past presents today an obstacle to viewing them.

2. Thomas Roe, *The Embassy of Sir Thomas Roe to the Court of the Great Mogul, 1615–1619*, ed. William Foster, Wiesbaden, Germany, 1967 (orig. 1899), 414–415 (reporting events on 9 September 1617), and note 544, identifying the atlas presented by Roe to Jahangir as the fourth edition of *Gerardi Mercatoris Atlas . . .* , Amsterdam, 1612. This episode is discussed in Sumathi Ramaswamy, "Conceit of the Globe in Mughal Visual Practice," *Comparative Studies in Society and History* 49:4 (2007), 756–758, and Ebba Koch, "The Symbolic Possession of the World: European Cartography in Mughal Allegory and History Painting," *Journal of Economic and Social History of the Orient* 55 (2012), 562–564.

3. Roe, *The Embassy of Sir Thomas Roe to the Court of the Great Mogul*, 414–417.

4. Terry's account is republished in ibid., 417n, and see 527n for its publishing history.

5. Johann Christian Götze, *Die Merckwürdigkeiten der Königlichen Bibliothek zu Dressden ausführlich beschrieben, und mit Anmerckungen erläutert*, Dresden, 1746, 1:486. Thomas Roe's account of the atlas incident appears in Samuel Purchas, *Purchas His Pilgrimes. In Five Bookes*, London, 1625, 1:569–570. It is unclear whether Edward Terry's account was also available in Dresden in one of the two different forms in which it was published, as an independent volume in 1655 and anonymously together with Pietro Della Valle's letters in 1665, but cf. Götze, *Die Merckwürdigkeiten der Königlichen Bibliothek*, 3:39–40, for Della Valle in Dresden. The story of Roe's gifted atlas was also retold (without its return) in a book that was frequently used by Dinglinger: Erasmus Francisci, *Ost- und west- indischer wie auch sinesischer Lust-und Stats-Garten*, Nuremberg, 1668, 2:1454.

6. For Slinkachu's playful subversions of expectations of scale set in public places that touchingly braid humor with melancholy, see for instance *Little People in the City: The Street Art of Slinkachu*, London, 2008.

7. Claude Lévi-Strauss, *The Savage Mind*, Chicago, 1966, 22–24; Susan Stewart, "The Miniature," in Stewart, *On Longing: Narratives of the Miniature, the Gigantic, the Souvenir, the Collection*, Durham, NC, 1993, 37–69, 55 (quotation). Other general discussions include John Mack, *The Art of Small Things*, London, 2007; Simon Garfield, *In Miniature*, Edinburgh, 2018; and Jack Davy and Charlotte Dixon (eds.), *Worlds in Miniature: Contemplating Miniaturisation in Global Material Culture*, London, 2019.

8. For a similar chronology for the history of miniaturization in a British context, in a study that focuses on Swift and on literature more broadly, see Melinda Alliker Rabb, *Miniature and the English Imagination: Literature, Cognition, and Small-Scale Culture, 1650–1765*, Cambridge, 2019.

9. Stefano Casciu, "Anna Maria Luisa, Electress Palatine: Last Art Patron and Collector of the Medici Family," in Giovanna Benadusi and Judith Brown (eds.), *Medici Women: The Making of a Dynasty in Grand Ducal Tuscany*, Toronto, 2015, 323–346; Casciu, " 'Principessa di gran saviezza': Dal fasto barocco delle corti al *Patto di famiglia*," in S. Casciu (ed.), *La principessa saggia: L'eredità di Anna Maria Luisa de' Medici Elettrice Palatina* (exh. cat.), Florence, 2006, 30–57; Daniel Fulco, *Exuberant Apotheoses: Italian Frescoes in the Holy Roman Empire*, Leiden, 2016, 189 and passim.

10. Yvonne Hackenbroch and Maria Sframeli, *The Jewels of the Electress Palatine in the Museo degli Argenti*, Florence, 1988, 53, 148–149 (with the full text of the 1695 letter); Marilena Mosco, "The Jewels and 'Galanterie Gioiellate' of Anna Maria Luisa de' Medici, Electress Palatine," in Marilena Mosco and Ornella Casazza, *The Museo degli Argenti: Collections and Collectors*, Florence, 2004, 189; Casciu (ed.), *La principessa saggia*, 242–243; Markus Neuwirth, *Barock: Kunstgeschichte eines Wortes*, Innsbruck, Austria, 2015, 152–153. For the Johann Wilhelm quote, see Casciu, "Anna Maria Luisa, Electress Palatine," 331. For Anna Maria Luisa's miscarriages, induced perhaps by a sexually transmitted disease contracted from her husband, see Harold Acton, *The Last Medici*, London, 1980 (orig. 1932), 183, 215, but also Hermine Kühn-Steinhausen, *Die letzte Medicäerin—eine deutsche Kurfürstin*, Düsseldorf, Germany, 1939, 41n9, insisting, based on the electress's letters, that she had only one miscarriage in 1692.

11. Carl Knappett, "Meaning in Miniature: Semiotic Networks in Material Culture," in Niels Johannsen et al. (eds.), *Excavating the Mind: Cross-Sections Through Culture, Cognition and Materiality*, Aarhus, Denmark, 2012, 87–109, 103 (quotation).

12. Stefano Casciu, " 'Principessa di gran saviezza': Dal fasto barocco delle corti al *Patto di famiglia*," in Casciu (ed.), *La principessa saggia*, 38 (quoted from a 1697 letter to her uncle), and catalog, 227–243; Hackenbroch and Sframeli, *The Jewels of the Electress Palatine*, 11, 47 (including a comprehensive catalog of sixty-eight objects from Anna Maria Luisa's jewel and miniature collection that are preserved at the Palazzo Pitti in Florence, as well as the full inventory of 1743). See also Maria Sframeli, "The Gems of Anna Maria Luisa de' Medici, Electress Palatine," in Cristina Acidini Luchinat (ed.), *Treasures of Florence:*

The Medici Collection, 1400–1700, Munich, 1997, 199–220, and Mosco, "The Jewels and 'Galanterie Gioiellate' of Anna Maria Luisa de' Medici." For details on the electress's considerable expenditures on her collections, see Jörg Engelbrecht, "Anna Maria Luisa von Medici und ihr Hof zu Düsseldorf: Zur Bedeutung des Luxus im Zeitalter des Absolutismus," and Karl Bernd Heppe, "Kurfürstin Anna Maria Luisa und die Goldschmiedekunst," in *Anna Maria Luisa Medici, Kurfürstin von der Pfalz* (exh. cat.), Düsseldorf, 1988, 125–145. I am grateful to curator Valentina Conticelli for a memorable morning with Anna Maria Luisa's collection of miniatures at the Palazzo Pitti.

13. Hans Thoma and Herbert Brunner, *Schatzkammer der Residenz München: Katalog*, Munich, 1964, 319–320. The figurine is likely to have arrived in the Munich collection together with other *Schatzkammer* objects via Mannheim, the residence of Johann Wilhelm's younger brother and successor. See Hackenbroch and Sframeli, *The Jewels of the Electress Palatine*, 54, with the letter from Karl Philipp von der Pfalz to his brother Johann Wilhelm in Hans Schmidt, *Kurfürst Karl Philipp von der Pfalz als Reichsfürst*, Mannheim, Germany, 1963, 281n82.

14. *En värld i miniatyr: Kring en samling från Gustav II Adolfs tidevarv*, Stockholm, 1982, 85–86; Michael Conforti and Guy Walton (eds.), *Sweden: A Royal Treasury, 1550–1700* (exh. cat.), Washington, DC, 1988, 172–174; Lis Granlund, "Queen Hedwig Leonora of Sweden: Dowager, Builder, and Collector," in C. C. Orr (ed.), *Queenship in Europe, 1660–1815: The Role of the Consort*, Cambridge, 2004, 56–76; Lisa Skogh, "The Pretiosa Cabinet at Ulriksdal Palace," in Kristopher Neville and Lisa Skogh (eds.), *Queen Hedwig Eleonora and the Arts: Court Culture in Seventeenth-Century Northern Europe*, London, 2017, 59–77 (esp. 60–61); Skogh, *Material Worlds: Queen Hedwig Eleonora as Collector and Patron of the Arts*, Stockholm, 2013, 151–153. I am grateful to Lars Ljungström, head curator of the Swedish royal collections, for information about these objects, drawn in part from the inventory taken after the death of Hedwig Eleonora in 1715 and from her account books, both in the Palace Archives, Stockholm.

15. Skogh, *Material Worlds*, 35–40. It is also possible that the Saxon coins and coinbox entered the Swedish collection not through Hedwig Eleonora's Saxon roots but following the Swedish occupation of Saxony in 1706, perhaps as a kind of war souvenir.

16. Both miniature camels are today in the Dresden collections: Jutta Kappel and Ulrike Weinhold, *The New Grünes Gewölbe: Guide to the Permanent Collection*, Dresden, 2007, 176, 192–193.

17. *Beschreibung des Grünen-Gewölbes in Dressden*, 2nd edn., Frankfurt and Leipzig, 1739, describing a visit in 1733, quoted in Dirk Syndram and Ulrike Weinhold, ". . . *Und ein Leib von Perl": Die Sammlung der barocken Perlfiguren im Grünen Gewölbe*, Dresden, 2007, 8, and see 8–9 for the Corner Cabinet, with its inventory of 463 objects consisting of miniatures as well as small-scale *pretiosa*. See also Dirk Syndram, *Die Schatzkammer Augusts des Starken: von der Pretiosensammlung zum Grünen Gewölbe*, Leipzig, 1999, 197–199.

18. Kappel and Weinhold, *The New Grünes Gewölbe*, 148–149; Dirk Syndram, "Monument to a Royal Collector—August the Strong and His Grünes Gewölbe," in Dirk Syndram and Claudia Brink (eds.), *The Dream of a King: Dresden's Green Vault*, Munich, [2012], 36; Dirk Syndram, *Juwelenkunst des Barock: Johann Melchior Dinglinger im Grünen Gewölbe*, Munich, 2008, 18–19. In addition to conjuring up memories from Augustus's visit to Versailles of almost a decade earlier, as is often suggested, it is possible that the maker of this miniature cabinet was influenced by the design of the Augsburg silversmiths who during those same years created the "Berlin Silver Buffet," an extraordinary display cabinet for the elector of Brandenburg that was itself influenced by Louis XIV buffets, and that like Augustus's miniature sported acanthus leaves to support the displayed objects. See Lorenz Seelig, "Late Baroque Wall-Mounted Buffets in Berlin and Dresden," in Seelig, *Silver and Gold: Courtly Splendour from Augsburg*, Munich, 1995, 31–33.

19. Compare, however, another miniature figurine of a reigning king made in the 1690s, the 2.4-centimeter-tall equestrian statuette of King Christian V of Denmark on top of a miniature column: Jørgen Hein, *The Treasure Collection at Rosenborg Castle II: The Inventories of 1696 and 1718*, Copenhagen, 2009, 163.

20. Elizabeth Rodini, "Baroque Pearls," *Art Institute of Chicago Museum Studies* 25:2 (2000), 68–71; Syndram and Weinhold, ". . . *Und ein Leib von Perl*." On the trade in rare baroque pearls, taken by some to be valuable while others, like Jean-Baptiste Tavernier, saw them as synonymous with bad taste, see also Molly Warsh, *American Baroque: Pearls and the Nature of Empire, 1492–1700*, Chapel Hill, NC, 2018, 219–220, 248–255.

21. Hackenbroch and Sframeli, *The Jewels of the Electress Palatine*, 53–55; Syndram and Weinhold, ". . . *Und ein Leib von Perl*," 13–14; Halgard Kuhn, "Guillaume Verbecq, der Juwelier Augusts des Starken, und seine Beziehungen zu Frankfurt am Main," *Dresdener Kunstblätter* 44:5 (2000), 138–142. The spread and nature of baroque pearl figures is confirmed by Verena

Suchy, "Perlpreziosen. Barocke Materialität, deviante Körperlichkeit und die Kunst des Grotesken," PhD diss., Justus Liebig University Giessen, 2022. I am grateful to her for a rich exchange.

22. These pieces were subsequently "corrected" to their original form by twentieth-century curators. Syndram and Weinhold, ". . . Und ein Leib von Perl," 10.

23. Kappel and Weinhold, The New Grünes Gewölbe, 148–149.

24. Thoma and Brunner, Schatzkammer der Residenz München, 186–188.

25. Miniature knife-grinders from this period can be found in Dresden (twice; the first made by Köhler in 1708), in Anna Maria Luisa de Medici's collection in Florence, in Munich (also originating in the Electors Palatine collection), in Hedwig Eleonora's parental court in Gottorf (now in Schwerin), in Saint Petersburg (see below), in Gotha (now lost), in the dispersed collection of Sibylla Augusta margravine of Baden-Baden (now in private hands), as well as several others known from documents that are no longer traceable. The best discussions of the genre of ivory figurines are Hackenbroch and Sframeli, The Jewels of the Electress Palatine, 55–57; Ulrike Weinhold, " 'Ein scheer schleifer von helfenbein': Facetten spätbarocker Schatzkunst," in Studien zur europäischen Goldschmiedekunst des 14. bis 20. Jahrhunderts, Munich, 2001, 287–306; and for the pieces in the Dresden collection, Jutta Kappel, Elfenbeinkunst im Grünen Gewölbe zu Dresden, Dresden, 2017, 240–284. For a similar fourteen-centimeter figurine of a market crier from the end of the seventeenth century, made of silver, suggesting that such miniatures were made of other materials as well, see Die Kostbarkeiten der Renaissance und des Barock: "Pretiosa" und "allerley Kunstsachen" aus den Kunst-und Raritätenkammern der Herzöge von Braunschweig-Lüneburg aus dem Hause Wolfenbüttel, Brunswick, Germany, 1997, 37–39.

26. Beschreibung des Grünen-Gewölbes in Dressden, quoted in Syndram and Weinhold, ". . . Und ein Leib von Perl," 9.

27. The Saxon archive inventories describing both eggs are quoted and translated in Dirk Syndram, Renaissance and Baroque Treasury Art: The Green Vault in Dresden, transl. D. Kletke, Dresden, 2005, 14, 19–20nn26–27; Joanna Marschner, "The Ivory Egg: Elisabeth Charlotte, Princess Palatine's Gift to Caroline of Ansbach," in J. Bepler and S. Norrhem (eds.), Telling Objects: Contextualizing the Role of the Consort in Early Modern Europe, Wiesbaden, Germany, 2018, 247–251. The Dresden ivory egg, which also enclosed a motto in French, appeared at auction in 1988.

28. Hackenbroch and Sframeli, The Jewels of the Electress Palatine, 54; Syndram and Weinhold, ". . . Und ein Leib von Perl," 12. Several museums (the

Hermitage, the Rijksmuseum, the Landesmuseum Württemberg) have sometimes described baroque pearl figures in their possession as by Dinglinger or in his manner, with little evidence.

29. See Kappel and Weinhold, *The New Grünes Gewölbe*, 161–162, 192–193, and Sigfried Asche, *Balthasar Permoser: Leben und Werk*, Berlin, 1978, 71, 109, 164–165, and plates 166–173. Asche suggests that the theme of the Africans and their subsequent transformation into small figurines was initiated by Permoser rather than by Dinglinger. Dirk Syndram, " 'Mohrenfiguren' von Balthasar Permoser und Johann Melchior Dinglinger," in Syndram, *Juwelenkunst des Barock*, 91–95. For Köhler's miniatures, see also Dirk Syndram and Ulrike Weinhold, *Der Dresdner Hofjuwelier Johann Heinrich Köhler: Dinglingers schärfester Konkurrent*, Dresden, 2019, including the complete list of works in the appendix.

30. For the fascination with Africa in Augustus's court see André Thieme and Matthias Donath (eds.), *Augusts Afrika: Afrika in Sachsen, Sachsen in Afrika im 18. Jahrhundert* (exh. cat.), Königsbrück, Germany, 2022.

31. Melchior Lorch's 1576 drawing of a caparisoned Turkish camel with rider was published in *Dess Weitberühmten, Kunstreichen und Wolerfahrnen Herrn Melchior Lorichs . . . wolgerissene vnd geschnittene Figuren . . . vnd allerhand was in der Türckey zu sehen*, Hamburg, 1626, reproduced in Erik Fischer (ed.), *Melchior Lorck*, vol. 2, *The Turkish Publication, 1626 Edition*, Copenhagen, 2009, 13. As far as I know, this source for Dinglinger's camel design has not been noted by previous scholars, including Walter Holzhausen and Erna von Watzdorf.

32. In Dinglinger's ensemble, of course, the different pieces can be moved about. So whereas the curators of the Grünes Gewölbe have decided to display the chest open with its contents spread out, it can be packed again and closed shut.

33. Menzhausen, *At the Court of the Great Mogul*, 31; part 2:77, 79; Dirk Syndram, *The Throne of the Great Mogul in the Green Vault*, Leipzig, 2013, 68. Syndram and Schöner, *August der Starke und sein Grossmogul*, 18, point out that some of the pieces from the chest mentioned in "Kurzer Entwurff der Magnificenz des großen Moguls"—scissors and a signet—are today missing.

34. Hannah Baader, "Das Objekt auf der Bühne: Diamante, Dinge und Johann Melchior Dinglingers Imaginationen einer Geburtstagfeier in Agra," in Manuela De Giorgi et al. (eds.), *Synergies in Visual Culture / Bildkulturen im Dialog*, Munich, 2013, 276. For "scale error" in cognitive science, see Rabb, *Miniature and the English Imagination*, esp. 57.

35. Giorgio Maria Rapparini, "Le portrait du vrai mérite," in *Die Rapparini-Handschrift der Landes-und Stadt-Bibliothek Düsseldorf*, Düsseldorf,

Germany, 1958, 64–65; I am grateful to Achille Varzi for his thoughtful translation of the Italian original. The model could be seen until World War II: cf. Werner Dobisch, *Das neue Schloss zu Bensberg*, Düsseldorf, Germany, 1938, 30–37 (incl. photographs), and for the poem, 120–121; and recently Fulco, *Exuberant Apotheoses*, 112–114 (including a different English translation of Rapparini's verses) and photograph on 156.

36. Matthew Mindrup, *The Architectural Model: Histories of the Miniature and the Prototype, the Exemplar and the Muse*, Cambridge, MA, 2019, chap. 4, 121, 133 (quoting Leon Battista Alberti, *On the Art of Building in Ten Books*, mid-fifteenth century, and Henry Wotton, *Elements of Architecture*, 1624). Malcom Baker, "Representing Invention, Viewing Models," in Soraya de Chadarevian and Nick Hopwood (eds.), *Models: The Third Dimension of Science*, Stanford, CA, 2004, 36, draws attention to the same transition from the early modern period into the eighteenth century in the uses and valuation of models—in his case, primarily sculptors' models—that became autonomous aesthetic objects within a newly developed narrative of artistic creativity.

37. Another impressive example of this emphasis on the aesthetic and artistic qualities of architectural models for their own sake is the collection of models of town fortifications that Louis XIV amassed and installed in 1700 in the Louvre (today at the Musée des Plans-Reliefs in the Hôtel des Invalides). Measuring up to fifteen meters across, these models show buildings, fortifications, and surrounding landscape in naturalistic detail—all the way to the differentiation of different species of trees—that greatly exceed any military need. Cf. Martha Pollak, *Cities at War in Early Modern Europe*, Cambridge, 2010, 48, and Isabelle Warmoes, *La Musée des Plans-Reliefs: Maquettes historiques des villes fortifiées*, Paris, 1997.

Chapter 6. Miniatures

1. Although this genre was to expand further its inventory of designs during the eighteenth century, all the examples mentioned here are from the seventeenth century or the first decade of the eighteenth. In addition to the many objects in such online collections as the Rijksmuseum, the Victoria and Albert Museum, and the Metropolitan Museum, see Victor Houart, *Miniature Silver Toys*, transl. D. Smith, New York, 1981, 47–92; Kristin Duysters, *"Al 's werelds goed is poppegoed": Miniatuurzilver in Nederland* (exh. cat.), Arnhem, Netherlands, 1999 (see 18 for Dirk van de Graeff); John Endlich, *Nederlandse zilveren miniaturen uit de 17de en 18de eeuw*, The Hague,

2011, 16–57; and Emiel Aardewerk and Esther Aardewerk, *Tall and Small: Antique Dutch Silver Miniatures*, The Hague, 2012. For the rarer Dutch miniatures in cheaper materials like lead, pewter, and tin, see Annemarieke Willemsen, " 'Kinder-spel en poppe-goet': 17de-eeuwse miniatuur gebruiksvoorwerpen en hun functie," *Antiek* 28 (1994), 392–399. I am grateful to Dirk Jan Biemond of the Rijksmuseum for sharing his knowledge about these objects.

2. The best single account of miniature objects across Europe remains Houart, *Miniature Silver Toys*. For English miniatures, and their subsequent appearance in early eighteenth-century literature, see Melinda Alliker Rabb, *Miniature and the English Imagination: Literature, Cognition, and Small-Scale Culture, 1650–1765*, Cambridge, 2019.

3. Jet Pijzel-Dommisse, *Het Hollandse pronkpoppenhuis: Interieur en huishouden in de 17de en 18de eeuw*, Amsterdam, 2001 (see 446 for *poppegoet*); Pijzel-Dommisse, *The 17th-Century Dolls' Houses of the Rijksmuseum*, Amsterdam, 1994; Jet Pijzel-Dommisse and Madelief Hohé, *XXSmall: Poppenhuizen en meer in miniatuur* (exh. cat.), The Hague, 2011. The largest collection of miniature silver, with more than a hundred pieces, is in the dollhouse of Petronella Dunois in the Rijksmuseum.

4. Shirley Glubok, "The Doll's House of Petronella de la Court," *Antiques* 137:2 (1990), 488–501; Pijzel-Dommisse and Hohé, *XXSmall*, 18–21. The dollhouse of Petronella Oortman (Rijksmuseum) has another *mise-en-abyme* cabinet with a collection of shells: cf. Hanneke Grootenboer, "Thinking with Things in Petronella Oortman's Miniature Shell Collection," in Marisa Anne Bass et al., *Conchophilia: Shells, Art, and Curiosity in Early Modern Europe*, Princeton, NJ, 2021, 103–123. Also notable is the spectacular miniature Dutch dollhouse-like apothecary's shop from 1730 with more than three hundred tiny containers of medicines, fifty-five secret drawers, and over two thousand tiny *naturalia* specimens: Paul van Duin (ed.), *Collector's Cabinet with Miniature Apothecary's Shop, Rijksmuseum*, Amsterdam, 2017.

5. For seventeenth-century German dollhouses in the Germanisches National-museum, see Heidi Müller, *Good Housekeeping: A Domestic Ideal in Miniature*, Nuremberg, 2007. The first dated English dollhouse was a gift from Queen Anne to her goddaughter, 1691–1703: Rabb, *Miniature and the English Imagination*, 44. An early Georgian dollhouse in Nostell in West Yorkshire, recently restored, is closely reminiscent of the Dutch examples, replete with miniature Chippendale furniture and hallmarked silverware. The two earliest documented dollhouses in Sweden are that of Queen Ulrika Eleonora from

1686 and another c. 1700, now at the Nordic Museum in Stockholm: Birgita Lindencrona, "Dollhouses and Miniatures in Sweden," in Amy Ogata and Susan Weber (eds.), *Swedish Wooden Toys* (exh. cat.), New Haven, CT, 2014, 189–195. I am also aware of two extant late seventeenth-century groups of luxury miniatures of silver filigree furniture and domestic items, including filigree cradles resembling Anna Maria Luisa de Medici's, which were designed as ensemble sets, presumably as dollhouse furnishings. One in the Kulturen Museum in Lund is probably Dutch (inv. no. KM 67026); the other at the Metropolitan Museum in New York, which includes miniatures of Alpine-style chairs, is identified as South German (inv. no. 31.37.1-.23; I am grateful to Wolfram Koeppe for the opportunity to examine it together).

6. In addition to the miniature annunciation illustrated here, note for example the astonishing lampworked glass interior scene from the end of the seventeenth or the beginning of the eighteenth century, showing card players in a Rococo gilded drawing room complete with chandeliers, wicker-back chairs, and a servant, which was auctioned at Christie's Paris, sale 3531, 3–4 October 2012, lot 242, one of several miniature lampwork scenes and figurines in the auction (lots 246, 250–251). See Dwight P. Lanmon, "Lampworking," in D. P. Lanmon with David B. Whitehouse, *The Robert Lehman Collection XI: Glass*, New York, 1993, 231–266.

7. Wolfram Koeppe (ed.), *Making Marvels: Science and Splendor at the Courts of Europe* (exh. cat.), New Haven, CT, 2019, 244 (carriage); inv. no. BK–1955–19 (boxwood beggar), Rijksmuseum, Amsterdam, sometimes attributed to Albert Jansz. Vinckenbrinck. For the stone miniatures in the Herzog Anton Ulrich-Museum in Braunschweig, see *Weltenharmonie: Die Kunstkammer und die Ordnung des Wissens*, Brunswick, Germany, 2000, cat. nos. 74, 85.

8. See Louis Bondy, *Miniature Books: Their History from the Beginnings to the Present Day*, London, 1981, chap. 3, with Pijzel-Dommisse and Hohé, *XXSmall*, 47, and John Mack, *The Art of Small Things*, London, 2007, 10. Some of these miniature books ended up in dollhouse libraries. Petronella Oortman's dollhouse (c. 1686–1705) has 85 miniature books, of which 4 were actually printed and the others handmade, including a 5.3-centimeter atlas reminiscent of Dinglinger's, made with cutouts from larger prints. Pijzel-Dommisse, *Het Hollandse pronkpoppenhuis*, 335–345; Pijzel-Dommisse, *The 17th-Century Dolls' Houses of the Rijksmuseum*, frontispiece, 28–29.

9. Lorenzo Magalotti, *Travels of Cosmo the Third, Grand Duke of Tuscany, Through England During the Reign of King Charles the Second (1669)*, London,

1821, 346; August Koester, *Ship Models of the Seventeenth to the Nineteenth Centuries*, New York, 1926, ix–x, xxi–xxiii, plate 10; Brian Lavery, *Ship Models: Their Purpose and Development from 1650 to the Present*, London, 1995, chaps. 1–3; Rabb, *Miniature and the English Imagination*, 47–49, 136–137.

10. "Mode-Puppen oder Docken," in *Johann Heinrich Zedlers Grosses vollständiges Universal-Lexicon aller Wissenschaften und Künste*, Leipzig, 1739, vol. 21, col. 722; "Docke," "Dockemacher," and "Dockenwerk," in *Deutsches Wörterbuch von Jacob und Wilhelm Grimm*, Leipzig, 1860, vol. 2, cols. 1208–1215. On Weigel, see Michael Bauer, "Christoph Weigel (1654–1725): Kupferstecher und Kunsthändler in Augsburg und Nürnberg," *Archiv für Geschichte des Buchwesens* 23 (1983), 693–1186, 753, 759 (for his training as goldsmith).

11. Christoff Weigel, *Abbildung der gemeinen Haupte-Stände*, Regensburg, 1698, 219 (excerpted in Karl Eward Fritzsch and Manfred Bachmann, *Deutsches Spielzeug*, Leipzig, 1965, 16). The same was echoed in "Puppenwerck, Dockenwerck, Spielsachen," in *Johann Heinrich Zedlers Grosses vollständiges Universal-Lexicon aller Wissenschaften und Künste*, Leipzig, 1741, vol. 29, col. 1634: there is no craft "that does not also produce in very small models every thing that it normally makes in full size, whereby the cities of Augsburg and Nuremberg stand out particularly" (translated in Müller, *Good Housekeeping*, 14).

12. Weigel, *Abbildung der gemeinen Haupte-Stände*, 218. A pair of luxurious museum objects bears out Weigel's account very well indeed. The Germanisches Nationalmuseum in Nuremberg exhibits a showpiece travel service with fifty-three items (inv. no. HG 4885), created in the last decade of the seventeenth century by Meister Tobias Baur of Augsburg. The Bayerisches Nationalmuseum in Munich displays a very similar object, created in the first decade of the eighteenth century by another Augsburg master craftsman, Johann Christoph Hünning (inv. no. 15/20.1). Although Hünning's box holds a toiletry set, it resembles Baur's set closely in design, colors, materials, and many details. Hünning's toiletry set, however, is a miniature, mimicking the larger object at less than twenty centimeters from side to side. In Augsburg c. 1700, a town of 25,000 people, it is likely that these master craftsmen knew each other and were aware of each other's big projects. One can easily imagine Hünning, impressed with Baur's eighty-centimeter-wide showpiece travel set, choosing to imitate it but rendering it his own by altering the scale to miniature, as if he had read Weigel.

13. Lessing's letter is translated and quoted in Yair Mintzker, *The Many Deaths of Jew Süss: The Notorious Trial and Execution of an Eighteenth-Century Court*

Jew, Princeton, NJ, 2017, 237, and see 236–238 for the international nature of the fair.

14. Dirk Syndram, *Juwelenkunst des Barock: Johann Melchior Dinglinger im Grünen Gewölbe*, Munich, 2008, 29.

15. When ceramicist and writer Edmund de Waal—a leading connoisseur of miniatures—loaned the Jewish Museum in Vienna his netsuke (miniature Japanese sculpture) collection that is the subject of his well-known book *The Hare with Amber Eyes*, he insisted on "one stipulation, and it's the most unlikely loan agreement I think you'll ever hear of, which is that these objects have to be handled. . . . People who go through the Jewish Museum in Vienna, will be asked to pick them up, and handle them, and pass them on." Edmund de Waal, "In Touch: Objects, Families, Stories," *Emmanuel College Magazine* 101 (2018–2019), 36.

16. Quoted in Syndram, *Juwelenkunst des Barock*, 28. The original document is lost.

17. This question is raised in Carsten-Peter Warncke, "Sehen, fühlen und verstehen: Johann Melchior Dinglingers 'Hofstaat des Grossmoguls,' " *Dresdener Kunstblätter* 48 (2004), 278–281. See also Larry Silver, "The Images of Power: Dinglinger's Dresden Miniatures," in Claudia Swan (ed.), *Tributes to David Freedberg: Image and Insight*, Turnhout, Belgium, 2019, 339.

18. Dirk Syndram, *The Throne of the Great Mogul in the Green Vault*, Leipzig, 2013, 25 (including translated quote), 46.

19. Annette Cremer, *Mon Plaisir: Die Puppenstadt der Auguste Dorothea von Schwarzburg (1666–1751)*, Cologne, 2015; Cremer, "A Miniature State: The Dollhouse City of Princess Augusta of Schwarzburg (1666–1751)," *Court Historian* 20:2 (2015), 167–186. I am grateful to Annette Cremer for discussing this topic with me.

20. Cremer, "A Miniature State," 183n38, a purchase bill from 1697. For Augusta Dorothea's visits to the Leipzig Fair, with possible overlaps with Augustus the Strong, see Cremer, *Mon Plaisir*, 301–302, and 172, 179, for her requests for Augustus's political patronage. It is worth noting that in 1715 Augusta Dorothea converted to Catholicism, like Augustus the Strong, and even included a miniaturized Catholic church among her dollhouses.

Chapter 7. Magi

1. Victor Houart, *Miniature Silver Toys*, transl. D. Smith, New York, 1981, 19.

2. Albrecht's *Dockenhaus*, now lost, is described in a detailed inventory of 1598. James Bryan, "Material Culture in Miniature: Historic Dolls' Houses

Reconsidered," PhD diss., University of Wisconsin–Madison, 2003, chap. 2. And note Samuel Quiccheberg's discussion of the role of dolls in princesses' education, perhaps based on his close contacts with Albrecht V's court; see Mark Meadow and Bruce Robertson (eds.), *The First Treatise on Museums: Samuel Quiccheberg's Inscriptiones, 1565*, Los Angeles, 2013, 84–85. In France there is also record of a set of silver and diamond dollhouse furniture in an inventory of the silverware of Jeanne d'Albret, the mother of Henry IV of France: Houart, *Miniature Silver Toys*, 19.

3. Inv. no. Kunstkammer, 406–425, Schloss Ambras, Austria. There were also other types of small-scale objects that emerged not as miniatures but for specific purposes, such as late medieval and early modern chess pieces, which developed independently even if they may have subsequently inspired some miniatures' designs.

4. Frits Scholten (ed.), *Small Wonders: Late-Gothic Boxwood Micro-Carvings from the Low Countries* (exh. cat.), Amsterdam, 2016; Evelin Wetter and Frits Scholten (eds.), *Prayer Nuts, Private Devotion, and Early Modern Art Collecting*, Riggisberg, Switzerland, 2017; Joaneath Spicer, "Miniature Mysteries: New Proposals on the Handling, Creation, and Authentication of Late Medieval Prayer Nuts," *Journal of the Walters Art Museum* 73 (2018), 79–86; Boxwood Project, http://boxwood.ago.ca/. The current view is that most of the boxwood micro-carvings originated in one workshop, that of Adam Dircksz, perhaps in Delft, but there are examples from other workshops, including German ones.

5. Frits Scholten, "The Boxwood Carvers of the Late Gothic Netherlands," in Scholten (ed.), *Small Wonders*, 28, 63.

6. Frits Scholten, "Scale, Prayer and Play," in Scholten (ed.), *Small Wonders*, 171–210, 202 (quotation); Reindert Falkenburg, "Prayer Nuts: Feasting the 'Eyes of the Heart,' " in Wetter and Scholten (eds.), *Prayer Nuts, Private Devotion*, 13–26, borrowing the concept of "seeing with the eyes of the heart" from the contemporary religious movement *devotio moderna*. For the distinctive group of transparent rock-crystal pendants from the late sixteenth and early seventeenth centuries with miniature devotional scenes, ascribed variously to Germanic, Spanish, or Mexican origins, see Parker Lesley, *Renaissance Jewels and Jeweled Objects from the Melvin Gutman Collection*, Baltimore, 1968, 63; Hugh Tait, *Catalogue of the Waddesdon Bequest in the British Museum*, vol. 1, *The Jewels*, London, 1986, 231–237; and Ian Wardropper and Priscilla Muller, "Renaissance Jewelry in the Alsdorf Collection," *Art Institute of Chicago Museum Studies* 25 (2000), 79–81. Compare

also the French or Spanish ring of c. 1620 in the Albion Art collection, Japan, boasting an incredibly detailed multifigure miniature ivory tableau of the crucifixion: Albion Art, https://www.albionart.com.

7. Brian Lavery, *Ship Models: Their Purpose and Development from 1650 to the Present*, London, 1995, 9; Caroline Walker Bynum, *Dissimilar Similitudes: Devotional Objects in Late Medieval Europe*, New York, 2020, 59–96; Virginia Reinburg, *French Books of Hours: Making an Archive of Prayer, c. 1400–1600*, Cambridge, 2012, 123; Jessica Keating, *Animating Empire: Automata, the Holy Roman Empire, and the Early Modern World*, University Park, PA, 2018, chap. 4; Reindert Falkenburg, "Marginal Motifs in Early Flemish Landscape Paintings," in Norman Muller et al. (eds.), *Herri met de Bles: Studies and Explorations of the World Landscape Tradition*, Turnhout, Belgium, 1998, 153–169; Falkenburg, "The Devil Is in the Detail: Ways of Seeing Joachim Patinir's 'World Landscapes,' " in Alejandro Vergara (ed.), *Patinir: Essays and Critical Catalogue* (exh. cat.), Madrid, 2007, 61–79.

8. I am not suggesting of course that before the seventeenth century miniaturization was introduced exclusively to serve devotional objects. Goldsmiths like those in Augsburg also produced miniature objects playful for their own sake and as demonstrations of their skills. For an unusual example, see Jessica Wolfe, "*Circus Minimus*: The Early Modern Theater of Insects," in Karen Raber and Monica Mattfeld (eds.), *Performing Animals: History, Agency, Theater*, University Park, PA, 2018, 111–122.

9. Erna von Watzdorf, *Johann Melchior Dinglinger: Der Goldschmied des deutschen Barock*, Berlin, 1962, 1:171–173. See Ulla Krempel, "Augsburger und Münchner Emailarbeiten des Manierismus," *Münchner Jahrbuch der Bildenden Kunst* 18 (1967), 154–159; Rainer Rückert, *Der Schatz vom Heiligen Berg Andechs* (exh. cat.), Munich, 1967, 60–61, and illus. 68–69 (labeling this altar, because of its freestanding figures, a "Krippenaltärchen").

10. Hans Thoma and Herbert Brunner, *Schatzkammer der Residenz München: Katalog*, Munich, 1964, 70; Herbert Brunner, *The Treasury in the Residenz Munich*, Munich, 1967, 12.

11. This miniature altar (inv. no. Kunstkammer, 3233, Kunsthistorisches Museum, Vienna) was apparently first recorded in *Führer durch die Franzensburg in Laxenburg*, Vienna, 1873, 14, and entered the Vienna collection in 1881. I am grateful to Paulus Rainer for offering to examine this object together. Dr. Rainer suggests the attribution of date and place through comparisons with other objects in the imperial treasury with imagery of Emperor Leopold and his son Joseph, dating to 1690–1705.

12. Dating this object (inv. no. Kunstkammer, 3231, Kunsthistorisches Museum, Vienna) relies again on Paulus Rainer, curator of the Kunsthistoriches Museum's *Kunstkammer* collections.

13. The lampwork glass annunciation from the turn of the eighteenth century (height 34 cm) appeared in Christie's Paris auction on 3–4 October 2012, lot 249. The late seventeenth-century carved bone annunciation (height 14.5 cm), consisting of two freestanding figurines and two freestanding furnishings, was sold by Matthew Holder in London. The three-dimensional coral miniature tableau of the annunciation from Trapani from the end of the seventeenth century (height without frame c. 50 cm) was displayed by Jaime Eguiguren of Buenos Aires at the European Fine Arts Fair in Maastricht in March 2019. For a similar Trapani coral annunciation from a somewhat later date, see Maria Concetta di Natale, "Serpotta e le arti decorative," in Vincenzo Abbate (ed.), *Serpotta e il suo tempo*, Milan, 2017, 83. Another example is kept in the Monastery of Las Descalzas Reales in Madrid.

14. "Testament et inventaire de Mademoiselle de Guise 1688," *Nouvelles archives de l'art francais* (3rd series) 12 (1896), 230–231; Jonathan Spangler, "Material Culture at the Guise 'Court': Tapestries, a Bed and a Devotional Dollhouse as Expressions of Dynastic Pride and Piety in Seventeenth-Century Paris," *Seventeenth-Century French Studies* 34:2 (2002), 170–171. I am grateful to Jonathan Spangler for sharing with me his expertise.

15. Philippe Malgouyres, *Histoires d'ivoire* (exh. cat.), Châlons-en-Champagne, France, [2007], 118–121, 127; P. Malgouyres and Jean-Luc Martinez, *Venus d'ailleurs: Matériaux et objets voyageurs* (exh. cat.), Paris, 2021, 66–68. I am grateful to Philippe Malgouyres, the Louvre curator of Renaissance and Baroque, for many wonderful conversations about early modern objects.

16. Johan Huizinga, *Homo Ludens: A Study of the Play-Element in Culture*, transl. R. F. C. Hull, London, 1949; Stefan Laube, *Von der Reliquie zum Ding: Heiliger Ort—Wunderkammer—Museum*, Berlin, 2011.

17. Jonathan Sheehan and Dror Wahrman, *Invisible Hands: Self-Organization and the Eighteenth Century*, Chicago, 2015. For the effects on imagining human identity, see Dror Wahrman, *The Making of the Modern Self: Identity and Culture in Eighteenth-Century England*, New Haven, CT, 2004.

18. Two essential collections of nativity scenes are in Certosa di San Martino in Naples and in the Bayerisches Nationalmuseum in Munich. The following paragraphs rely primarily on Rudolf Berliner, "The Origins of the Crèche," *Gazette des Beaux Arts* 30 (1946), 249–278; Berliner, *Die Weihnachtskrippe*,

Munich, 1955; Nicola Spinosa (ed.), *Il presepe: Le collezioni del Museo di San Martino*, Naples, 2005; Nina Gockerell, *Krippen im Bayerischen Nationalmuseum*, Munich, 1993; Gockerell and Renate Eikelmann (eds.), *Bayerisches Nationalmuseum: Handbook of the Art and Cultural History Collections*, Munich, [2002], 293–301; and C. D. Dickerson III and Sabina de Cavi (eds.), *A Nativity from Naples: Presepe Sculpture of the Eighteenth Century* (exh. cat.), Fort Worth, TX, 2008. I am grateful to Sybe Martena of the Bayerisches Nationalmuseum for help in gathering these sometimes obscure materials in the time of the coronavirus. For the Genoese *presepe* tradition, see *Venite Adoremus: Notes on the Genoese Crèche* (exh. cat.), Genoa, 1993.

19. Annette Cremer, *Mon Plaisir: Die Puppenstadt der Auguste Dorothea von Schwarzburg (1666–1751)*, Cologne, 2015, 67n58.

20. I owe this observation to Philippe Malgouyres. For the chronological development of the nativity scene, noting the second half of the seventeenth century as a key turning point, see Berliner, "The Origins of the Crèche," and Gockerell, *Krippen im Bayerischen Nationalmuseum*, esp. 9–45. For Naples, note the 1702 date of a *presepe* gifted by a Neapolitan merchant to Philip V: Giuseppe Morazzoni, *Il presepe Napoletano*, Naples, 2016 (orig. 1921), 30. An early south German example is noted in Berliner, *Die Weihnachtskrippe*, 78. Among the earliest datable records of the Neapolitan nativity crib are two sketches of a double-grotto *presepe* made by the German painter Anton Clemens Lünenschloß (presently reconstructed at the Bayerisches Nationalmuseum), whose patron during his travels in south Italy c. 1713 was none other than the avid miniature collector and Augustus's competitor Johann Wilhelm von der Pfalz.

21. In Sicily other biblical scenes were staged in similar settings, for instance the massacre of the innocents.

22. Giorgio Agamben, "Fable and History: Considerations on the Nativity Crib [*Presepe*]," in Agamben, *Infancy and History: The Destruction of Experience*, transl. Liz Heron, London, 2007 (orig. 1993), 141–146 (emphasis added). The same shift can also be seen in the innovative, small-scale polychrome terracotta sculptural groups of the Spanish sculptress La Roldana (Luisa Roldán, c. 1650–c. 1706). In her "jeweled objects" she represented religious themes transformed into tender, detailed genre domestic scenes with animals and still-life additions but few elements characteristic of sacred art. Roberto Contini et al., *The Spanish Golden Age: Painting and Sculpture in the Time of Velázquez* (exh. cat.), Munich, 2016, cat. no. 97, and Patrick Lenaghan, "Luisa Roldán's Career in Madrid: Intimate Masterpieces in Terracotta," in *Luisa*

Roldán: Court Sculptor to the Kings of Spain, Madrid, 2016, 20–41. La Roldana made at least one nativity scene with 149 pieces, now lost.

23. Berliner, "The Origins of the Crèche," 272.

24. Although camels could occasionally be seen in European cities, and drew attention from artists in residence, reasonably naturalistic images of camels were surprisingly rare in European painting before the middle of the seventeenth century, as is attested by llama- or horse-like camels in multiple adoration of the magi paintings by artists such as Jacob Jordaens, Paolo Veronese, Pieter Aertsen, Pieter Breugel the Elder, and numerous others. In natural history books a new era began with John Jonston, *Historiae naturalis de quadrupetibus libri*, Frankfurt, 1652, which offered no less than ten efforts at representing naturalistic camels: cf. Dániel Margócsy, "The Camel's Head: Representing Unseen Animals in Sixteenth-Century Europe," *Netherlands Yearbook of Art History* 61 (2011), 62–85. In Augsburg c. 1600, however, we already find impressively naturalistic three-dimensional camel clocks: Alexis Kugel, *A Mechanical Bestiary: Automaton Clocks of the Renaissance*, Paris, 2016, cat. 14, 18.

25. In painting, treasure chests were not very common in early modern adoration of the magi paintings. For examples in which the magi's gifts include a treasure chest echoing the *presepi*, see paintings by Jan Brueghel the younger of c. 1620 in the Alte Pinakothek in Munich, and Gaspar Dias (attrib.), painted in Portugal c. 1550–1560, in Hugo Miguel Crespo, *At the Prince's Table: Dining at the Lisbon Court (1500–1700)*, Lisbon, 2018, 84–85. I am grateful to Doron Lurie, former curator of Renaissance and Baroque art at the Tel Aviv Museum of Art, for discussing these paintings with me.

26. Hannah Baader notes the thematic affinity of the *Throne of the Great Mogul* with the three magi in "Das Objekt auf der Bühne: Diamante, Dinge und Johann Melchior Dinglingers Imaginationen einer Geburtstagfeier in Agra," in Manuela De Giorgi et al. (eds.), *Synergies in Visual Culture / Bildkulturen im Dialog*, Munich, 2013, 277–278.

27. "Kurzer Entwurff der Magnificenz des großen Moguls, an seinen Geburths Tage bey Überreichung derer Geschencke," in Dirk Syndram and Jörg Schöner, *August der Starke und sein Grossmogul*, Munich, 2014, 103–104; Olfert Dapper, *Asia; oder, Ausführliche Beschreibung des Reichs des Grossen Mogols*, Nuremberg, 1681, 149. Dapper, an armchair geographer, derived his information—with acknowledgment and an incorrect rendering of *Cham-i-Alem*—from the Italian traveler Pietro Della Valle: *De Volkome Beschryving Der Voortrefelijcke Reizen van de deurluchtige reisiger Pietro Della Valle,*

Amsterdam, 1666, 166. Visually, the Chinese Mir Miron in his sedan chair was modeled after an illustration of a Chinese dignitary with no connection to the Mughal Empire, from Pieter van Hoorn, *Die Dritte Gesandtschafft an den Käyser von Sina oder Taising, und Ost-Tartarien*, published with Olfert Dapper, *Gedenkwürdige Verrichtung Der Niederländischen Ost-Indischen Gesellschaft in dem Kaiserreich Taising oder Sina*, Amsterdam, 1674, following 44. See Watzdorf, *Johann Melchior Dinglinger*, 1:152–153.

28. This interpretation of the magi was more in line with their original appearance in the gospel of Matthew. For the evolution of the representation and meaning of the three magi, including in the seventeenth century, see especially Richard Trexler, *The Journey of the Magi: Meanings in History of a Christian Story*, Princeton, NJ, 1997, 187 and passim. See also Joseph Leo Koerner, "The Epiphany of the Black Magus circa 1500," in David Bindman and Henry Louis Gates Jr. (eds.), *The Image of the Black in Western Art*, vol. 3, part 1, *Artists of the Renaissance and Baroque*, Cambridge, MA, 2010, 7–92, and Manuela Beer et al. (eds.), *The Magi: Legend, Art and Cult* (exh. cat.), Munich, 2014.

29. For the correlation between the magi's cultural significance and the use of their names as Christian names, see Dan Ewing, "Magi and Merchants: The Force Behind the Antwerp Mannerists' Adoration Pictures," *Jaarboek Koninklijk Museum voor Schone Kunsten Antwerpen 2004/5*, Antwerp, 2005, 291.

30. Trexler, *The Journey of the Magi*, 75, 79ff, 82.

31. After speculating further on the star that brought the three kings to witness the birth, Meisenbug also compared Friedrich I to King Solomon and the visiting royals to the queen of Sheba, the Old Testament prefiguration of the three magi. Karl Wilhelm von Meisenbug, *Remarques sur l'entrevue des trois roys*, in Vinzenz Czech, *Das Potsdamer Dreikönigstreffen 1709*, Göttingen, 2008, 171–176, 173 (quotation), and cf. "Tre Re Uniti: Sonetto," reprinted on 178. For Pöllnitz, see Edith Cuthell, *A Vagabond Courtier: From the Memoirs and Letters of Baron Charles Louis von Pöllnitz*, London, 1913, 1:43.

32. Schlottheim, the son of a Saxon clockmaker, had a long-standing relationship with the Dresden court. Schlottheim's automaton could be seen in the Dresden collections until World War II, when it was badly damaged. See Max Engelmann, "Das Krippenwerk des Augsburgers Hans Schlottheim," *Der Kunstwanderer* 3–4 (1921–1922), 147–150; Julia Fritsch, "Hans Schlottheim?" in *Ships of Curiosity: Three Renaissance Automata*, Paris, 2001, 11–17; Peter Plassmeyer, "Renaissance Musical Automata in the Art Collection of the Saxon Electors in Dresden," in J. J. L. Haspels (ed.), *Royal Music*

Machines (exh. cat.), Zutphen, Netherlands, 2006, 49–50; and, most recently and comprehensively, Keating, *Animating Empire*, chap. 3. The Dresden *Kunstkammer* held another automaton attributed to Schlottheim, a "world upside-down" clock with miniature figures.

33. Keith Thomas, *Religion and the Decline of Magic*, Harmondsworth, U.K., 1971; Marcel Gauchet, *The Disenchantment of the World: A Political History of Religion*, transl. O. Burge, Princeton, NJ, 1998. For Max Weber, see for instance *The Protestant Ethic and the Spirit of Capitalism*, transl. Talcott Parsons, New York, 1958, 104–105.

34. Tony Sharp, *Pleasure and Ambition: The Life, Loves and Wars of Augustus the Strong*, London, 2001, 136; Helen Watanabe-O'Kelly, *Court Culture in Dresden from Renaissance to Baroque*, Basingstoke, U.K., 2002, 221.

35. The Victoria and Albert Museum, London, holds a much simpler earthenware miniature cradle that doubled as a fertility charm from exactly the same period at the turn of the century (inv. no. C.305–1921). Interestingly, in 1693—that is to say, virtually at the same time as Johann Wilhelm's gift to his wife—the rather uncommon phrase *auguror eveniet* appeared in a poetic prophesy in a parallel context, regarding the future success predicted for the princely heir of another German elector in Bavaria whose mother died at birth after two miscarriages: Guilielmus vander Slooten, *Epicedion in obitum serenissimæ principis ac ducissæ . . . Leopoldi Ignatii Romanorum, Germanorumque imperatoris filiæ dilectissimæ . . . Maximiliani Emmanuëlis . . . utriusque Bavariæ, & Superioris Palatinatûs ducis . . . conjugis defunctæ . . . 24, Decembris 1692*, Brussels, 1693, 3. I am grateful to Ayelet Even-Ezra for help with this reference.

Chapter 8. Hands

1. Lorenzo Pignoria, *Mensa Isiaca, qua sacrorum apud Ægyptios ratio et simulacra . . . exhibentur et explicantur*, Amsterdam, 1669 [also 1670]. We can be reasonably certain that Dinglinger had access to this particular edition of Pignoria, as is explained below. On the role of the *Mensa Isiaca* in early modern Europe and in particular in seventeenth-century Egyptian antiquarianism, see Daniel Stolzenberg, *Egyptian Oedipus: Athanasius Kircher and the Secrets of Antiquity*, Chicago, 2013, 143–147. Erna von Watzdorf, *Johann Melchior Dinglinger: Der Goldschmied des deutschen Barock*, Berlin, 1962, 1:138, noted the connection of the *Mensa Isiaca* to the *Throne of the Great Mogul*. For its significance in Dinglinger's future work, see Dirk Syndram, *Die Ägyptenrezeption unter August dem Starken: Der "Apis-Altar" Johann Melchior Dinglingers*, Meinz, Germany, 1999, 30–34.

2. Lorenzo Pignoria, *Magnae Deum Matris Ideae et Attidis initia ex vetustis monumentis edente et explicante*, Venice, 1624; Giacomo Filippo Tomasini, *Manus æneæ Cecropii votum referentis dilucidatio*, Padua, 1649. Pignoria's tract was also published in Paris in 1623 and dedicated to Nicolas-Claude Fabri de Peiresc, who had probably supplied him with the original image. Peiresc wrote to Pignoria on 25 July 1618 and again on 19 March 1619, announcing the discovery of a "hieroglyphic hand" and promising to send him drawings of it (MS 1875, ff. 351v and 357v, Bibliothèque Inguimbertine, Carpentras, France). See Peter Miller, "Taking Paganism Seriously: Anthropology and Antiquarianism in Early Seventeenth-Century Histories of Religion," *Archiv für Religionsgeschichte* 3:1 (2010), 204. I am grateful to Peter Miller for sharing these references with me.

3. Ian Maclean, "Andreas Frisius (Fries) of Amsterdam and the Search for a Niche Market, 1664–1675," in Maclean, *Episodes in the Life of the Early Modern Learned Book*, Leiden, 2021, 280–345. I am grateful to Ian Maclean for sharing with me his work in progress.

4. Pignoria, *Mensa Isiaca*, 1669 edition, folio plates folded into the quarto book between 66 and 67. These plates were reengraved from Lorenzo Pignoria, *Characteres Aegyptii, hoc est Sacrorvm, Quibvs Aegyptii Vtvntvr, Simvlachrorvm Accvrata Delineatio Et explicatio*, Frankfurt, 1608. They were also included in Hans Georg Herwart von Hohenburg, *Thesaurus hieroglyphicorum è museo*, Munich (?), 1610 (?). A century later Gotthold Ephraim Lessing judged the 1669 edition of Pignoria's *Mensa Isiaca* to be the best ever published, due to Frisius's additions that included the larger plates: *Gotthold Ephraim Lessings sämmtliche Schriften: Neue rechtmässige Ausgabe*, Berlin, 1839, 11:199–200.

5. Frisius also included at the end of the volume Tomasini's account of Pignoria's life, collection, and library: cf. catalog raisonné of Frisius's publications, 1664–1675, in Maclean, "Andreas Frisius (Fries) of Amsterdam," no. 10.

6. For instance, the distinctive Cheerio-like eye of the frog together with the arch of its back (see fig. 15), when set against Pignoria's 1605 edition, his 1608 edition, and the Frisius reissue of 1669, is clearly derived from Frisius's later publication.

7. The best scholarly inventory of Sabazius Hands, Maarten Vermaseren, *Corpus Cultus Iovis Sabazii (CCIS)*, vol. 1, *The Hands*, Leiden, 1983, 31–32, omits any mention of the Cecrops inscription in describing this hand. See also Frederick Thomas Elworthy, *Horns of Honour and Other Studies in the By-Ways of Archeology*, London, 1900, 210.

8. Dinglinger to Augustus, 11 October 1707, 10026 Geheimes Kabinett loc. 896.2, Hauptstaatsarchiv Dresden, from a section on f. 14v transcribed by Erna von Watzdorf but left out of her partial publication of this text (*Johann Melchior Dinglinger*, 2:388).

9. "Kurzer Entwurff der Magnificenz des großen Moguls, an seinen Geburths Tage bey Überreichung derer Geschencke," in 10009, no. 34 (Nachtrag zum Pretiosen-Kabinettstücken-Inventario 1725–1733), ff. 1r–47v, Hauptstaats-archiv Dresden; and in 10026 Geheimes Kabinett loc. 2928/2 (Inventar über das Juwelenzimmer in der geheimen Verwahrung des Grünen Gewölbes zu Dresden, 1733, bd. 2), ff. 657–725, Hauptstaatsarchiv Dresden. For this book I have used the latter version, next to two modern transcriptions: of the latter version in Watzdorf, *Johann Melchior Dinglinger*, 2:392–400, and of the former version in Dirk Syndram and Jörg Schöner, *August der Starke und sein Gross-mogul*, Munich, 2014, 101–113. An English translation is included in Joachim Menzhausen, *At the Court of the Great Mogul*, Leipzig, 1965, part 2:8–92.

10. Chapter 2 follows closely the unpublished part of Dinglinger's 1707 letter, as in chapter 4, note 44 above, ff. 13r–14v. It should also be noted that the earlier manuscript copy of the second chapter (10009, no. 34, Hauptstaatsarchiv Dresden) includes three corrections in red, all of which enhance the inven-tory function of this section of the text. These corrections were presumably made at a subsequent point by a court official and then fully integrated into the text in the later copy.

11. "*Von etlichen Antiquischen Figuren und deren eigentlichen Bedeutungen*." The quotes are from the English translation in Menzhausen, *At the Court of the Great Mogul*, part 2:10, 28. Menzhausen translates "deren eigentlichen Bedeu-tungen" as "their proper meaning."

12. A close comparison of the sections on the two hands in the *Short Outline* and the two seventeenth-century Latin tracts shows that while much in the origi-nals was left out, and while the order of the passages was often altered, the early eighteenth-century writer made virtually no original addition to the Latin texts. Only occasionally did he add a tangential intervention, such as the extra praise for the collection of Francesco Barberini, where one hand was kept, "which is filled with many rare and precious things": Menzhausen, *At the Court of the Great Mogul*, part 2:76. I am grateful to Ayelet Even-Ezra for her help with these Latin texts.

13. "Die Fackel kann dahin gedeutet werden, weil sie, wenn der Mond des Nachts scheinet, denen Reisenden den Weg zeiget, deßwegen sie auch Hege-mone, eine Führerin und Nacht-Leuchterin genennet wurde. Das

Klang-Spiel zielet außer Zweifel auf den Brauch der Alten, die bey Nachtzeit unter freyen Himmel auf ehernen, oder eisernen Gefäßen ein großes Gethöne machten, wenn etwa eine Monds-Finsternüße sich ereignete, umb hierdurch der Verdunckelung des Monds zu Hülffe zu kommen: denn die albern Leuthe bildeten sich ein, es litte der Mond durch Zauberey große Noth; Wie sich denn bey ihnen Leuthe funden, die sich rühmeten, daß sie durch ihre Zauberey stückgen auch wohl den Mond vom Himmel herab bringen könnten, wovon beym Virgilio in Pharmacentria [sic] zulesen": "Kurzer Entwurff der Magnificenz des großen Moguls," ff. 695–696; transcribed in Syndram and Schöner, *August der Starke und sein Grossmogul*, 108, and with some errors in Watzdorf, *Johann Melchior Dinglinger*, 2:397. The English translation is based on Menzhausen, *At the Court of the Great Mogul*, part 2:54–56, with my corrections.

14. Hannah Baader, "Das Objekt auf der Bühne: Diamante, Dinge und Johann Melchior Dinglingers Imaginationen einer Geburtstagfeier in Agra," in Manuela De Giorgi et al. (eds.), *Synergies in Visual Culture / Bildkulturen im Dialog*, Munich, 2013, 275. Watzdorf in her *Johann Melchior Dinglinger*, 1:165, identified the author of this text as Moritz Conrad Rüger, a scholar who spent much time with Dinglinger and eventually married his daughter, based on claims he made years later in his diary; see Kurt Arnold Findeisen, *Der Goldschmied Johann Melchior Dinglinger und sein Glück*, Biberach-Riss, Germany, 1951, 43. This claim, however, is not credible, since Rüger was born in 1703: Kurt Burkhardt, "Gestorben im 'kayserlichen Carlsbad,' begraben in Johanngeorgenstadt," *Familie und Geschichte* 1:2 (1993), 210. Dirk Syndram summarizes the current opinion that the author of the text was an unknown intellectual with a humanistic education who had not been involved in the actual creation of the artwork: Syndram and Schöner, *August der Starke und sein Grossmogul*, 21.

15. The correspondences to the passage from "Kurzer Entwurff der Magnificenz des großen Moguls" in note 13, above, are marked in italics. Joachim von Sandrart, *Iconologia Deorum, oder Abbildung der Götter, welche von den Alten verehret worden*, Nuremberg, 1680, 39–40: "Von der brennenden Fakkel führet Pausanias fast eben dergleichen Worte es habe nämlich der Diana ehrinnes ohngefehr sechs Schuhe hohes Bild eine *Fackel* in der Hand gehalten; welches vielleicht auch *dahin kan gedeutet werden daß sie wann sie als der Mond deß Nachts scheinet denen Reisenden den Weg ʒeiget; wie sie dann deßwegen Hegemone, das ist eine Führerin* und zu Rom in dem Tempel welcher ihr im Palatio gewidmet war die *Nachtleuchterin genennet wurde*." And 44–45:

"Etliche halten dafür der Dryangel oder vielmehr das in der Hand tragende *Kling-Spiel ziehle auf den Gebrauch der Alten die bey Nachtzeit unter freyem Himmel auf ehrinnen oder eisernen Gefäßen einen grossen* Schall und *Gethöne machten wann etwan eine Mondfinsternus sich ereignete um hierdurch der Verduncklung des Monds zu Hülffe zu kommen.* Dann weil sie die Ursach der Finsternus (welche ist die Zwischenkunfft der Erde zwischen der Sonne und dem Monde) nicht wusten *bildeten sie sich ein es litte der Mond durch Zauberey große Noht* und Anstösse; dann es waren *bey ihnen Leute gefunden die sich rühmten daß sie mit ihren Zaubereyen auch wohl den Mond vom Himmel herab bringen könten wie Virgilius in Pharmaceutria sagt.*"

16. I have identified thirty-one passages in the "Discourse on Divers Antique Figures" that were substantively copied from the works of Sandrart, Francisci, and Montanus. Together they amount to more than two-thirds of the description of the sun and moon pyramids. I have little doubt that further efforts—this comparative research is rather time-consuming—would have yielded more parallel passages to account for the remainder of the text. Certain passages also bear a clear resemblance to Vincenzo Cartari, *Le imagini degli dei degli antichi* (probably in Pignoria's 1615 edition published in Padua), which was the basis for Sandrart's *Iconologia Deorum*. Cartari's description of Hecate's torch, for example, is echoed closely in the passage quoted above: see John Mulryan (transl. and ed.), *Vincenzo Cartari's* Images of the Gods of the Ancients: The First Italian Mythography, Tempe, AZ, 2012, 85. For the relationship of Sandrart and Cartari, see Anna Schreurs, "Die Götterbilder des Vincenzo Cartari in der Darstellung von Joachim von Sandrart," in Hartmut Böhme et al. (eds.), *Übersetzung und Transformation*, Berlin, 2007, 475–523. As she points out on 520, Sandrart's goal was to be an example for other artists—like Dinglinger—in fusing ancient with contemporary art. I am grateful to Anna Schreurs-Morét for sharing with me her expertise.

17. Arnoldus Montanus, *Denckwürdige Gesandtschafften der Ost-Indischen Gesel- schaft in den Vereinigten Niederländern an unterschiedliche Keyser von Japan*, Amsterdam, 1670, following 240; Erasmus Francisci, *Neu-polirter Geschicht- Kunst-und Sitten-Spiegel ausländischer Völcker*, Nuremberg, 1670, following 1012; Joachim von Sandrart, *Der Teutschen Academie Zweyter und letzter Haupt-Theil*, Nuremberg, 1679, following 89. For Georg Friedrich's reliance on several images from Sandrart, see Watzdorf, *Johann Melchior Dinglinger*, 1:157, 168–170, 2:369–370n240; and for Montanus, 1:112–115 (*Kaffeezeug*), 132, 145; and Walter Holzhausen, "Die Rolle der Graphik im Werk Johann Melchior Dinglingers," *Die graphischen Künste* 4 (1939), 96–98.

18. I have not been able to do so myself but have been able to reconstruct the pyramids' appearance from all sides with the aid of old photographs. I am grateful to Dirk Weber in the SKD photographic archive for his unwavering help.

19. This was the case for Dinglinger's *Hercules Bowl* of 1713 (cf. Dirk Syndram, *Juwelenkunst des Barock: Johann Melchior Dinglinger im Grünen Gewölbe*, Munich, 2008, 44); for his *Obeliscus Augustalis* made for Augustus in 1722 ("Obeliscus Augustalis," Dinglinger to Augustus, 9 February 1722, loc. 896.2, f. 28, Hauptstaatsarchiv Dresden); probably for Dinglinger's complex late work, now lost, the *Mons Philosophorum* (the unsigned text is reproduced in Watzdorf, *Johann Melchior Dinglinger*, 2:402–404); and for Dinglinger's last big work, the *Apis Altar*, created over many years (dated 1729, 1731), cf. Syndram, *Die Ägyptenrezeption unter August dem Starken*, 5–6.

20. "Kurzer Entwurff der Magnificenz des großen Moguls," ff. 701–702; transcribed in Syndram and Schöner, *August der Starke und sein Grossmogul*, 110, and in Watzdorf, *Johann Melchior Dinglinger*, 2:397. The English translation is from Menzhausen, *At the Court of the Great Mogul*, part 2:64–66. Francisci, *Neu-polirter Geschicht-Kunst-und Sitten-Spiegel*, 1011, citing Erasmus Stella's *De Borussiæ antiquitatibus libro duo* of 1518. The detail added to this passage is copied from Christoph Hartknoch, *Alt-und Neues Preussen oder Preussischer Historien*, Frankfurt and Leipzig, 1684, 171: it concerns the festival of Ozinek, which is mistakenly copied in the "Kurzer Entwurff der Magnificenz des großen Moguls" as "Ozine." Stella was one of a group of writers in early modern German-speaking lands who developed ideas about ancient Germanic roots; see Frank Borchardt, *German Antiquity in Renaissance Myth*, Baltimore, 1971; for Stella, 156–157. Elsewhere in this project, Dinglinger does not appear to have been interested in such "local" traditions.

21. The image is from Sandrart, *Der Teutschen Academie Zweyter und letzter Haupt-Theil*, following 89. For the text, see Sandrart, *Iconologia Deorum*, 151; to be juxtaposed with "Kurzer Entwurff der Magnificenz des großen Moguls," f. 724, transcribed in Watzdorf, *Johann Melchior Dinglinger*, 2:400, and with some errors in Syndram and Schöner, *August der Starke und sein Grossmogul*, 113.

22. The English translation (with corrections) is from Menzhausen, *At the Court of the Great Mogul*, part 2:86–88. This paragraph also acknowledges Arnoldus Montanus as a source for ancient drinking customs, in connection with the horn. On Ole Worms (Wormius) and the Danish Golden Horn (subsequently lost), see Jørgen Hein, *The Treasure Collection at Rosenborg Castle II: The Inventories of 1696 and 1718*, Copenhagen, 2009, 45–46.

Chapter 9. Gods

1. "Kurzer Entwurff der Magnificenz des großen Moguls, an seinen Geburths Tage bey Überreichung derer Geschencke," transcribed in Dirk Syndram and Jörg Schöner, *August der Starke und sein Grossmogul*, Munich, 2014, 102, with an English translation in Joachim Menzhausen, *At the Court of the Great Mogul*, Leipzig, 1965, part 2:8.

2. Syndram and Schöner, *August der Starke und sein Grossmogul*, 104–105. The translation is based on Menzhausen, *At the Court of the Great Mogul*, part 2:28, 32 (with corrections). These paragraphs follow closely Montanus, who focused his observations, however, only on the Japanese: Arnoldus Montanus, *Denckwürdige Gesandtschafften der Ost-Indischen Geselschaft in den Vereinigten Niederländern an unterschiedliche Keyser von Japan*, Amsterdam, 1670, 250, 252, and for the beginning, 318.

3. Edward Brerewood, *Enquiries Touching the Diuersity of Languages, and Religions Through the Cheife Parts of the World*, London, 1614, 79, 118.

4. In the growing literature on this subject, I found the following recent contributions especially useful: Martin Mulsow, "Antiquarianism and Idolatry: The *Historia* of Religions in the Seventeenth Century," in Gianna Pomata and Nancy Siraisi (eds.), *Historia: Empiricism and Erudition in Early Modern Europe*, Cambridge, MA, 2005, 181–209; Jonathan Sheehan, "Sacred and Profane: Idolatry, Antiquarianism and the Polemics of Distinction in the Seventeenth Century," *Past and Present* 192 (2006), 35–66; Peter Miller, "Taking Paganism Seriously: Anthropology and Antiquarianism in Early Seventeenth-Century Histories of Religion," *Archiv für Religionsgeschichte* 3:1 (2010), 183–209; and Renaud Gagné et al. (eds.), *Regimes of Comparatism: Frameworks of Comparison in History, Religion and Anthropology*, Leiden, 2018, chapters by Vladimir Levitin, "What Was the Comparative History of Religions in 17th-Century Europe (and Beyond)? Pagan Monotheism/Pagan Animism, from T'ien to Tylor" (49–115), and Joan-Pau Rubiés, "Comparing Cultures in the Early Modern World: Hierarchies, Genealogies and the Idea of European Modernity" (116–176).

5. Montanus, *Denckwürdige Gesandtschafften der Ost-Indischen Geselschaft*, 251. Translation based on the English edition: Arnoldus Montanus, *Atlas Japannensis: Being Remarkable Addresses by Way of Embassy from the East-India Company of the United Provinces to the Emperor of Japan*, London, 1670, 284–287, 286 (quotation).

6. Joachim von Sandrart, *Iconologia Deorum, oder Abbildung der Götter, welche von den Alten verehret worden*, Nuremberg, 1680, 20; Vincenzo Cartari, *Le*

imagini degli dei degli antichi, Padua, 1608, before 1. The caption to the illustration translates as "Image in the act of worship, thanking God for the benefits received or asking for help." Sandrart omitted this illustration together with many others when he translated Cartari, because he considered them to be of low quality. Compare also the evocative illustration of sun, moon, and star worship on the title page of the posthumous edition of Gerhard Johannes Vossius, *De theologia gentili*, Frankfurt, 1668, perhaps the most significant seventeenth-century effort to engage with the issue of idolatry (reproduced in Mulsow, "Antiquarianism and Idolatry," 188).

7. Lorenzo Pignoria, *Le vere e nove imagini de gli dei delli antichi di Vicenzo Cartari Reggiano*, Padua, 1615, part 2:iv; François Bernier, *Auffgezeichnete Beobachtungen was sich in dem Reich deß grossen Mogols begeben und zugetragen hat*, Frankfurt am Main, 1673, 169 (translation based on François Bernier, *Travels in the Mogul Empire, A.D. 1656–1668*, revised edn., transl. Irving Brock and Archibald Constable, London, 1891, 340). Behind this seeming consensus there were in fact deep divisions regarding whether such idolatrous sun worship practices were indications of an esoteric monotheism practiced by pagan peoples of antiquity or signs of incommensurate difference, but these theological disagreements are not our concern here.

8. George Psalmanaazaar [*sic*], *An Historical and Geographical Description of Formosa, an Island Subject to the Emperor of Japan*, London, 1704, 169, 174, 191–194. Many years later, in his reveal-all memoir, Psalmanazar (whose real name is not known) made clear the central role that sun and moon worship played in his deception from the very beginning: "I made me a little book with figures of the sun moon and stars and such other imagery as my phrensy suggested to me." *Memoirs of ****, Commonly Known by the Name of George Psalmanazar, a Reputed Native of Formosa, Written by Himself*, 2nd edn., London, 1765, 144. See Susan Stewart, "Antipodal Expectations: Notes on the Formosan 'Ethnography' of George Psalmanazar," in George Stocking (ed.), *Romantic Motives: Essays on Anthropological Sensibility*, Madison, WI, 1989, 44–73, and Benjamin Breen, "No Man Is an Island: Early Modern Globalization, Knowledge Networks, and George Psalmanazar's Formosa," *Journal of Early Modern History* 17 (2013), 391–417.

9. [La Créquinière], *Conformité des coutumes des Indiens Orientaux avec celles des Juifs et des autres peuples de l'antiquité*, Paris, 1704; *The Agreement of the Customs of the East-Indians, with Those of the Jews, and Other Ancient People*, London, 1705, 24 (quotation); Carlo Ginzburg, "Provincializing the World: Europeans, Indians, Jews (1704)," *Postcolonial Studies* 14:2 (2011), 135–150;

Rubiés, "Comparing Cultures in the Early Modern World," 154–158. For another example from the same moment, see Noël Alexandre, *Conformité des cérémonies chinoises avec l'idolatrie grecque et romaine*, Cologne, 1700.

10. Ginzburg, "Provincializing the World," 138; Rubiés, "Comparing Cultures in the Early Modern World," 155–156. For efforts in this period to find "conformities" among different pagan religions, especially between Asian religions and the ancient world, see Frank Manuel, *The Eighteenth Century Confronts the Gods*, Cambridge, MA, 1959, chap. 1.

11. Syndram and Schöner, *August der Starke und sein Grossmogul*, 107. The English translation is based on Menzhausen, *At the Court of the Great Mogul*, part 2:48–50 (with corrections).

12. Erasmus Francisci, *Ost- und west- indischer wie auch sinesischer Lust-und Stats-Garten*, Nuremberg, 1668, 2:1039. For Sandrart, see note 20, below. One telling editorial change had to do with scale. Francisci prefaced the list of unusual things held in the goddess's arms—swords, halberds, fruits, wheels, and so on—with the interjection *"aus weiß nicht was für Geheimer Bedeutung"*—"for who knows what secret meaning." Dinglinger reproduced the list of unusual objects and likewise kept the authorial interjection but altered it to "so difficult to guess (*so schwer zu errathen*)" what these objects might be. This was a befitting warning for the viewer of such a tiny goddess figure with virtually indistinguishable objects in her hands. Furthermore, because of the size limitations, the jeweler could practically fit the goddess with only five arms on each side, not eight. The mismatch in the number of arms between the (accurate) textual description and the compromise in execution of course indicates once again that the miniature figure was based on the textual sources and not the other way around.

13. Athanasius Kircher, *China illustrata*, Amsterdam, 1667, 140–141; and cf. Rubiés, "Comparing Cultures in the Early Modern World," 138–141 (with Kircher's images and English translation of excerpts from the text). Kircher presumably had in front of him a Chinese woodblock print of Zhŭntí Púsà (Cundi, the Chinese version of Avalokiteśvara), one of many emanations of the bodhisattva Guanyin. The textual descriptions of Pussa in Kircher and in Francisci are very close, yet from turns of phrase that appear in Dinglinger and Francisci but not in Kircher it is clear that Dinglinger used the German book rather than the Latin one, as we would expect. The sun and moon pyramids, and Dinglinger's Pussa, are discussed briefly in Erna von Watzdorf, *Johann Melchior Dinglinger: Der Goldschmied des deutschen Barock*, Berlin, 1962, 1:162–164, 2:370n246: Watzdorf recognized that Dinglinger himself was personally

responsible for the pyramids and assumed the description of Pussa was based directly on Kircher.

14. Erasmus Francisci, *Neu-polirter Geschicht-Kunst-und Sitten-Spiegel ausländischer Völcker*, Nuremberg, 1670, following 1008; Pignoria, *Le vere e nove imagini de gli dei delli antichi di Vicenzo Cartari Reggiano*, part 2:xxxii; and see Urs App, *The Cult of Emptiness: The Western Discovery of Buddhist Thought and the Invention of Oriental Philosophy*, Kyoto, Japan, 2012, 113–114.

15. For the Renaissance interest in *prisca theologia* and the Egyptian tradition, see Erik Iversen, *The Myth of Egypt and Its Hieroglyphs in European Tradition*, Copenhagen, 1961, chap. 3; Frances Yates, *Giordano Bruno and the Hermetic Tradition*, London, 1964 (and 416–423 for Kircher as a seventeenth-century echo of this tradition); and Daniel Walker, *The Ancient Theology: Studies in Christian Platonism from the Fifteenth to the Eighteenth Century*, Ithaca, NY, 1972. To the extent that ancient artifacts were considered at all during this earlier period, their understanding was radically different from that of the seventeenth century: see Christopher Wood, *Forgery, Replica, Fiction: Temporalities of German Renaissance Art*, Chicago, 2008.

16. In addition to the sources in note 4, above, see especially Daniel Stolzenberg, *Egyptian Oedipus: Athanasius Kircher and the Secrets of Antiquity*, Chicago, 2013. Further discussions include Iversen, *The Myth of Egypt*, 89–100; David Mungello, *Curious Land: Jesuit Accommodation and the Origins of Sinology*, Honolulu, 1989, esp. 136–137; Haun Saussy, "*China Illustrata*: The Universe in a Cup of Tea," in Daniel Stolzenberg (ed.), *The Great Art of Knowing: The Baroque Encyclopedia of Athanasius Kircher*, Stanford, CA, 2001, 105–114; App, *The Cult of Emptiness*, chap. 9; Paola von Wyss-Giacosa, "Investigating Religion Visually: On the Role and Significance of Engravings in Athanasius Kircher's Discourse on Idolatry," *ASDIWAL: Revue genevoise d'anthropologie et d'histoire des religions* 7 (2012), 119–150; Von Wyss-Giacosa, "Through the Eyes of Idolatry: Pignoria's 1615 Argument on the Conformità of Idols from the West and East Indies with Egyptian Gods," in Giovanni Tarantino and Paola Wyss-Giacosa (eds.), *Through Your Eyes: Religious Alterity and the Early Modern Western Imagination*, Leiden, 2021, 103–144; and Thijs Weststeijn, "The Chinese Isis, or the Sino-Egyptian Hypothesis," in M.-J. Versluys et al. (eds.), *Temple—Monument—Lieu de Mémoire: The Iseum Campense from the Roman Empire to the Modern Age*, Rome, 2019, 301–313. Another proponent of the continuity among Near Eastern, Egyptian, and Greek beliefs about the divine was Pierre Gassendi; Gassendi's secretary, confidant, and interpreter was none other than François Bernier before his travels.

17. Adam Olearius, *Gottorfische Kunst-Cammer, worinnen allerhand ungemeine Sachen*, Schleswig, 1666, 5 (quotation), plate 4, in which the Asian statuette is placed next to two Egyptian ones. In chapter 10 we will note a copy of Olearius's book in Dinglinger's vicinity. The Dutch collector who sold the Thai statuette to the duke of Gottorf described it simply as "an idol of Isis the most ancient and highest goddess of the Egyptians": see Joanneath Spicer, "The Shifting Identity of a Thai Buddha in Seventeenth-Century Europe," *Journal of the Walters Art Museum* 64–65 (2007), 207–210, 208 (quotation). See also Paola von Wyss-Giacosa, "Ein thailändischer Buddha in Gottorf: Zur Bedeutung materieller Zeugnisse im frühneuzeitlichen Idolatrie-Diskurs," in A. Cremer and M. Mulsow (eds.), *Objekte als Quellen der historischen Kulturwissenschaften*, Cologne, 2017, 211–224. For idols in *Kunstkammern*, see more broadly Christine Göttler, "Extraordinary Things: 'Idols from India' and the Visual Discernment of Space and Time, circa 1600," in C. Göttler and M. Mochizuki (eds.), *The Nomadic Object: The Challenge of World for Early Modern Religious Art*, Leiden, 2018, esp. 48–50.

18. The intellectual program of this work, combining Egyptian and Christian themes, is excellently analyzed in Dirk Syndram, *Die Ägyptenrezeption unter August dem Starken: Der "Apis-Altar" Johann Melchior Dinglingers*, Meinz, Germany, 1999 (see 19 for the quotation of the 1731 inscription). See also Ragna Enking, *Der Apis-Altar Johann Melchior Dinglingers*, Leipzig, 1939.

19. Dinglinger twice changed Francisci's "See Blumen" and "Wasser Blumen" (sea flower, water flower) to "einer Egyptischen Seeblumen" and added a gratuitous mention of Egyptians: "wherein the Chinese and those wise Egyptians think alike."

20. Joachim von Sandrart, *Der Teutschen Academie Zweyter und letzter Haupt-Theil*, Nuremberg, 1679, 53. For Valeriano, see Brian Curran, *The Egyptian Renaissance: The Afterlife of Ancient Egypt in Early Modern Italy*, Chicago, 2007, 227–228. Two pages later (55) Sandrart invoked the authority of the Latin neo-platonist Macrobius, one of Pignoria's principal sources: "*Isidem*, welche *Macrobius* für die Erd-Mutter selbst gehalten." Dinglinger, once again reinforcing the Egyptian-Chinese connection beyond Sandrart's own words, reproduced this sentence as "Isis, oder Sinesische Pussa, welche Macrobius für die Erd Mutter selbst gehalten": Syndram and Schöner, *August der Starke und sein Grossmogul*, 108.

21. Syndram and Schöner, *August der Starke und sein Grossmogul*, 107 (parenthetical interjection in the original, emphasis added).

22. Ibid., 108; translated in Menzhausen, *At the Court of the Great Mogul*, part 2:50. Sandrart, *Der Teutschen Academie Zweyter und letzter Haupt-Theil*, plate 4 (unpaginated).

23. Syndram and Schöner, *August der Starke und sein Grossmogul*, 110–113; with translations based on Menzhausen, *At the Court of the Great Mogul*, part 2:70–78.

24. Athanasius Kircher, *Ad Alexander VII. Pont Max obelisci Ægyptiaci nuper inter Isæi Romani rudera effossi interpretatio hieroglyphica*, Rome, 1666, 109. Many years later, in creating the *Apis Altar*, Dinglinger returned to this illustration from Sandrart and reconstructed the Nile-god figures: Watzdorf, *Johann Melchior Dinglinger*, 1:274, 277, and Syndram, *Die Ägyptenrezeption unter August dem Starken*, 24–25. The Nile-gods in the *Apis Altar* are holding the offering tables topped with the same element but rotated 180 degrees, perhaps a sign of careless restoration.

25. Lafitau, writing in Rome c. 1719–1722 with access to the earlier works in this tradition, placed both images, drawn from later reproductions, in two plates showing various appearances of the holy cross in pre-Christian artifacts. Joseph-François Lafitau, *Moeurs des sauvages amériquains, comparées aux moeurs des premiers temps*, Paris, 1724, 1:plates 16–17, following 442, 444 (with unpaginated explanations at the beginning of the volume). Note also plate 6, following 140, for recycled images of Pussa with which we are already familiar. For Lafitau in the tradition of antiquarian comparative religion and his parallels with Kircher, see Rubiés, "Comparing Cultures in the Early Modern World," 159–171.

Chapter 10. Scripts

1. Daniel Stolzenberg, *Egyptian Oedipus: Athanasius Kircher and the Secrets of Antiquity*, Chicago, 2013; Stolzenberg, "Kircher Among the Ruins: Esoteric Knowledge and Universal History," in Daniel Stolzenberg (ed.), *The Great Art of Knowing: The Baroque Encyclopedia of Athanasius Kircher*, Stanford, CA, 2001, 127–139. See also Joan-Pau Rubiés, "Comparing Cultures in the Early Modern World: Hierarchies, Genealogies and the Idea of European Modernity," in Renaud Gagné et al. (eds.), *Regimes of Comparatism: Frameworks of Comparison in History, Religion and Anthropology*, Leiden, 2018, 137–138; Byron Ellsworth Hamann, "How Maya Hieroglyphs Got Their Name: Egypt, Mexico, and China in Western Grammatology Since the Fifteenth Century," *Proceedings of the American Philosophical Society* 152:1 (2008), 1–68 (esp. 25, 31); Thijs Weststeijn, "From Hieroglyphs to Universal

Characters: Pictography in the Early Modern Netherlands," *Nederlands Kunsthistorisch Jaarboek* 61 (2011), 238–280 (esp. 247); and Weststeijn, " 'Signs That Signify by Themselves': Writing with Images in the Seventeenth Century," in Rens Bod et al. (eds.), *The Making of the Humanities*, vol. 1, *Early Modern Europe*, Amsterdam, 2020, 133–159. Nicholas Hudson, *Writing and European Thought, 1600–1830*, Cambridge, 1994, 17, points out that despite the post-factum condescension, Kircher's work marks the beginning of serious research into the origins and history of writing.

2. Dirk Syndram and Jörg Schöner, *August der Starke und sein Grossmogul*, Munich, 2014, 108; Joachim von Sandrart, *Der Teutschen Academie Zweyter und letzter Haupt-Theil*, Nuremberg, 1679, 52–53. There may be more going on here. The sign is named in the text *Signum Salutis*, itself a clever Kircherite pun on "sign of health"—which it was for the ancient Egyptians—that for Christians became "sign of salvation," especially in the form of the staurogram. Whether Dinglinger was aware of this additional genealogical layer or not, his text also describes another *Signum Salutis* in the sun pyramid, in the form of a pentagram interlacing Greek and Latin letters, based on Joachim von Sandrart, *Iconologia Deorum, oder Abbildung der Götter, welche von den Alten verehret worden*, Nuremberg, 1680, 32. I have been unable to find this sign in the *Throne of the Great Mogul*, due to the difficulties in accessing the smaller elements in the central parts.

3. Athanasius Kircher, *Turris Babel sive archontologia*, Amsterdam, 1679, 157. This device brings to mind again George Psalmanazar, whose most impressive achievement in faking the ethnography of Formosa at precisely the same moment was the invention of an imaginary language, complete with a fictive alphabet arranged in a table much like Kircher's. Psalmanazar later admitted to deliberately rendering some of his "Formosan" letters to resemble Hebrew and Greek ones, as if he were trying to fabricate a Kircherite genealogy. See Michael Keevak, *The Pretended Asian: George Psalmanazar's Eighteenth-Century Formosan Hoax*, Detroit, 2004, chap. 3, esp. 63–64.

4. Syndram and Schöner, *August der Starke und sein Grossmogul*, 102; with translation in Joachim Menzhausen, *At the Court of the Great Mogul*, Leipzig, 1965, part 2:14 (corrected); Olfert Dapper, *Asia; oder, Ausführliche Beschreibung des Reichs des Grossen Mogols*, Nuremberg, 1681, 62; Erasmus Francisci, *Neupolirter Geschicht-Kunst-und Sitten-Spiegel ausländischer Völcker*, Nuremberg, 1670, following 1012; Athanasius Kircher, *China illustrata*, Amsterdam, 1667, 161. In fact, Kircher's caption "Bhavani" was a mistaken characterization for

his image, which represented Buddha as the ninth avatar of Vishnu (and male), a mistake then transferred to Dinglinger. See Paola von Wyss-Giacosa, *Religionsbilder der frühen Aufklärung: Bernard Picarts Tafeln für die Cérémonies et coutumes religieuses de tous les peuples du monde*, Bern, 2006, 228–253. I am grateful to Paola von Wyss-Giacosa for sharing with me her expertise on idol images.

5. Paola von Wyss-Giacosa, "Investigating Religion Visually: On the Role and Significance of Engravings in Athanasius Kircher's Discourse on Idolatry," *ASDIWAL: Revue genevoise d'anthropologie et d'histoire des religions* 7 (2012), 126.

6. Jean-Baptiste Tavernier, *Beschreibung der sechs Reisen, . . . in Türckey, Persien und Indien*, Geneva, 1681, book 4, "Neue und Sonderbare Beschreibung des Königreichs *Tunquin*," image following 78. See Olga Dror and Keith Taylor (eds.), *Views of Seventeenth-Century Vietnam: Christoforo Borri on Cochinchina and Samuel Baron on Tonkin*, Ithaca, NY, 2006, 74, 80–81. The parallel illustration in the French edition of Tavernier ("Relation nouvelle et singuliere du royaume de Tunquin," *Suite des voyages de Mr Tavernier*, Paris, 1680, following 88) is quite different, with the figure inside the structure resembling more a crouching lion. (In passing, this confirms that Dinglinger used the German translation of Tavernier.) And cf. Wyss-Giacosa, *Religionsbilder der frühen Aufklärung*, 188–197.

7. Dinglinger was in fact misled by Tavernier's unreliable illustration. He could have picked up a clue that something was wrong from the fact that the same structure with an incongruous peering head already appeared earlier in the same volume, illustrating ascetics in India: Tavernier, *Beschreibung der sechs Reisen*, book 3, following 160. Conversely, using Indian gods as visual models for Chinese and Japanese ones, as Tavernier did in Tonkin, was facilitated precisely by the diffusionist theory of Asian religion. See Paola von Wyss-Giacosa, "Confronting Asia's 'Idolatrous Body': Reading Some Early Modern European Sources on Indian Religion," in Alexander Darius Ornella et al. (eds.), *Commun(icat)ing Bodies: Body as a Medium in Religious Symbol Systems*, Zurich, 2014, 387–423, esp. 389–390.

8. Sanjay Subrahmanyam, *Courtly Encounters: Translating Courtliness and Violence in Early Modern Eurasia*, Cambridge, MA, 2012, 216.

9. Syndram and Schöner, *August der Starke und sein Grossmogul*, 105; with translation in Menzhausen, *At the Court of the Great Mogul*, part 2:32 (emphasis added). Montanus, on whom these paragraphs were based, did not mention "Indians" in this context, though a similar line in a discussion of devil

worship can be found in his *Denckwürdige Gesandtschafften der Ost-Indischen Geselschaft in den Vereinigten Niederländern an unterschiedliche Keyser von Japan*, Amsterdam, 1670, 248.

10. François Bernier, *Auffgezeichnete Beobachtungen was sich in dem Reich deß grossen Mogols begeben und zugetragen hat*, Frankfurt am Main, 1673, 75–76 (translation based on Bernier, *Travels in the Mogul Empire, A.D. 1656–1668*, revised edn., transl. Irving Brock and Archibald Constable, London, 1891, 283). The edifice that Bernier saw was probably the Iron Pillar at the Qutb complex in Delhi, which bears several inscriptions, including one in Sanskrit in Brahmi script from the fourth century.

11. 10684, Stadtgericht Dresden, no. 1449, Sächsisches Hauptstaatsarchiv Dresden. The 363 titles are analyzed cumulatively in Elisabeth Tiller and Maria Lieber (eds.), *Pöppelmann 3D: Bücher—Pläne—Raumwelten* (exh. cat.), Dresden, 2013, 147, including, notably, 9.1 percent geography and 17.9 percent history titles.

12. Margaret Jacob, *Strangers Nowhere in the World: The Rise of Cosmopolitanism in Early Modern Europe*, Philadelphia, 2006, 63–64. For Tschirnhaus's library, with its 1,353 titles, see Matthias Ullmann, "Ehrenfried Walther von Tschirnhaus: Der Modernisierer Sachsens und seine verschollene Bibliothek," in Elisabeth Tiller (ed.), *Bücherwelten—Raumwelten: Zirkulation von Wissen und Macht im Zeitalter des Barock*, Cologne, 2015, 171–186; with Tiller and Lieber, *Pöppelmann 3D*, 150–151, 143, for the coterie of Dresden intellectuals to which both Dinglinger and Tschirnhaus belonged, together with the court architects Matthäus Daniel Pöppelmann and Zacharias Longuelune. For Tschirnhaus's biography, including his time with Kircher in Rome, see also "Biography of Ehrenfried Walther von Tschirnhaus," Tschirnhaus Society, https://web.archive.org/web/20131128231554/http://www.tschirnhaus-gesellschaft.de/e_t_leben.html.

13. The invading Swedish forces destroyed Tschirnhaus's mill in 1706. Werner Quellmalz, *Die edlen Steine Sachsens*, Leipzig, 1990, 35–36; Joachim Menzhausen, "Sächsische Landedelsteine für Export und Staaträpresentation," in Manfred Bachmann (ed.), *Der silberne Boden: Kunst und Bergbau in Sachsen*, Leipzig, 1990, 234–235; Wolfram Koeppe (ed.), *Art of the Royal Court: Treasures in Pietre Dure from the Palaces of Europe*, New Haven, CT, 2008, 255–256.

14. *Catalogus und Specification unterschiedener gebundener und ungebundener Bücher . . . des Hrn. Raths von Tschirnhaus*, [Görlitz, Germany], 1723. As an auction catalog, this source is problematic and not necessarily complete. The several Kircher titles in the catalog do not include his historical works.

15. Montanus, *Denckwürdige Gesandtschafften der Ost-Indischen Geselschaft*, 252; "Kurzer Entwurff der Magnificenz des großen Moguls," 10026 Geheimes Kabinett loc. 2928/2, f. 673, Hauptstaatsarchiv Dresden, where the digits and the word "Minute" in "in einer Minute 16666 2/3" are emphasized with larger writing; transcribed in Syndram and Schöner, *August der Starke und sein Grossmogul*, 104.

16. Tschirnhaus's report is quoted and translated in Maureen Cassidy-Geiger, "Meissen and Saint-Cloud, Dresden and Paris: Royal and Lesser Connections and Parallels," in Bertrand Rondot (ed.), *Discovering the Secrets of Soft-Paste Porcelain at the Saint-Cloud Manufactory, ca. 1690–1766* (exh. cat.), New Haven, CT, 1999, 98, 108n13. For Tschirnhaus's role in the development of mirror manufacturing in Saxony and Germany, see Werner Loibl, *Die kurmainzische Spiegelmanufaktur Lohr am Main (1698–1806) im Rahmen der allgemeinen Geschichte*, Neustadt an der Aisch, Germany, 2012, 1:96–99. Also see Ullmann, "Ehrenfried Walther von Tschirnhaus," 171–186, and Peter Plassmeyer, "La politique scientifique à Dresde," *Bulletin du Centre de recherche du château de Versailles*, 2011, https://doi.org/10.4000/crcv.11479.

17. Dinglinger's letter to Augustus of 11 October 1707 mentions one large mirror, whereas the second chapter of the "Kurzer Entwurff der Magnificenz des großen Moguls" mentions one large mirror on one side and another mirror of unspecified size on the other. Syndram and Schöner, *August der Starke und sein Grossmogul*, 104. This detail was added in red ink to one of the two surviving manuscript copies of the full text and then incorporated seamlessly into the second (presumably later) copy. Anna Maria Werner's 1739 drawing of the *Throne of the Great Mogul* shows two large mirrors, one on each side. Today one mirror is missing (unusually—this is the only large object mentioned in the description that is missing). The discrepancy between the letter and the description may indicate that after Augustus's viewing following Dinglinger's invitation in October 1707, a second mirror was added that later disappeared, and that someone in court with an interest in a correct inventory of all the parts of Dinglinger's work made the correction in red.

Chapter 11. *Uniqueness*

1. Dirk Syndram and Jörg Schöner, *August der Starke und sein Grossmogul*, Munich, 2014, 17.

2. *Khafi Khan's History of Alamgir: Being an English Translation of the Relevant Portions of "Muntakhab al-lubāb" with Notes and an Introduction*, Karachi, 1975, 420; Philip Stern, "From the Fringes of History: Tracing the Roots of

the English East India Company-State," in S. Agha and E. Kolsky (eds.), *Fringes of Empire: Peoples, Places, and Spaces in Colonial India*, New York, 2009, 26–28; Stern, *The Company-State: Corporate Sovereignty and the Early Modern Foundation of the British Empire in India*, Oxford, 2011, 135–136. I am grateful to Phil Stern for generous exchanges on this topic.

3. Jean-Baptiste Tavernier, *Beschreibung der sechs Reisen, . . . in Türckey, Persien und Indien*, Geneva, 1681, book 2, plate following 50 and explanation on 86–87 ("Wapen oder Pittschaft").

4. Cf. Hannah Baader, "Das Objekt auf der Bühne: Diamante, Dinge und Johann Melchior Dinglingers Imaginationen einer Geburtstagfeier in Agra," in Manuela De Giorgi et al. (eds.), *Synergies in Visual Culture / Bildkulturen im Dialog*, Munich, 2013, 282.

5. Amy Singer, *Charity in Islamic Societies*, Cambridge, 2008, 114. See also Antje Flüchter, "Weighing the Mughal: German Perception of Governmental Structures and the Staging of Power in the Early Modern Indian Mughal Empire," in Antje Flüchter and Susan Richter (eds.), *Structures on the Move: Technologies of Governance in Transcultural Encounter*, Heidelberg, 2012, 147–166. Flüchter is less interested in the question of value than in the weighing ceremony as the epitome of the well-ordered Mughal state in European eyes. As she notes, it was the only Mughal ceremonial that Johann Christian Lünig, the contemporary expert on European court ceremonies, included for comparison in his standard work *Theatrum Ceremoniale Historico-Politicum, Oder Historisch- und Politischer Schau-Platz Aller Ceremonien*, Leipzig, 1720, anderer Theil, 1463.

6. Tavernier, *Beschreibung der sechs Reisen*, book 2, 86–87, and for the original French phrase as *pieces de liberalitez*, Jean-Baptiste Tavernier, *Les six voyages de Jean-Baptiste Tavernier*, Paris, 1676, 2:204–205. Such tokens were called *nisars*. Aurangzeb retired the weighing ceremony, but counter to Tavernier's report continued to mint *nisars* of his own. Cf. Stanley Lane-Poole, *The History of the Moghul Emperors of Hindustan Illustrated by Their Coins*, London, 1892, lxxxv–lxxxvi.

7. Claude-Charles Guyonnet de Vertron, *Parallèle de Louis le Grand avec les princes qui ont été surnommés grands*, Paris, 1685, 50, and Jean de Préchac, *Contes moins contes que les autres: Sans Parangon et la reine de fées*, Paris, 1698, both translated and discussed in Hall Bjørnstad, *The Dream of Absolutism: Louis XIV and the Pre-Modern Logic of Modernity*, Chicago, 2021, 152; André Félibien, *Le songe de Philomathe*, Paris, 1683, following the translation and analysis in Jacqueline Lichtenstein, *The Eloquence of Color: Rhetoric and*

Painting in the French Classical Age, Berkeley, CA, 1993, 125–127. See also Corinna Forberg, "Copying the World's Emperor: Dinglinger's Great Moghul and the French Model of Absolute Power," in C. Forberg and P. W. Stockhammer (eds.), *The Transformative Power of the Copy*, Heidelberg, 2017, 394.

8. Louis XIV, *Memoires for the Instruction of the Dauphin*, transl. Paul Sonnino, New York, 1970, 80.

9. Karl Wilhelm von Meisenbug, "Remarques sur l'entrevue des trois roys," in Vinzenz Czech, *Das Potsdamer Dreikönigstreffen 1709*, Göttingen, 2008, 171.

10. Bernard de Fontenelle, *Conversations on the Plurality of Worlds*, transl. H. A. Hargreaves, Berkeley, CA, 1990, 44–45. For further discussion, see Jonathan Sheehan and Dror Wahrman, *Invisible Hands: Self-Organization and the Eighteenth Century*, Chicago, 2015, 37, chaps. 1, 4; Catherine Wilson, *The Invisible World: Early Modern Philosophy and the Invention of the Telescope*, Princeton, NJ, 1995; and Ofer Gal and Raz Chen-Morris, *Baroque Science*, Chicago, 2013. I am grateful to Achille Varzi for enthusiastic exchanges on this point.

11. "Obbeschriebene grösse des Wercks ist alles von Silber, der Thron aber mit den Figuren und praesenten alles von klaren Golde, mit Diamant, Schmaragd, Rubin und Perlen garnisiret, auf das allerartigste und zierlischste verfertiget, mit den angenehmsten coloriten emaillirt und geschmeltzt, daß, ohne unzeitigen und eigen Ruhm zumelden, dergleichen Arbeit noch niemahln von einen Künstler ist vorgestellet worden, auch nach der Zeit nicht geschehen wird, inmassen viel(e) die capacité nicht haben, solches zu praestiren, wo auch dieses wäre, hindert doch dasselbe der große Verlag und noch mehr die länge der Zeit, sothanen Hazard zu thun, dahero dergleichen Stück in keines großen Herrn Cabinet sich nirgend finden wird." Transcribed in Erna von Watzdorf, *Johann Melchior Dinglinger: Der Goldschmied des deutschen Barock*, Berlin, 1962, 2:388. Forberg, "Copying the World's Emperor," 395–396, also reads this letter in the context of the singularity of absolutism.

12. Visit and conversation with Dr. Rainer Richter, 10 November 2017. I am grateful to Rainer Richter for his ongoing generosity. Augustus the Strong recognized Georg Friedrich Dinglinger's special contribution as enamellist to the *Throne of the Great Mogul*: cf. Watzdorf, *Johann Melchior Dinglinger*, 2:304, 306.

13. Dirk Syndram, *Juwelenkunst des Barock: Johann Melchior Dinglinger im Grünen Gewölbe*, Munich, 2008, 67; Martin Eberle, *Die Kunstkammer auf Schloss Friedenstein Gotha*, Gotha, Germany, 2010, 63–64.

14. Watzdorf, *Johann Melchior Dinglinger*, 2:388, with Syndram and Schöner, *August der Starke und sein Grossmogul*, 12, and cf. 8 for Augustus's similar act of princely value-setting and rounded pricing a few years earlier, this time for the *Goldenes Kaffeezeug*.

15. C. Willemijn Fock, "Jacobus Jancke, goud-en zilversmid en juwelier," in J. W. Marsilje (ed.), *Uit Leidse bron geleverd: Studies over Leiden en de Leidenaren in het verleden*, Leiden, 1989, 269–273 (including full text transcription), with Fock, "Two Unusual Dutch Prints for Furniture from the End of the Seventeenth Century," *Furniture History* 29 (1993), 1–10, 4 (quotation). The print can be dated through a payment for its framing, recorded on 20 April 1688 in the accounts of the Leiden guild of goldsmiths and silversmiths. Jancke died shortly thereafter, in June of that year.

16. Elio and Corrado Catello, *Argenti napolitani dal XVI al XIX secolo*, Naples, 1973, 155, 288–289; Catello and Catello, *La Cappella del Tesoro di San Gennaro*, Naples, 1977, 105, plate 89; *Le trésor de Naples: Les joyaux de San Gennaro* (exh. cat.), Paris, [2014], 170; *Naples's Treasure: Masterpieces from the Museum of Saint Januarius*, exhibition at the Museo Fondazione Roma, 30 October 2013–2 March 2014, Rome.

17. Ernst Polaczek, "Das Straßburger Tagebuch des Johann Friedrich von Uffenbach aus Frankfurt (1712–1714)," *Elsaß-Lothringisches Jahrbuch* 1 (1922), 106–107. Uffenbach's 1712 visit to the Strasbourg jeweler is discussed in Verena Suchy, "Perlpreziosen. Barocke Materialität, deviante Körperlichkeit und die Kunst des Grotesken," PhD diss., Justus Liebig University Giessen, 2022.

18. The twelve carved ivory "towers," all from the end of the seventeenth and the beginning of the eighteenth centuries, include a pair from both halves of the same elephant tusk at the Victoria and Albert Museum in London, two in the Bode Museum in Berlin, two in the Grünes Gewölbe in Dresden, and others in the Bayerisches Nationalmuseum in Munich (illustrated here), in Stift Klosterneuburg in Austria, in the National Archeological Museum in Madrid, in the Reiner Winkler collection in Frankfurt, in the Nelson-Atkins Museum of Art in Kansas City, and in the Galleria Regionale della Sicilia in Palermo. See Christian Theuerkauff, *Die Bildwerke in Elfenbein des 16.–19. Jahrhunderts*, Berlin, 1986, 351–366. I am grateful to Holly (Marjorie) Trusted and to Philippe Malgouyres for discussing these works with me.

19. I am grateful to Paulus Rainer for an illuminating discussion of this point while visiting the *Kunstkammer* display at the Kunsthistoriches Museum, Vienna, on 9 February 2018. For an example made from a walrus tusk, see Matthias Steinl's *Allegory of the Elements Water and Air* of 1688 (inv. no. Kunstkammer, 4533, Kunsthistorisches Museum, Vienna).

20. Three of the four tableaus are today in the Real Academia de Bellas Artes de San Fernando, Madrid. Richard Ruhland, *Wunderwerke aus Wachs: Die Tittmoninger Wachsbossierer Johann Baptist (1671–1738) JBC und Nikolaus Engelbert (1713–1746) NEC Cetto*, Tittmoning, Germany, 2013. I am grateful to Richard Ruhland, director of the Tittmoning Museum, which holds the largest group of Cetto micro-waxes, for his hospitality and expertise, and to Giulio Sommariva, curator for the Museo dell'Accademia Ligustica in Genoa, for showing me the Cetto miniature nativity scene.

21. The Temple of Solomon model (currently at the Museum for Hamburg History) was completed for Hamburg city councilor Gerard Schott (1641–1702) in the 1690s and subsequently became Augustus the Strong's last important museum acquisition shortly before his death, adding a comparison to King Solomon to his royal self-image. In between, the model was displayed in London from 1724 and described in the words quoted here in an advertisement in the London *Daily Courant*, 28 December 1724. Michael Korey, "The Temple of Solomon and the Jewish Cabinet in the Dresden Zwinger: The Search for Their Historic Traces," in Michael Korey and Thomas Ketelsen (eds.), *Fragments of Memory: The Temple of Solomon in the Dresden Zwinger*, Dresden, 2010, 12–25; Tessa Morrison, "Architectural Models of the Temple of Solomon Exhibited in London in the 17th and 18th Centuries," in Morrison, *Isaac Newton and the Temple of Solomon*, Jefferson, NC, 2016, 86–92, 89 (*Daily Courant*). I am grateful to Michael Korey for many insightful exchanges.

22. Several examples of this particular genre of reliefs by Elhafen are displayed in the permanent exhibition "Baroque Luxury" at the Bayerisches Nationalmuseum, Munich. Elhafen had been in Johann Wilhelm's court since 1703–1704 and specialized in unique works that had no functional use: Christian Theuerkauff, "Der 'Helffenbeinarbeiter' Ignaz Elhafen," *Wiener Jahrbuch für Kunstgeschichte* 21 (1968), 92–157.

23. Jeffrey Chipps Smith, *Nuremberg, a Renaissance City, 1500–1618*, Austin, TX, 2014, 80–82; Pamela Smith and Tonny Beentjes, "Nature and Art, Making and Knowing: Reconstructing Sixteenth-Century Life-Casting Techniques," *Renaissance Quarterly* 63 (2010), 128–179.

24. Reinier Baarsen, *Kwab: Ornament as Art in the Age of Rembrandt* (exh. cat.), Amsterdam, 2018; with Allison Stielau, "Fit Vessel: Kwab at the Rijksmuseum," *West 86th* 26:1 (2019), 110–132. I am grateful to Allie Stielau for discussing with me the motivations of early modern jewelers.

25. Quoted in Maija Jansson, "Ambassadorial Gifts," in Olga Dmitrieva and Natalya Abramova (eds.), *Britannia and Muscovy: English Silver at the Court of the Tsars* (exh. cat.), New Haven, CT, 2006, 203. In another example, when the Venetians sent to Istanbul exquisite, newly fashioned aigrettes (*penachi*) in the summer of 1594, the sultan's powerful mother purchased them all and wrote a fiery letter to the Venetian ambassador demanding that all production of this new decorative object be stopped so that hers would remain unique. A few months later she realized the futility of this effort to preserve singularity and released the Venetians from her impossible demand. Recounted in Luca Molà, "Material Diplomacy: Venetian Luxury Gifts for the Ottoman Empire in the Late Renaissance," in Zoltán Biedermann et al. (eds.), *Global Gifts: The Material Culture of Diplomacy in Early Modern Eurasia*, Cambridge, 2018, 75–77.

26. "Obeliscus Augustalis," Dinglinger to Augustus, February 1722, loc. 896.2 "Dinglingeriana," ff. 27–31, Hauptstaatsarchiv Dresden. Similar language appears several times in the document.

27. Dror Wahrman, *Mr. Collier's Letter Racks: A Tale of Art and Illusion at the Threshold of the Modern Information Age*, Oxford, 2012, esp. chap. 5; Walter Benjamin, *The Work of Art in the Age of Its Technological Reproducibility, and Other Writings on Media*, ed. Michael Jennings et al., Cambridge, MA, 2008.

28. Christopher White, *Rembrandt as an Etcher: A Study of the Artist at Work*, University Park, PA, 1969, 1:19, 67, 72, 77–78; Robert Fucci, *Rembrandt's Changing Impressions* (exh. cat.), New York, 2016, esp. 16–19; Nicola Suthor, *Rembrandt's Roughness*, Princeton, NJ, 2018, esp. 68. This practice is quite distinct from that of painting multiple versions of a single painting (Titian is an oft-cited example), which is not very relevant to the discussion here.

29. Soldani Benzi to the prince of Liechtenstein, 5 July, 30 August 1695, in Klaus Lankheit, *Florentinische Barockplastik: Die Kunst am Hofe der letzten Medici, 1670–1743*, Munich, 1962, 328–330, doc. nos. 644, 647. This exchange is recounted in Hannah Wirta Kinney, "Transcribing Material Values in Doccia's 'Medici Venus,'" in Antonia Putzger et al. (eds.), *Nichts neues schaffen: Perspektiven auf die treue Kopie, 1300–1900*, Berlin, 2018, 79. I am grateful to Achille Varzi for help with Italian translation.

30. Viccy Coltman, *Fabricating the Antique: Neoclassicism in Britain, 1760–1800*, Chicago, 2006, 131–133.

31. The best technical-cum-historical explanations are in Peta Motture, *The Culture of Bronze: Making and Meaning in Italian Renaissance Sculpture*, London, 2019, chap. 2, and Claudia Kryza-Gersch, "Über die Anfänge der Reproduzierbarkeit von Kleinbronzen in der italienischen Renaissance," in Walter Cupperi (ed.), *Multiples in Pre-Modern Art*, Zurich, 2014, 147–172. I am grateful to Philippe Malgouyres of the Louvre Museum and to Peta Motture of the Victoria and Albert Museum for their advice and expertise on these matters.

32. Quoted and discussed in Walter Cupperi, " 'You Could Have Cast Two Hundred of Them': Multiple Portrait Busts and Reliefs at the Court of Charles V of Habsburg," in Cupperi (ed.), *Multiples in Pre-Modern Art*, esp. 173–180, 177 (quotation).

33. Malcolm Baker, "The Ivory Multiplied: Small-Scale Sculpture and Its Reproductions in the Eighteenth Century," in A. Hughes and E. Ranfft (eds.), *Sculpture and Its Reproductions*, London, 1997, 61–78, 63 (quotation). The sense of loss brings to mind Walter Benjamin's famous discussion of artworks' loss of aura in the age of mechanical reproduction (see note 27, above). And yet as Baker and many others have pointed out, transporting Benjamin's claims from the modern to premodern period obfuscates more than it clarifies (and does not always do justice to Benjamin's original meaning). See also Malcolm Baker, "A Genre of Copies and Copying? The Eighteenth-Century Portrait Bust and Eighteenth-Century Responses to Antique Sculpture," in Tatjana Bartsch et al. (eds.), *Das Originale der Kopie: Kopien als Produkte und Medien der Transformation von Antike*, Berlin, 2010, 289–312, and Baker, "Multiples, Authorship and the Eighteenth-Century Portrait Bust's Aura," in Cupperi (ed.), *Multiples in Pre-Modern Art*, 271–293: "The concepts of aura and multiple are not so at odds as has often been assumed. . . . It is indeed with sculpture, its making and replication, that the problems with Benjamin's influential notion have been most apparent, both conceptually and historically" (271, with further bibliography in 271n2). I am grateful to Malcolm Baker for insightful conversations on this subject.

34. Baker, "The Ivory Multiplied," 69–72, 69 (quotation); Malcolm Baker, "Francis van Bossuit, Böttger Stoneware and the 'Judith' Reliefs," in Rainer Kahsnitz and Peter Volk (eds.), *Skulptur in Süddeutschland, 1400–1770*, Munich, 1998, 281–293. For the number of *Judith* copies in 1711, see Ingelore Menzhausen, "Das Älteste aus Meissen: Böttgersteinzeug und Böttgerporzellan," in *Johann Friedrich Böttger zum 300. Geburtstag: Meissen, Frühzeit und Gegenwart* (exh. cat.), Dresden, 1982, 100. This group of Bossuit replicas was

already identified by Christian Theuerkauff, "Zu Francis van Bossuit (1635–1692), 'beeldsnyder in Yvoor,' " *Wallraf-Richartz Jahrbuch* 37 (1975), 153.

35. For Permoser and Bossuit, as well as Permoser and Böttger, see Marjorie (Holly) Trusted, "The Same but Different: Baroque Ivories and Reproduction," in Cupperi (ed.), *Multiples in Pre-Modern Art*, 248–250. For the gift to Frederik IV, see Jørgen Hein and Mogens Bencard, "Denmark and Saxony: Family Ties and Meissen Porcelain," in Maureen Cassidy-Geiger (ed.), *Fragile Diplomacy: Meissen Porcelain for European Courts*, New Haven, CT, 2008, 181–183.

36. Baker, "The Ivory Multiplied," 72.

Chapter 12. Epilogue

1. Walter Holzhausen, "Sächsisches Rubinglas und Steingefäße von J. F. Böttger," *Belvedere* 12 (1934–1937), 16–22, 17 (quotation, Böttger to Georg Hermann von Holtzbrinck, 30 July 1713); Dedo von Kerssenbrock-Krosigk, "Gold Ruby Glass," in Kerssenbrock-Krosigk, *Glass of the Alchemists: Lead Crystal—Gold Ruby, 1650–1750* (exh. cat.), Corning, NY, 2008, 123–137.

2. The history of the reinvention of European porcelain has recently been retold with flair in Suzanne Marchand, *Porcelain: A History from the Heart of Europe*, Princeton, NJ, 2020, chap. 1. Among many accounts, see Robert Röntgen, *The Book of Meissen* (2nd edn.), Atglen, PA, 1996, 22–29, and Ulrich Pietsch, "Meissen Porcelain: Making a Brilliant Entrance, 1710 to 1763," in U. Pietsch and C. Banz (eds.), *Triumph of the Blue Swords: Meissen Porcelain for Aristocracy and Bourgeoisie, 1710–1815*, Dresden, 2010, 11–33.

3. The controversy over the respective credit due to Tschirnhaus versus Böttger in the European discovery of porcelain is an old chestnut going back to the early days of the Meissen factory itself. A good summary is Ulrich Pietsch, "Tschirnhaus und das europäische Porzellan," in Peter Plaßmeyer et al. (eds.), *Experimente mit dem Sonnenfeuer: Ehrenfried Walther von Tschirnhaus (1651–1708)* (exh. cat.), Dresden, 2001, 68–74, 73 (quotation), and Pietsch, "Die Erfindung des europäischen Hartporzellan 1708 in Dresden," in U. Pietsch and Peter Ufer, *Mythos Meissen: Das erste Porzellan Europas*, Dresden, 2008, 8–29.

4. Quoted in Günter Reinheckel, "Johann Jakob Irminger: Der erste Formgeber der Meissner Manufaktur," *Keramos* 21 (1963), 14.

5. Pietsch, "Tschirnhaus und das europäische Porzellan," 73; Otto Walcha, "Paul Wildensteins Eingabe," *Mitteilungsblatt Keramik-Freunde der Schweiz* 42 (1958), 17–22, 21 (for the teapot demonstration); Nicholas Zumbulyadis, "Böttger's Eureka! New Insights into the European Reinvention of

Porcelain," *Bulletin for the History of Chemistry* 35:1 (2010), 24–32; Maureen Cassidy-Geiger, "Luxury Markets and Marketing Luxuries: The Leipzig Fair and the Dresden Merceries Under Augustus the Strong," in Christof Jeggle et al. (eds.), *Luxusgegenstände und Kunstwerke vom Mittelalter bis zur Gegenwart*, Constance, Germany, 2015, 443–444. I am grateful to Maureen Cassidy-Geiger for generously sharing her expertise.

6. *Meissen: La découverte de la porcelaine européenne en Saxe. J. F. Böttger, 1709–1736*, Paris, 1984, 52. For another connection between Dinglinger and Böttger that involves the figure of another Dresden goldworker, arcanist, enameller, and porcelain decorator, see Ruth Berges, "C. K. Hunger: Itinerant Enameller Extraordinary," *Connoisseur* 163:2 (1966), 202–205.

7. An enameled Böttger stoneware octagonal plate, dated to 1711–1712 and attributed to Böttger's collaboration with Georg Friedrich Dinglinger, is in the Victoria and Albert Museum, London, inv. no. C.366–1921. For a second example today in Gotha, see Ulrich Pietsch, "*Of Red or Brown Porcelain—Decoration and Refinement of Böttger Stoneware*," in Dirk Syndram and Ulrike Weinhold (eds.), *Böttger Stoneware: Johann Friedrich Böttger and Treasury Art*, Dresden, 2009, 46–48.

8. Reinheckel, "Johann Jakob Irminger," esp. 14–17; Juliane Wolschina, "Der 'Mons Philosophorum': Ein Meisterwerk Dinglingers in Braunschweig," in Dirk Syndram and Juliane Wolschina (eds.), *Herzog Anton Ulrich zu Gast in Dresden: Schatzkammerstücke des Herzog-Anton-Ulrich-Museums Braunschweig* (exh. cat.), Dresden, 2012, 54–67. During Böttger's childhood, when his father lost his job, the family moved in with the father's brother, a prosperous goldsmith; see Marchand, *Porcelain*, 31.

9. Eva Ströber, "*La maladie de porcelaine . . .*": *Ostasiatisches Porzellan aus der Sammlung Augusts des Starken* (exh. cat.), Leipzig, 2001, 9 (for Augustus's admission of his "maladie"); Cordula Bischoff, "Women Collectors and the Rise of the Porcelain Cabinet," in Jan van Campen and Titus Eliëns (eds.), *Chinese and Japanese Porcelain for the Dutch Golden Age*, Zwolle, Netherlands, 2014, 171–189; Susan Broomhall and Jacqueline Van Gent, "The Gendered Power of Porcelain Among Early Modern European Dynasties," in James Daybell and Svante Norrhem (eds.), *Gender and Political Culture in Early Modern Europe, 1400–1800*, Abingdon, U.K., 2017, 49–67.

10. Christine Jones, *Shapely Bodies: The Image of Porcelain in Eighteenth-Century France*, Newark, DE, 2013, chap. 1; Samuel Wittwer, *The Gallery of Meissen Animals: Augustus the Strong's Menagerie for the Japanese Palace in Dresden*, Munich, 2006, 24.

11. Johann von Besser, "First Coronation Ceremony in the Electoral House of Brandenburg," translated in Karin Friedrich and Sara Smart (eds.), *The Cultivation of Monarchy and the Rise of Berlin: Brandenburg-Prussia 1700*, Farnham, U.K., 2010, 247; Samuel Wittwer, "Fragile Splendour and Political Representation: Baroque Porcelain Rooms in Prussia and Saxony as Meaningful Treasures," *International Ceramics Fair and Seminar*, London, 2004, 36–44; Wittwer, *The Gallery of Meissen Animals*, 21–24. Interestingly, Augustus's reference to his own *maladie de porcelaine* likewise coupled it with an addiction to orange trees.

12. Wittwer, *The Gallery of Meissen Animals*, 18, 46; Wittwer, "Fragile Splendour and Political Representation"; Meredith Martin, "Porcelain Rooms," in Erin Griffey (ed.), *Early Modern Court Culture*, Abingdon, U.K., 2022, 343–358. I am grateful to Meredith Martin for sharing this essay with me.

13. Dirk Syndram and Jörg Schöner, *August der Starke und sein Grossmogul*, Munich, 2014, 12. It is sometimes suggested that Louis XIV's *Trianon de Porcelaine* was an important influence on Augustus, who saw it in Versailles during his visit in 1687. But at that point the *Trianon* was rather run down and about to be dismantled, and thus perhaps less likely as a direct influence on Augustus than the fresh experiences during the meeting of the three kings.

14. Julia Weber, "Copying and Competition: Meissen Porcelain and the Saxon Triumph over the Emperor of China," in C. Forberg and P. W. Stockhammer (eds.), *The Transformative Power of the Copy*, Heidelberg, 2017, 331–373, 346, 366 (quotations); also Wittwer, *The Gallery of Meissen Animals*, 36, 136, 266, and Christiane Hertel, *Siting China in Germany: Eighteenth-Century Chinoiserie and Its Modern Legacy*, University Park, PA, 2019, 18–34.

15. Weber, "Copying and Competition," 341–347; Wittwer, *The Gallery of Meissen Animals*, 45–46, 54, 164–167.

16. Jonas Hanway, *An Historical Account of the British Trade over the Caspian Sea: With a Journal of Travels*, London, 1753, 2:223. Hanway visited Dresden in 1750 and wrote what he believed was the first detailed account "of the profusion of expensive trinkets" in the Grünes Gewölbe, "of most exquisite art, collected at a prodigious expence" (221).

17. Jean de Préchac, "Sans Parangon," in Préchac, *Contes merveilleux*, ed. Tony Gheeraert, Paris, 2005 (orig. 1698), 700, 712; Jones, *Shapely Bodies*, 54–56; Hall Bjørnstad, *The Dream of Absolutism: Louis XIV and the Pre-Modern Logic of Modernity*, Chicago, 2021, 185 (quotation).

18. Wittwer, *The Gallery of Meissen Animals*. See 264 for Augustus's instruction to break the molds of the menagerie animals, as reported by Johann Georg

Keyssler, *Neueste Reisen durch Deutschland*, 2nd printing, Hanover, 1751, letter of 23 October 1730. See also Cassidy-Geiger, "Luxury Markets and Marketing Luxuries," 443–444.

19. Lothar Ledderose, *Ten Thousand Things: Module and Mass Production in Chinese Art*, Princeton, NJ, 2000, 85–101; Ströber, *"La maladie de porcelaine,"* 114.

20. Pietsch, "Die Erfindung des europäischen Hartporzellan," 27–29; Siegfried Ducret, *Die Zürcher Porzellanmanufaktur und ihre Erzeugnisse im 18. und 19. Jahrhundert, Band II: Die Plastik*, Zurich, 1959, 21; Maureen Cassidy-Geiger, "Rediscovering the *Specksteinkabinett* of Augustus the Strong and Its Role at Meissen: An Interim Report," *Keramos* 145 (1994), 4–10; Cassidy-Geiger, "Forgotten Sources for Early Meissen Figures," *American Ceramic Circle Journal* 10 (1997), esp. 59. An early Böttger stoneware Guanyin, dated to c. 1710–1713, is in the Metropolitan Museum of Art, New York (inv. no. 1974.356.319). For Pagod figures, and for a Guanyin porcelain figure based on a soapstone one, see Melitta Kunze-Köllensperger, "Meissen. Dresden. Augsburg: Meissen Porcelain Sculpture Before Kirchner and Kaendler," in Pietsch and Banz (eds.), *Triumph of the Blue Swords*, 54–56, cat. 170–171. See also the pair of early Meissen oriental figurines in Erika Pauls-Eisenbeiss, *German Porcelain of the 18th Century: The Pauls-Eisenbeiss Collection*, London, 1972, 1:72–73. European imitations of Chinese Pagod figures appeared already before Meissen in Dutch Delftware: cf. Suzanne Lambooy, "Imitation and Inspiration: The Artistic Rivalry Between Dutch Delftware and Chinese Porcelain," in Van Campen and Eliëns (eds.), *Chinese and Japanese Porcelain for the Dutch Golden Age*, 246.

21. For the tensions in the Meissen factory between the market-driven production of multiples and the urge to create one-of-a-kind pieces, see Otto Walcha, *Meissen Porcelain*, New York, 1981, 96–100, and Marchand, *Porcelain*, 38, 44–46. For the technical processes that allowed for the making of Meissen porcelain figurines in multiples that were nevertheless somewhat different from one another, see Röntgen, *The Book of Meissen*, 148–150. The question of replication in porcelain figurines and its cultural consequences is taken up in Ray Schrire and Dror Wahrman, *The Lady in Porcelain: A Tale of Eighteenth-Century Generic Crossings and Cultural Metamorphoses*, forthcoming.

Photographic Credits

Figures

1: Photo: Jörg Schöner
2: Staatliche Kunstsammlungen Dresden, photo: Bildarchiv Grünes Gewölbe
3: Photo: Jörg Schöner
4: Public domain
5: Sebastian Neumeister
6: Top: public domain; bottom: photo: Dirk Weber
7: Left: public domain; right: photo: Jörg Schöner
8: Collection of National Museum in Warsaw
9: Collection of National Museum in Warsaw
10: © AFP via Getty Images
11: Left: public domain; right: Grünes Gewölbe, Staatliche Kunstsammlungen Dresden, photo: Jürgen Karpinski
12: Top left: Frans Hals Museum, photo: Arend Velsink; all others: public domain
13: Top: photo: Dror Wahrman; bottom: Grünes Gewölbe, Staatliche Kunstsammlungen Dresden, photo: Jürgen Karpinski
14: © bpk / Staatliche Kunstsammlungen Dresden
15: Photo: Jörg Schöner; inserts: public domain
16: Top left: photo: Jörg Schöner; bottom left: Grünes Gewölbe, Staatliche Kunstsammlungen Dresden, photo: Jürgen Karpinski; top and bottom right: The Trustees of the British Museum. All rights reserved
17: Public domain
18: Grünes Gewölbe, Staatliche Kunstsammlungen Dresden, photo: Jürgen Karpinski
19: Staatliche Kunstsammlungen Dresden, photo: Bildarchiv Grünes Gewölbe
20: Public domain

21: Top: photo: Grünes Gewölbe, Staatliche Kunstsammlungen Dresden, photo: Jürgen Karpinski; bottom: public domain

22: Top: photo: Grünes Gewölbe, Staatliche Kunstsammlungen Dresden, photo: Jürgen Karpinski; bottom (left and right): public domain

23: Top: photo: Jörg Schöner; bottom: public domain

24: Top: photo: Jörg Schöner; bottom: public domain

25: Top: photo: Jörg Schöner; bottom: public domain

26: Left: public domain; right: Grünes Gewölbe, Staatliche Kunstsammlungen Dresden, photo: Jürgen Karpinski

27: Top: Bibliothèque nationale de France; bottom: Grünes Gewölbe, Staatliche Kunstsammlungen Dresden, photo: Jürgen Karpinski

28: Public domain

Plates

1: Public domain

2: Photo: Jörg Schöner

3: Public domain

4: Photo: Jörg Schöner

5: Photo: Jörg Schöner

6: Photo: Jörg Schöner

7: Photo: Jörg Schöner

8: Photograph © The State Hermitage Museum, photo: Pavel Demidov

9: Public domain

10: Public domain

11: Grünes Gewölbe, Staatliche Kunstsammlungen Dresden, photo: Jürgen Karpinski

12: Top: Royal Collection Trust / © Her Majesty Queen Elizabeth II 2020; bottom: University of Michigan Museum of Art, Museum Purchase, 1968/2.62

13: Top: The Royal Danish Collection, The Amalienborg Museum, photo: Iben B. Kaufmann; bottom: Rüstkammer, Staatliche Kunstsammlungen Dresden, photo: Jürgen Karpinski

14: Public domain

15: Grünes Gewölbe, Staatliche Kunstsammlungen Dresden, photo: Jürgen Karpinski

16: Grünes Gewölbe, Staatliche Kunstsammlungen Dresden, photo: Jürgen Karpinski

17: Regents of the University of Michigan, Department of the History of Art, Visual Resources Collections

18: Freer Gallery of Art, Smithsonian Institution, Washington, DC: Purchase—Charles Lang Freer Endowment, F1942.15a

19: Top: © bpk / Kupferstichkabinett, SMB / Jörg P. Anders; bottom right: The Royal Danish Collection; bottom left: Kungl. Hovstaterna, photo: Håkan Lind

20: Public domain

21: Photo: Dror Wahrman

22: Top: photo: Dror Wahrman; bottom: © The Royal Court, Sweden, photo: Alexis Daflos

23: Photo: Dror Wahrman

24: Top right: photo: Jörg Schöner; bottom center: photo: Dror Wahrman; others: Grünes Gewölbe, Staatliche Kunstsammlungen Dresden, photo: Jürgen Karpinski

25: Grünes Gewölbe, Staatliche Kunstsammlungen Dresden, photo: Jürgen Karpinski

26: Grünes Gewölbe, Staatliche Kunstsammlungen Dresden, photo: Jürgen Karpinski

27: Top: Grünes Gewölbe, Staatliche Kunstsammlungen Dresden, photo: Jürgen Karpinski; bottom: photo: Jörg Schöner

28: Public domain

29: © The Thomson Collection at the Art Gallery of Ontario, Toronto AGOID.29458

30: Photo: Dror Wahrman

31: Photo: Dror Wahrman

32: Photo: Dror Wahrman

33: Christie's images, 2012

34: Top: photo: Dror Wahrman; bottom: Photo © Musée du Louvre, Dist. RMN-Grand Palais / Martine Beck-Coppola

35: Top: The Summus Custos of the Cathedral, photo: Berthold Kress; bottom: Creative commons, Museo di San Martino, Napoli

36: Creative commons, Museo di San Martino, Napoli

37: Top: photo: Jörg Schöner; center and bottom: Grünes Gewölbe, Staatliche Kunstsammlungen Dresden, photo: Jürgen Karpinski

38: Photo: Jörg Schöner

39: Top left, top right, bottom right: photo: Jörg Schöner; bottom left: Grünes Gewölbe, Staatliche Kunstsammlungen Dresden, photo: Jürgen Karpinski; center: public domain

40: Photo: Jörg Schöner

41: Top: photo: Jörg Schöner; bottom: public domain

42: Photo: Jörg Schöner

43: Photo: Jörg Schöner

44: "The Most Bejeweled Saint," postcardsfromsanantonio.com

45: Photo: Dror Wahrman

46: Photo: Dror Wahrman

47: Photo: Jörg Schöner

Index